Fundamentals of Lithographic Printing

Fundamentals of Lithographic Printing

Volume I
Mechanics of Printing

by
John MacPhee

GATFPress
Pittsburgh

Library of Congress Catalog Card Number: 97-78414
International Standard Book Number: 0-88362-214-9

Printed in the United States of America

GATF Order No. 1440

GATF*Press*
Graphic Arts Technical Foundation
200 Deer Run Road
Sewickley, PA 15143-2600
Phone: 412/741-6860
Fax: 412/741-2311
http://www.gatf.org

Contents

To Betty

I often say that when you can measure what you are speaking about, and express in numbers, you know something about it; but when you cannot express it in numbers, your knowledge is of a meagre and unsatisfactory kind; it may be the beginning of knowledge, but you have scarcely, in your thoughts, advanced to the stage of *science, whatever the matter may be.*

William Thomson
(Lord Kelvin)

In God we trust. All others bring data.

Mike Houser

Preface

This work is directed to all those who seek a better understanding of the lithographic printing process. The need for such a work was first felt by the author when he entered the printing industry in 1972 as an experienced development engineer, but with zero knowledge of lithography. In addition to appealing to like engineers entering the industry, it is hoped that this book will be useful to both students training for a career in printing and workers already in the field.

Originally, a single book was planned. As writing progressed and a more detailed organization of the material evolved, it was decided to divide the work into two volumes. Thus, this first volume, on the mechanics of printing, is to be followed by a second, that will take up interactions on press, and that will also include chapters on the three consumable materials used in lithographic printing: ink, paper, and fountain solution.

As the title suggests, a major emphasis has been placed on conveying a better understanding of the principles of lithographic printing, rather than on presenting prescriptions for solving specific problems. This has been done on the theory that one who is armed with a good understanding of fundamentals is much better equipped to take a systematic approach to both the solving of problems and improving the process. Because of this emphasis, the bulk of this first volume has been limited to the simpler segment of single-color sheetfed printing. A chapter has been included, however, that identifies and discusses the major differences encountered in web printing. The complexities of multicolor or process-color printing have been reserved for Volume II.

A second major emphasis has been placed on presenting factual and quantitative information, and avoiding subjective and speculative arguments. Toward this end, equations are used from time to time to provide exact descriptions of certain phenomena. An effort has been made, however, to compose the text so that the reader can skip over the equations and still gain a worthwhile understanding and insight of the subject at hand.

A few words are also in order about what this book is not. Nothing contained herein should be construed as an assessment of the merits of any of the specific manufacturers designs, that are identified. The purpose of this book is to provide insight, not to pass judgment. To do otherwise would mislead the reader because almost every successful piece of hardware or system must be evaluated under the operating conditions for which it was designed, and this is a task that is beyond both the intent and scope of this work.

In general, values have been expressed in English units and, in most cases, are followed parenthetically by equivalent values in metric units. Exceptions are the values of ink film thickness, expressed in microns. The

reason for this is that printed ink film thicknesses are about one micron. Thus the many ink film thicknesses discussed in the text can be specified in terms of relatively small numbers, greater than zero. For example, 2 microns is easier to grasp and remember than the equivalent values of 0.00008 inches, 0.08 mils, and 0.002 millimeters.

To avoid misunderstanding, abbreviations generally have not been used. An exception has been made in the lists of references at the end of each chapter. They have been simplified by using abbreviations of familiar organizations, such as TAGA, and by omitting their locations. Complete information on such sources is, however, given under the appropriate listings in the glossary that has been included as an appendix. In another regard to references, italics have been used to designate publications including books, journals, magazines, and patents.

In keeping with industry jargon, the terms water and fountain solution have been used interchangeably. For the same reason the term vibrating roller has been used over the more grammatically correct term oscillating roller.

The important topics of ink film splitting and ink transfer have not been included in Chapter 2 on Cylinders, Blankets, and Plates, as might be expected. Rather, these subjects are included in Chapter 3, on Rollers and Rolling Action, because all of the other topics related to rolling action are presented there.

Several reviewers suggested the addition of a section on the measurement of surface roughness. Although this was not done, this suggestion serves as a reminder that it is not always easy to obtain accurate measurements of surface roughness, especially of soft or compliant materials. Thus, the results of such measurements quoted here should not be accepted on blind faith.

It is believed that this book contains much information that has not been presented before. For example, of the over 200 diagrams and photographs contained herein, more than half of them have never been published before. Examples of new topical information are the explanation of starvation ghosting, given in Section 4.2.4 in the chapter on inking system design, the analysis of feedrate versus speed in squeeze-roller dampening systems, given in Section 5.5.2 of the chapter on dampening system design, and the explanation of the principles of web tension given in Section 6.3 of the chapter on the unique features of web printing.

In general, the new information presented is consistent with existing knowledge, and therefore contains no surprises. One minor exception is the data on the pressures existing in typical roller nips, given for example, in Table 3.1 in Chapter 3. These pressures are about double the values given in an earlier paper by the author, and result from the improved method of calculation that was used and is presented in the same chapter.

The material presented in this volume was developed from two main sources: the many published results of researchers in graphic arts

technology throughout the world, and the many discussions the author has had over the years with both printers and suppliers. The former source is acknowledged in the list of references that appear at the end of each chapter. The latter source, personal contacts, can never be fully acknowledged because there are so many people who have contributed to the author's store of information and insights.

There is a smaller group however, whom the author has called upon frequently over the years, and the many hours spent by these individuals in the discussions that followed is gratefully acknowledged herewith. This group includes Bob Bassemir of Sun Chemical, Larry Bain of Goss, Bruce Blom of Mead, Dan Clark of RIT, Tyler Dahlgren of Epic, Chet Daniels of RIT, Lloyd DeJidas of GATF, Julius Domotor of Advanced Litho, Brad Evans of GATF, Harold Gegenheimer of Baldwin, Dave Gerson of Printers Service, Andy Hagler of Thebault, Larry Lester of Lester Litho, John Lind of GATF, and Bill Tasker of INX. The author also wishes to thank Harold Gegenheimer, Wendell Smith and Gerry Nathe, all of Baldwin, who encouraged and supported his research of the lithographic process over the years. A special note of thanks is owed to Mary Grace Desiderio, the librarian at GATF, for ferreting out many references; and to my wife, Betty, for typing the entire manuscript.

Invaluable assistance was provided by a group of my colleagues who agreed to review specific chapters and sections as follows: Bill Tasker of INX, Chapter 1; Richard Goodman of Polychrome and Dennis O'Rell formerly of Grace, Chapter 2; Bob Bassemir of Sun and Chem-Mong Chou of Goss, Chapter 3; Chem-Mong Chou of Goss and Phil Tobias of Tobias Associates, Chapter 4; Birger Hansson of Jimek and Tyler Dahlgren of Epic, Chapter 5; Joe Abbott of MAN Roland and Ted Niemiro of Goss, Chapter 6; Tom Fadner, consultant, and Dick Warner of GATF, Chapter 7; Ed Hudyma of Goss, Section 6.3 on web tension; Lou Tyma formerly of Goss, Section 7.1 on reverse dampening; Brian Chapman of Pisces and Richard Holub of Imagicolor, the sections in Chapter 7 on screening; and Phil Tobias of Tobias Associates, the section in Chapter 7 on gelatin coated plates. In this regard, Harold Gegenheimer of Baldwin and John Lind of GATF, deserve separate mention for their contributions in reviewing the entire volume. The meticulous review and editing of Tom Destree, Editor in Chief of GATF, was most welcomed and proved invaluable in reducing the manuscript to the final form presented herein.

All of these reviews produced many helpful comments and suggestions that added greatly to this book. The reader is reminded, however, that these reviews do not constitute endorsements, and that any errors or omissions he may find must be attributed to the author.

The author wishes to acknowledge the provenance of the following illustrations and to express his gratitude to the respective publishers for their permission to reproduce them in this book: Figures 1.6, 5.10(a), 5.17(a), 5.17(b), 5.18(a), 5.18(b), and 5.25 from an article by the

author in the April 1981 issue of *Graphic Arts Monthly*; Figures 5.18(c), 5.18(d), 5.18(e), and 5.18(f), from an article by the author in the September 1984 issue of *Graphic Arts Monthly*; Figure 5.5 from a paper by Trollsas, Eriksson, and Malmqvist in TAPPI's 1992 Proceedings of International Printing & Graphic Arts Conference, Figure 7.15 from the Goss Graphic Systems brochure *Newsliner,* Figure 7.16 from the KBA brochure *KBA Anilox Offset,* Figure 7.17 from a diagram provided by MAN Roland, Figure 7.18 from the Mitsubishi Heavy Industries brochure *Keyless Tower Unit,* Figure 7.19 from a diagram provided by TKS, and Figure 7.20 from the WIFAG brochure *Keyless, Short Yet Adjustable.* Thanks are also due Tony Cieri and Gene Brandon of Sun Chemical for making the photomicrographs of the collotype prints used in Figure 7.35.

John MacPhee
6 Nylked Terrace
Rowayton, CT 06853

December 16, 1997

Chapter 1

Overview

Mechanical printing involves using a master or plate, containing an image, to repetitively produce inked reproductions of the image on a substrate, which is usually paper. The lithographic process is unique among the three major processes (lithography, flexo/letterpress, and gravure) in that the image and nonimage areas of the plate are, for all practical purposes, in the same plane. In contrast, the image areas are raised on a flexo plate and depressed on a gravure or intaglio plate.

A typical lithographic plate consists of a 0.012-inch-thick aluminum sheet, coated with a material sensitive to light. The desired image to be printed is produced by placing a photographic film, containing the image, over the plate and exposing it to light. The exposed plate is then developed, wherein the coating that had been located under the nonimage areas of the film is washed away, leaving a positive image on the plate, formed by the coating that remains.

The plate is installed in the press by mounting it on a rigid steel cylinder. The basic task of printing is then accomplished by (1) first applying a thin film of aqueous dampening or fountain solution that need only stick to the nonimage area of the plate, (2) applying ink that should only stick to the image areas, and (3) then transferring the inked image to paper. It is the job of a printing press to repeat these three basic steps over and over again as successive sections of paper are passed or fed through the press.

Some appreciation for the demands that these tasks place on the various subsystems of a press can be had by considering the dimensions of the various materials used. Figure 1.1 identifies and compares the dimensions of four major elements of printing: the thickness of a typical paper to be printed, the required ink film thickness on the plate, the required water or fountain solution film thickness on the plate, and the thickness of the plate itself. This figure also shows how these printing elements, along with a human hair, would look to the reader if he were to shrink in size by a factor of 6000, or to a height of twelve thousandths of an inch (300 microns). The implication of these dimensions is that very accurate and sophisticated systems are needed to meter out and deliver both ink and fountain solution to the plate.

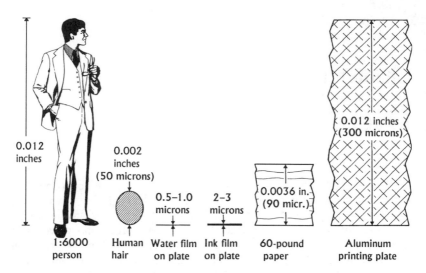

Figure 1.1 Comparison of the dimension of some materials used in lithographic printing. Note that one micron is equal to approximately 0.04 thousandths of an inch.

1.1 Typical Press Design

Most of the large lithographic printing presses currently being produced are designed to print several different color inks in succession, so as to achieve a broad spectrum of colors in the printed product. To do this, the press is equipped with a station or unit for each different color to be printed. This book, however, is limited to single-color printing, since it is directed toward an understanding of the basic process of delivering ink to paper, so as to produce the desired image in a consistent manner.

A typical single-color lithographic press consists of four major elements or subsystems: the printing cylinders, the inking system, the dampening system, and the paper handling system. All of these are identified on the diagram of a typical high-speed rotary sheetfed press given in Figure 1.2.

1.1.1 **Printing Cylinders.** In the early 1900's, it was discovered that better printing could be achieved by transferring the inked image on the plate to the paper via a rubber-covered cylinder. (This extra operation is sometimes referred to as offsetting, hence the alternate name of offset for the lithographic printing process.) Thus, modern presses designed to print on only one side of the paper at a time contain three different printing cylinders in each printing unit: a plate cylinder, a blanket cylinder, and an impression cylinder.

These three cylinders differ in several respects from the rollers that make up the inking and dampening systems. First, they are all of the same

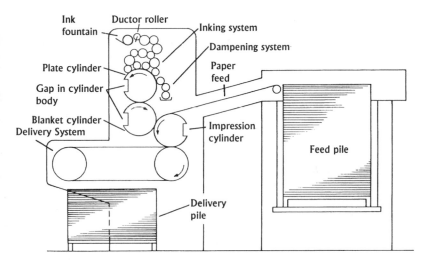

Figure 1.2 Side view of a typical sheetfed lithographic printing press.

diameter, and this diameter is two or more times larger than those of the rollers. A second very significant difference is that the plate and blanket cylinders have printing surfaces made up of thin detachable covers, typically an aluminum plate, 0.008–0.012 inches thick, and a composite rubber blanket, typically 0.070 inches thick.

Another important difference is that the center-to-center distance between plate and blanket cylinders is controlled by hardened steel rings or bearers running in contact with each other, as shown in Figure 1.3. Since the diameters of the cylinder bodies are smaller than those of the bearers, a precisely controlled clearance exists between the cylinder bodies, also as shown in Figure 1.3. Thus the pressure existing between the two printing surfaces at the nip, or conjunction, of the two cylinders, is governed by the thickness of the plate and blanket plus the thin sheets of packing material placed under them that fill the gap.

The fourth significant difference is that the cylinder nip pressures are over thirty times greater than the nip pressures between the rollers in the inking and dampening systems. All three cylinders are geared to the press drive and are driven at essentially the same surface speed.

As already stated, the purpose of the plate cylinder is to provide a carrier for the master or plate, since each job to be printed requires its own plate. Accordingly, clamps are installed in the plate cylinder gap to enable the operator to quickly change plates. On each revolution of the plate cylinder, the image area is re-inked by the inking system, following which the inked image is transferred to the blanket cylinder.

The main job of the blanket cylinder is to transfer the inked image to the paper being printed. Since the thin composite rubber sheet or blanket

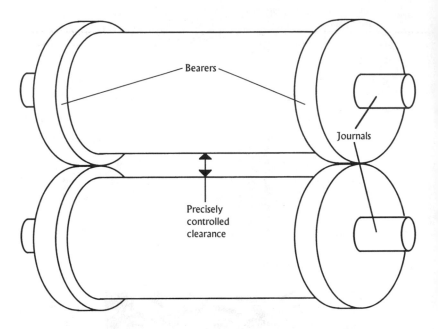

Figure 1.3 Typical plate and blanket cylinder arrangement. Running on bearers produces a precisely controlled clearance between cylinder bodies.

that covers the blanket cylinder must be replaced periodically because of wear or damage, clamps are also provided in the gap of the blanket cylinder to enable the blanket to be changed quickly as well.

The impression cylinder has two jobs: to transport the paper sheets to be printed to the blanket cylinder nip, and to support the high pressure needed to effect good transfer of the inked image from blanket cylinder to paper. To accomplish its first task, a set of grippers is located in the impression cylinder gap. As the gap rotates past the paper feed section of the press, the grippers are closed to clamp the leading edge of a paper sheet. Thus the paper sheet is carried around the impression cylinder circumference to the nip formed with the blanket cylinder. Some time after exiting this nip, the grippers are opened and the pull on the sheet is transferred to a set of grippers in the delivery section of the press, which transports it to the delivery pile.

1.1.2 **Inking System.** The task that the inking system is called upon to perform is by no means simple, in that it must deliver a consistent supply of ink to the image area of the plate at speeds of up to 15,000 plate cylinder revolutions per hour on a sheetfed press and 60,000 or more on a web press. The precision with which this must be accomplished is highlighted by the fact that the thickness of the ink film deposited on the

paper is about 1 micron (0.00004 inch) for coated paper as shown in Figure 1.4 (MacPhee, 1979). In newspaper printing, the film thickness may be as high as 1.5 microns.

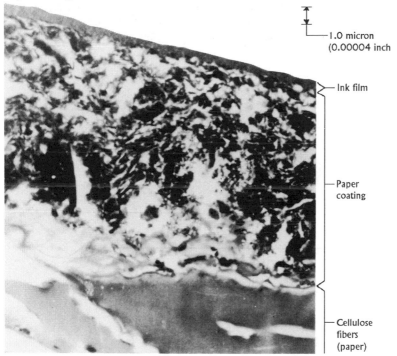

1.0 micron
(0.00004 inch

Ink film

Paper
coating

Cellulose
fibers
(paper)

Figure 1.4 Electron microscope photograph of section through coated paper showing dry printed ink film. Maximum film thickness is slightly less than 1.0 micron.

Furthermore, variations in a one-micron film thickness of as little as 0.1 micron can produce a variation in print density of 0.08 density units. This latter variation is higher than can be detected by the eye of a skilled pressman and is also greater than what many print buyers consider acceptable. For the ensuing discussion in this chapter, the required film thickness on paper will be taken as one micron.

As shown in Figure 1.2, the press inking system consists of a train of rollers, alternately rubber-covered and hard-surfaced, that transport ink from a reservoir or fountain to the plate. Except for the ductor and fountain rollers (to be described later on), all of the rollers run at the same surface speed, within a few percent, as the plate. Thus, ink transfer at the respective nips takes place primarily due to the averaging process that results when the two films of ink on the adjoining rollers are joined and then split apart, as they pass through the nip. Although film splitting is not a simple process, as brought out by the many detailed investigations of it

that have made, it will be sufficiently accurate for the purposes of this book to assume a 50/50 split. That is, the ink film thicknesses on the rollers at the nip exit are assumed to be the same and thus equal to the average of the sum of the film thicknesses on the rollers prior to entering the nip. Using this model, and the above final film thickness, the ink film thicknesses can be calculated throughout the roller train, assuming 100 percent coverage of the plate.

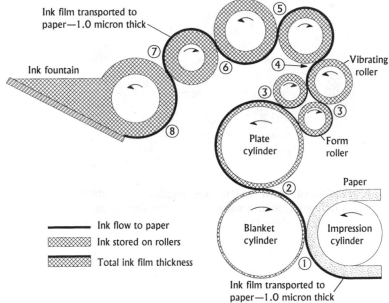

Figure 1.5 Roller diagram of an idealized inking system with ink film thicknesses shown to scale. Circled numbers indicate total film thickness in microns at given location.

This has been done for an idealized inking system design similar to a design proposed over 85 years ago (Wood, 1918). This system, along with the calculated film thicknesses, is shown in Figure 1.5. This shows that the ink film thickness on the vibrator above the form rollers is 3 to 4 microns, which compares reasonably well with the values of 4 to 6 microns that were measured at the end of a run of 1000 impressions on a sheetfed press (Adams, 1954) using radioactive tracer techniques.

Further study of Figure 1.5 reveals a number of other interesting facts as follows:

1. The ink film thickness carried by the plate is 2 to 3 microns.
2. The total ink film thickness on a roller (other than a form roller) is some multiple of the thickness of the ink film being transported times one plus the number of nips it is removed from the plate.

3. The gradient in ink film thickness that develops down the roller train only exists while ink is being transported. Thus, if the roller train is disconnected from both the fountain and the plate (the normal action when not printing), the ink remaining on the rollers will be redistributed so that each roller will have the same ink film thickness. For the example shown in Figure 1.5, this average film thickness would be 4 to 6 microns. This point is significant in that when printing is resumed, the ink film on the form rollers will be somewhat thicker than required and desired. Thus an excessive amount of ink will be transferred initially, causing the first few sheets off the press to have higher print densities.

4. To meter out the desired amount of ink, the gap or opening between the ink fountain roller and blade must be 8 microns (0.00032 inch)—clearly impractical in a real system, for reasons that are explained in Chapter 4.

Although the idealized design shown in Figure 1.5 is useful in understanding how an inking system works, practical inker designs differ considerably. These differences, listed as follows, are elaborated on in subsequent chapters:

1. Additional form rollers are employed to minimize ghosting. Ghosting is defined as abrupt variations in print density on the sheet caused by the uneven films of ink that are left on the form rollers by the difference in ink transfer to image and nonimage areas of the plate.

2. Some, if not all, of the hard-surface rollers are provided with a lateral vibratory or oscillatory motion to randomize rib formation and to reduce ghosting.

3. The number of rollers used is much larger—as in Figure 1.2.

4. The ink fountain roller speed is reduced so as to permit the use of a wider metering gap between the fountain blade and roller.

5. A ductor roller, as shown in Figure 1.2, is used to intermittently transport ink from the slow-moving fountain roller to the higher-speed ink train. This results in an uneven rate of ink feed and is another reason why a larger number of rollers is used in practice.

6. On sheetfed presses, the plate cylinder surface is interrupted by a gap in the circumference that can be as long as 30 percent of the cylinder circumference. This gap presents an additional obstacle to providing an even ink feed rate. Corresponding gaps exist in the blanket and impression cylinders.

1.1.3 Dampening System. As already pointed out, the primary function of the dampening system is to supply and maintain a thin film of aqueous fountain solution (or water as it is often called) on the nonimage areas of the plate. The thickness of this film is significant, not only to the design of the dampening system, but also to an understanding of the

mechanism of lithography, taken up further along in this chapter. Although the literature on actual water film thicknesses is limited, there is consistency in the data that is available. Jorgensen (Jorgensen, 1962) states flatly that the water film thickness on the plate is about one micron, and his statement is supported by measurements of the actual film on an operating press, made using an infrared sensing device (Albrecht and Wirz, 1967). The discussion of a second completely independent set of measurements (Lawson and Watkinson, 1975) also indicates that, typically, the water film on the plate is about one micron.

A series of fountain solution consumption measurements made on a large number of different presses (MacPhee, 1985) indicated that fountain solution usage is equivalent to a web-like stream of water, equal to press width and traveling at press speed, that has a thickness of approximately 0.4 microns. This rate of consumption is entirely consistent with the aforementioned measured film thicknesses on the plate. The very important conclusion to be drawn from all this data is that the required water film thickness on the nonimage areas of the plate is one-half to one-third the thickness of the ink film carried by the plate image areas and ink form rollers.

Thirty to forty years ago, practically all of the lithographic presses made were equipped with dampening systems that used a metering method very similar to current design inking systems. That is, dampeners of that era were of the ductor type, consisting of a fountain pan, a slow moving or ratcheting roller immersed in the pan, and a ductor roller that periodically transferred dampening solution from the fountain roller to a relatively short train of rollers, running at press speed, that in turn carried dampening solution to the plate. In today's presses, the ductor type dampener has been largely replaced by a wide variety of designs. The reasons for this great diversity in modern dampening system designs are explained in Chapter 5. For the purpose of explaining the basics of dampening however, the discussion in this chapter will be limited to the relatively simple design shown in Figure 1.2.

Figure 1.6 is a detailed diagram of the very simple dampening system (MacPhee, 1981) shown in Figure 1.2. Fountain solution is stored in a pan-like reservoir and picked up by the rubber pan roller that is partially immersed in it. The operating speed of the pan roller is high enough such that more water than needed is carried to the inlet of the nip formed by its junction with the chrome transfer roller. The inlet of this nip is thus flooded. The amount of fluid that passes through a given metering nip is, however, precisely controlled by four factors as follows:

1. Speed of both rollers.
2. Hardness of the rubber pan roller.
3. Roller setting, i.e., pressure existing in the nip.
4. Viscosity of the fountain solution.

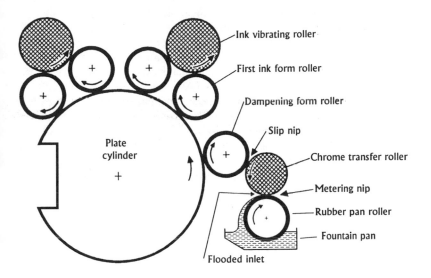

Figure 1.6 Detailed diagram of dampening system shown in Figure 1.2.

Because of the squeezing action between this pair of rollers, this technique of metering is referred to as the "squeeze roller method."

The chrome transfer and pan rollers are geared together and driven by a separate variable-speed motor, at a much lower speed than the other rollers and cylinders on the press. Although the consumption or usage of fountain solution is remarkably consistent, it is necessary in practice for the press operator to vary the amount of water fed to the plate. This is because the minimum amount of water needed varies with the type of ink, the type of fountain solution, and the type of plate used, along with the thickness of ink that is printed. To satisfy this requirement, the controller for the motor that drives the pair of squeeze rollers is equipped with an adjustment that permits the operator to vary the speed of these rollers, and hence the water feed rate.

The dampener shown in Figures 1.2 and 1.6 may also be equipped with an ink-receptive vibrating roller running in contact with the dampening form roller. In some designs, this roller also contacts the first ink form roller, thereby acting as a bridge between the dampening and inking systems. Much more is said about this in Chapter 5 on dampening.

1.2 Three Important Phenomena

Mechanical printing involves two basic operations: pressing two surfaces together and then separating them. On a rotary printing press,

these two operations occur over and over again in each of the conjunctions or nips formed by rollers and cylinders in contact with each other. That is, the fluid film existing on two rollers running in contact are first pressed together on entering their common nip, and then pulled apart on exiting. In situations where a single fluid is present on one or both surfaces, the outcome is straightforward and rather easy to understand: the fluid film is split more or less evenly at the exit, such that half of the fluid is carried away by each roller surface.

The outcome of this pressing together and separating operation is not straightforward in lithographic printing because two different fluids, ink and fountain solution, coexist on the rollers of a lithographic press. Thus to understand how and why lithography works, it is necessary to understand how ink and water interact when they meet on the surface of the plate. This in turn requires a knowledge of three important phenomena that have a direct bearing on this interaction:

1. Wetting of a solid surface by a liquid.
2. The emulsification of ink and fountain solution.
3. Fluid behavior in a nip.

1.2.1 **Wetting.** The underlying principle of lithography is that a given solid surface can have properties such that it will be wetted by a given fluid in the presence of a second fluid. The reason why such a property is needed is that, in a lithographic press, the ink form rollers must press against the plate image areas in order to ink them, but in so doing they also press against the nonimage areas that must remain free of ink. Conversely, the dampening form roller presses against both areas with the objective of only dampening (i.e., wetting as defined below) the nonimage areas. For these discriminations to take place, it is necessary that the materials forming the image and nonimage areas possess surface properties such that the image areas will be wet by ink, in the presence of water; and the nonimage areas will be wet by water, in the presence of ink.

In the field of surface chemistry, wetting is defined in terms of the angle of contact between a drop of liquid and a solid on which it is placed, using the convention shown in Figure 1.7. The liquid is said to wet the solid if the angle is close to zero so that the liquid spreads over the solid easily. Non-wetting describes the situation where the contact angle is greater than 90°, so that the liquid tends to ball or bead up and run off the surface easily.

In using this convention, it is essential that the third phase, or material that forms the interface with both the solid and liquid, be specified, since its properties profoundly affect the contact angle. In most of our everyday observations of this phenomenon, the third phase is air, as in the case of a drop of rain that beads up on a newly waxed surface of an automobile. In lithography, however, the contact angles of interest involve a given solid

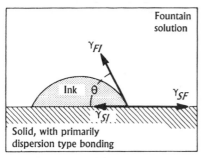 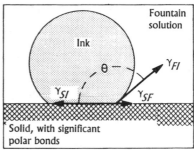

Figure 1.7 Ink contact angle θ, formed on two different solid surfaces in the presence of fountain solution. Solid on left is wet by ink. Solid on right is wet by fountain solution.

and two immiscible liquids, ink and fountain solution, as shown in Figure 1.7. The resultant contact angle provides an indication of which of the two liquids has a greater affinity for the solid, and hence a greater tendency to coat or wet the solid.

The properties that govern which phase has a greater tendency to wet, i.e., the contact angle, are the interfacial surface free energies or interfacial surface tensions. Although it is more correct to define this property as the work or energy necessary to create a unit area of additional surface, it is easier to visualize it as the force per unit length that acts to contract a surface; hence the name, surface tension. The relationship between contact angle and these properties is described by Young's Equation (Young, 1855), which was derived by considering the balance of horizontal surface tensions present at the interface of a liquid drop on a solid surface. This force balance is illustrated in Figure 1.7 and is expressed by (Young's) equation (1.1) for the special case of a drop of ink on a solid in a fountain solution environment.

$$\gamma_{SF} = \gamma_{SI} + \gamma_{FI} \cos \theta \qquad (1.1)$$

where:
γ = interfacial surface tension
θ = contact angle, as in Figure 1.5
S denotes solid
I denotes ink
F denotes fountain solution

The dependence of the contact angle, and hence wetting, on the three interfacial surface tensions can be seen by rearranging equation (1.1) as follows:

$$\cos \theta = (\gamma_{SF} - \gamma_{SI}) / \gamma_{FI} \qquad (1.2)$$

Table 1.1 Calculated interfacial tensions for typical lithographic materials.

Material	Surface tension with respect to vapor (dynes/cm)			Interfacial tension with other materials (dynes/cm)	
	Dispersion bond component α^2	Polar bond component β^2	Total γ	Ink	Fountain solution
Plate image area	36.5	2.9	39.4	0.2	9.3
Plate non-image area	24.8	44.6	69.4	27.9	9.7
Rubber	26.9	4.8	31.7	0.8	4.4
Chrome	26	26.4	52.4	14.0	3.4
Ink	32.5	2.1	34.6	—	9.0
Fountain solution	14.7	14.4	29.1	9.0	—

It would seem that equation (1.2) would be extremely important in that it could be used to screen materials for their suitability or compatibility in lithography. Unfortunately, this is not the case for several reasons. To begin with, none of the interfacial surface tensions defined in equation (1.1) can be measured directly. An added complication arises from the fact that it is the dynamic interfacial surface tensions, i.e., the properties of newly created fluid surfaces, that govern. Finally, there is no universally accepted method for calculating the desired interfacial surface tensions from surface properties that can be measured. Nevertheless, the concept of contact angles is useful in explaining how lithography works. To illustrate this, the postulated relationship of Kaelble (Kaelble, Dynes, and Pav, 1975), given by equation (1.3) and a consistent set of surface tension measurements found in the literature (Pav, Kaelble, Hamermesh, 1976), were used to calculate contact angles for various combinations of lithographic materials. The data used on interfacial tensions are given in Table 1.1 and the calculated contact angles are illustrated in Figure 1.8.

$$\gamma_{ij} = \left(\alpha_i - \alpha_j\right)^2 + \left(\beta_i + \beta_j\right)^2 \tag{1.3}$$

where:

γ = interfacial tensions between phases *i* and *j*

α = square root of that part of γ due to dispersion type (London) bonding forces

β = square root of that part of γ due to polar type (Keesom) bonding forces

For these specific materials and measurements, the calculated contact angles show the following:

1. Both the plate nonimage material and chrome, a typical dampening roller surface material, are wet by fountain solution in the presence of ink. Thus these materials are said to be water-receptive, or hydrophilic.

2. Both the plate image material and rubber, a typical resilient roller cover material, are wet by ink in the presence of fountain solution. Thus these two materials are said to be ink-receptive, or oleophilic.

3. Fountain solution applied to an inked surface in air has a greater tendency to spread, rather than bead up.

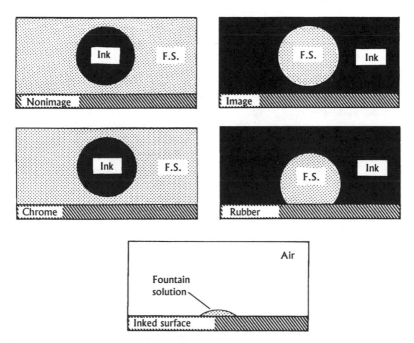

Figure 1.8 Contact angle diagrams showing degree of wetting of some lithographic surfaces by ink and fountain solution. Angles were calculated using equation (1.1) and data on interfacial tensions given in Table 1.1.

1.2.2 Emulsification.

Another principle that is essential to the success of lithography is that the identities of the ink and fountain solution used must be preserved, even after they meet at the plate. This is self-evident from the fact that, if the two fluids were soluble in each other, complete mixing would occur on press, with the result that only a single fluid would exist.

It is also essential that ink and fountain solution emulsify on press. More specifically, the two fluids must be formulated such that the small beads of fountain solution or surface water that transfer to the inked image areas of the plate, when they pass through the nip formed with the dampening form roller, will become dispersed in or emulsified into the ink on subsequent passages through the nips formed with the ink form rollers. There is much experimental evidence to show that this is indeed what happens on a well performing press, i.e., that fountain solution is emulsified into the ink.

One commonly used method for measuring the degree to which these two constituents emulsify is to mix ink and fountain solution in a Mixmaster

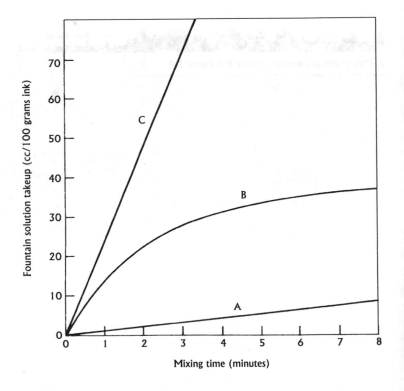

Figure 1.9 Water take-up curves for three different inks.

and measure the water take-up after each minute (Surland, 1967). Typical results obtained from such a test are given in Figure 1.9 for three different inks. Inks that follow Curve A are almost water repellent, and experience has shown that such inks do not print well due to poor transfer and snowflaking. Similarly, inks that take up too much water, as indicated by Curve C, also do not perform well on the press due to scumming—the appearance of smudges of ink in nonimage areas. The best lithographic inks have water take-up curves similar in shape to Curve B. Some controversy exists in the industry regarding whether measurements such as these can be used to predict on-press performance of ink and fountain solution. This controversy aside, there is no doubt that behavior of the ink and fountain combinations exhibited by Curves A and C, in Figure 1.9, preclude good performance on press.

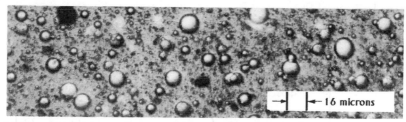

16 microns

(a) Photograph of ink-water mixture B in Figure 1.9.

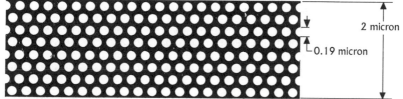

2 micron

0.19 micron

(b) Idealized scale model of 2-micron-thick film assuming face centered cubic structure.

Figure 1.10 Two possible emulsions of 26 cc of fountain solution in 100 grams of ink.

Another requirement is that the emulsifying action that takes place on press must produce a micro-emulsion. That is, the water must be dispersed in very small size particles. In fact, the size of the water globules in emulsified ink taken from a press is less than one micron, since the globules cannot be observed with an optical microscope. In contrast to this, an ink sample emulsified in a Mixmaster, as described above, contains fountain solution globules on the order of tens of microns, as shown in Figure 1.10(a). Figure 1.10(b) is an idealized model of what an on-press ink film containing the same amount of fountain solution (about 21 percent by weight) might look like. In this model, the fountain solution globules are less than 0.2 micron in diameter, in keeping with the fact that they cannot be detected with an optical microscope. Figure 1.10(b) is, of course,

highly idealized because, in the actual case, the diameters of the globules would not all be the same.

1.2.3. Nip Action. The two basic operations carried out by a mechanical printing press, that of pressing two surfaces together and then pulling them apart, are carried out in the nips or conjunctions formed where the press rollers and/or cylinders come in contact with one another. With few exceptions, all the nips in a printing press are formed by the conjunction between a hard-surfaced roller and a relatively soft roller. (In practice, hard rollers have surfaces of either copper, plastic, chrome, or a ceramic, while soft rollers are generally covered with a rubber compound.) Fluid behavior within such a nip is governed by the following conditions or properties:

1. Diameter of each roller.
2. Surface speed of each roller.
3. Hardness of each roller material.
4. Load between rollers, per unit length.
5. Fluid properties.

In the case of nips formed by rollers (as opposed to cylinders), the press operator controls the load by adjusting roller setting to achieve a prescribed stripe, or width of nip, with the press stopped. In the case of cylinders, the plate-to-blanket-cylinder load is adjusted by varying squeeze or degree of interference. This is accomplished by varying the thickness of the thin layers of packing material placed under the plates and blankets. The impression-to-blanket-cylinder load is adjusted by moving the impression cylinder.

Typically, under dry conditions, the average pressures in roller nips are on the order of 5 pounds/square inch versus 150 pounds/square inch in cylinder nips as shown in Table 3.1 in Chapter 3. Also, the deformation of the resilient roller or cylinder that produces these pressures is large, compared to the fluid film thicknesses encountered on press. Thus, the presence or introduction of the fluid film has a very small effect on deformation, and hence on pressure in the nips. As a consequence, the nip can be regarded as a relatively long gap that opens up between the two roller surfaces to a constant height, equal to the sum of the film thicknesses on the rollers, and through which the fluid is carried.

An idea of the relative length of this gap is afforded by examining the typical roller nip, shown to scale in Figure 1.11(a). From Figure 1.5 it can be seen that the ink film thickness in the nip formed by an ink form roller and vibrating roller is between 5.5 and 7.0 microns, say 6.0 microns (0.00024 inch). For this film thickness and the nip width in Figure 1.11(a), the length-to-height ratio of this gap through which the fluid is carried is 780. For a human, this is equivalent to passage through a head-high tunnel that has a length of almost one mile, as illustrated in Figure

Figure 1.11(a) Scale drawing of a nip between two 3-inch-diameter rollers. Line representing ink film is too thick by a factor of one hundred.

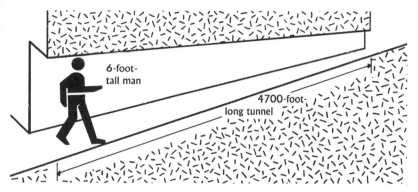

Figure 1.11(b) Pedestrian tunnel having a length-to-height ratio equal to the nip-length-to-ink-film-ratio of the nip shown in Figure 1.11(a).

1.11(b). Another perspective on this is provided by the fact that to display a 0.00024-inch film between rollers to scale, the line representing it in Figure 1.11(a) would have to be one-hundredth as wide as shown. It should also be noted that the amount by which the rubber roller in Figure 1.11(a) is deformed is twenty-four times greater than the above ink film thickness.

In its passage through a nip, a fluid is subjected to three actions that are of significance to the lithographic process: shearing action in the nip, rapid pressure reversal at the nip exit, and film splitting.

In theory, most of the rollers and cylinders on a press travel at the same surface speed. In reality, small differences occur in the nips, due primarily to the fact that the resilient surface is deformed, i.e., indented. Since the resilient material is incompressible, i.e., cannot be made to occupy a smaller volume, the surface speed of the material in the indented region must increase, relative to the surface speed of undeformed regions

of the roller. The end result of this is that the surface of the resilient member speeds up as it travels from the entrance to the center of the nip and then slows down as it travels from the center to the nip exit. These speed changes subject the fluid film to a shearing action, with shear rates on the order of 10^4 reciprocal seconds (MacPhee, Shieh, and Hamrock, 1992). The important effect of this shearing action is to emulsify any fountain solution that is encased by ink in the nip.

The second important action to which the fluid is subjected is the sudden pressure reversal that occurs at the nip exit. This is a consequence of the separation of the two roller surfaces at the nip exit that acts to pull apart or stretch whatever is between them. This pulling apart subjects a fluid film to tensile forces that, in the case of inks, have been measured to be as high as 58 pounds/square inch or 0.4 MPa (Zang, Aspler, Boluk, and De Grâce, 1991). What this means is that very high negative pressures are developed in the ink films as they are split. These negative pressures are high enough to flash-evaporate some of any emulsified water carried by the ink, and to even evaporate some of the petroleum solvents in the inks used on heatset web presses.

The third action, film splitting, has already been discussed on page 5.

1.3 How Lithography Works

Based on the above maxims or precepts on wetting, emulsification, and nip action, it is now possible to outline the rudiments of a theory on how lithography works. The outline that follows consists of a listing of the necessary conditions, a description of the various ink-water interactions that occur in the roller/cylinder nips, and an explanation of how and where ink and water are transported in a press.

1.3.1 Necessary Conditions. Three of the more important conditions that are necessary to achieve satisfactory lithographic performance are as follows:

1. The ink and fountain solution to be used must be formulated such that the ink will take up or emulsify some, but not too much, water on press.

2. The properties of the plate image material must be such that the image areas of the plate will be wet by ink in the presence of both fountain solution and ink, i.e., the image material must be ink-receptive.

3. The properties of the plate nonimage material must be such that the nonimage areas of the plate will be wet by fountain solution in the presence of both ink and fountain solution, i.e., the nonimage material must be water-receptive.

In practice, Condition 3 is the most difficult of the three to achieve. This is because most solid materials are oil-loving, or oleophilic, which explains why so many different surfaces are easily soiled by grease. For example, aluminum, the common choice for use as the plate nonimage areas is oleophilic. Thus, in general, the nonimage areas on a plate are formed by coating aluminum with a thin layer of a desensitizing agent, usually gum arabic or a synthetic gum. The aluminum surface is, in most cases, also treated to improve the bond between the gum and the metal. In any case, it is the thin layer of gum that causes the nonimage area to become hydrophilic (water loving) or not sensitive to ink.

During printing, the nip actions subject the plate surface to abrasion, with the result that the thin layer of gum gradually wears away. For this reason, fountain solution must contain the necessary chemicals to restore or maintain the nonimage surfaces. Traditionally, the two primary chemicals used are phosphoric acid, to treat or etch the surface to improve the bond, and gum arabic, to replace the gum that is worn away.

1.3.2 Ink-Water Interactions. The ink-water interactions on press that are of prime concern are those that take place in the various roller and/or cylinder nips. Of these, the most important by far are the interactions that occur in the nips formed by the plate cylinder, with the ink and dampening form rollers. The reason for this is that the plate is where ink and water meet, and where the presence of water is necessary to prevent the transfer of ink to the nonimage areas of the plate.

In order to account, in this regard, for the wide variety of roller configurations used in current press designs, it is only necessary to explain six different nip conditions. This is because almost all of the materials used in practice can be, for this purpose, grouped into a small number of categories as follows: two different plate surfaces, image and nonimage; two different fluids, ink and fountain solution; and two different types of form roller surfaces employed, rubber (oleophilic) and fabric covered (hydrophilic). The resulting six different sets of conditions are illustrated in Figure 1.12 and will now be discussed in detail.

The two diagrams in Figure 1.12(a) show the conditions existing in the plate/dampening form roller nips on presses that use a fabric-covered dampening form roller. Under normal printing conditions, a single fluid, fountain solution, exists in the nip or junction of the roller and the non-image areas of the plate, as in the diagram on the left. The action here is straightforward and the film splits evenly, thus transferring water to the plate. In the nip formed with an image area, as shown on the right, the plate surface carries some residual ink. Thus the nip contains a composite film of the ink and water. There are no data or observations that indicate that any of the water is emulsified into the ink during the passage of this composite film through the nip. Theoretical considerations do not lead to this conclusion either, since whatever shearing occurs in the nip would be expected to be confined to the weaker water film. For these reasons, it is

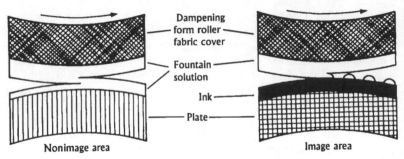

(a) Conditions for fabric-covered dampening form rollers.

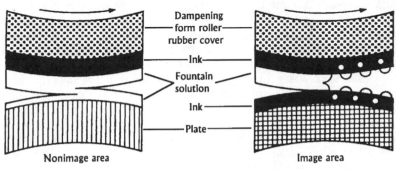

(b) Conditions for rubber-covered dampening form rollers.

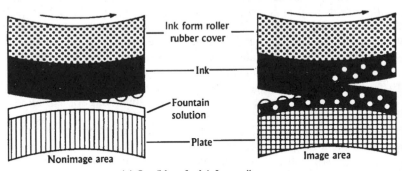

(c) Conditions for ink form rollers.

Figure 1.12 The six different conditions needed to explain the ink-water interactions on a majority of lithographic press designs.

assumed that no emulsification takes place under the conditions shown in the right-hand diagram, Figure 1.12(a).

This assumption is not essential to the explanations given here because little would change if it were to become known that *some* emulsification takes place. What is essential, though, is the premise that a film of fountain solution survives passage through the nip, and this is known to be true from

experience. At the exit, the weaker film of water will be split and thus some water will be carried away on the surface of the ink on the image area either in the form of droplets, as shown, or in the form of a thin layer.

Many modern presses utilize oleophilic (rubber) dampening form rollers with the result that a thin film of ink can be deposited on them. The resultant ink-water interactions in the plate nips, however, are much the same as in the previous case for hydrophilic rollers, as illustrated in Figure 1.12(b). One significant difference does exist, however, as shown in the right-hand diagram, for an image area. Here, the film of fountain solution is sandwiched between two ink films that in turn are carried by oleophilic surfaces. Thus, in this case, most of the fountain solution is emulsified, although some may survive on the two surfaces as shown.

The last sets of conditions to be discussed entail the rubber ink form roller and plate nips as illustrated in Figure 1.12(c). Under normal conditions, the nonimage areas of the plate will be dampened when they arrive at an ink form roller. Thus, as shown in the left-hand diagram of Figure 1.12(c), fluid entering such a nip will be a composite film, consisting of a relatively thin layer of fountain solution on the nonimage area and a much thicker layer of ink on the ink form roller. This is analogous to the case illustrated in the right-hand diagram of Figure 1.12(a). Applying the same logic yields the same result: that the film of fountain solution survives passage through the nip. At the nip exit, the weaker film of fountain solution will be split, leaving the ink film intact. As a result of this film split, the exiting ink film on the form roller will carry some fountain solution on its surface, either as a film or in the form of droplets as shown. The nonimage area leaving the nip will remain clean or uninked, by virtue of the survival of the film of fountain solution.

The right-hand diagram of Figure 1.12(c) shows that at the entrance of a rubber ink form roller nip, an image area on the plate will be carrying ink that may contain some emulsified water. In addition, there may be some water droplets or a film of water on the surface of the ink. The ink form roller will be carrying a thicker film of ink. The two films of ink are merged in the nip and the shearing action that occurs during passage will emulsify any water present, provided, of course, that the amount of water present is not excessive.

At the nip exit, the ink film is split, thus transferring some ink from the form roller to the image area. Also, the large pressure reversal that occurs in rupturing the ink film at the exit will flash-evaporate some of the water emulsified in the ink.

1.3.3 Ink and Water Transport. A printing press can be looked upon as a small factory. The raw materials fed into it are paper, ink, and the water and chemicals that make up fountain solution. The output is, of course, the printed sheets coming off the press. The path followed by ink in passing through this factory or process is straightforward. That is, the bulk of the ink travels from shipping container to the press ink fountain, and

from there along the rollers and cylinders until it is transferred to the paper. During its travel through the press, small amounts of ink may become deposited on the blanket and rollers, and on dampening system components. Thus, some small fraction of ink leaves this factory as waste, primarily in three forms: residual ink remaining in shipping containers; ink removed from the ink fountain and rollers during press cleanup or washup; and ink removed during the periodic blanket cleaning operations that are required to maintain print quality.

In the case of heatset web presses, the ink is dried by heating the printed paper, to drive off the bulk of the ink oil through evaporation. This vaporized ink oil, which represents a significant fraction of the ink used, is then either recovered and disposed of in solvent form, or else converted to harmless vapors and discharged to the atmosphere.

The fate of the fountain solution used in lithographic printing is less certain. This is due partly because there is no need for adding water to the final product, the printed form. For this reason, the output is seldom monitored for changes in moisture levels. A second reason for this relative uncertainty is that there are no known measuring techniques for easily and accurately tracking the water used. The consistency of water consumption rates suggest that evaporation in the ink roller nips accounts for the bulk of water usage on the press. (The chemicals added to make fountain solution are left behind and are carried away by the ink.) This theory is given added weight by the results of press tests that showed that water consumption decreased very little when no paper was fed, and ink was removed from the press by ink stripping wheels (MacPhee, 1985).

One other possible transport mechanism for water is the printed ink film. The relative quantities of ink and water consumed, however, do not support this hypothesis. For example, the ink film thickness on a printed sheet is typically 1.0 micron, or 1.0 grams per square meter of image surface. Assuming a typical 15 percent coverage (an image area that covers 15 percent of the paper surface) and a water content in the ink of 15 percent, the amount of water carried away by the ink would be 0.023 grams per square meter of paper. This is less than 6 percent of the amount of water consumed, i.e., 0.4 grams per square meter of paper surface.

1.4 Summary

The central feature of the lithographic printing process is that two different fluids, ink and water (fountain solution) are applied to a flat-surfaced plate to effect printing. The printing press characteristics, material properties, and physical phenomena that are important to a basic understanding of how lithography works are as follows:

1. A single-color lithographic printing press consists of four main

elements or subsystems: an inking system, a dampening system, three printing cylinders, and the paper handling system.

2. The basic printing operation involves first applying water to the nonimage areas of the plate following which ink is applied to the image areas. Printing is effected by then transferring the inked image to the blanket, and thence to the paper.

3. In the course of applying their respective fluids to the plate, both the ink and dampening form rollers press against both types of plate areas.

4. Because ink must only be applied to the image areas of the plate, these areas must be made of a material that is wet by ink in the presence of water. Conversely, the nonimage areas must be made of a material that is wet by water or fountain solution in the presence of ink.

5. The identities of the ink and fountain solution must be preserved after they meet on the press. It is also essential, however, that they should, to a limited extent, emulsify on press. This is to insure that the small amounts of fountain solution that are transferred to image areas will become dispersed as finely divided particles in the ink, and hence not be visible as unwanted specks (snowflakes).

6. The primary purpose of the rollers used in a press is to transport fluid from one place to another. The mechanism by which this is accomplished is the averaging process that occurs during film splitting at the exit of roller nips or conjunctions.

7. Overall press performance is governed by the different interactions that occur in the various roller nips or conjunctions where both ink and water are present. The various types of interactions that can occur are shown in Figure 12.

8. Generally, the ink film thickness on paper necessary to produce an adequate print density is equal to about 1.0 micron (0.00004 inch). The amount of fountain solution normally required for satisfactory printing is equivalent to a web or sheet of water, about 0.4 micron thick, equal to press width and traveling at press speed.

9. The bulk of the ink consumed is applied to and carried away by the paper. The bulk of the fountain solution consumed is evaporated into the air from the inking roller nips.

1.5 References

Adams, D.N., "An Experimental Study of Ink Film Thickness," *1954 TAGA Proceedings*, p 194.

Albrecht, J. and Wirz, B., "New Measurements of Ink-Water Balance on the Running Offset Press," *9th IARIGAI Research Conference Proceedings*, 1967, p 23.

Jorgensen, G.W., *The LTF Press Inkometer and the Automatic Control of Press Dampening*, GATF Research Progress Report No. 58, 1962, 4 pp.

Kaelble, D.H., Dynes, P.J., and Pav, D., "Surface Energetics Analysis of Lithography," *Adhesion Science and Technology*, edited by L.H. Lee, Plenum Publishing (New York), Vol 9B, 1975, pp 735–759.

Lawson, L.E. and Watkinson, L.J., "Dampening Hydrophilic Metal Plate Surfaces," *Professional Printer,* Institute of Printing (London), 1975, Vol. 19, No. 5, p 3.

MacPhee, J., "An Engineer's Analysis of the Lithographic Printing Process", *1979 TAGA Proceedings,* p 237.

MacPhee, J., "Trends in Litho Dampening Systems Show Vast Improvements in Designs," *Graphic Arts Monthly,* Technical Publishing Company (New York), April 1981, p 35.

MacPhee, J., "Further Insight into the Lithographic Process—With Special Emphasis on Where the Water Goes," *1985 TAGA Proceedings,* p 269.

MacPhee, J., Shieh, J., and Hamrock, B.J., "The Application of Elastohydrodynamic Lubrication Theory to the Prediction of Conditions Existing in Lithographic Printing Press Roller Nips," *21st IARIGAI Research Conference Proceedings,* 1991, p 242.

Pav, D.E., Kaelble, D.H., and Hamermesh, C., "Dampener Roll Wetability," *1976 TAGA Proceedings,* p 156.

Surland, A., "The Effects of Alcohol on Inks," *GATF Lithographic Dampening Conference Proceedings,* 1967, p 55.

Wood, H.A.W., "Apparatus for Inking Printing Presses," *U.S. Patent 1,275,348,* August 13, 1918.

Young, T., *Miscellaneous Works,* Vol I, edited by J.G. Peacock, Murray (London), 1855, p 418.

Zang, Y.H., Aspler, J.S., Boluk, M.Y., and DeGrâce, J.H., "Direct Measurement of Tensile Stress (Tack) in Thin Ink Films," *Journal of Rheology,* April 1991, Vol. 35, No. 3, p 345.

Chapter 2

Cylinders, Blankets, and Plates

The most important components of a printing press are those directly involved in transferring the inked image from where it is created, to the substrate or paper. On a modern press, these components comprise the plate or master, the blanket, and their associated cylinders. The job of these press elements is made especially demanding by the accuracy requirements of the halftone process, used to enable a press to reproduce pictures, such as photographs, that require a range of tones between the lightest (no ink on paper) and the darkest (solid ink film on paper). Therefore, to fully understand the critical role of these components, it is necessary to understand the halftone process and its unique demands.

2.1 Demands Imposed by Halftones

2.1.1 Concepts of Tone and Density. In printing, tone refers to the degree of darkness (or lightness) in a given area of the print. Maximum lightness occurs where no ink is printed and therefore its magnitude is very much a function of the substrate on which a given job is printed. Maximum darkness (minimum lightness) occurs in those areas of the print where a solid film of ink has been printed and is dependent on the thickness of the printed ink film. Tone can be measured using an instrument called a densitometer. This device contains a constant intensity light source and measures the amount of light from that source that is reflected by the target area on the print. Print density is read out on the instrument as the logarithm, to the base ten, of the ratio of the light reflected by a perfect-reflecting and perfect-diffusing material, to the light reflected by the target area. That is, the densitometer measures the reflectance factor of the target and then calculates reflection density, D, using equation (2.1) (ANSI, 1985) as follows:

$$D = \text{Log}_{10}\,(1/\text{Reflectance factor}) = \text{Log}_{10}(\phi_p/\phi_t) \tag{2.1}$$

where:

D = reflection density of target area
ϕ_p = intensity of light reflected by perfect material
ϕ_t = intensity of light reflected by target area

The value of ϕ_p is normally stored in the densitometer, but at least one densitometer design (Kishner, 1977) includes a standard surface whose reflectance is measured as a stand-in for ϕ_p every time a reading is taken. This is done to eliminate errors due to variations in light source intensity.

Table 2.1 lists the reflectance factors that correspond to the densities normally found on lithographic prints. From this tabulation it can be seen that darker areas have high densities while lighter areas have low densities. In the case of lithographic prints, the darkest areas (solid ink film) typically have densities as low as 1.0 on prints made on uncoated paper and as high as 1.6–1.8 for prints made on coated paper. The lightest areas (no ink) on a print can have densities as low as 0.02–0.04 for a good coated paper and as high as 0.20 for some of the poorer grades of uncoated paper.

Table 2.1 Range of reflectance factors and corresponding densities normally found on lithographic prints on paper. Reflectance factor is the ratio of the light reflected by the target area to the light reflected by a perfect reflector.

Reflectance factor (%)	1.6	2.5	4.0	6.3	10.0	12.6	15.8
Density	1.80	1.60	1.40	1.20	1.00	0.90	0.80
Reflectance factor (%)	25.1	39.8	63.1	79.4	87.1	91.2	95.9
Density	0.60	0.40	0.20	0.10	0.06	0.04	0.02

2.1.2 Principles of Halftone Printing. The planographic character of the lithographic printing plate, coupled with the roller type inking system used, makes it impossible to vary the ink film thickness from one point to the next on the plate in the circumferential direction. Thus, a lithographic press is limited, at any given time, to printing a uniform ink film thickness, at least in the ideal case. In this sense, lithography can be looked upon as a binary process in that a given area on the paper either can be covered with a layer of ink, or not. Put another way, gradations in the tone cannot be produced by varying ink film thickness from one point to another on the sheet. Thus, to achieve gradations in the tone, some other stratagem must be employed.

The stratagem actually used is known as the halftone process, developed in the latter half of the nineteenth century for use in printing photographs by the letterpress process. Traditional halftones utilize a square array of equally spaced dots, wherein the spacing is small enough that the dots cannot be readily resolved by the eye under normal viewing conditions. Thus, the eye perceives some average of the light reflected by the paper between the dots and by the inked dots. This creates the optical illusion of a tone that is lighter in shade than the tone produced by a solid

ink film. In this way, varying gradations of shading or tone can be produced by varying the size of the dots, and hence the fraction of the areas of the rectangular cells occupied by the dots.

(a) Actual-size halftones that have a screen ruling of 85 lines per inch.

(b) Same halftones as in (a) magnified by a factor of approximately 20.

Figure 2.1 Sample halftones of four different dot areas of, from left to right, 10, 30, 50, and 70 percent.

This principle is illustrated in Figure 2.1 using round dots, but it is to be understood that other shapes, such as elliptical and square, can be and are used in practice. As shown in Figure 2.1(a), the dimensions of the individual dots must be quite small for the tone to have a pleasing appearance, i.e., the dots must be fine enough such that the tones appear uniform to the eye. Very large dots, as in Figure 2.1(b), are not pleasing to the eye in that their presence is readily detected. Before proceeding further in this discussion, the convention used to describe the fineness and size of dots should be described.

This convention stems from the photographic method developed over 100 years ago for converting continuous-tone pictures to halftones that could be printed. In this technique, a sandwich of glass plates containing a square grid of fine lines was placed in a camera used to make a halftone photograph of a continuous-tone picture (Levy and Levy, 1893). The square grid came to be known as a screen, and the process was alternately referred to as screening. (Additional detail on screening is given in Section 7.6.1.) The spatial frequency of the lines on the screen used to produce a halftone determines the fineness of the halftone. This is referred to as the screen ruling and is expressed in lines per inch. It defines both the spatial frequency of the screen lines and the spatial frequency of the halftone dots produced by the screen. Figure 2.2 shows the relationship between spatial

frequency and the dimensions of the halftone unit cell. Dot area is defined as the percentage of the unit cell area that is occupied by the dot. Thus, in terms of the dimensions defined in Figure 2.2, percent dot area is equal to πD^2 divided by L^2 and multiplied by 100.

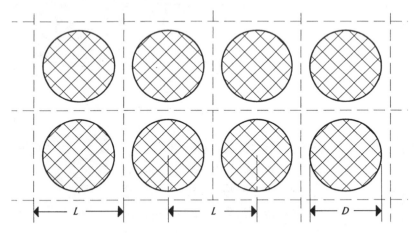

Figure 2.2 Magnified view that identifies dimensions used to define halftone properties. Distance between lines, L, is identical to width of unit cell. Value of L is equal to the reciprocal of spatial frequency, or number of lines (or dots) per inch. For 50% dot shown and 150 lines per inch screen, $L=0.0067$ inch and $D=0.0053$ inch.

Under normal viewing conditions a screen ruling of more than about 125 lines per inch is needed to avoid a grainy appearance of the halftone print (Eliezer, 1991). It is also obvious that finer screen rulings will result in higher fidelity prints that are more pleasing in appearance. Currently, a screen ruling of 133 lines per inch is regarded as a minimum for most commercial printing, and much of this class of work is now printed at 150 lines per inch. The bulk of newspaper printing utilizes 85-lines-per-inch halftones. For very high resolution printing, screen rulings as high as 300 lines per inch or more have been employed.

2.1.3 Potential Defects in Dot Reproduction. Because the halftone process is widely used by printers, a printing press must be capable of faithfully reproducing halftone dots. This requirement carries with it some unique demands on the dimensional stability of the press components directly involved in the creation and transfer of the dots, i.e., the plate, the blanket, and the printing cylinders.

The first step in determining what these demands are is to consider the various ways in which a dot can be changed during printing. In theory, imperfections in press performance can introduce three different types of change in dot area, as shown in Figure 2.3. Any one of these changes, commonly referred to as dot gain, can, if it is sufficiently large enough,

produce a perceptible change in tone. In addition, where several different inks are overprinted to produce a desired color, changes in dot area will, if large enough, produce shifts in color hue.

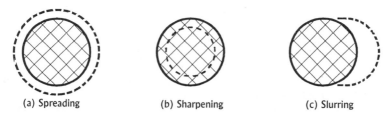

(a) Spreading (b) Sharpening (c) Slurring

Figure 2.3 Three ways that dot area can change during transfer of image from plate to print. Solid lines show dot boundary on plate. Dashed lines show dot boundary on print.

Of course, dots can be changed by problems that also affect line or monotone printing. For example, their boundaries may become fuzzy and not sharp. Also, poor transfer can result in the appearance of snowflakes or light spots within the dot. Poor transfer or a reduction in ink feedrate can also lead to a thinning of the printed ink film, and to a consequent lightening of all of the tones being printed.

Of all the possible errors in dot reproduction just mentioned, slurring is the most important, insofar as the demands placed upon the dimensional stability of press components. There are several reasons for this, as follows:

1. Changes in dot size and/or shape generally are only a problem if they occur randomly over time or are unpredictable for other reasons. This is because consistent or predictable changes can be compensated for in the prepress operations culminating in the production of the plate.

2. Although some spreading of dots is unavoidable, it is a relatively constant and predictable phenomenon on a well-run press. Furthermore, spreading cannot be totally eliminated since it seems to be an inherent consequence of the process of transferring dots from plate to blanket (Takahashi, Fujita, and Saketa, 1986–7). Further support for this theory on the major source of dot spreading is provided by the fact that approximately one-third less dot gain was observed when printing newspapers directly from the plate to paper (Croteau, 1993). Also, the amount of dot spreading that does occur can, if necessary, be changed by the pressman, because spreading is a strong function of both ink film thickness and ink properties. That is, increasing ink film thickness and reducing ink tack both act to produce larger dots (MacPhee and Lind, 1991).

3. Dot sharpening on press occurs infrequently, and when it does it is invariably due to wear or erosion of the plate.

4. Slurring of dots is caused by relative motion between two or more of the elements involved in transferring the dots from plate to paper. Because such relative motion is frequently unpredictable, it must be held to within rather small limits. Therefore, it is these limits on relative motion that constitute the greatest demands placed on press design by the halftone process.

The industry convention used to report increases (and decreases) in dot area is to express the change or gain in dot area as the difference between the enlarged and the target dot, where both area and gain are expressed as a percentage of the unit cell area. Thus a gain of 10 percent in a 50 percent dot expresses the fact that a 50 percent dot is being printed as a dot having an area of 60 percent.

2.1.4 Demands Imposed by Dot Slurring. Dot slurring can appear in two forms as illustrated in Figure 2.4. Doubling, shown in Figure 2.4(a), is caused by a relative movement while the dot is not in a nip. This type of defect is frequently encountered in web printing and is produced by the offsetting of a slightly displaced imprint of the same dot on the blanket of the next-in-line printing unit. It is caused by variability in the position of the paper as it passes through the next-in-line printing unit. A similar defect will

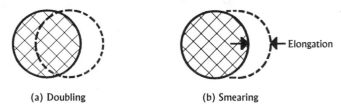

(a) Doubling (b) Smearing

Figure 2.4 Two types of dot slurring.

of course be generated within a printing unit if there is variability in the positioning of a given blanket relative to its mating plate cylinder. In contrast, smearing, illustrated in Figure 2.4(b), is caused by a relative motion while the dot is pressed against another surface.

In practice, it is often difficult to discern through observation of dots whether slurring is due to doubling or smearing. Thus, negligible error will be introduced if all slurring is assumed to occur as a smear. In such a case dot area increases linearly with elongation, where elongation is defined in Figure 2.4(b). This relationship was used to obtain the plot, in Figure 2.5, of the increase in dot area, or dot gain, as a function of elongation, for a 150-lines/inch (60-lines/cm) 50-percent dot. This plot provides the means for quantifying the demands placed on the positioning consistency of the printing cylinders.

Although there are no US. standards for printing, current practice and industry specifications provide a gauge of how much slurring is tolerable.

The current Specifications for Web Offset Printing (SWOP, 1993) place a tolerance on dot gain, due to all causes, of ±4 percent for a 133-lines/inch (52-lines/cm) screen. This infers that the tolerance on dot gain due only to slurring should be something less. Support for this has been provided by observations of the author that slurring, as measured with the UGRA slur target (UGRA, 1982), is in the range of 1–2 percent on well-run and properly designed and maintained sheetfed and web presses. If a tolerance of ±2 percent is thus assumed, a corresponding positioning tolerance of slightly less than ±0.0001 inches (±2.5 microns) is obtained from Figure

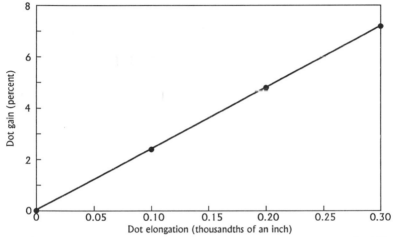

Figure 2.5 Dot gain due to slurring versus elongation in thousandths of an inch for 150-line/inch 50-percent dots (diameter=0.0053 inches).

2.5. Thus, it is seen that the printing cylinders and associated components must be designed (and maintained) so as to achieve a repeatability in positioning of approximately ±0.0001 inches (±0.0025 mm). Of interest later on is the fact that the slippage or differential speed between cylinders necessary to produce a similar amount of slur due to smearing is 1.9 percent (0.0001 inches divided by 0.0053 inches).

2.2 Cylinders

A printing unit on a typical sheetfed press is equipped with three cylinders arranged most often as in Figure 2.6(a). This particular arrangement has found favor with press designers because it requires a relatively simple throw-off mechanism design. That is, only the blanket cylinder needs to be moved in order to go "off impression," as indicated in Figure 2.6(b). Thus, both the plate and impression cylinder bearing mounts can be fixed to the frames. The blanket cylinder bearings may be

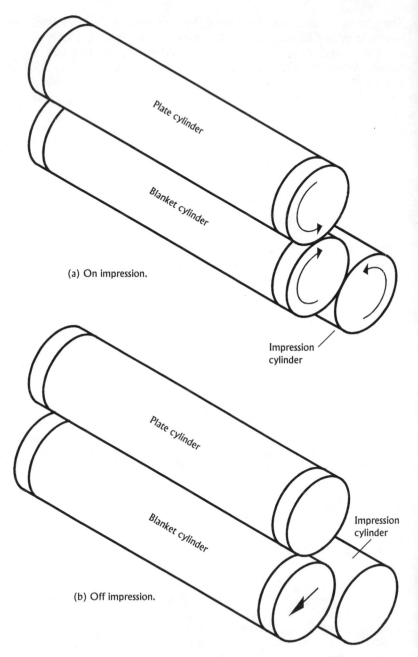

(a) On impression.

Impression
cylinder

(b) Off impression.

Impression
cylinder

Figure 2.6 A common cylinder arrangement on sheetfed presses. Cylinders are caused to go
"off impression" by moving blanket cylinder in direction shown by arrow in (b).

mounted in double eccentrics to permit the blanket cylinder to be set to both the plate and impression cylinders. Alternately, single eccentrics may be used, in which case the impression cylinder bearing mounts are provided with a small amount of adjustment for setting the blanket-impression cylinder pressure or squeeze. On presses designed *not* to run on bearers, the plate cylinder is also provided with a small amount of adjustment for setting the plate-blanket cylinder squeeze.

As a result of the widespread use of the cylinder arrangement shown in Figure 2.6, the impression cylinder is often referred to as the back cylinder, because it is behind, or in back of, the blanket cylinder on many sheetfed presses.

2.2.1 Primary Purpose. The primary purpose of the printing cylinders is twofold: to provide an area where the desired inked image can be repetitively generated, and to transfer those inked images to successive sheets of the substrate being printed. To insure that this seemingly simple function is correctly performed, a number of very demanding requirements must be met in the design and manufacture of printing cylinders, and the components associated with them.

2.2.2 Requirements. There are four major requirements placed on printing cylinders, and these are identified and discussed in the following paragraphs.

1. As the names of two of the cylinders suggest, one requirement is that means must be included for securely locking the plate and blanket onto their respective cylinders. Included here is the need to tension both plate and blanket, and to design the locking mechanisms to allow for rapid removal and replacement of both plate and blanket. Typically, the blanket tension is 50 pounds/inch or 88 N/cm (Shrimpton and Dunkley, 1972).

2. The plate must also be positioned relative to some reference point so that the image being printed can be superimposed on, or registered to, the sheet. In addition, a capability must be provided for changing both the circumferential and axial position of the plate to correct for small errors in register on the paper that may occur. Finally, it must be possible to slightly cock the plate to correct for small image misalignments due to tilting. The tolerance on all of these positioning requirements is governed by the amount of misregistration that can be accepted. In many cases this can be as large as half the space between a row of dots (Jorgensen, 1982), or a little over 0.003 inches (75 microns) for a screen ruling of 150 lines/inch (60 lines/cm). In summary, this requirement states that the plate must be positioned in the press with an accuracy of plus or minus a half row of dots, and means must be provided for adjusting that position by small amounts in three directions to enable the printed image to be registered to some reference point on the sheet.

3. Another very important cylinder requirement is that the pressure necessary to effect good ink transfer must be generated in both the plate-

blanket and blanket-impression cylinder nips. Although loads as high as 300 pounds/inch (525 N/cm) of nip length have been reported in the literature (Reed, 1983), there is much evidence to suggest that a load of 50 pounds/inch (88 N/cm) is adequate in both nips to achieve effective transfer. More will be said about the corresponding pressures in Section 2.2.4. Although 50 pounds per inch may not sound high, this equates to a total nip load of 2000 pounds, or a ton, on a 40-inch-wide press. Of course, some safety margin must be provided in designing the components that must withstand this load to insure against damage due to overloading. Thus, the loads assumed for design purposes are much higher than 50 pounds per inch.

4. The last requirement to be listed here is the repeatability with which the image must be positioned in the various stages of transfer from plate to paper. This tolerance is established by the previously discussed demands of the halftone process: ±0.0001 inches or ±2.5 microns. This requirement is especially demanding in view of the relatively heavy loads that must be generated to effect image transfer.

2.2.3 **Design.** The two main elements of a printing cylinder are the body and the bearers, illustrated in Figure 1.3 on page 4. According to one report (Tyma, Koebler, Stoeckl, and Engel, 1982), bearers have been in use on presses for over one hundred years. This same report explains that they were originally fitted to letterpresses to overcome the effects of the clearance required in plain sleeve-type journal bearings. Without bearers, the cylinders would move away from each other, by the amount of the bearing clearance, whenever one of the cylinder gaps entered the given nip. This movement would generate print defects due to changes in pressure and/or to relative motion in nearby nips.

If bearer-equipped cylinders are pressed together so that the bearers run in contact with each other, the clearance between the cylinder bodies will be precisely controlled, thereby eliminating relative movement and attendant print defects. In this mode of operation, the cylinders are said to be running on bearers. Although the advent of zero-clearance roller bearings might appear to have obviated the need for bearers, most U.S. printers are convinced that bearers are still needed to avoid gear streaks (horizontal streaks with regular spacings that correspond to the pitch of the cylinder gears). Consequently, most U.S. printers operate their presses so that the plate and blanket cylinders run on bearers. In Europe, many printers prefer presses that are designed *not* to run on bearers. Such presses do have bearers but they are smaller in diameter and are used only as reference points for checking packing and the like. Most impression cylinders are not designed to run on bearers so as to eliminate the need for packing the impression cylinder.

All three printing cylinders generally are fitted with helical gears that have a pitch or effective diameter equal to the diameter of the plate and

blanket cylinder bearers. These gears mesh with each other so that the cylinders are driven in unison at the same speed. Helical gears are employed so that the gear contact load is distributed over several teeth, thereby achieving smoother and quieter operation. The impression and blanket cylinder gears are firmly affixed to their respective cylinders. The position of the plate cylinder, with respect to its gear, however, is made adjustable in both the axial and the around-the-cylinder directions. In this way, both the axial and the circumferential position of the plate cylinder can be changed to effect register.

On sheetfed presses, cylinder bodies are normally made of cast iron and have a cross section similar to a spoked wheel. The use of a spoked wheel cross section reduces cylinder weight, with little sacrifice in crush resistance. This also makes it possible to compensate for the weight loss due to the presence of the gap, and thereby balance the cylinder. The bearing journals are an integral part of the casting and are as large in diameter as possible, so as to reduce cylinder deflection under load, and to increase bearing life.

Figure 1.2 on page 3 shows that rather large gaps must be provided in the bodies of the printing cylinders. These allow space for the mounting clamps needed to secure the plate and blanket, and for the gripper bar needed in the impression cylinder to grasp the lead edge of the sheet.

Means for accurately locating a plate on the plate cylinder is provided through the use of accurately located punched holes or slots in the plate that fit onto pins or the like contained in the mounting clamps on the cylinder. The mounting clamps have an adjustment that permits the plate to be cocked, or tilted, to correct for misregistrations of that nature. On some presses, however, the plate cylinder itself can be cocked slightly.

The bearers are hardened steel rings or flanges that are pressed over the journals and bolted onto each end of the cylinder body. After assembly, the surface of the bearers and the cylinder body are ground to produce very accurately controlled concentric diameters, such that the body is recessed or undercut with respect to the bearer. This is illustrated in Figure 2.7. Typically, the plate cylinder undercut is 0.020 inch (0.5 mm), while that of the blanket cylinder is much larger, say 0.100 inch (2.5 mm), because blankets are much thicker than plates. The bearers are ground to a diameter that is equal to the effective, or pitch, diameter of the cylinder drive gear. This is done because, theoretically, gears are in perfect rolling contact when they are meshed such that their pitch circles are tangent to each other.

Printing pressure between the plate and blanket cylinders is created by installing enough sheets of packing material under both plate and blanket such that the blanket will be squeezed when passing through the plate-blanket nip. Thus, the combined thickness of plate, blanket, and packing material must be greater than the sum of the plate and blanket cylinder undercuts. More will be said about this in subsequent sections.

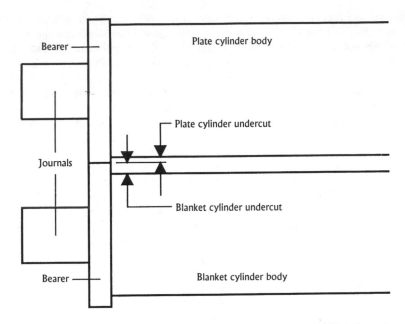

Figure 2.7 Schematic showing cylinder undercuts. Typical undercuts are 0.020 inch on the plate cylinder and 0.100 inch on the blanket cylinder.

In most currently manufactured sheetfed presses, no provision is made for fitting the impression cylinder with a tympan; thus it cannot be packed. Because of this, the diameter of the impression cylinder bearers is less than the pitch diameter of the cylinder gears, and the impression cylinder does not run on bearers against the blanket cylinder. (The diameter of the impression cylinder is, however, made equal to the pitch diameter of the drive gear.) A second consequence of not packing the impression cylinder is that printing pressure between blanket and impression cylinders must be controlled by varying the spacing between the two cylinder bodies. To accomplish this, accurately calibrated adjustment knobs (back-cylinder pressure controls) are provided to enable the press operator to set the body-to-body spacing of the two cylinders, prior to the start of a job.

2.2.4 **Required Printing Pressures.** Regardless of what process is used, successful printing requires that some minimum pressure exist in all nips where the inked image is transferred from one surface to another. In lithography, there are two such nips: plate-to-blanket and blanket-to-paper. One assessment of the comparable pressures required in the three major processes to transfer the image to paper is given in Table 2.2.

Failure to achieve the minimum pressures required in the two printing nips found on lithographic presses will result in a variety of problems. For example, a very low pressure in either nip will cause large patches of

unprinted areas to appear, which is a problem that is very easy to detect. In contrast, a marginally low pressure, especially in the plate-blanket cylinder nip can be much more insidious in that it is not readily detectable, and can lead to a multitude of problems (Martin, 1963).

Table 2.2 Relative printing pressures used to establish conditions under which paper roughness is measured (Parker, 1981).

Printing process	Printing pressure
Gravure	75 pounds/square inch (0.5 MPa)
Offset lithography	150 pounds/square inch (1.0 MPa)
Letterpress	300 pounds/square inch (2.0 MPa)

Not only is it important to insure that enough pressure is generated, but it is also necessary to insure against developing excessive pressure. This is because too much pressure can result in disturbances that generate print defects such as streaks. Excessive pressure also generates excessive loads that can result in failure or accelerated wear of press components. For example, one study (Latham, 1963) showed that, for the particular plate and blanket used, plate life was drastically shortened by excessive squeeze (pressure). The data obtained in that study is given in Table 2.3.

Table 2.3 Test results showing how wear due to excessive squeeze between short-run ungrained plate and blanket reduced plate life (Latham, 1963). Normal squeeze was 0.002 inch (0.051 mm) for the conventional blanket used in the test.

Plate-to-blanket squeeze	Plate life (impressions)
0.002 inches (0.051 mm)	40–50,000
0.003 inches (0.076 mm)	30,000
0.004 inches (0.1 mm)	15,000
0.005 inches (0.13 mm)	5,000

On lithographic presses, cylinder nip pressures are gauged or set by adjusting the amount by which the blanket is compressed or squeezed when it passes through the nips formed with both the plate and impression cylinders. (This differs from the method used on ink rollers wherein pressures are gauged by measuring the width of the stripe, or impression of the nip, left on a roller under static conditions.)

Some idea of the relationship between blanket squeeze and printing pressure can be gained from the plots of static load versus squeeze for both a compressible and a conventional blanket that are given in Figure 2.8. (These two different types of blankets are described in Section 2.3, starting on page 50.) These plots are similar to plots of data obtained for tensioned

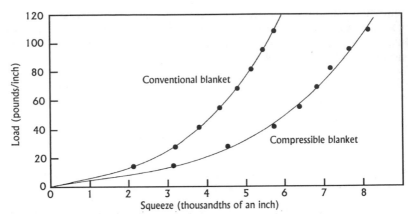

Figure 2.8 Static load versus squeeze or compression for two different types of blankets (Tyma, Koebler, Stoeckl, and Engel, 1982).

blankets under dynamic conditions and therefore can be taken as reasonably representative (Miller and Poulter, 1962; and Miller, 1970). It must be kept in mind, however, that the loads will be different under the dynamic conditions because of the viscoelastic properties of rubber, as explained in Chapter 3.

As already mentioned, the operator controls pressure in the plate-blanket nip by inserting the amount of packing material beneath both plate and blanket that is necessary to achieve the desired squeeze. For example, consider a press with a plate cylinder undercut of 0.020 inch and a blanket cylinder undercut of 0.100 inch. If the combined thickness of plate, blanket, and packing material used is 0.122 inch, the resulting plate-to-blanket squeeze will be 0.003 inch, which is in the range of the 0.002 to 0.003 inch generally recommended when using conventional blankets. From Figure 2.8, it can be seen that the corresponding nip load in the plate blanket nip will be about 25 pounds/inch (44 N/cm) of nip or cylinder length. This compares reasonably well with a study of such loads (Eschenbach and Wagenbauer, 1960) in which a value of about 30 pounds/inch (52 N/cm) was measured under dynamic conditions.

In a perfecting press, the printing nip is formed by the conjunction of two blanket cylinders, as explained in Section 6.4.2 in Chapter 6. From this it is known that the squeeze in the printing nip will be somewhat higher due to the presence of paper, say 0.004 for the example just given. Thus, the corresponding nip load will be 45 pounds/inch (80 N/cm) according to Figure 2.8.

The average pressure in the printing nip can be calculated from the above lineal load, provided that the width of the nip is known. Nip width can be found through a series of trial and error calculations using equation (3.2) in Section 3.2.1 and the appropriate values of squeeze (depth of

penetration), blanket thickness, and blanket cylinder diameter.

The reference from which Figure 2.8 was obtained does not specify cylinder diameter. However, it seems reasonable to assume a value of 7 inches, since the cylinders illustrated were identified as being from a web press. Using this value, a squeeze of 0.004 inch, and an assumed blanket thickness of 0.070 inch (1.8 mm), the corresponding stripe width is found to be 0.293 inches (7.4 mm). From this, and the lineal load of 45 pounds per inch, an average printing pressure of 154 pounds/square inch (1.1 MPa) is calculated. This compares very well with the figure of 150 pounds/square inch (1.0 MPa) given in Table 2.2. It should be noted that the peak pressure in the nip will be about 50 percent higher than the average value, as illustrated in Figure 3.11 in Chapter 3.

Repeating the above exercise for an increase and decrease in squeeze of 0.001 inch yields the data in Table 2.4. These increments represent the smallest change that standard sheets of packing material allow. They also point up why proper packing is so critical, since they show that the magnitude of printing pressure is extremely sensitive to packing thickness.

Figure 2.4 Calculated data that illustrate how printing pressure varies with squeeze. For conventional blanket on 7-inch-diameter cylinder, based on data in Figure 2.8.

Total Squeeze (inch)	Nip Load (pounds/inch)	Stripe width (inch)	Average pressure (pounds/square inch)
0.003	26	0.245	106
0.004	45	0.293	154
0.005	76	0.335	227

The plate-to-blanket squeeze normally used when running compressible blankets is 0.004 to 0.005 inch. Again assuming an additional squeeze of 0.001 due to paper, and using the higher squeeze, the data in Figure 2.8, and equation 3.2, the corresponding lineal load is found to be 50 pounds/inch (88 N/cm), the width of nip 0.374 inch (9.5 mm), and the average pressure 134 pounds/inch (0.9 MPa). The corresponding loads and stripes that are produced when the same two types of blankets are mounted on a larger (10-inch-diameter) cylinder as used on a typical 40-inch-wide sheetfed press are given in Table 3.2 in Chapter 3, along with comparative data on typical rollers.

Measurements of the load between blanket and impression cylinders during printing (Eschenbach and Wagenbauer, 1961) showed that the lineal load is about the same as that just obtained, i.e., 50 pounds per inch.

While the previous exercise has shown why the amount of packing is important, nothing has been said so far about whether the excess packing

should be placed under the plate, or under the blanket, or distributed some other way. For example, consider the above conditions in which the recommended squeeze is 0.003 inch. As already described, this is provided by adding enough packing sheets such that the sum of the blanket, plate, and packing material thicknesses exceeds the sum of the two cylinder undercuts by 0.003 inch. The excess packing sheets can be distributed in any number of ways including:

1. Pack the plate to be level with the bearers and pack the blanket 0.003 inch above the bearers.
2. Pack the blanket to be level with the bearers and pack the plate 0.003 inch above the bearers.

The question of whether or not there is an optimum distribution of the excess packing needed to achieve the necessary squeeze is discussed in full in Section 2.2.7. Before proceeding to that, however, it is in order to describe the methods used by the press operator to adjust or control printing pressures and to identify the major factors that affect print length.

2.2.5 **Control of Printing Pressures.** For presses that run on bearers, two different methods are used to set printing pressure or squeeze: one for the plate-blanket cylinder nip, and one for the blanket-impression cylinder nip.

The squeeze between plate and blanket is established by the amount of packing—thin sheets of special paper or foil—placed under both plate and blanket. Resultant squeeze is measured by measuring the height of both plate and blanket relative to their respective bearers. For the example cited above, wherein a squeeze of 0.003 inch is to be provided, it is common practice to pack the blanket to the bearers, and the plate 0.003 inch over the bearers, when running on bearers. While this can be done by measuring the thicknesses of plate and blanket, and then adding packing based on the respective cylinder undercuts, a much more reliable method is to use a packing gauge.

The packing gauge is a device designed to measure, on press, the height of plates and blankets, relative to their bearers. Although many different designs exist, the one pioneered by GATF, and now manufactured by Baldwin, possesses several important advantages (Siebein, 1971). Figure 2.9 shows how this gauge is placed on a cylinder, so as to measure the height of the blanket or plate surface, relative to the bearer.

A different method is used to establish squeeze between blanket and impression cylinders, because those cylinders do not run on bearers (for the reason explained in Section 2.3). That is, two knobs, equipped with calibrated scales, are provided to enable the press operator to set the body-to-body spacing or gap between the cylinders at each end (assuming stock thickness has been changed). The scales showing cylinder position are normally calibrated to read zero when the pitch diameters of two cylinder

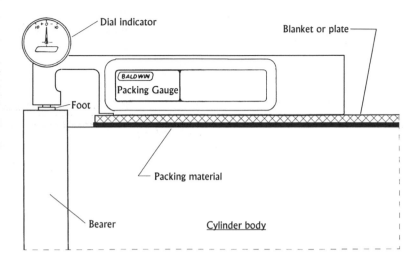

Figure 2.9 Schematic showing how packing gauge is positioned to measure height of plate or blanket relative to bearer. Dial indicator responds to movement of sensing foot to provide measure of height above (plus reading) or below (minus reading) bearer in either inches or millimeters.

drive gears are tangent to each other. After initially setting the knobs to provide the desired squeeze, say 0.004 inch (height of blanket above blanket bearer, plus stock caliper, minus scale reading), some press operators then back off on the setting at the start of printing until a solid area "breaks," i.e., until patches of unprinted areas appear. Then the back-cylinder pressure controls are turned in to increase squeeze by 0.001 to 0.002 inch. In most plants, however, operators rely solely on the calibrated scales to set back-cylinder pressure or squeeze.

2.2.6 Cylinder-Related Factors Affecting Print Length. Ideally, the length of the image printed on paper should be equal to the length of the image on the film used to make the plate. However, even if there are no changes in the dimensions of the paper (and there frequently are, due for example to changes in moisture content), there are two cylinder-related factors that will cause the length of the print to deviate from that of the film as follows:

1. Stretching of the outside surfaces of both plate and stock as a result of being bent around their respective cylinders. Stretching of the plate outside surface acts to increase print length while stretching of the stock outside surface acts to decrease print length.

2. Deviations in the diameters of the hard-surface cylinders from nominal, that is, from the gear pitch diameter. Specifically, packing the plate cylinder above the bearers will result in a "short" print, while packing

below will result in a "long" print. Similarly, a finite stock thickness produces an effective impression cylinder diameter larger than nominal and that in turn results in printing longer. Thus, thicker stocks give rise to longer prints. (Note that blanket cylinder diameter, and hence blanket packing, in theory is not a factor that affects print length.)

The reason why stretching of both plate and stock, due to bending, affects print length can be understood by referring to Figure 2.10. This is an exaggerated view of what happens when a sheet of material is bent around a cylinder so as to form a cover. If the mechanical properties of the

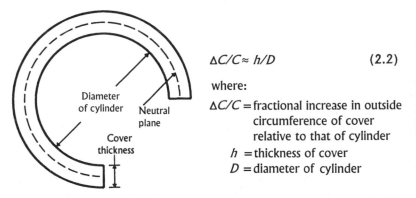

$$\Delta C/C \approx h/D \qquad (2.2)$$

where:

$\Delta C/C$ = fractional increase in outside circumference of cover relative to that of cylinder

h = thickness of cover

D = diameter of cylinder

Figure 2.10 Exaggerated view of thin sheet, bent around a cylinder to form a cover. Bending causes outside surface to stretch, and inside surface to compress, in the circumferencial direction. Neutral plane is unchanged.

material are homogeneous, the cover's neutral plane, so-called because it is neither stretched nor compressed, will be located in the middle. Consequently, the outer surface of the sheet will be stretched and the inner surface compressed. The fractional amount by which the outside circumference of the sheet exceeds that of the cylinder is given by equation (2.2). Based on this model, it will be understood that the outside surface of a plate will be stretched when mounted on the plate cylinder. Hence the image being printed will be elongated by an amount that can be calculated using equation (2.2). Similarly, the surface of the stock being printed will also be stretched during the process because it is bent around the impression cylinder. The effect of this is to shorten the print, since the printed surface of the stock will be compressed when the sheet is flattened out. Equation (2.2) can also be used to calculate this deviation.

The way in which changing the cylinder diameter affects print length is illustrated in Figure 2.11. Figure 2.11(a) shows an assumed condition where the plate is packed to the bearers and the length of the image corresponds to three-quarters of a cylinder revolution, or 270 degrees.

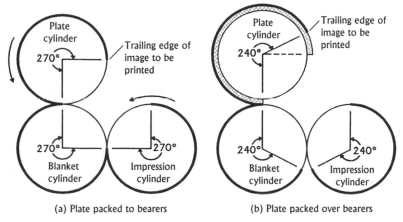

(a) Plate packed to bearers (b) Plate packed over bearers

Figure 2.11 Exaggerated schematics showing how increase in plate cylinder diameter, due to added packing, acts to reduce print length.

Because all three cylinders are driven in synchronization by their gears, both the blanket and impression cylinders must travel 270 degrees to transfer the image. Thus, 270 degrees of the impression cylinder corresponds to the image length. Figure 2.11(b) illustrates, in an exaggerated way, what happens if the plate is packed above the bearers. The diameter of the printing surface is increased and, as a result, the length of the image now corresponds to something less than 270 degrees of plate cylinder travel, as for example, 240 degrees as shown. Thus, the impression cylinder must only rotate 240 degrees to receive the image. Since the diameter of the impression cylinder is unchanged, the length of the printed image will be shorter by virtue of occupying less of the circumference of the impression cylinder. (To increase the height of the plate over the bearers, as represented in Figure 2.11(b), it would, of course, also have been necessary to reduce the blanket packing by a corresponding amount, provided that the plate and blanket cylinders are running on bearers. Such a change in blanket packing would, however, have no effect on print length. This is because print length on the blanket corresponds to the same number of degrees of blanket cylinder rotation as the plate cylinder, regardless of the diameter of the blanket surface.)

The reason why increasing the effective diameter of the impression cylinder acts to increase print length, as occurs when printing on thick versus thin stock, is illustrated in Figure 2.12. Figure 2.12(a) represents the ideal case of printing on an infinitely thin stock, with the plate packed to the bearers, and 270 degrees of plate cylinder rotation corresponding to the image length. For this hypothetical case of an infinitely thin stock, 270 degrees of impression cylinder travel would also correspond to the image length. If thick stock were substituted, the situation would be as shown in

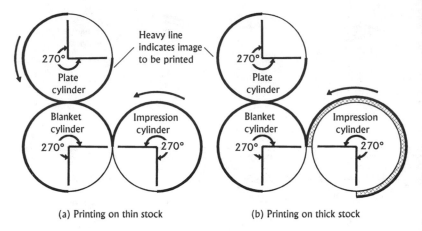

(a) Printing on thin stock (b) Printing on thick stock

Figure 2.12 Exaggerated schematics showing how increase in impression cylinder diameter,
due to running thicker stock, acts to increase print length.

Figure 2.12(b). The thicker stock would increase the working diameter and
the circumference of the impression cylinder. As a consequence, the 270
degrees that the impression cylinder must travel to receive the image now
corresponds to a greater distance along its circumference, or surface. Thus,
the image printed on the thick stock will be longer than on the thin stock.
(Figures 2.11 and 2.12 were suggested by similar illustrations used in a
MAN Roland training module entitled "Cylinder Rolling and Packing.")

The magnitude of the diameter effect on print length can be
calculated using the following equation:

$$\Delta C/C = 2\,\Delta H/D \tag{2.3}$$

where:

$\Delta C/C$ = fractional increase in cylinder circumference
ΔH = height of actual cylinder surface above gear pitch line
D = diameter of cylinder

When equation (2.3) is used to calculate the effect of plate packing, ΔH is
the height of the plate above bearers and the sign to the right is positive;
when used for the effect of stock thickness, ΔH is equal to the stock
thickness and the sign to the right is negative. To avoid confusion, the
appropriate equations are summarized as follows, wherein the net change in
print length is equal to the sum of the four individual components:

Factor	Appropriate Equation	
Plate stretch	$\Delta L/L = +h_{pt}/D$	(2.4)
Stock stretch	$\Delta L/L = -h_{st}/D$	(2.5)
Plate cylinder diameter	$\Delta L/L = -2h_p/D$	(2.6)
Impression cylinder diameter	$\Delta L/L = +2h_{st}/D$	(2.7)

where:

$\Delta L/L$ = fractional change in print length, relative to film
h_{pt} = plate thickness
h_{st} = stock thickness
h_p = height of plate above bearers
D = approximate cylinder diameter

Table 2.5 Sample calculations of deviation in length of print from that on film. Based on a plate thickness of 0.012 inch (12 mils), cylinder diameters of 10.0 inches, and a 26-inch print length.

	Fractional deviation in print length, $\Delta L/L$		
	Case 1	Case 2	Case 3
Factor affecting print length	$h_{st}=4$ mils $h_p= +6$ mils	$h_{st}=16$ mils $h_p= +6$ mils	$h_{st}=16$ mils $h_p=+12$ mils
Plate stretch ($+h_{pt}/D$)	+0.12%	+0.12%	+0.12%
Stock stretch ($-h_{st}/D$)	−0.04%	−0.16%	−0.16%
Plate cylinder diam. ($-2h_p/D$)	−0.12%	−0.12%	−0.24
Impression cylinder diam. ($+2h_{st}/D$)	+0.08%	+0.32%	+0.32%
Net deviation	+0.04%	+0.16%	+0.04%
	+ 10 mils	+ 42 mils	+ 10 mils

To illustrate the magnitude of the various effects, sample calculations for three different sets of realistic press conditions are given in Table 2.5. Case 1 is for printing on approximately 80-pound stock on a 40-inch-wide press. The calculations indicate the prints will be 0.010 inch (10 mils) longer than the film, assuming that the paper itself has not changed. Case 2

shows that the effect of switching to 16-point board would cause the print to be longer by 0.042 inch (42 mils), compared to Case 1. Case 3 illustrates how the effect of the thicker stock can be corrected for by adding 0.006 inch of packing to the plate, and removing a like amount from the blanket. (On a press that does not run on bearers it would not be necessary to remove any blanket packing because the plate cylinder could be moved to compensate for the change in packing.)

It should be noted that, in practice, the change in print length will deviate from the value predicted by equations (2.4)–(2.7), even if there are no changes in the dimensions of the paper. This is because the equations assume no slippage occurs between the paper and the hard cylinders, i.e., the impression cylinder. In practice, however, it has been shown (Peery, 1983) that a slippage of about 0.1 percent occurs for cylinders with a diameter of 4.95 inch. That is, paper travel is about 0.1 percent less than predicted by theory. The explanation given for this is that the paper is elongated or stretched while in the nip; thus the paper slows down upon being restored to its relaxed length upon emerging from the nip. The fact that the paper is stretched while in the nip was demonstrated in a simple yet elegant experiment wherein a strip of tracing paper was split by squeezing it between a rubber roller and the greased platen of a small hydraulic press (George, Oppenheimer, and Kimball, 1964).

2.2.7 **Attainment of True Rolling.** It might appear that it does not matter where the excess packing needed to achieve the necessary squeeze between plate and blanket cylinders is placed. That is, it would seem that, at worst, one cylinder would be larger in diameter than the other by 0.08–0.12 percent. Because the cylinders are equipped with gears that drive them in synchronization, there would be a resultant slippage between cylinder surfaces amounting to the same percentage. (This type of slippage is termed macroslip to distinguish it from microslip, described in Section 2.2.8.) Slippage of this magnitude is of no concern, because it was shown in Section 2.1.4 that a much larger slippage, or differential speed, of 1.9 percent is needed to produce a just tolerable dot gain of 2 percent due to slurring.

Many years ago, however, it was pointed out by Benjamin Sites that a roller having an elastic or resilient cover does not behave in a straightforward manner when placed in rolling contact with a hard surface (Sites, 1936). The demonstration he used to illustrate the phenomenon that does occur is shown in Figure 2.13. A small roller, about 0.8 inch in diameter, covered with a 1/8-inch-thick rubber layer, was inked up and then rolled on a piece of paper mounted on a hard surface. Two inked strips were rolled out on the paper: one where pressure was applied to the roller so as to indent the cover during rolling, and a second where little or no pressure was applied. As shown in Figure 2.10, the distance corresponding to one revolution of roller travel *was about 10 percent longer when pressure was applied* so as to compress the cover to half its

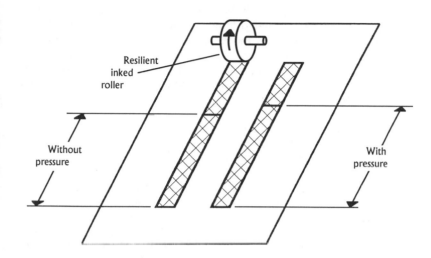

Figure 2.13 Demonstration of how increase in compression of thin resilient cover can change the effective diameter of a roller. Lines on inked areas, marking off roller travel in one revolution, show that compression of cover in the nip area increases the effective roller diameter.

thickness, compared to the strip where no pressure was applied. Thus *the effect of indenting or compressing the roller was to increase its effective diameter.* More elaborate experiments run years later confirmed that this is indeed a general rule (Miller, 1960), *but only for monolithic covers.*

The conclusion drawn by Sites from his observation re printing cylinders was as follows: "Therefore, due to the compression and consequent displacement of the resilient material, namely the rubber blanket on the blanket cylinder, the effective diameter of the latter will increase and consequently the impression transferred from the plate cylinder to the blanket cylinder and then from the blanket to the material to be printed will print long." Sites further concluded that in order to produce true rolling, the cylinders should be packed so that the uncompressed diameter of the blanket cylinder is smaller than the diameter of the plate cylinder. More specifically, for example, Sites recommended packing 8-inch-diameter cylinders as follows:

Plate cylinder 0.005 inch over bearers
Blanket cylinder 0.001 inch under bearers
(Resultant squeeze 0.004 inches)
Impression cylinder 0.005 inch over bearers

This method of packing is referred to as the true rolling method where true rolling expresses the condition of zero macroslip. The true rolling

method of packing has gradually become accepted over the years and is now used by most U.S. sheetfed printers. The exact prescription followed varies slightly from one press model to the next, depending on cylinder diameter, press manufacturer, and type of blanket. For example a common recipe for packing a compressible blanket is to slightly overpack (to compensate for some initial sinking) as follows for a press with 10-inch-diameter cylinders:

Plate cylinder	0.006 inch over bearers
Blanket cylinder	to the bearer
Resultant squeeze	0.006 inch

The major advantage claimed by Sites for using the true rolling method of packing was that the length of the printed image would be the same regardless of stock thickness. To achieve this, Sites, as noted above, recommended packing the impression cylinder the same as the plate (which was possible in Sites' time because some presses were equipped with tympans on their impression cylinders). Sites argued that with no slip in the blanket-impression cylinder nip, the effective diameter of the impression cylinder would not change with stock thickness; thus print length would not vary with stock thickness. This claimed advantage of true rolling packing is no longer achievable because, by and large, it is no longer possible to pack the impression cylinders on modern presses.

Other advantages claimed for the true rolling packing method were less smudging (Sites, 1936), and less wear and reduced heat generation (Kuehn and Sites, 1953). While all of these latter claims may be true, it would appear that the magnitude of the resulting improvements in print performance are so small as to be unobservable. The main reason for arriving at this conclusion is that there is relatively little difference, in terms of dot slurring, between the true rolling method of packing and its alternative, the equal diameter method.

As its name implies, the equal diameter method of packing is based on the objective of packing cylinders so that the two diameters, when compressed, will be the same. As a general rule, this recipe involves packing the plate to the bearers, and the blanket over, by an amount equal to the desired squeeze. For the example immediately above, equal diameter packing would be as follows:

Plate cylinder:	to the bearer
Blanket cylinder:	0.006 inch over bearers
Resultant squeeze:	0.006 inch

A comparison of these two examples reveals that if the amount of macroslip is zero in the first, then the amount of macroslip in the second will be 0.24%, assuming a cylinder diameter of 10 inches. Even if it is

assumed that the total slip affecting the print is double this amount (due to this amount of slip occurring again in the blanket-impression nip), it will still be much less than the value of 1.9% necessary to produce the maximum tolerable slip, as calculated in Section 2.1.4.

In addressing the question of how best to pack cylinders, it is also important to understand that blankets are complex structures made up of layers of both relatively compliant and relatively stiff materials. Consequently, they behave quite differently than do monolithic soft elastic covers, such as used in the demonstration shown in Figure 2.13. Specifically, studies at both PIRA (Miller, 1970) and IGT (Heyne, 1979) showed that a blanket cylinder can exhibit an effective diameter either equal to the actual diameter, or larger, depending on the design features of the particular blanket used. Some blanket brands, tested by Heyne, even exhibited slightly smaller effective diameters. The data from both of these investigations suggest that a cylinder-mounted blanket of given design will exhibit an effective diameter that can range, at worst, from about 0.5% larger than actual to, at best, essentially the same as actual—depending on how the given blanket is constructed. This is much less than the 10% increase in effective diameter exhibited in the demo shown in Figure 2.13. (Another factor accounting for the relatively small change exhibited by blankets is that the amount a blanket is squeezed on press is less than one-tenth its thickness, whereas the cover in the Figure 2.13 demo was squeezed one half its thickness.) These considerations carry with them the following implications that are of great practical significance:

1. There is no universal recipe on how to distribute packing so as to achieve true rolling, since blanket rolling characteristics can vary from one blanket design to the next.

2. The magnitude of the packing change needed to produce a just-perceptible amount of dot slur is relatively large. This is a fact discovered by every printer who has tried to make large changes in print length (say 1/8 inch) by switching packing between plate and blanket. This fact leads to an advantage for presses designed not to run on bearers. On such presses, it is only necessary to change the plate packing to effect a change in print length, because the resultant needed corrections to squeeze can be effected by moving the plate cylinder so as to adjust the plate-blanket squeeze. This results in less change in slip in the plate-blanket nip and no change in the blanket-impression nip. Thus, a given plate packing change on a press that does not run on bearers will produce a much smaller change in slip, compared to a press running on bearers.

2.2.8 Microslip. It would appear that the term "microslip" was first coined by Miller (Miller, 1970) to describe slippage occurring due to changes in tangential strain in the blanket, that *may* occur as it passes through a nip. Miller distinguished microslip from the slippage caused by

tangential forces that will arise if there is a mismatch between the drive motion generated by the gears and the drive motion generated by the net friction produced by the contact between the two cylinders in the nip. This latter type of slippage is referred to in this book as "macroslip." Miller went on to point out that microslip can be present even when true rolling conditions exist.

Miller's definition of the two types of slip can be better understood by considering a blanket and plate cylinder that have been packed to achieve true rolling. In such a case, the cylinders would rotate in synchronization even if the drive gears were removed. By definition, this is the condition where there is no macroslip. Under these same conditions, however, slippage may still be present in the nip, because the resilient cover of the blanket cylinder is being compressed as it travels from the entrance of the nip to the nip center, and then expands in traveling from the center line to the exit. If this compression in the thickness or radial direction is accompanied by a corresponding stretching or strain in the tangential direction, slippage *may occur* from point to point in the nip, depending on how much friction exists between the two surfaces.

From this discussion, it can be seen that microslip is dependent on the mechanical properties of the resilient cover and the amount of friction present. In other words, microslip may or may not occur. Only two projects in which measurements of microslip were made are known to the author (George, Oppenheimer, and Kimball, 1964; and Brink, 1963). Both involved rollers with relatively thick rubber covers and thus are not directly applicable to blanket cylinders. Nevertheless, it is worth noting that both studies showed that the largest change in tangential strain occurred outside of the nip, suggesting that the changes in strain that produce microslip (i.e., those within the nip) are relatively very small.

Practical experience on press also indicates that microslip in practice is either non-existent or so small as to produce no ill effects. The basis for this conclusion is the fact that perceptible dot slurring does not occur on a press in good operating condition and packed so as to reduce macroslip to a negligible amount.

2.3 Blankets

Today, lithography is synonymous with offset, but that has not always been the case. For the first one hundred years, following its invention in 1798 (Senefelder, 1821), lithographic printing was done direct, meaning that the image was transferred directly from stone plate to paper. By the year 1900, lithographic presses had evolved to a design that included a rubber-covered tympan cylinder that pressed the sheets of paper, hand-fed to the press, against the inked plate. The principle of offsetting was first used in England for printing on tinplate as evidenced by a patent filed in

1875 by Robert Barclay (Davis, 1975). It would appear that the advantage of offsetting when printing on paper was independently discovered sometime later by two different inventors: Ira Rubel of Nutley, New Jersey (Cogoli, 1967) and Charles Harris of Niles, Ohio (Harris, 1972). The events that led to the discoveries by these men were the same. While standing near a running press, the "discoverer" noticed that the operator missed feeding a sheet to the press, with the result that the image was transferred to the tympan cylinder. When a sheet was then fed on the next stroke of the press, it was printed on both the front, direct from the plate; and on the back, by offsetting from the tympan cylinder. It was observed that the quality of the offset print was "a more delicate and faithful reproduction, every line sharp," compared to the direct print, and it was this observation that prompted both inventors to build presses (Rubel in 1905 and Harris in 1906) equipped with rubber-covered "offset" cylinders, that we know today as blanket cylinders.

The improved print quality achieved through offsetting is generally accepted as being due to the ability of the compliant blanket to more closely conform to the uneven surface of paper. This is in contrast to the hard plate in direct printing that can only touch the high points of the paper surface. An added advantage of offsetting is that the corresponding plate is right-reading, making it easier to check a press-ready plate for errors in typesetting.

2.3.1 Purpose. In today's lithographic presses, there are two extremely important jobs assigned to the blanket, as follows: to produce a printing surface superior to that of a metal plate, and to generate the pressure necessary to transfer the inked image from plate to blanket to stock.

2.3.2 Requirements. Blankets are very sophisticated structures and are so designed because of the many demands placed upon them. Five of the more important of these requirements are identified and discussed in the following paragraphs.

1. One very obvious requirement is that the surface of a blanket must be ink receptive in order to transfer the inked image.

2. Print or image sharpness has been defined as "The clarity of fine detail and distinctness of edges in the image when examined at normal viewing distance" (Jorgensen and Lavi, 1977). As noted above, the improved sharpness, observed by the discoverers of offsetting, was the driving force that led to the widespread use of the blanket cylinder. In order to realize this advantage, the printing surface of lithographic blankets must be relatively smooth. Typically, the roughness of blanket surfaces is comparable to both the roughness of the best coated papers used in printing, and that of the plate image area. For example, average roughness measurements made using a stylus-type device with a 5-micron (0.0002-inch) tip radius (Lind, 1993), yielded the following results:

Blanket	0.6 micron (25 microinch)
Plate image area	0.6 micron (25 microinch)
#1 Coated Paper	0.5 micron (20 microinch)
#1 Uncoated Paper	2.7 micron (105 microinch)

3. Blankets must also possess a complex and seemingly conflicting set of mechanical properties. First, a blanket must be compliant, yet relatively firm, in the thickness direction, so that the necessary printing pressure will be developed with an amount of squeeze in the range of 0.004–0.006 inch. (If a very soft blanket were used, requiring a much greater squeeze, dot slurring due to slippage would be excessive.) A blanket must also be very stiff in the around-the-cylinder direction, so that it can be pulled tight to the cylinder, thereby preventing slippage between the blanket and the cylinder on which it is mounted. (A tension of about 50 pounds/inch is used on sheetfed presses and 100 pounds/inch on webs) Experience has shown that, for certain applications, the blanket must also be mechanically stabilized by the incorporation of a relatively rigid membrane, close to the printing surface (Shrimpton and Dunkley, 1972). It has been found that such a membrane reduces tangential strain (Rodrigues, 1981) and thereby significantly reduces spreadout of the printing surface that otherwise would be excessive. Another essential mechanical property is that a blanket must be resilient in the thickness direction. This means that the blanket must be capable of returning to its original state, or of springing back, after being compressed many many times. For example, it is not uncommon for a blanket to last for ten million impressions, and to do so it must be capable of withstanding twenty million cycles of being compressed and then relaxed, with no significant change in either caliper or compliance.

4. Another important demand placed on a blanket is that its caliper or thickness must be held to close tolerances, to insure that printing pressure is uniform in both the across- and around-the-cylinder directions. (The effect of a variation of 0.001 inch in blanket caliper, and hence squeeze, is illustrated by the data in Table 2.4.)

5. The fifth important requirement is that the blanket materials exposed to the inks, fountain solutions, papers, and washup solvents used on press must be chemically resistant to these materials. For example, there are many elastomers that are not usable because they swell and/or soften after being wetted for a prolonged time by common washup solvents. This requirement is more difficult to satisfy when printing with UV inks because the UV washup solvents are very aggressive.

2.3.3 Conventional versus Compressible Types. Generally, current blankets can be classified as either conventional or compressible. According to one source (Chamberlain, 1978), compressible blankets were developed in the U.S. in the 1960's in response to a demand for greater smash resistance. This demand was generated by the America practice of using

single blankets, versus the European practice of building presses with larger cylinder undercuts that permitted double blankets to be used.

The property that determines whether a blanket is of the conventional or compressible type is the deformation characteristics of the material incorporated in the blanket structure to provide compliance or springiness in the thickness direction. Specifically, if the material used does not change volume to any appreciable extent when deformed by squeezing, the blanket is said to be of conventional construction. An example of such behavior is a rubber eraser that maintains its volume by bulging at the sides when its ends are compressed.

In contrast, the ideal compressible blanket utilizes a compliant material that can be compressed in the thickness direction without any significant change in its lateral dimensions. A material that behaves in this manner is said to be compressible because its volume decreases when it is squeezed. An example of such behavior is a coil spring that responds to a force along its axis simply by moving in the same direction as the force. The different responses of these two types of material are illustrated in Figure 2.14.

(a) Rubber eraser (b) Coil spring

Figure 2.14 Difference in behavior exhibited by conventional (incompressible) and compressible materials. Rubber eraser, shown in (a), is said to be incompressible because its volume remains constant under an axial load. Coil spring in (b) is a model of a compressible material because only its height changes when subjected to the same load.

The choice of a compliant material for use in a compressible blanket is not straightforward because monolithic elastomers, such as natural rubber, are for all intents, incompressible. Thus an early concept for producing a compressible material was to disperse compressible fibers in a matrix of an elastomer. Currently, the most common way of producing a suitable compressible material is to generate voids, or cells, in the elastomer of choice during its manufacture. The resulting product is akin to sponge rubber, except that the voids are very small in size and the total void volume is controlled so as to achieve the necessary firmness.

The relative behavior of a conventional and a compressible blanket is illustrated by the simplified diagrams in Figure 2.15. Figure 2.15(a) is a

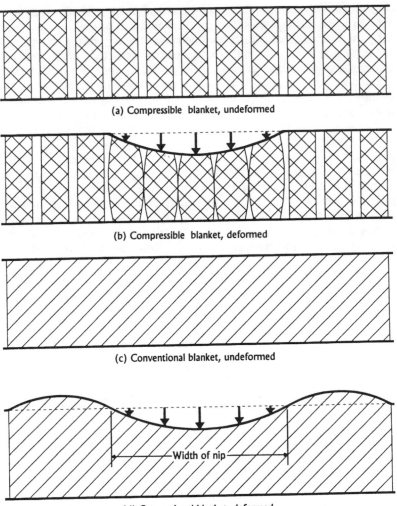

(a) Compressible blanket, undeformed

(b) Compressible blanket, deformed

(c) Conventional blanket, undeformed

(d) Conventional blanket, deformed

Figure 2.15 Models showing response to squeeze in nip of compressible and conventional blankets. Cross-hatched rectangles in (a) represent small rubber columns. Spaces in between prevent column interaction in response to squeeze forces represented by arrows in (b). Monolithic conventional blanket in (c) responds to squeeze by bulging beyond nip, as in (d), due to volumetric incompressibility.

model of a compressible blanket shown in its relaxed or undeformed state. Compressibility is modeled by an array of small rubber columns placed side by side, represented by the cross-hatched rectangles. Enough void volume is provided between these columns such that each column can bulge out when squeezed without contacting its neighbor. (The space between

columns is analogous to the voids employed in real compressible blankets.) The resulting response of the blanket to the squeezing force produced by a hard or unyielding cylinder is portrayed in Figure 2.15(b).

The contrasting makeup and behavior of a conventional blanket is represented in Figures 2.15(c) and (d). Because the volume of the monolithic structure of the conventional blanket cannot decrease, material is pushed or caused to flow away from the nip area by the squeeze forces, producing the bulges shown in Figure 2.15(d)

The diagrams in Figure 2.15 are intended to illustrate a gross difference and should not be interpreted literally for several reasons. First, these models do not reflect the additional forces present under dynamic conditions produced when the two contacting cylinders are turning. These additional forces can produce significant shear in both types of blankets, and skew the bulging portrayed in Figure 2.15(d). A second reason is that there is probably no material that is perfectly compressible; thus all compressible blankets exhibit some degree of incompressible behavior. The main value of Figure 2.15, then, is to demonstrate how compressible and conventional blankets differ in principle.

Many write-ups in the trade literature have suggested that bulging, as shown in Figure 2.15(d), or lack thereof as in 2.15(b), is an indicator of the slip generated by a blanket. By inference these write-ups suggest that compressible blankets are superior to conventional ones in this regard. The fact of the matter is that experience has shown that specific blanket design, rather than degree of compressibility, governs how much slip occurs. Thus, compressible blankets possess no inherent advantage insofar as slip is concerned.

What experience has shown is that compressible blankets have superior smash resistance, and this is a major reason why most printing today is carried out with them. Compressible blankets are also more tolerant of deviations in plate thickness, blanket thickness, and packing that would otherwise result in unacceptable variations in printing pressure. The data in Figure 2.8 demonstrate this very well in that the slope of the load versus squeeze curve is much lower for the compressible blanket.

2.3.4 Design and Construction. Although blankets have been in use for almost 100 years, a universal design has not evolved. This is due partly to the steady stream of new materials that have become available over the years to blanket designers and partly because it has been found that different printing applications have different requirements. Rather than address all of the different designs currently available, this section will describe a typical design, based on the current patent literature.

Figure 2.16 shows a typical compressible blanket design that embodies all of the elements described in a recent patent (O'Rell and Holleran, 1989). It is a composite structure made up of a textile carcass, with three layers above it: compliant, stabilizing, and printing. The carcass consists of three plies of woven fabric bonded together by layers of a suitable

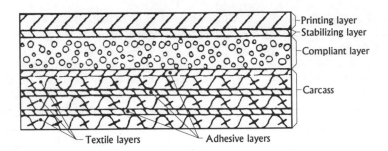

Figure 2.16 Cross section of a typical blanket. Thicknesses of printing, stabilizing, and adhesive layers have been increased for clarity.

adhesive. The textile plies act as fiber reinforcements and provide the required mechanical stiffness in the around-the-cylinder direction. Stiffness in this direction is enhanced by various means such as prestretching the threads in the warp or lengthwise direction of the fabric before being incorporated in the blanket. For this reason, the blanket should always be mounted so that the warp direction of the carcass is in the around-the-cylinder direction. To aid in this, the backsides of blankets supplied without mounting bars are marked with arrows or colored stripes to indicate the warp direction.

The compliant layer, bonded to the carcass, provides most of the blankets cushioning or springiness, in the thickness direction. The material selected for this layer determines whether the blanket is of the conventional or compressible type, as described in the preceding section.

Although Figure 2.16 is not drawn to scale, it correctly shows that the compliant layer and carcass account for most of the blanket's volume or thickness. In this regard, it is to be noted that blankets generally range in total thickness from 0.066 to 0.076 inches (1.7 to 1.9 mm), and that the top printing layer is very thin; in the range of 0.005 to 0.015 inches (0.13 to 0.38 mm).

The printing layer, or face, of the blanket is a homogeneous coating of material that is elastic, ink-receptive, and chemically compatible with the inks, fountain solution, and washup solvents used in the printing application for which the blanket is designed. Aside from the material used, a very important characteristic of this blanket element is its surface finish or roughness. This can range from an almost glass-like surface to a nappy one with a matte appearance. The three different techniques currently used by the industry (Chamberlain, 1989, and O'Rell, 1990) to achieve the desired finish are described in the following paragraphs.

1. **Cast Finishing.** In this method, surface finish is controlled by curing the surface rubber while it is tightly pressed against a layer of paper. When the paper is removed following curing, an imprint of its surface

texture is left on the blanket face. As a result, it is possible to produce blankets with varying degrees of smoothness depending on the surface texture of the paper.

2. **Mechanical Finishing.** As the name suggests, this method utilizes some type of mechanical machining device to grind or buff the blanket surface. In so doing, the blanket is reduced to its finished thickness. Thus, this method has the advantage that both blanket caliper and surface topography can be controlled so that the blanket can be sized to go on press without packing. The surface roughness can also be controlled quite closely and, in addition, a wide variety of surface finishes can be produced.

3. **Chemical Etching.** In this third method, which is relatively new, the blanket surface is dusted with starch instead of talc, prior to vulcanization. The normal procedure is to dust the blanket with talc before vulcanizing to prevent sticking. Following curing, the residual starch is removed by chemical etching to produce a finish that contains many tightly packed shallow holes (resembling an anilox roller or gravure cylinder).

The surface finish produced on a given blanket represents a trade-off between a very smooth finish, desired for maximizing print fidelity, and a rough surface desired for better release. Release is fully explained in the subsequent section. One study of the effect of blanket roughness on print fidelity concluded that the threshold roughness that affects sharpness and white spots in solid areas is an R_z of approximately 6 microns, i.e., an average roughness, R_a, of about 3 microns or 120 microinches (Iwasaki, Okada, and Takahashi, 1988). This is consistent with one set of average roughness measurements of some typical blanket finishes (Chamberlain, 1989) that ranged from a low of 22 microinches (0.5 microns) for the smoothest blanket to 115 microinches (3 microns) for the roughest.

The last blanket element in Figure 2.16 to be discussed is the stabilizing layer, placed just under the printing layer. The purpose of this layer is to limit distortion of the blanket in shear that occurs when tangential loads are applied. Such loads are generated by pull on the paper in contact with the blanket and as a result of the squeeze that occurs when the blanket passes through a nip. The effect of the latter, spreadout of the printing surface, is illustrated in Figure 2.17(a). If spreadout is excessive, the compliant layer may be split and/or dot gain may reach unacceptable levels (Rodriguez, 1981). The stabilizing layer, used primarily in compressible blankets, is comprised of a relatively thin section of a relatively rigid material, compared to the compliant layer. The effect of this membrane is to constrain the spreadout of the printing layer, as shown in Figure 2.17(b).

When first devised, stabilizing layers were made of woven fabric (Shrimpton and Dunkley, 1972). It was discovered, however, that the use of a fabric layer near the printing layer could lead to a phenomenon known as "falloff at the gap" (O'Rell and Holleran, 1989). This refers to a

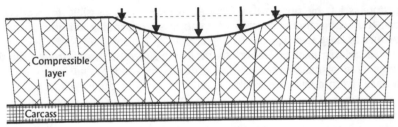

(a) Deformation without stabilizing layer

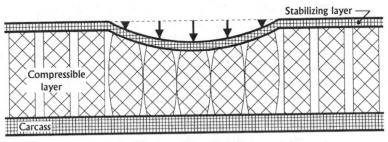

(b) Deformation with stabilizing layer

Figure 2.17 Diagrams showing how stabilizing layer reduces spreadout of printing surface.

reduction in the blanket thickness in the areas near the blanket cylinder gap. It is caused by the longer path that the upper fabric layer must follow as it is bent over into the gap for retention on the cylinder. Because it cannot elongate accordingly, the upper fabric compresses the compliant layer, producing a corresponding reduction in blanket thickness. This results in a decrease in printing pressure, which causes the so-called falloff in print quality at these locations. To eliminate this phenomenon, modern blankets utilize a thin film of hard rubber or a thin specially designed fabric for the stabilizing layer, as portrayed in Figure 2.16.

2.3.5 **Performance Attributes.** Much insight about the influence of blankets on lithographic printing can be gained by reviewing how printers evaluate blankets: by their performance on press. In addition to cost effectiveness, there are at least eight other performance attributes that are of interest in most applications, and these are identified and discussed in the following paragraphs.

1. **Dot Gain.** Although most printers will agree that dot gain is a function of blanket design or brand, there is no agreement on what blanket design characteristics are desirable in this regard. One quantitative study of the performance of eight different blankets (Loibl and Koessler, 1985) yielded similar findings. For example, while measured dot gain in the 40 percent screen area of an UGRA test image ranged from a low of 17

percent (film to print) to a high of 20.5 percent, no correlation was evident between this variation in performance and the various blanket properties that were also measured. This study also included results showing that increasing plate-to-blanket squeeze by 0.002 inch increased dot gain by as little as 0.5 percent for the best to as much as 3.0 percent, for the worst performing blanket in this respect.

2. **Smash Resistance.** This refers to a blanket's ability to recover from excessive compression that will occur if multiple layers of paper pass through the impression nip. This can happen, of course, whenever there is a paper jam on a sheetfed press or a web break on a web press. Smash resistance is of great importance because it is generally found to be the leading reason blankets are replaced (Hagler, 1988). It has already been mentioned in Section 2.3.3 that compressible blankets have been found to be superior in this regard. The damage done to a blanket in a smash can be a rupture of the face and/or permanent set (a low spot). A blanket damaged by permanent set, caused by compression of one or all of the textile plies, can sometimes be restored by removing it from the press and simply allowing it to rest. If the damage is more severe, soaking the blanket in water will sometimes succeed in swelling the fabric back to its original size (Whitney, 1990). Unfortunately, these remedies are mainly of academic interest, because once a blanket is removed from a high productivity press, it rarely finds its way back onto a cylinder.

3. **Release.** In passing through the blanket-impression-cylinder nip, the paper-blanket interface is subjected to considerable pressure in order to transfer the inked image to the paper. The combination of the high pressure and thin film of ink has the effect of pasting the paper to the blanket. Consequently, considerable force is required to separate or peel the paper from the blanket cylinder. The magnitude of this force depends on many factors including the ink properties, coverage, and thickness; the blanket properties; and the angle formed between the paper and cylinder, i.e. the peel angle. One off-press test method (Concannon and Wilson, 1992) has shown that this force is in the range of 2–4 pounds per inch of paper width for a full-coverage print (Plowman, 1993). The properties of the blanket that affect this separation force are known as "blanket release." Printers are vitally interested in minimizing separation force because it is a major factor in paper picking, tail-end hook (on sheetfed presses), and web flutter (on web presses). A study conducted many years ago found that rougher blanket surfaces gave better release (Hull, 1971) and printers' experience since that time has usually confirmed this. The method used in Hull's study, and by sheetfed printers, to gauge release is to observe the degree of tail-end hook on sheets in the delivery pile. This refers to the amount of paper curl produced when the trailing edge of a sheet is peeled away from the blanket. (This requires, of course, printing a form having an area of high ink coverage that extends to the trailing edge of the sheet.) Curl at the tail-end is used because curl is severest at the tail-end and easy

to observe. From this it can be correctly inferred that the separation force is greatest at the end of the sheet. The cause of this in some press designs has been explained as a shifting of the point on the blanket cylinder where separation occurs, due to a less than ideal delivery system geometry (Bolza-Schunemann, 1971). The reason why the separation force decreases as blanket surface roughness increases is because the percent contact in the inked areas decreases. Evidence of this phenomenon is given in Section 3.5.5 in connection with the discussion of the Walker-Fetsko equation. A recent study of release (Iwasaki, Takahashi, Yukawa, and Okada, 1993) indicates that separation force increases as print density (and hence ink film thickness) is increased, in keeping with the observation that thicker ink films on an inkometer result in higher readings of tack. The absorption properties of the blanket surface also appear to affect separation force because it is possible for two different blankets with the same surface roughness to have significantly different releases (Plowman, 1993).

4. **Propensity to Pile.** Piling refers to debris that builds up on both the image and nonimage areas of a blanket as printing progresses. It is of concern because the task of periodically cleaning blankets can affect productivity significantly if the press is not equipped with an automatic washup system. There is, however, no general agreement on how the properties of a blanket affect piling. Nevertheless, there are some hints. For example, paper picking aggravates piling, and picking is initiated by the separation force that in turn is affected by blanket release.

5. **Need for Packing.** A relatively recent development is the availability of blankets of specified caliper. These are used either with no packing at all, or with so-called permanent packing sheets. With the former, the specified caliper is equal to the cylinder undercut, plus the desired height above bearers. With the latter, a common practice in Europe on both commercial and newspaper web presses, the required packing is in the form of a polyester film with an adhesive backing that is glued to the cylinder. The objective in eliminating the need to custom-pack each blanket is to reduce press downtime. This advantage can only be realized in applications where there is little change in stock caliper from job to job, as in newspaper printing.

6. **Caliper Stability.** Caliper instability refers to the development of depressions in a blanket's surface that result in loss of printing pressure. When located randomly, such defects are referred to as low spots; when the reduction in caliper is more or less uniform over a larger area, it is called sinking. With some blanket designs, this may occur in a narrow region adjacent and parallel to the cylinder gap, in which case it is referred to as "fall-off at the gap" (O'Rell and Holleran, 1989).

7. **Resistance to Embossing.** Embossing is the swelling of an image area on the blanket that is severe enough to cause uneven printing on a subsequent job. One of the leading causes of blanket replacement, it is caused by a chemical incompatibility between the ink and blanket face that

causes the blanket to swell. This is especially true when using UV inks.

8. **Resistance to Edge Cutting.** Edge cutting is a form of blanket failure encountered when printing on coated paper. It is brought on by the buildup of a thin line of paper-colored piling in the around-the-cylinder direction, located at the edge of the paper. This type of piling consists primarily of paper coating particles and some cellulose fibers, and most likely can be explained as being due to loose materials exposed at the edge of the sheet or web as a result of slitting or cutting the paper to size, prior to printing. The fibers become stuck to the blanket and are pulled out of the paper, along with some pieces of coating (MacPhee, Gasparrini, and Arnolds, 1982). If such piling is allowed to build up, it can result in cuts in the blanket face or printing layer. Although resistance to such failure will vary with blanket design, it generally can be avoided by paying proper attention to blanket washup.

2.4 Plates

The element that most clearly distinguishes one printing process from another is the master or plate. The name of the lithographic printing process, derived from the Greek words for stone (lithos) and to write (graphos), reflects the fact that the original plates were prepared by transferring a greasy material (that formed the image) onto flat pieces of limestone. Although most modern plates are made from thin sheets of aluminum, the distinguishing planographic character of the early stone lithographic plates remains. Thus, on a lithographic plate the image and nonimage areas are, for all practical purposes, in the same plane. This is in contrast to gravure where the image areas are recessed, and to flexo and letterpress where the image areas are raised.

During the almost 200 years of lithography's existence, three different types of plate have been used, based on the method used to produce the ink-receptive image areas. These are described as follows:

1. **Original Plates.** Image is hand-drawn, using a greasy crayon or a special ink called tusche (Reed, 1967). Such plates are no longer used except for special art work.

2. **Transfer Plates.** Image is lifted from a master plate and deposited on the printing plate using special paper (Reed, 1967). This type of plate also is no longer used.

3. **Photographic Plates.** Image is produced by exposing (and then developing) a radiant-energy-sensitive coating on the plate. Exposure is effected either by placing an image-bearing film over the plate in a vacuum frame and exposing it to light or by placing the plate in an imagesetter, described in Section 7.6.2 of Chapter 7, and exposing it to a narrow beam of radiant energy, as from a laser. The latter method is referred to as

computer to plate (CTP) and employs either light-sensitive or thermal plates. Thermal plates are so named because the absorption of energy results in the generation of heat that acts in one of two ways, depending on the type of thermal plate. In the first type, the heat produces a physical change in the coating (Lewis and Cassidy, 1996). In the second type, the heat triggers the generation of a free acid. The plate is then baked to produce a chemical reaction similar to the reaction that occurs in light-sensitive plates upon exposure (Walls, 1994).

All subsequent discussions of plates in this book are limited to the two types of photographic plates just described because commercial use of the other types is now insignificant.

Within the past forty years, lithography has replaced letterpress as the dominant printing process, both in the U.S. and in the world. Its ascendancy can be traced to the development, at the beginning of the same period, of a reliable and inexpensive master, the presensitized photographic aluminum plate. (Presensitized defines a plate that is already sensitive to energy as delivered to the printer, i.e., the energy-sensitive coating has been applied by the plate manufacturer.) Some appreciation for the impact of this development can be had by briefly reviewing plate making operations carried out by printers before and after the advent of the presensitized plate.

Prior to the 1950's, photographic plates were literally manufactured in the printing plant. This labor-intensive process started with raw materials in the form of mill-finished aluminum sheets and the necessary chemicals which were converted into press-ready plates through a series of batch operations. Once the light sensitive coatings were applied, the plates did not have long shelf lives, so it was necessary to produce plates to order rather than for stock.

With the advent of presensitized plates with long shelf lives, all this changed. All of the steps in manufacturing, prior to exposure, could be carried out in a series of continuous in-line operations performed on a moving web of thin aluminum stock. Because this process could benefit from economies of scale, this phase of platemaking moved from a multitude of small printer-based plate rooms to a few very large supplier-run manufacturing plants. Thus, the platemaking operations performed in today's printing plants are generally limited to exposure and development.

One exception to this is the newspaper industry, where there are many printing plants that still use so-called "wipe-on plates," wherein the light sensitive coating is applied as part of their platemaking operation.

This suggests that the bulk of plates in current commercial use are surface plates, so-called because the image is made up of those areas of the very thin coating that remains on the plate surface following exposure and development. This is indeed true, because the alternative, chemically etched plates, have largely been retired for environmental reasons. (With

chemically etched plates, the photosensitive coating is only used as a resist, or stencil, for chemically engraving the plate metal.)

2.4.1 Purpose and Requirements. The plate is a key element in the lithographic printing process because it is where the image to be printed is generated, by virtue of the distinct differences between its image and nonimage areas. Thus, it must satisfy a very necessary set of lithographic requirements and also possess several important physical and chemical properties. All of these are described in the following paragraphs.

1. The properties of the plate image material must be such that, in the presence of both ink and fountain solution, the image areas of the plate will be wet by ink, i.e., be ink-receptive.

2. The properties of the plate nonimage material must be such that, in the presence of both ink and fountain solution, the nonimage areas of the plate will be wet by fountain solution, i.e., be water-receptive.

3. The developed plate must be readable in the sense that it must be possible to visually distinguish between the image and nonimage areas. This might seem unimportant, but there are several good reasons for this. Plates can be identified simply by looking at them, and in that way an operator can confirm that he has the right plate(s) for a given job, and that the plate is mounted correctly in the press. In addition, a plate can be visually inspected for readily detected errors.

4. The surface of the image areas must be relatively smooth in order to achieve adequate print sharpness. In practice, the surface finish is in the range of 0.6 microns (24 microinches).

5. As in the case of blankets, the thickness of plates must be held to close tolerances to insure that printing pressure is uniform in both the across and around-the-cylinder directions. (The effect of a variation of 0.001 inch in plate thickness, and hence squeeze, is illustrated by the data in Table 2.4.)

6. Both the plate base material and the coating must be chemically compatible with the inks, fountain solutions, papers, and washup solvents used on press.

7. Both the image and nonimage areas must have sufficient abrasion resistance to prevent wearout due to the forces generated in the plate-blanket nip. These areas must also be resistant to the mechanical abuse that they are subjected to during normal handling.

8. The plate must have sufficient mechanical strength to resist the loads to which it is subjected on press. These include the tensile load applied by the cylinder plate clamps, the peel force generated by ink film splitting at the plate-blanket nip exit, and the complex loads generated in the plate-blanket and plate-form roller nips.

9. The plate must transfer the inked image to the blanket in a manner that results in consistency in both the printed ink film thickness and dot gain.

10. Image creation, as a result of plate exposure and development, must be consistent in terms of dot size, image sharpness, and run life.

2.4.2 Negative- versus Positive-Working Photographic Plates. It has already been mentioned that most photographic plates used today are classified as surface types. With this type of plate, a hard coating is left on the surface after development to form the image areas, while the non-image areas are formed by those regions of the aluminum base that are uncovered when the light-sensitive coating is removed. The coating that forms the image areas is very thin, having a typical thickness of 2 microns or 0.00008 inch (Hoechst, 1985 and Nakanishi et al, 1987).

Although there is a great variety in the materials and treatments used by different plate manufacturers, one important distinguishing characteristic of a surface plate is whether it is positive- or negative-working. In the case of plates exposed in a vacuum frame, the plate is said to be negative-working if a negative film is necessary; conversely, a plate is described as positive-working if a positive film must be used. This distinction is far more significant than simply defining the film, because the relative merits of negative- and positive-working plates are quite different. Prior to discussing these, the basic differences between these two classes of plates will be described.

These two types of plates are similar in that following exposure, the energy-sensitive coating in the nonimage areas is washed away during the development stage to uncover the base material. The fundamental difference is that a negative-working plate is coated with an energy-sensitive material that is soluble in the fluid (usually water-based) used in the development stage to wash away the coating covering the nonimage areas. In contrast, positive-working plates utilize an energy-sensitive coating that is insoluble in the washing fluid used in the development state. Thus, the response to energy exposure must be different for the two coatings: the negative-working coating is hardened, or made insoluble by exposure, while the positive-working coating is solubilized by energy exposure.

These differences are illustrated in Figures 2.18(a)–(c) that show a light-sensitive negative plate in various stages of preparation, and Figures 2.18(d)–(f) that show the corresponding stages for a positive plate. Figure 2.18(a) is a schematic of a negative-working plate during the exposure stage. The negative film required is so-called because the image areas are transparent to light, whereas the nonimage areas are opaque. As a result of exposure, the coating regions corresponding to the image areas are made insoluble as in Figure 2.18(b). Thus, during the subsequent development stage, these areas of coating remain while the unexposed regions are washed away to produce distinct image and nonimage areas on the plate, as shown in Figure 2.18(c). Normally, the coating that forms the image areas is lacquered to improve its wear characteristics on press. If this image-reinforcing lacquer is applied along with the light-sensitive coating, the plate

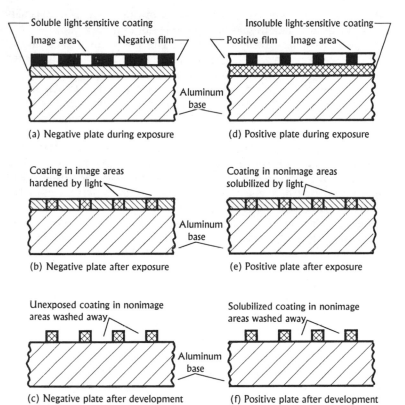

Figure 2.18 Schematics of negative- and positive-working plates in various stages of preparation.

is characterized as "subtractive," because the lacquer in the nonimage areas is removed during developing, along with the unexposed coating. If the lacquer is applied during development, the plate is said to be "additive."

Figure 2.18(d) is a schematic of a positive-working plate during the exposure stage. The positive film used is transparent in the nonimage areas, and thus it is these areas of the insoluble light-sensitive coating that are exposed to light. Figure 2.18(e) illustrates that the coating in the non-image areas is converted to a soluble material as a result of exposure. Consequently, these areas are washed away during development to uncover the base material, while the coating corresponding to the image areas remains in place. Thus, distinct image and nonimage areas are formed as portrayed in Figure 2.18(f).

The distinction between positive- and negative-working plates is sharply drawn by the fact that most U.S. printers prefer negative-working plates, whereas most printers in Europe and Asia opt for positive-working

plates. Although this preference may have its origins in relative availability and cost, advocates on both sides have valid reasons for their choice.

Proponents of negative-working plates cite lower costs, simplicity of the development process, and greater immunity to defects (unwanted specks) caused by dust particles on the film.

Proponents of positive plates argue that it is practical to standardize plate exposure because the degree of hardening, and hence bonding to the aluminum, of the image area coating is independent of exposure (Hoechst, 1985).

In contrast, the hardness of the coating in the image area of a negative-working plate is dependent on how long the plate is exposed. This, coupled with the existence of a variety of proprietary negative-working coatings means that different makes of plates require different exposures. Therefore, it is not practical to standardize exposure.

Another advantage claimed for positive-working plates is that halftone dots can be sharpened by overexposing a plate (as opposed to negative plates where overexposure produces dot spreading). This provides the printer who uses positive plates with an easy way to compensate for an unexpected dot gain problem on press, because a gain problem on press is much more likely to involve dot spreading. The wear resistance of the coating of a developed positive plate can be enhanced through additional treatments such as fusing the image by baking the plate, and the resultant long life and coating toughness are a decided advantage.

2.4.3 **Design and Construction of Light-Sensitive Plates.** As in the case of blankets, different designs of light-sensitive plates have evolved in response to the different requirements of the various segments of the printing industry. Nevertheless, enough commonality exists so that a single typical design can be described here. The description that follows is based on selected papers and patents that are historically significant and/or noteworthy in disclosing information on specific aspects of light-sensitive photographic plate design (Dean and Ford, 1973; Eklund and Huang, 1985; Fromson, 1965; Gumbinner, 1960; Hoechst, 1985; Huang et al, 1985; Jewett and Case, 1955; Manhart, 1977; Nakanishi et al, 1987; Platzer, 1986; Powers, 1970; Richter and Reavis, 1989; Toyama et al, 1987; and Zelley, 1972).

Figure 2.19 is a schematic of a typical presensitized surface plate. It shows the undeveloped plate to be comprised of successive layers of four different materials: an aluminum support or base, a film of anodized aluminum, a passivating layer, and a light-sensitive coating.

The support or base is a thin sheet of aluminum that can range in thickness from 0.006 to 0.020 inch. For most applications, however, plate thickness is between 0.008 and 0.012 inch. The aluminum alloys normally used are either 1050, 1100, or 3003. The alloy of almost pure (99.5 percent) aluminum, 1050, is preferred for its superior response to electrochemical processing and greater resistance to staining. Key to this

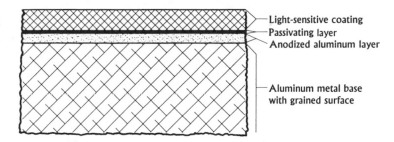

Figure 2.19 Cross section of a typical presensitized light-sensitive surface plate prior to exposure and development.

performance is the low copper content (less than 0.05 weight percent) of alloy 1050. Alloy 3003, containing 1.5 weight percent manganese, possesses better fatigue resistance and greater strength and is therefore often used in applications where those properties are important. Some work has also been directed toward developing a 5000 series alloy that combines the mechanical attributes of 3003 alloy and the good response of 1050 alloy to electrochemical processing.

Experience has shown that the as-rolled finish of aluminum as supplied by a mill is too smooth for use in most plate applications. The main reason given for this is that some surface roughness or grain is necessary to provide the coating adhesion needed for a long plate life. It is also widely believed that rougher surface finishes are desirable because they provide a greater margin in water feedrate, due to a greater water-carrying capacity. This belief, however, was not born out in the only systematic study of this known to the author (Lawson and Watkinson, 1975) where it was found that no difference existed, in either the minimum required water feedrate or the water consumption, between a typical (grained) and both a lightly grained and a grainless plate.

In practice, roughening or graining of the plate surface is done by either mechanical, chemical, or electrochemical means or some combination of these. Mechanical graining is carried out using a slurry of abrasive particles that is circulated in a ball mill, or by rotating nylon brushes. The former method, ball graining, has all but died out because it is limited to the batch graining of sheets, whereas wet brush graining can be carried out continuously on a traveling web. Some manufacturers follow brush graining with a stage of electrochemical graining. The aluminum can also be grained with a dry rotating wire brush, but the resultant surface texture is inferior because it is directional. Mechanical graining produces sharper surface asperities, compared to chemical and electrochemical methods. This is illustrated by the scanning electron microscope micrographs in Figure 2.20 that show the topography of the various surfaces discussed here.

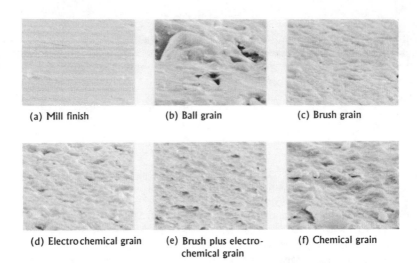

(a) Mill finish	(b) Ball grain	(c) Brush grain
(d) Electrochemical grain	(e) Brush plus electro- chemical grain	(f) Chemical grain

Figure 2.20 Comparison of topography of mill finish of aluminum sheet with various types of grained plate surfaces. Width of each photo is 33 microns (0.0013 inches).

Whatever graining method is used, the objective is to produce an average roughness between 0.8–1.2 microns (32 and 48 microinches). Coarser finishes are not used because print resolution will suffer, while a very much finer finish will, as already noted, result in a poor coating bond that in turn results in a relatively short plate life. It is interesting to note that the preferred surface roughness of plates is comparable to both the thickness of the light-sensitive coating on the plate and the printed ink film.

Following graining, the plate surface is given an anodizing treatment whereby a thin layer of a cellular aluminum oxide is formed on the surface. This coating improves the wear, scratch, and corrosion resistance of the plate. The term "anodizing" stems from the fact that it is an electrolytic process wherein the surface to be coated forms the anode. The anodized layer is typically 1 micron thick (0.00004 inch) and has a Mohs hardness of about 7.0, i.e., it is harder than most steels. This coating is also quite porous and must be sealed to prevent staining. (Although such stains have no adverse effect on performance, they are undesirable from a commercial point of view because many users consider them to be an indication of inferior quality.) The simplest sealing process is to immerse the anodized sheet in boiling water, but some other aqueous solution is normally employed in platemaking.

After graining, the plate surface is chemically treated to produce a passivating film. In the first successful presensitized plate this film consisted of a monomoleculer layer of a silicate compound. Since then other passivating schemes have been developed. The primary purpose of the passivating film is to insulate the light-sensitive coating from the aluminum.

This prevents the light-sensitive coating from chemically reacting with the aluminum base during the period between plate manufacture and exposure and development by the user. This is extremely important because such a reaction causes the coating to become insoluble with the result that it cannot be washed away when the plate is developed. For example, the root cause of the frustrating problem of random toning that plagued users of wipe-on plates was traced to this reaction (MacPhee, 1987). Thus it will be appreciated that the discovery of a satisfactory passivating film was the key element in the development of the presensitized plate, because it is the presence of this film that eliminates the need to apply the light-sensitive coating shortly before the plate is to be used. The passivating film also enhances the water receptivity of the nonimage surface.

The topmost plate layer is the light-sensitive coating. In the case of subtractive plates, it is made up of three components: a photo-sensitive material, a dye, and a lacquer. In addition to other requirements, this layer must be ink-receptive following development. Most plates utilize either a diazo compound or a photopolymer for the light-sensitive material. Most such materials are translucent, so a colored dye is added to provide contrast between the image and nonimage areas of the developed plate, i.e., to make the developed plate readable. Most manufacturers also use a printout dye so that exposure can be checked prior to development. Different colored dyes are used by manufacturers for their different model plates for ease of distinguishing one from another.

The lacquer strengthens or reinforces the as-developed coating, thereby increasing its wear resistance and the life of the plate. The light-sensitive coating of a negative-working plate is soluble in the (usually aqueous) fluid employed in the developing stage and is hardened and made insoluble when exposed to light. Thus the film or stencil, through which the plate is exposed to produce the desired pattern or form to be printed, is transparent in the image areas, i.e., is a negative of the desired form. More detail on the exposure and development of plates is given in Section 2.4.2 starting on page 64.

2.4.4 **Design and Construction of Thermal Plates.** The technology of thermal plates for use in traditional lithography (as opposed to waterless) is very new and changing rapidly. To date, two types have appeared on the market. Common to both is an energy-absorbing coating layer that generates heat when exposed to an infrared laser.

In the first type of plate, the heating results in the generation of a free acid. Following exposure, the plate is baked to trigger a chemical reaction with the acid that renders the coating insoluble. The plate is then developed in conventional chemistry, much like a light-sensitive photographic plate (DeBoer, 1995).

In the second type, the heating produces a physical change that results in either removal of the layer by ablation, or conversion of the layer from a water-receptive to an ink-receptive surface.

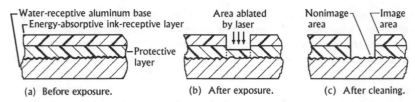

(a) Before exposure. (b) After exposure. (c) After cleaning.

Figure 2.21 Schematics showing one type of thermal plate in various stages of preparation. Purpose of protective layer is to prevent damage to aluminum base during exposure.

Figure 2.21 shows the various steps in the preparation of a thermal plate of the latter type, wherein the top ink-receptive layer is ablated by the laser-generated heat (Lewis and Cassidy, 1996).

The claimed advantages of thermal plates are as follows:

1. Dot size is insensitive to overexposure.
2. Plates can be handled in daylight. This greatly simplifies the design of the imagesetter needed to expose them.
3. Potential for chemical-free processing.

2.4.5 Performance Attributes. The task of designing a specific plate is a complex issue because of the many tradeoffs that must be made. A better appreciation for this can be had by reviewing the following performance attributes that are important to users. In addition to cost, there are at least the six that are identified and discussed in the following paragraphs.

1. Lithographic Qualities. The key role of the plate in the lithographic process stems from the requirement that it possess a very necessary set of lithographic properties. The degree to which this requirement is met by a given plate is judged by its printing characteristics. Foremost is its ability to both accurately reproduce halftone dots and to produce a uniform solid. In addition, propensity to tone, the margin in water feed over which a satisfactory print can be obtained, and propensity to blind are also important. Toning refers to the appearance of unwanted ink in the nonimage areas, and blinding refers to the failure of image areas to accept ink. Different plate designs do differ in these performance attributes. Although relatively little has been published in this regard, such differences often can be discerned by simultaneously running two half plates, side by side, on the same cylinder.

2. Life. The life on press of a lithographic plate is measured in terms of the number of acceptable impressions that can be run before the plate must be replaced—due usually either to wear in the image areas, scratches, or mechanical failure (cracking). Manufacturers generally specify a minimum plate life for a given model plate, and this can range from as low

as 10,000 to over one million impressions. Actual life is often longer because the decision to replace a plate is usually a subjective one. In addition, plate life is much longer when printing on coated paper compared to uncoated paper. Plate wear occurs almost entirely in the plate-blanket nip due to the much higher pressures that exist, relative to the plate-form-roller nips. This has been demonstrated by experience with small samples of plate material mounted in the plate cylinder gap so as to only contact the form rollers (Lawson and Watkinson, 1975).

3. **Resistance to Damage in Handling.** Once a plate has been made ready for press, it is subject to considerable handling; e.g., in transporting it to a temporary storage area at the press, and then in mounting it on the plate cylinder. The two most common forms of damage during such handling are scratches and fingerprints. Scratches severe enough to require remaking the plate can occur in both the image and nonimage areas. Vulnerability in this regard is a function of the toughness of the topmost layers in these two areas. Damage caused by fingerprints generally can be avoided by properly gumming the plate during the development stage.

4. **Dot Gain.** The amount of exposure given a plate can change dot size by a measurable amount. In the case of negative-working plates, dot size increases with exposure, while dot size on positive-working plates decreases. The changes that occur with both types of plates can be as much as 4 percent in the midtone of a 150-line-per-inch screen. Normally, these changes are not a problem because they can be compensated for during the screening process, provided, of course, that the value of the gain is predictable and consistent. Generally, problems with dot gain on press are not due to plates, although excessive gain on press is sometimes compensated for by adjusting dot gain in the platemaking process.

5. **Compatibility with the Environment.** In the past, some of the chemicals used by printers in the platemaking process were very toxic. Because of concerns for the environment, disposability of platemaking chemicals has become an important attribute. This has led to the development of aqueous plates, so-called because the developing fluid required contains at least 95 percent water.

6. **Energy Sensitivity.** This refers to both the amount of electromagnetic energy needed to expose a plate, and what band of frequency, or wavelength, that energy must possess. The former governs the size or intensity of the energy source and the time needed for exposure, because exposure energy is equal to the product of intensity and time. With currently used equipment, a conventional plate can be exposed in a few minutes. The required wavelength of the energy source, or spectral response of the plate, determines what type of safe light (if any) can be used to illuminate the room where plates are made. For example, diazo-based conventional plates have a spectral response in the range of 350–400 nanometers. Because this is just beyond the violet end of the visible spectrum (410–720 nanometers), it is possible to illuminate a

conventional plate room with a light source rich in yellow (570–590 nanometers). Thus, such plates need not be handled in the dark. The energy sensitivity of plates has received much attention in recent years because of the desire to use a scanning laser imaging device to go direct to plate from computer (CTP), thereby eliminating film. Table 2.6 is a condensation of a listing of the characteristics of some photographic systems (Thomas, 1973) that has been expanded to include a CCD array (EG&G Reticon, 1992), a conventional diazo plate (Bauman, Herting, and Timpe, 1993), a relatively high speed photopolymer plate (Goto, 1984), one of the many currently available light-sensitive direct plates (3M, 1992), and a thermal plate (Walls, 1994). Given the drive toward direct plates and the relatively new technology of thermal plates, it is anticipated that this tabulation will require frequent updates.

Table 2.6 Approximate characteristics of some photographic systems.

System	Equivalent ASA Speed	Sensitivity (μjoules/cm^2)	Spectral Response (nanometer)	
			Range	Peak
Vidicon camera	20,000	1×10^{-6}	visible	---
Human eye	2,000	1×10^{-4}	410–720	555
Color print film	200	1×10^{-3}	visible	---
CCD area array	0.2	1.0	visible	840
Direct plate (Onyx)	0.2	1.0	400-580	540
Litho film	0.2	1.0	blue/green	---
High-speed photopolymer plate	2×10^{-3}	100	310–540	---
Cromalin (Dupont)	1×10^{-4}	2,000	200–380	340
Thermal Plate (Kodak)	7.5×10^{-5}	150,000	830	---
Diazo plate	1×10^{-6}	200,000	350–400	380

2.5 Summary

The central elements of a lithographic printing press are the printing cylinders, the plate, and the blanket. Acting in consort, they produce the inked image and transfer it to the substrate being printed. The salient characteristics and functions of these elements are as follows:

1. Modern lithographic printing presses utilize the offset principle whereby the inked image created on the plate cylinder is transferred, or offset, to a blanket cylinder that in turn transfers the inked image to the substrate. For this reason, a sheetfed press unit is equipped with three printing cylinders: plate, blanket, and impression.

2. The halftone process is utilized in lithographic printing to achieve gradation in tone. In order to avoid slurring the halftone dots used in this process, the printing cylinders must carry out image transfer with an estimated positioning accuracy of ± 0.0001 inch (± 2.5 microns). This equates to an allowable slippage of 1.9 percent when printing a 150-line per-inch screen.

3. The average pressure in the blanket-impression-cylinder nips necessary for effective transfer of the inked image is about 150 pounds per square inch. This pressure is generated by a load between cylinders of about 50 pounds per inch of nip length.

4. Printing pressure in both the plate-blanket and blanket-impression cylinder nips is created by causing the blanket, mounted on the blanket cylinder, to be squeezed a precise amount as it passes through each nip. This squeeze is typically 0.003 to 0.006 inch.

5. In the U.S., squeeze in the plate-blanket cylinder nip is controlled by running the cylinders on bearers and by placing sheets of packing material under both plate and blanket. The thickness of the packing sheets is selected so as to adjust plate and blanket height with respect to their cylinder bearers, as shown in Figure 2.9, to achieve the desired squeeze.

6. Squeeze between the impression or back cylinder and the blanket cylinder is achieved using adjusting knobs that accurately control the spacing between the two cylinder bodies.

7. Blankets are typically 0.068 inch thick, and two types are used: conventional and compressible. Both types are complex structures, the design of which varies from one manufacturer to the next. Consequently, it is not possible to predict how a blanket should be packed to achieve true rolling, i.e., to reduce to zero the slippage between plate and blanket resulting from driving the cylinders with gears in a 1:1 relationship. This is not a problem, however, because slippage is negligible in practice. A common practice on a sheetfed press is to pack the blanket to the bearers and pack the plate above bearers by an amount equal to the desired squeeze.

8. Important performance attributes of blankets are dot gain, smash resistance, release, propensity to pile, need for packing, caliper stability, resistance to embossing, and resistance to edge cutting.

9. Most plates used by U.S. printers can be characterized as being of the presensitized, subtractive, negative-working, surface type. Presensitized means ready for exposure; subtractive that the image reinforcing chemicals are part of the factory-applied coating; negative-working that exposure to energy hardens the sensitive coating, and surface type that the plate is truly planographic in that the image areas are formed by an extremely thin coating, i.e., about 2 microns (0.00008 inch).

10. Important performance attributes of plates are lithographic qualities, life, resistance to damage in handling, dot gain, compatibility with environment, and energy sensitivity.

2.6 References

ANSI, *Density Measurements—Geometric Conditions For Reflection Density, American National Standard for Photography (Sensitometry),* American National Standards Institute (New York), ANSI/ISO 5/4–1983, ANSI PH2.17–1985, July 5, 1985, 10 pp.

Bauman, H., Herting, H.P., and Tempe, H.J. "Modern Plates for Offset Printing," *Jor. Inf. Rec. Mats.,* 1993, Vol 20, p 301.

Bolza-Schünemann, H.B., "The Sheet Delivery Mechanism as Cause of Paper Curls and Back-edge Stretch in Sheet-fed Offset Presses," *1971 TAGA Proceedings,* p 188.

Brink, R. "Instrumentation for Roller Nip Studies," *1963 TAGA Proceedings,* p 103.

Chamberlain, N.G. "New Developments in Offset Blankets," *Professional Printer* (London) Vol 22, No. 6, Nov/Dec 1978, p 2.

Chamberlain, N.G., "The Final Final Point of Transfer," *Professional Printer* (London), Vol 33, No. 5, Sept/Oct 1989, p 8.

Cogoli, J.E., *Photo Offset Fundamentals,* McKnight & McKnight (Bloomington), 2nd Edition, 1967, p 12.

Concannon, P.W. and Wilson, L.A., "A Method of Measuring Tack Build of Offset Printing Inks on Coated Paper," *1992 TAGA Proceedings,* p 282.

Croteau, T., Personal Communication, American Newspaper Association (Reston), Sept. 23, 1993.

Davis, A., "Offset Litho Began 100 Years Ago," *Tin International,* Feb. 1975, p 59.

DeBoer, C., "Graphic Art Applications of Laser Thermal Printing," *1995 TAGA Proceedings,* p 39.

Dean, S.W. and Ford, J.A., "Mechanisms of Plate Wear and Failure in Anodized Aluminum Litho Plates," *1973 TAGA Proceeding,* p 198.

E.G.&G. Reticon, *RA0512] Full Frame CCD Imager,* Product Data Sheet, E.G.&G. Reticon (Sunnyvale), Feb 1992, 6 pp.

Eisenback, W. and Wagenbauer, K., "Impression Forces and Pressure Distribution in the Cylinder Contact Areas of a Sheet-fed Offset Printing Press," *5th IARIGAI Research Conference Proceedings,* 1961, p 109.

Eklund, N., and Huang, J., "Planographic Printing Plate Having Cationic Compound in Interlayer," *U.S. Patent 4,552,827,* Nov. 12, 1985.

Eliezer, C., "Color Screening Technology: A Tutorial on the Basic Issues," *The Seybold Report on Desktop Publishing,* Seybold Publications (Media, Pa), Vol 6, No 2, Oct 2, 1991, p 9.

Fromson, H.A., "Photographic Plate," *U.S. Patent 3,181,461,* May 4, 1965.

George, H.F., Oppenheimer, R.H., and Kimball, J.J., "Gravure Nip Mechanics," *1964 TAGA Proceedings,* p 151.

Goto, Y., High-Speed Photopolymers for Laser Scanning," *1984 Lasers in Graphics Conference Proceedings,* Dunn Technologies (Vista), Vol II, p 743.

Gumbinner, R. "Presensitized Printing Plate and Method for Preparing Same," *U.S. Patent 2,922,715,* Jan. 26, 1960.

Hagler, A., "Variables and Procedures Which Affect Blanket Life and Related Downtime," *PIA Web Offset Section, 1988 Annual Meeting Proceedings,* WOA, p 62.

Harris, *The Harris Story,* Harris-Intertype Corporation (Cleveland), 1972, p 14.

Heyne, M.J.M., "Rolling Phenomena in Offset Printing," *14th IARIGAI Research Conference Proceedings,* 1979, p 425.

Hoechst, *Reliability in Offset Printing,* Hoechst AG (Wiesbaden), 1985, 16 pp.

Huang, J., Von Greenberg, G., and Riley, O.J., "Method of Electrolytically Graining a Lithographic Plate," *U.S. Patent 4,548,683,* Oct. 22, 1985.

Hull, H.H., "The Measurement of Blanket Release," *1971 TAGA Proceedings,* p 285.

Iwasaki, Y., Okada, H., Takahashi, Y., "The Effect of Surface Roughness of Offset Printing Blanket on Ink Transfer," *1988 TAGA Proceedings,* p 669.

Iwasaki, Y., Takahashi, Y., Yukawa, H., and Okada, H., "Study on Paper Releasing Phenomena in Offset Printing by Acoustic Approach," *1993 TAGA Proceedings,* p 238.

Jewett, C.L. and Case, J.M., "Planographic Printing Plate," *U.S. Patent 2,714,066,* July 26, 1955.

Jorgensen, G.W., *Control of Color Register,* GATF Research Project Report No 114, 1982, 5 pp.

Jorgensen, G.W. and Lavi, A., *Lithographic Pressman's Handbook,* GATF, 1977, pp 56.

Kishner, S.J., "Pulsed-Xenon Densitometry," *Journal of Applied Photographic Engineering,* Vol 3, No 1 (1977) p 4.

Kuehn, A.T. and Sites, B.L., "True Rolling and Cylinder Packing," *1953 TAGA Proceedings,* p 72.

Latham, C.W., *Advanced Pressmanship,* GATF, 1963, p 235.

Lawson, L.E. and Watkinson, L.J., "Dampening Hydrophilic Metal Plate Surfaces," *Professional Printer* (London), Vol 19, No 5, 1975, p 3.

Levy, L. E. and Levy, M., "Screen for Photomechanical Printing," *U.S. Patent 492,333,* Feb. 21, 1893.

Lewis, T. E., and Cassidy, K. R., "Laser Imageable Printing Members and Method for Wet Lithographic Printing," *U.S. Patent 5,493,971,* Feb 27, 1996.

Lind, J.T., Personal Communication, GATF, March 9, 1993.

Loibl, D. and Koessler, P., *Investigation of Printing Blankets–II,* Bundesverband Druck E.V. (Weisbaden) Report No. 1/1985, 8 pp (in German).

MacPhee, J., "An Investigation Into The Cause and Cure of Random Toning in Newspaper Printing," *1987 TAGA Proceedings,* p 471.

MacPhee, J., Gasparrini, C.R., and Arnolds, C., "Development of a System for Automatically Cleaning the Blankets of a Web Offset Press," *1982 TAGA Proceedings,* p 378.

MacPhee, J. and Lind, J.T., "How Paper and Ink Properties Interact to Determine the Characteristic Curve of a Lithographic Printing Press Unit," *1991 TAGA Proceedings,* p 296.

Manhart, J.H., "Brush Graining of Aluminum for Lithographic Printing Plates," *1977 TAGA Proceedings,* p 12.

Martin, E.J., *All for Want of a Tissue,* GATF Research Progress Report No. 61, June 1963, 4 pp.

Miller, R.D.W., "Theory of Impression and Rolling Contact," *The Penrose Annual,* Vol 54, 1960, p 111.

Miller, R.D.W., "Printing Blanket Properties and Nip Conditions on Two Blanket-testing Instruments," *10th IARIGAI Research Conference Proceedings,* 1970, p 55.

Miller, R.D.W., and Poulter, S.R.C., "Pressure and Speed Effects of Cylinder Covering During Printing," *6th IARIGAI Research Conference Proceedings,* 1962, p 35.

Nakanishi, H., Sakaki, H., Yamazaki, T., and Okishi, Y., "Process for Producing an Aluminum Support for a Lithographic Printing Plate," *U.S. Patent 4,678,551,* July 7, 1987.

O'Rell, D.D., "What's New in Blanket Technology," *Press Conference Notes,* R & E Council, Oct. 1990, 6 pp.

O'Rell, D.D. and Holleran, M., "Printing Blanket," *U.S. Patent 4,812,357,* Mar. 14, 1989.

Peery, W.E., "A Method and Mathematics for Studying Web Feed-up and Tensions in Multi-stage Offset and Gravure Presses," *1983 TAGA Proceedings, p 300.*

Platzer, S.J., "Aluminum Support Useful for Lithography," *U.S. Patent 4,581,996,* Apr. 15, 1986.

Plowman, N., "Ink/Paper Interaction—Measuring the Absorption Rate of Various Ink and Paper Combinations," 37th NAPIM Technical Conference, Miami Lakes, FL., Oct 21-23, 1993.

Powers, J.H., "Anodizing for the Graphic Arts Industry," *1970 TAGA Proceedings,* p 166.

Reed, D., "Measurement of Cylinder Deflection Including Finite Element Analysis," *1983 TAGA Proceedings,* p 341.

Reed, R.F., *Offset Lithographic Platemaking,* GATF, 1967, p 2.

Richter, R.T. and Reavis, H.G., "Method for Making Lithoplate," *U.S. Patent 4,818,300,* Apr. 4, 1989.

Rodriguez, J.M., "Closed Cell Foam Printing Blanket," *U.S. Patent 4,303,721,* Dec. 1, 1981.

Senefelder, A., *The Invention of Lithography,* translated by J.W. Muller, The Fuchs & Lang Manufacturing Company (New York), 1911 (original in German dated 1821), 229 pp.

Shrimpton, H.R. and Dunkley, K.W., "Printers' Blankets," *U.S. Patent 3,700,541,* Oct. 24, 1972.

Siebein, W.A., "New Instrumentation for Plate and Blanket Packing," *1971 TAGA Proceedings,* p 275.

Sites, B.L., "Transfer Method and Means," *U.S. Patent 2,036,835,* April 7, 1936.

SWOP, *Specifications Web Offset Publications 1993,* SWOP Incorporated, 39 pp.

Takahashi, Y., Fujita, H., and Sakata, Y., "Ink Transfer and Dot Gain Mechanisms in Offset Printing Process," *Graphic Arts Japan,* Japan Federation of Printing Industries (Tokyo), Vol 28, 1986-7, p 22.

Thomas, W. (editor), *SPSE Handbook of Photographic Science and Engineering,* John Wiley & Sons (New York), 1973, p 336.

3M, , *3M Onyx™ 1190 Plates—4 Mill Rolls,* Product Information Brochure, 3M (St. Paul), 1992, 6 pp.

Toyama, T., Kobayashi, K., Koike, M. and Tamoto, K., "Light-Sensitive Planographic Printing Plate with Layer of Diazo Resin Containing Photo-Polymerizable Composition," *U.S. Patent 4,687,727,* Aug. 18, 1987.

Tyma, L.S., Koebler, I., Stoeckl, H., and Engel, A., "Bearers—A Necessary Evil?," *1982 TAGA Proceedings,* p 402.

Walls, J. E., "Unconventional Printing Plate Exposed by IR (830 NM) Laser Diodes," *1994 TAGA Proceedings,* pp 259-267.

Whitney, R.G. (Editor), *Offset Litho Blankets,* Dunlop Ltd (Skelmersdale), reprint of revised edition, 1990, 96 pp.

UGRA, *UGRA Plate Control Wedge PCW,* 1982, UGRA, 1982, 16 pp.

Zelley, W.G., "Surface Characteristics of Ball Grained and Brush Grained Aluminum Lithographic Plates," *1972 TAGA Proceedings, p 262.*

Chapter 3

Rollers and Rolling Action

Reduced to its most elementary form, a printing press is simply an assembly of alternately rigid and compliant rolling elements running in contact with each other. The basic purpose of this assembly is twofold:

1. To transport one or more of lithography's three ingredients—ink, fountain solution, and paper—along the paths that lead from one contact point, or nip, to another.
2. To effect or inhibit the transfer of one of the three ingredients from one surface to another at each of the nips.

Thus the success of the rolling actions that occur during operation of a press can be measured in terms of how well the desired material transports and transfers are carried out (or not). These, in turn, depend on three sets of properties: the properties of the rolling elements, the properties of the materials they are assigned to handle, and the properties of, or conditions within, the various nips.

Based on this perspective, the discussions in this chapter are concerned primarily with the types of fluid behavior that take place as a result of the rolling actions that occur on press. Accordingly, three core sections have been included on the subjects of transport of fluid to nips, fluid behavior within nips, and fluid behavior at nip exits. These are preceded by two introductory sections on rollers as individual elements that identify and discuss the pertinent roller design properties and that treat the static and dynamic behavior of the compliant rollers used.

3.1 Roller Design Properties

There are five intrinsic properties or characteristics that define a given roller: structural configuration, hardness of the surface material, fluid affinity of the surface, means used to drive it, and whether or not the roller vibrates (moves back and forth along its axis). Figure 3.1 lists these five characteristics along with the alternatives that describe the rollers used on lithographic printing presses. Given these alternatives, there are, in theory, 32 different kinds of rollers. Certain features, however, are mutually

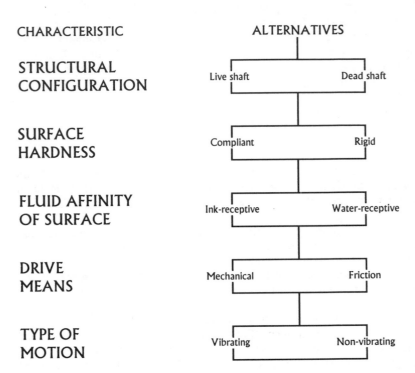

| CHARACTERISTIC | ALTERNATIVES |

STRUCTURAL CONFIGURATION — Live shaft / Dead shaft

SURFACE HARDNESS — Compliant / Rigid

FLUID AFFINITY OF SURFACE — Ink-receptive / Water-receptive

DRIVE MEANS — Mechanical / Friction

TYPE OF MOTION — Vibrating / Non-vibrating

Figure 3.1 Characterization of press rollers.

exclusive. In particular, dead shaft type rollers are seldom if ever mechanically driven. Thus, in practice, only sixteen different basic roller types are found on presses. If the type of motion is not considered separately but taken as another element of structural configuration, roller distinction can be narrowed further to three central characteristics: structural configuration, fluid affinity of the surface, and surface hardness. These central properties are taken up in detail in subsequent sections on mechanical construction, ink-receptive roller materials, and water-receptive roller materials. These three sections are preceded by a section that identifies and discusses the requirements that must be considered in the design of any given roller, and a related section on the measurement of rubber roller hardness.

3.1.1 **Requirements.** The exact requirements placed on a given roller vary greatly depending on its use. For example, dynamic balancing is a must for large-diameter rollers run at very high speeds but is unnecessary in low-speed applications. Thus, at best, all that can be said here is to define what is meant by a given requirement and, in some cases, present generally accepted specifications.

1. **Dimensional Tolerances.** The most important requirements on roller dimensions are those specified on concentricity and diameter. This is because an eccentric roller can generate disturbances in the print, while proper settings are dependent on a correct diameter. Rigid or hard-surfaced rollers can be and are manufactured economically with dimensional tolerances smaller than 0.001 inches or 0.025 mm. For rollers with soft elastomeric or rubber-like covers, such tolerances are generally not practical. The standard dimensional tolerances recommended by the RMA (Rubber Manufacturer's Association, 1989) for rubber covered offset press rollers are as follows:

On diameter:	+0.045/−0.000 inches
On concentricity, total indicated runout:	0.003 inches

The RMA also cautions that greater precision than these standard tolerances can be specified, but that this will add to roller cost.

2. **Surface Finish.** A smooth surface is required, especially on form rollers, to avoid the appearance of grind or machining patterns on the print. Surface finish is much like dimensional tolerances in that finer finishes can be achieved on rigid or hard-surfaced rollers than on soft or compliant rollers. For example, it is not uncommon to require that a hard roller be ground to a 16-microinch (0.4-micron) average roughness and then polished to a smooth shiny finish. The surface of soft or compliant rollers can be polished after grinding to achieve a velvet-like surface free of machining and grind marks, but it is not the practice to specify a value for average roughness. The values achieved in practice, however, are probably in the same range as for plates, that is, 32–48 microinches (0.8–1.2 microns).

3. **Chemical Compatibility.** The materials used in rollers must be compatible with the various chemicals found in the environment of a press, e.g., in inks and fountain solutions. Otherwise, roller performance may deteriorate due to swelling, blistering, hardening, corrosion, cracking, and/or reversion as a result of exposure to one or more of such chemicals. (Reversion describes the transformation of the cover of a soft roller to an unusable gooey state.)

4. **Resistance to Mechanical Wear and Tear.** Ideally, rollers should not become unusable because of excessive mechanical wear or damage. Indeed, except for the chrome and copper platings used on some hard-surfaced rollers, it is seldom necessary to replace a roller because of wear.

5. **Structural Stability.** The structural design of a roller must be such that the roller does not bend or deflect unduly in response to the loads to which it is subjected in use. In addition, it must not generate unwanted vibrations when rotating at design speed. To satisfy this latter requirement, it may be necessary to either statically or dynamically balance the roller as part of the manufacturing process.

6. **Heat Buildup.** Rollers with rubber-like covers can generate significant amounts of heat for reasons explained in Section 3.2.3. Obviously, materials with low heat buildup are preferred.

7. **Heat Transfer Characteristics.** Because heat is generated in a roller train, some of the rollers may be required to possess good heat transfer characteristics. This is so that a cooling fluid (usually water) can be pumped through these rollers so as to regulate the temperature of the train. Normally, cooling is only provided in hard rollers because they can be designed to use a metallic roller shell that has a low resistance to heat flow.

8. **Thermal Stability.** This refers to the extent to which roller cover properties change with temperature. For example, a rubber cover may expand with temperature, producing a change in roller setting that could adversely affect printing.

9. **Resistance to Compression Set.** This requirement refers to the fact that the elastomers used for the covers of compliant rollers are visco-elastic materials, as opposed to metals, which are more like ideal elastic materials. When an elastomer is deformed by the application of a force, it does not immediately "spring back" to its original shape when the force is removed. (This is because the elastic modulus of an elastomer possesses a viscous component in addition to an elastic component.) This specific behavior is referred to as compression set and is defined as the deformation that remains in a rubber-like material after it has been subjected to and released from a given compressive stress that has been applied at a given temperature for a given period of time.

10. **Cover Hardness.** A very important property of the compliant elastomer covers used in making rollers is hardness, because of the wide range possible. This property provides an indication of the resistance of a roller cover to deformation. The compliant rollers used in the roller trains of offset presses generally require a hardness in the range of 20–40 Type A durometer (sometimes referred to as Shore A durometer). The method commonly used to measure it is described in the next section.

3.1.2 Measurement of Compliant Roller Hardness. As shown in Figure 3.1 and noted above, hardness is one of the central properties of printing press rollers, and it has two broad classifications: compliant and rigid. Rigid rollers include all rollers with metal or hard plastic surfaces, while compliant rollers include those with either rubber-like or fabric covers. The hardness of compliant rollers suitable for use on printing presses encompasses the relatively narrow range of 20–40 Type A durometer.

The measurement of Type A durometer is accomplished using a gauge that records the depth of penetration of the measured sample by a spring-loaded truncated cone, on a scale of 0–100 (ASTM, 1992). A reading of zero corresponds to a very very soft material such as a foam rubber, while a very hard rubber, like ebonite, would measure 90 or above. (An extremely

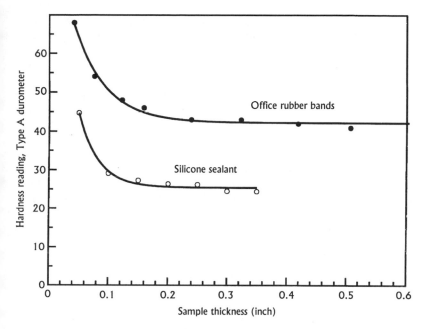

Figure 3.2 Effect of sample thickness on durometer gauge reading.

hard material like steel measures 100 on the Type A scale, although it must be understood that readings above 95 have no meaning.) The practical limits on compliant roller durometers correspond to the hardnesses of two common materials as follows:

20 Shore A durometer Freshly cured silicone sealant
40 Shore A durometer Stack of office rubber bands

The Type O durometer gauge is identical to the Type A except that it uses a 3/32-inch-diameter (2.38-mm-diameter) spherical indenter. The Type D durometer gauge is similar to the Type A except that the spring loading is much higher, and a pointed cone is used. A reading of 30 on a Type D durometer gauge corresponds to a reading of 80–90 on a Type A durometer gauge.

Two alternate methods are available for measuring rubber hardness: Pusey and Jones Indentation (ASTM, 1989-2) and International Rubber Hardness (ASTM, 1989-1). Both methods record the depth of penetration of the measured sample by a spherical indenter subjected to a constant load. The disadvantage of both methods is that it is difficult to design a compact and portable instrument based on them. It has been reported that readings on the International Rubber Hardness scale are about 4 units

higher than on the Type A durometer scale (Briscoe and Sebastian, 1993).

Portable Type A durometer gauges have become the de facto standard of the U.S printing industry for assessing and specifying compliant roller hardness. This is because they can be used at any attitude and therefore can be employed to measure the hardness of rollers on press. On the down side they are not very accurate, they vary with temperature, and they give erroneous results if used to measure thin samples, as illustrated in Figure 3.2. This data demonstrates why a sample at least 0.25 inch thick must be used for measurements, as recommended in the appropriate standard (ASTM, 1992).

Even with a sample of adequate thickness, however, the reproducibility of readings of soft materials will not be better than about ±2 where a single operator and instrument are involved, and ±4 where many operators and many instruments are involved (RMA, 1989). Worse still is the fact that there is no correlation between Type A durometer hardness measurements and Young's Modulus (MacPhee, 1996). Thus, two rollers covered with different compliant covers that have equal durometers will not necessarily have the same degree of softness. This fact, and the superiority in this regard of a durometer gauge with a spherical indenter, is taken up in Section 3.2.

3.1.3 **Mechanical Construction.** Broadly speaking, a roller is made up of four elements: a steel support shaft, a cylindrical core usually also made of steel, an ink-receptive or water-receptive material applied to the outer surface of the core, and a pair of support bearings. As shown in Figure 3.3, two basic configurations are used: either the shaft and core form a single structural element that rotates as one, or the shaft is fixed in place and the core rotates around it.

The former, referred to as a live shaft roller, is shown in Figure 3.3(a). In addition to its integral shaft/core assembly, this configuration is distinguished by support bearings that are externally mounted. The former feature makes it more costly to manufacture the roller while the latter allows the heat generated within the bearings to be dissipated to the air and surrounding structure, rather than within the core envelope. Thus, live shaft rollers run cooler but are more expensive to build.

If there is a requirement for a roller with long trunnions or shaft extensions, live shaft rollers have an advantage in that a stiffer structural member can be designed. That is because conical shaped trunnions can be used in place of the end disks, shown in Figure 3.3(a). This eliminates disk deflection and greatly reduces overall roller deflection when pressed against another roller or cylinder to form a nip. More detailed information on roller design is given in a recently published book (Roisum, 1996).

A wide variety of live roller shaft designs are to be found on sheetfed presses. Rollers having very small diameters are oftentimes fabricated by turning down the ends of a piece of bar stock to form the trunnions while the unmachined section of the bar stock serves as the core. On larger

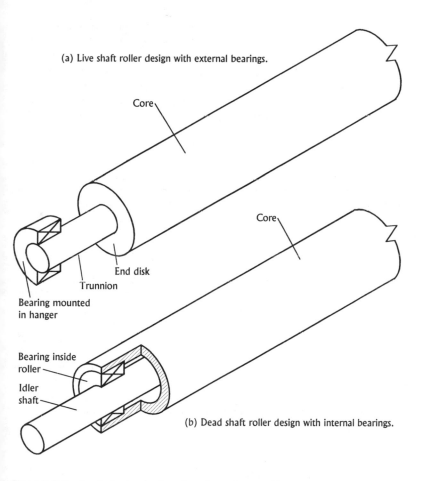

Figure 3.3 The two basic structural configurations of press rollers.

rollers, a piece of heavy-walled tubing is used for the core, and either a single forged or machined component serves as trunnion and end disk, or the trunnions and end disks are fabricated separately and then pressed and/or welded together.

Dead shaft roller designs, shown in Figure 3.3(b), are distinguished by a non-rotating shaft and the use of support bearings that are mounted within the core. Rollers of this type are relatively simple in design and inexpensive to build. Probably the most important drawback associated with this design is that much of the heat generated by the bearings must be dissipated within the core envelope, thus causing the roller to run hotter than a comparable live shaft design. An advantage gained by fixing the shaft is lower rotational inertia.

3.1.4 **Ink-Receptive Roller Materials.** In lithographic presses, the fluid affinity of a roller surface is extremely important. Two alternatives are of practical interest, as shown in Figure 3.1: an ink-receptive surface or a water-receptive surface. It has already been explained in Section 1.3 of Chapter 1 that, within the context of lithography, an ink-receptive material is defined as one that will be wet by ink in the presence of both ink and fountain solution, while a water-receptive surface is one that will be wet by fountain solution in the presence of both fluids.

Ink-receptive materials must be used to form the surfaces of the rollers used in inking systems to insure good transfer from roller to roller down the train from ink fountain to plate. If a water-receptive roller were placed in the train, some of the fountain solution carried or emulsified in the ink would eventually displace or strip the ink from its surface. Once coated with water, the roller would act as a barrier and prevent ink transfer. Thus, every roller in an ink train must be ink-receptive.

Figure 3.4 identifies materials that have been found to perform well as ink-receptive roller materials. Of the rigid materials, all of which are used in the form of a coating on a steel core, copper is relatively expensive but has very good heat transfer characteristics. This is because the copper coating is very thin and has a relatively high thermal conductivity. Hence copper is generally the choice on web presses where the ink roller train must be cooled. Of the two rigid polymers available, Rilsan®, a compound of Nylon®, is used more widely than ebonite, which is the term used to describe a very hard rubber-like compound. In the past, steel rollers were to be found in some inking trains. They are now rarely encountered because of their propensity to strip, i.e., to become water-receptive upon contact with fountain solution emulsified in the ink. Nevertheless, steel is still widely used for ink fountain rollers.

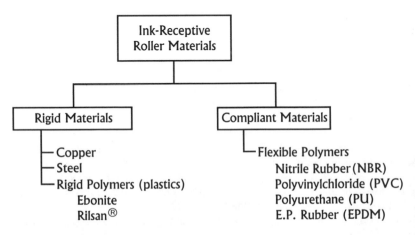

Figure 3.4 Classification of usable ink-receptive roller materials.

A much wider variety of compliant materials has been found to perform well as ink-receptive rollers, although all of these materials are some type of polymer. The four most commonly used polymer types are listed in Figure 3.4. It must be understood that these basic materials must be compounded or mixed with other materials to produce the desired properties, such as resistance to swelling in solvents. Because each roller manufacturer has its own recipe for compounding, the number of cover materials to choose from is much greater than indicated in Figure 3.4.

Compounds of nitrile (also known as buna-N) rubber are widely used to cover inking rollers. They have good resistance to conventional ink wash-up solvents, good compression set characteristics, abrasion resistance, and thermal stability. They are susceptible to attack by ozone and certain solvents such as acetone and the monomers used in UV inks.

PVC compounds are also favored by many users and manufacturers. This is evidenced by the many blends of PVC and nitrile that are available from roller manufacturers. PVC possesses the advantage that a much softer roller can be fabricated using it as a cover (MacPhee, 1996).

Polyurethane roller covers have been in use for many years. Two of their major attributes are the very smooth surface finish that can be achieved, and a relatively low coefficient of friction when wetted with either a thin film of ink or water. Urethanes also have excellent chemical and wear resistance and immunity to ozone attack. Thermal stability, however, is not as good as nitrile. A more important drawback is the perception of some printers that the material reverts badly in certain environments. These perceptions are based on experiences of the past that are not indicative of modern urethane compounds that contain reversion inhibitors. Care must be exercised in selecting a urethane compound because some are water-receptive.

EP rubber, or ethylene propylene, is used primarily on presses that print UV inks, because of its excellent resistance to the monomers used in UV inks. Ozone resistance is also very good.

3.1.5 Water-Receptive Roller Materials. As defined above, a water-receptive material is one that will be wet by fountain solution in the presence of both ink and fountain solution. As shown in Figure 3.5, the choice of water-receptive materials for compliant rollers is more limited than for ink-receptive rollers. That is, the choice is limited to time-proven fabric covers.

The time-proven fabric covers are not ideal in that they must be pre-wetted with water in order to behave as water-receptive. Because they are not always prewetted, fabric covers become fouled with ink over time and must be replaced periodically. Also, the large water storage capacity of these roller materials is disadvantageous because it increases the response time of the dampening system (MacPhee, 1976).

Although Figure 3.5 shows three different materials suitable for use in rigid water-receptive rollers, the choice is usually made between a hard

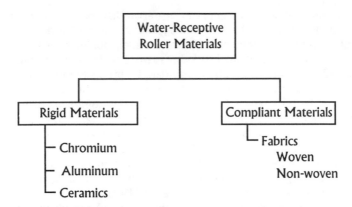

Figure 3.5 Classification of usable water-receptive roller materials.

chrome plating and ceramic because aluminum is not as robust and is also subject to corrosion. Ceramic-covered rollers are very long-lived and are claimed to be more water-receptive. These advantages are offset by their porous surface that tends to become embedded with ink over time, thereby degrading performance. The shiny surface of chrome-plated rollers is an advantage in that malfunctioning vis-à-vis ink pickup is readily observable.

Fortunately, it is not essential for every roller in a dampening system to be water-receptive. This is because water can be transferred to and carried by a roller that is coated with a thin film of ink, as was brought out in the discussion connected with Figure 1.12(b) on page 20. Of course, at least one of the rollers in a bi-directional or contact type dampening system must be water-receptive to prevent ink from being carried back and fouling the components used to meter fountain solution. (In Section 5.3.3, bi-directional type dampening systems are defined as having a return flow path from plate to metering system.)

3.2 Basic Roller Behavior

In the context of this chapter, basic roller behavior is defined as the interaction that results at the conjunction or nip of a rigid and compliant roller under dry conditions, i.e., with no fluid present. Given the long history of stress analysis, it might seem that any treatment here of such a simple subject would be unnecessary. This is not the case, because traditional stress analysis does .not adequately address the three unique characteristics of the elastomers used in compliant rollers, as follows:

1. **Layered Structure of Super Soft Material.** Compliant rollers consist of a rigid metal core covered with a relatively thin layer of a super

soft elastomer. Super soft refers to the very low values of Young's modulus possessed by these materials. As explained below, typical compliant roller cover materials have values of Young's modulus that range between 40 and 200 pounds per square inch (0.28–1.38 MPa). In contrast, Young's modulus for steel is 30 million pounds per square inch (207,000 MPa). Put another way, steel is over 150,000 times harder than the hardest compliant rubber used to cover rollers. Another characteristic of rubber rollers is that the Hertzian solution to the problem of two cylinders pressed against each other in line contact does not apply, because of the layered structure.

2. **Incompressibility.** For all practical purposes, these elastomers are incompressible in that Poisson's ratio for them approaches 0.5. Steel, by contrast, has a value of 0.27.

3. **Viscoelasticity.** The moduli of elasticity of the elastomers used in press rollers have a relatively large viscous component. Because of this, as mentioned in Section 3.1.1, the dynamic behavior of these viscoelastic materials differs significantly from that of metals, which approach ideal elastic materials in behavior.

The effect of these three unique characteristics will be taken up in the following sections on static settings and loads, change in effective diameter, and dynamic behavior.

3.2.1 **Static Settings and Loads.** When a rigid roller is pressed against a compliant roller to produce a given squeeze or penetration, the cover of the compliant roller is deformed. The deformation is not localized, however, but instead extends beyond the stripe or area of contact, as shown in Figure 3.6. The resultant load is supported by the stripe or area of contact. Thus, the pressing of one roller against another establishes three properties of their common nip or conjunction as follows:

1. Squeeze or depth of penetration.
2. Width of the contact area, commonly referred to as stripe width.
3. Load or force exerted by the roller pair on each other.

For a roller pair of given size and material, these three properties are directly related. Thus, for example, if a given squeeze is established, load and stripe settings follow automatically. The very important principle that follows from this is that the proper roller setting can be achieved by using any one of these three properties as the gauge or guide.

Stripe width is the most reliable method of gauging roller settings. A rule of thumb followed by many is that the optimum stripe width is 1/16 inch for each inch of diameter of the smaller roller. Thus, according to this rule, the ideal stripe width for a three-inch-diameter (76-mm-diameter) rubber roller running in contact with a plate cylinder is 3/16 inch (5 mm).

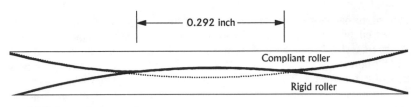

(a) Both axes to same scale.

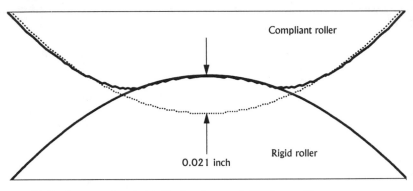

(b) X axis same scale as in (a), Y axis scale expanded by factor of four.

Figure 3.6 Deformation produced by pressing a 3-inch-diameter rigid roller against a 3-inch-diameter compliant roller that has a 3/8-inch-thick cover. Dotted lines show undeformed surface of compliant roller. Data is from a finite element analysis method calculation (MacPhee, 1996).

Because of the layered structure of the compliant roller, traditional methods of stress analysis cannot be used to determine the magnitude of the stripe produced by various loads. Fortunately there is an equation (MacPhee, 1996) that is in good agreement with both measurements of stripe width versus load and with comparable data calculated using a finite element analysis (FEA) method. This equation is as follows:

$$S = 2\left(\frac{R}{EP_1}\right)^m h^n F^m \tag{3.1}$$

where:

F = force (pounds per inch of roller length)
E = Young's modulus of compliant roller cover (pounds/inch2)
h = thickness of compliant roller cover (inches)

$$m = \frac{1}{2P_2} \qquad\qquad n = \frac{(P_2 - 1)}{P_2}$$

P_1 and P_2 are functions of S_{max}/h, as given in Figure 3.7

S = width of stripe (inch)

$$R = \left(\frac{R_r R_c}{R_r + R_c} \right)$$

R_r = radius of rigid roller
R_c = radius of compliant roller

This equation and the relationships of P_1 and P_2 to S_{max}/h were derived by fitting Deshpande's (Deshpande, 1978) equation (5) to a power law relationship of S/h over the range of $0 < (S/h) < 2.8$, where S_{max} is the stripe width corresponding to the maximum indentation. The constants in equation (3.1) are based on the assumption that the cover material is incompressible, i.e., that the value of Poisson's ratio is 0.5.

From Figure 3.7(b) it can be determined that for very small values of S_{max}/h, i.e., small indentations of the compliant cover, the exponent m approaches 0.5 while the exponent n approaches zero. In such a case, equation (3.1) takes on the following form where stripe width is independent of cover thickness:

$$S = 2 \left(\frac{R}{1.047\,E} \right)^{0.5} F^{0.5} \tag{3.2}$$

This is Hertz's equation for the case where Poisson's ratio is 0.5, i.e., the case for rubber.

For very deep indentations, m and n both approach 0.333, and equation (3.1) takes on the form derived by Deshpande as follows:

$$S = 2 \left(\frac{Rh}{2.017\,E} \right)^{0.333} F^{0.333} \tag{3.3}$$

This equation is appropriate for blanket cylinders where stripe width is several multiples of blanket thickness.

For rollers, it has been found (MacPhee, 1996) that values of m and n corresponding to a S_{max}/h ratio of about 1.5 generally produce a good fit of equation (3.1) to measured values of stripe width versus load. Thus the equation to be used for relating stripe width to load in press roller nips is as follows:

$$S = 1.572 \left(\frac{R}{E} \right)^{0.412} h^{0.176} F^{0.412} \tag{3.4}$$

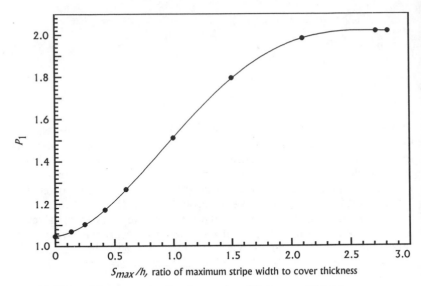

(a) Value of P_1 versus ratio of maximum stripe width to cover thickness.

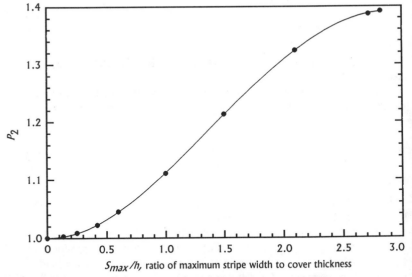

(b) Value of P_2 versus ratio of maximum stripe width to cover thickness.

Figure 3.7 Plots of relationships between the variables P_1 and P_2 and the ratio of maximum
stripe width, S_{max}, to roller cover thickness, h. P_1 is a variable in equation (3.1)
while P_2 is needed to evaluate the exponents m and n in equation (3.1). For
typical press rollers the values of P_1 and P_2 have been found to be 1.794 and
1.214 respectively, corresponding to an S_{max}/h ratio of 1.5.

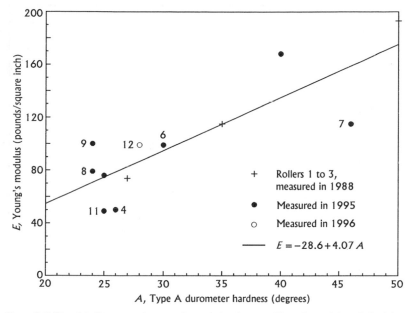

Figure 3.8 Plot that illustrates absence of correlation between Young's modulus of elasticity, E, and Type A durometer hardness measurements. Rollers 9 and 11, identical except for cover material, have values of E of 100 and 49 while durometer readings are 24 and 25 respectively. Roller 8, also identical except for cover material, has E of 79 and hardness of 24. In contrast, Rollers 9 and 7 have durometers of 24 and 46 yet have values of E (100 and 115) that differ by a very small amount. Rollers 1 to 3 were not included in best fit to allow direct comparison with best fit of data in Figure 3.9.

The above equations show that the relationship between stripe width and load depends not only on geometry but also on the stiffness of the compliant roller cover, as expressed by the value of Young's modulus, E, for the cover material. Unfortunately, the correlation between the type of hardness measurement used to characterize compliant press rollers, i.e., Type A durometer, and Young's modulus is very poor. This is demonstrated by measurements of stripe width versus load that were made on twelve typical press rollers (MacPhee, 1996). Values of Young's modulus were obtained by fitting these measurements to equation (3.1). The results, plotted versus Type A durometer hardness, are shown in Figure 3.8.

The poor correlation of the data in Figure 3.8 is highlighted by comparing Rollers 8, 9, and 11 that had identical diameters and cover thicknesses and thus differed only in cover material. The value of Young's modulus for Roller 9 was double that of Roller 11, yet their durometers were almost the same, 24 versus 25. In contrast, hardness readings obtained with a Type O durometer gauge (having a spherical-shaped

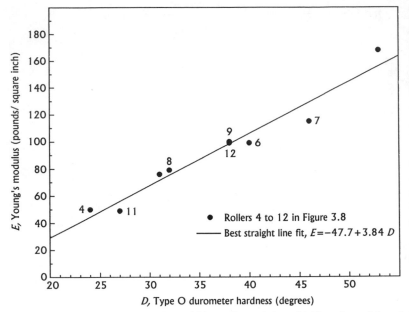

Figure 3.9 Hardness measurements that exhibit good correlation with Young's modulus of elasticity, E. Data obtained using a Type O durometer gauge mounted in the quill of a milling machine to prevent deformation of roller by gauge foot.

indenter) exhibit quite good correlation, as shown in Figure 3.9.

In spite of this superior performance of gauges with spherical indenters, the current de facto industry standard is to specify roller hardness in terms of Type A durometer readings. Consequently, calculations in this book of typical roller performance are based on the values of Young's modulus given by the best fit curve in Figure 3.8. It must be kept in mind, however, that this is somewhat arbitrary and that the actual value of E for a roller cover having a given Type A durometer reading can vary considerably from the value predicted by this correlation.

Figure 3.10 is a plot that illustrates the effect of both stripe width and Young's modulus of the rubber roller cover on the load exerted by a pair of touching rollers. Examination of Figure 3.10 discloses that the load on a 25 durometer roller set to the recommended stripe of 3/16 inch will be about 0.9 pounds/inch. The corresponding average pressure of 4.8 pounds/square inch is about 30 times lower than the typical average printing pressures calculated in Section 2.2.4 of Chapter 2 and Section 3.4 below. For a 35 durometer roller, the load increases by 42 percent to 1.28 pounds/inch, and for a 50 durometer roller by 100 percent to 1.84 pounds/inch.

Figure 3.10 also illustrates the powerful effect that stripe width has on load. It shows, for example, that an increase in stripe width of only 33

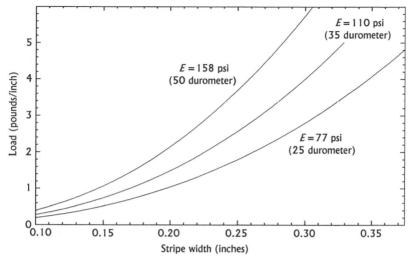

Figure 3.10 Relationship between load and stripe width for a 3-inch-diameter rigid roller in contact with a 3-inch-diameter compliant roller having a 3/8-inch-thick cover. Based on equation (3.4) and values of Young's modulus of elasticity, *E* (expressed in pounds/square inch), obtained from best fit curve in Figure 3.8.

percent, from 3/16 to 1/4 inch, results in doubling the load on a 25 durometer roller, from 0.9 to 1.8 pounds/inch.

The calculated pressure distribution within the nip is shown in Figure 3.11 for the same roller with a heavier stripe of 0.22 inch. The shape of this plot compares well with measured distributions (Scheuter and Pfeiffer, 1969). The calculated maximum pressure is 7.15 pounds/square inch and the average is 5.08 pounds/square inch, for a ratio of 1.43. In studying dynamic behavior, a sine wave is often used to approximate the pressure distribution curve. Figure 3.11 shows that the degree of fit provided by a sine wave is fairly good, although the maximum to average ratio is 1.57 as opposed to 1.43 for the calculated distribution. It is also to be noted that the pressure curve in Figure 3.11 is symmetrical around the nip centerline, reflecting static conditions. As will be shown in Section 3.2.3, pressure distribution changes significantly under dynamic conditions.

$$p = \left(\frac{Sh}{2R}\right) \left\{ \begin{array}{l} \left[0.5 + 0.5118 \cdot \left\langle \frac{S}{2h} \right\rangle^2 - 0.063625 \left\langle \frac{S}{2h} \right\rangle^4 \right] ln\left(\frac{8h}{S}\right) \\ -0.5848 - 0.4706 \left\langle \frac{S}{2h} \right\rangle^2 + 0.2543 \left\langle \frac{S}{2h} \right\rangle^4 + \cdots \end{array} \right\} \quad (3.5)$$

where:

p = penetration (inch)

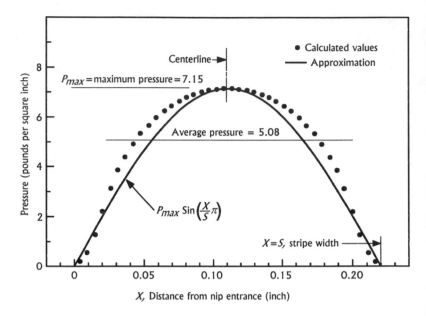

Figure 3.11 Pressure distribution in nip formed by rollers defined in Figure 3.10. Hardness of compliant roller is 25 Type A durometer. Calculated values are from a finite element analysis method calculation (MacPhee, 1996).

The depth of penetration that corresponds to a given stripe is a function only of the geometry of the roller pair, i.e., the roller diameters and the thickness of the cover on the compliant roller. Even so, the correct mathematical relationship between stripe and penetration is not a simple one, as illustrated by equation (3.5) taken from Deshpande's paper.

Figure 3.12 gives the calculated depth of penetration versus stripe width for two different roller pairs, based on equation (3.5). The plot in Figure 3.12 of the three points obtained from the above referenced finite element analysis method calculations shows good agreement with the calculations that are based on Deshpande's model.

Examination of Figure 3.12 discloses that the penetration corresponding to the recommended stripe width of 3/16 inch, for a pair of 3-inch-diameter rollers, is 0.01 inch. Because this amount of squeeze is only three times the normally specified total indicated runout of 0.003 inch, the actual stripe can vary significantly as the rollers rotate. For a pair of 6-inch-diameter rollers, the penetration corresponding to the recommended stripe of 3/8 inch is about 0.02 inch.

3.2.2 **Effective Drive Diameter.** When a compliant roller is rotated while being pressed against a rigid roller, its effective frictional drive diameter is increased in proportion to the percentage squeeze of its cover. This effect was described by Benjamin Sites, as mentioned in Section 2.2.7

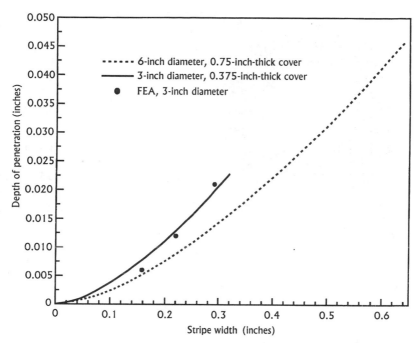

Figure 3.12 Relationship between stripe and depth of penetration for two different diameter roller pairs. Curves are of data calculated using equation (3.5). Points labeled FEA are from previously referenced finite element analysis method calculations.

(Sites, 1936). What this means is that when one roller is frictionally driven by the other, the rotational speed of the compliant roller will be inversely proportional to this effective diameter. The complete relationship of rotational speeds is given by equation (3.6) in Figure 3.13. A converse of this is that, if the rollers are geared together to produce a rotational speed ratio that is different from that given by equation (3.6), increased slippage will occur in the nip formed by the roller pair. A rule of thumb, expressed by equation (3.7), is that the percent increase in the effective drive diameter of a compliant roller is equal to about one-half the percentage squeeze. Support for this, for typical magnitudes of squeeze (as in Figure 3.11), can be found in the literature (Miller, 1960). For example, Miller's data for a roller with a 0.547-inch-thick cover show a linear relationship in which the ratio of percent speed reduction (and hence increase in effective diameter) to percentage squeeze of the cover is 0.53 for percentage squeezes of up to about 2 percent. Similar ratios were measured by the author on a roller with a 0.5-inch-thick cover at percentage squeezes that ranged as high as 36 percent.

The explanation for this phenomenon resides in the fact that, within the nip, the rubber is stretched tangentially to compensate for being

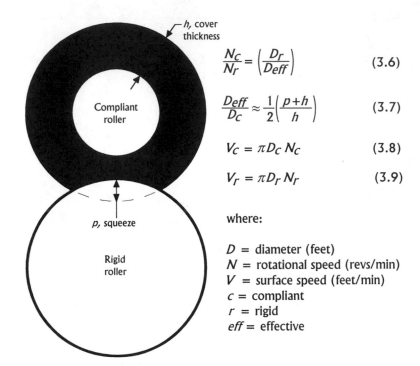

$$\frac{N_C}{N_r} = \left(\frac{D_r}{D_{eff}}\right) \qquad (3.6)$$

$$\frac{D_{eff}}{D_C} \approx \frac{1}{2}\left(\frac{p+h}{h}\right) \qquad (3.7)$$

$$V_C = \pi D_C N_C \qquad (3.8)$$

$$V_r = \pi D_r N_r \qquad (3.9)$$

where:

D = diameter (feet)
N = rotational speed (revs/min)
V = surface speed (feet/min)
c = compliant
r = rigid
eff = effective

Figure 3.13 Relationship between the effective frictional drive diameter and the properties and performance characteristics of a compliant roller.

compressed radially. This is illustrated in Figure 3.14. Referring to these diagrams, it can be seen that at a given rotational speed of the roller, the stretched surface within the nip must travel at a higher velocity than the undeformed surface outside the nip.

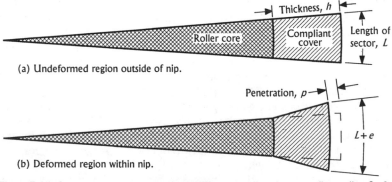

(a) Undeformed region outside of nip.

(b) Deformed region within nip.

Figure 3.14 Comparison of sectors from two different locations in a compliant roller. Surface strain, e, is proportional to fractional penetration, p/h.

If there is no slippage in the nip, the velocity of the deformed surface will be equal to that of the mating roller, while that of the surface outside the nip will be lower. Because relatively little slippage occurs under friction drive conditions, the compliant roller exhibits an effective frictional drive diameter that is larger than the actual roller diameter.

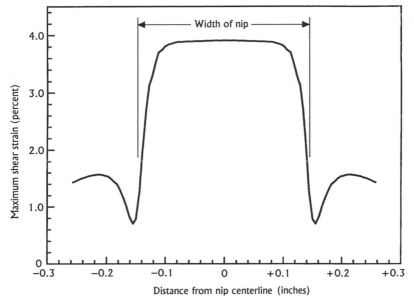

Figure 3.15 Maximum strain along the surface of a compliant roller. Diameter of compliant roller and mating rigid roller is 3 inches, cover thickness is 3/8 inch, and depth of penetration is 0.021 inch. Data is from previously referenced finite element analysis calculation.

Figure 3.15 is a plot of the surface strain of a compliant roller in and adjacent to the nip formed with a rigid roller, calculated under static conditions. This shows that surface strain increases rapidly at the nip entrance until it reaches a steady value that is maintained over about 60 percent of the width of the nip. This suggests that microslip, as defined in Section 2.2.8, at least occurs at both the nip entrance and exit, even when relatively little slippage occurs in the middle 60 percent of the nip. For the roller geometry in Figure 3.15, the percentage squeeze is 5.6 percent. Using the above rule of thumb, the expected increase in effective drive diameter is 2.8 percent, while that expected from the maximum strain shown in Figure 3.15 is 3.9 percent. This difference infers a circumferential slippage of 1.1 percent, which is in good agreement with the generally accepted value of about 1 percent.

3.2.3. Viscoelasticity and Dynamic Behavior. The elastomers used to cover compliant press rollers belong to that group of materials that

possess the property of viscoelasticity. Because the study of viscoelasticity is a field of its own, the reader should appreciate that the explanations given in this section are of a very elementary nature aimed only at providing a basic understanding of the dynamic behavior of compliant rollers. For this reason, the concept of the complex modulus has not been introduced per se. More in-depth analyses can be found in any one of a number of texts that treat the viscoelasticity of polymers (McCrum, Buckley, and Bucknall, 1988; Ferry, 1980; and Gent, 1992).

The dynamic behavior of the elastomers used to cover compliant press rollers differs significantly from that of ideal elastic materials. This is because the moduli of elasticity of these materials have a relatively large viscous component. Its effect can be explained in terms of the mechanical analogs shown in Figure 3.16. An ideal elastic material can be represented by a spring because its stress-strain behavior is linear and is the same for both increasing and decreasing strain, as shown by the stress-strain curve in Figure 3.16(a). The relationship represented by this curve is known as Hooke's Law and is expressed by equation (3.10), where E is the slope of the stress-strain curve. This is analogous to the behavior of a spring, as expressed by equation (3.11), in that the modulus of elasticity, E, for an ideal elastic material is analogous to K, the spring constant of the coil spring shown in Figure 3.16(a).

$$\sigma = Ee \qquad\qquad\qquad\qquad\qquad\qquad\qquad (3.10)$$

$$F = Kx \qquad\qquad\qquad\qquad\qquad\qquad\qquad (3.11)$$

where:

e = strain (change in length/length)
σ = stress (load/area)
E = Young's modulus (pounds/square inch)
x = displacement (inches)
F = applied force (pounds)
K = spring constant (pounds/inch)

Elastomers or rubber-like materials are also springy, but in addition exhibit viscous behavior. Viscous behavior refers to that type of response where the force or load is proportional only to the rate of change in position or displacement. A familiar analogy is the resistance felt when one's hand is moved through a body of water: the force experienced increases with the speed of movement. Thus, for purposes of understanding, an elastomer can be represented by the parallel combination of a spring and dashpot, in series with a second spring. This mechanical analog, known as the Zener model, is shown in Figure 3.16(b).

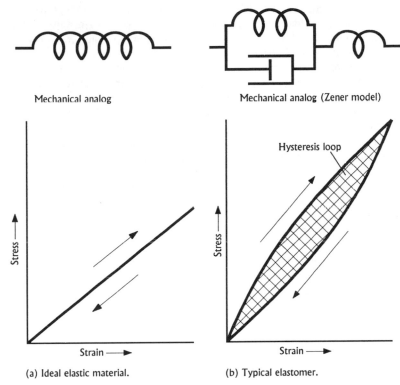

Mechanical analog Mechanical analog (Zener model)

(a) Ideal elastic material. (b) Typical elastomer.

Figure 3.16 Comparison of typical elastomer and ideal elastic material. Mechanical analogy
 of ideal elastic material is a spring; that of a typical elastomer is the parallel
 combination of a spring and a dashpot in series with a second spring. Arrows in
 the stress-strain curves indicate that strain was increased from zero to maximum
 and then decreased back to zero at a constant rate of change. Area of hys-
 teresis loop is proportional to the amount of heat generated.

The viscous component produces two fundamental changes in the
stress-strain curve. First, assume that the effective modulus exhibited by a
given elastic material and a given elastomer are equal for the case where
strain is increased at an infinitely slow rate. Next, consider the case where
strain is first increased and then decreased at a constant rate of strain, as in
Figure 3.16. For the elastomer, as in Figure 3.16(b), the portion of the
curve corresponding to increasing strain lies above the portion
corresponding to decreasing strain. This differs from the ideal elastic
material stress-strain curve shown in Figure 3.16(a) where the two portions
lie on top of one another. Furthermore, for the elastomer, the distance
between the two portions increases as the rate at which strain is increased.
(Conversely, if strain in Figure 3.16(b) were changed at an infinitely slow
rate, the two portions would coincide and the elastomer would appear as

an ideal elastic material.) This phenomenon accounts for the "compression set" referred to in Section 3.1.1 wherein an elastomer, when deformed by the application of a force, does not immediately spring back to its original shape when the force is removed.

The second change produced in the stress strain curve is to increase the amount of stress generated by a given strain when strain is changed at some finite rate. This is evident in the higher value of stress reached by the curve in Figure 3.16(b) for the same strain as in Figure 3.16(a). Furthermore the magnitude of the stress generated by a given strain is proportional to the rate at which strain is increased. Thus if strain in Figure 3.16(b) were changed at an infinitely slow rate, the maximum stress generated would be the same as for the ideal elastic material in Figure 3.16(a).

Because of these unique characteristics, the viscous component produces two changes, as follows, in the pressure distribution within a nip under dynamic or rolling conditions, compared to the pressure distribution when the rollers are at rest:

1. The maximum pressure generated will be larger, due to the increase in force produced by the fact that strain is increasing at some finite rate when the cover is being compressed.

2. The location of the maximum pressure will move away from the nip centerline toward the nip entrance.

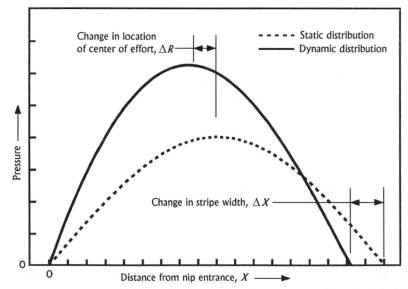

Figure 3.17 Curves that illustrate how pressure distribution within nip is skewed under dynamic or rolling conditions. Static distribution is approximated by a sine wave. Dynamic distribution was calculated for a phase angle of 18 degrees.

The end result, shown in Figure 3.17, is to skew the pressure distribution. As a result, the location of the center of effort between the rollers, shown in Figure 3.17, is moved away from the centerline by a distance, ΔR, toward the entrance. In addition, the nip width is decreased by an amount ΔX. The shifting of the equivalent force, F, located at the center of effort produces a moment ΔRF that constitutes a resistance to rolling, i.e., the rolling friction. To overcome this rolling friction, a drive torque must be transmitted to the compliant roller.

Thus, the net effect of the viscous component of the compliant roller is to require that work be done on the compliant roller to cause it to rotate. The amount of work done appears as heat generated in the compliant cover, and it increases with roller speed. A measure of the heat generated is given by the area of the hysteresis loop in Figure 3.16(b).

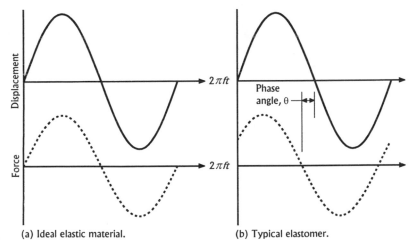

(a) Ideal elastic material. (b) Typical elastomer.

Figure 3.18 Comparison of the responses of an ideal elastic material and a typical elastomer to a sinusoidal variation in displacement. Response curve of force on elastomer leads displacement sine wave by phase angle, θ.

The way in which the various roller nip properties affect heat generation can best be understood by examining the response of an elastomer to a sinusoidal variation in strain. Suppose that a column of material is subjected to a sinusoidal displacement. If the column is made of an ideal elastic material, the reacting force will oscillate in phase with displacement as shown in Figure 3.18(a). If, however, the column is made of a typical elastomer, the resulting oscillating force will no longer be in phase with displacement, and instead will lead by some phase angle, θ, as shown in Figure 3.18(b). The magnitude of the phase angle, θ, is proportional to the relative size of the viscous component. For this more general case, displacement and force can be approximated by equations

(3.12) and (3.13) provided that total displacement is small:

$$Y = Y_{max} \sin(2\pi ft) \qquad (3.12)$$

$$F = F_{max} \sin(\theta + 2\pi ft) \qquad (3.13)$$

where:

f = frequency (Hertz)
F = force
Y = displacement
t = time
θ = phase angle
max denotes maximum value

The rate at which work is done (and heat is generated) is equal to the work done per cycle of strain multiplied by the number of cycles per second, as expressed by equation (3.14):

$$Q = f\int_{t=0}^{t=1/f} F\,dY = f\int_{0}^{1/f} F\left(\frac{dY}{dt}\right)dt \qquad (3.14)$$

where:

Q = heat generation rate

When equations (3.12) and (3.13) are substituted in equation (3.14), equation (3.15) is obtained:

$$Q = f\int_{0}^{1/f}\left[F_{max} \sin(\theta + 2\pi ft)Y_{max}\, 2\pi f \cos(2\pi ft)\right]dt \qquad (3.15)$$

Carrying out the integration yields the final form, equation (3.16):

$$Q = \pi f F_{max} Y_{max} \sin\theta \qquad (3.16)$$

For this simple case of a sinusoidally varying displacement, equation (3.16) shows that the rate of heat generation is directly proportional to four variables as follows:

1. The frequency of oscillation, f.
2. The peak value of the sinusoidally varying displacement, Y_{max}.

3. The peak value of the resultant sinusoidally varying force, F_{max}.
4. The sine of the phase angle, θ, i.e., the relative viscous behavior.

The tangent of the phase angle θ has also been referred to as the loss factor in one of the few published studies of the viscoelastic properties of printing press rollers (Scheuter and Pfeiffer, 1969). For the materials investigated in that study, the following was learned:

1. The value of the phase angle, θ, at a frequency of 200 Hertz, lies between 6 and 22 degrees, depending on material composition.
2. The sine of θ increases approximately as the 0.1 power of frequency.
3. The phase angle, θ, decreases markedly as temperature rises.

Equation (3.16) can be used in conjunction with static calculations of stripe width and depth of penetration to obtain rough estimates of the heat generation rate in compliant press rollers. To do so, consider a compliant roller that forms a single nip with an adjacent rigid roller. As the rollers rotate, each point on the surface of the compliant roller will undergo a displacement as it passes through the nip. If the pressure distribution within the nip is approximated by half a sine wave, as in Figure 3.11, it can be seen that each point on the roller surface will undergo a time-varying half sine wave pulse of pressure for each revolution of the roller, as illustrated in Figure 3.19.

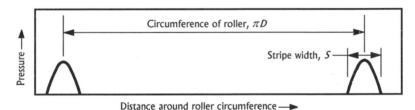

Figure 3.19 Plot of pressure pulses seen by each point on the surface of a compliant roller running in contact with a single rigid roller.

From this illustration it can also be seen that the half sine wave pulses in pressure will have a frequency given by equation (3.17), and occur over the fraction of time given by equation (3.18).

$$f = \frac{V}{2S} \tag{3.17}$$

$$\alpha = \frac{S}{\pi D} \tag{3.18}$$

where:

f = frequency
V = surface speed of roller
S = stripe width
D = roller diameter
α = duty cycle, i.e., the fraction of time that a point on the roller
 surface undergoes a sinusoidal pressure at frequency f.

This is equivalent to the condition where the entire surface of the roller is subjected to the same oscillatory displacement with the same duty cycle, α. Thus to use equation (3.16), it only remains to obtain estimates of F_{max} and Y_{max} and this can be done from static calculations.

The depth of penetration, p, calculated using equation (3.5) can be used as the stand-in for Y_{max}. A stand-in for F_{max} is obtained by deriving an equation for the peak pressure, P_{max} under static conditions. To do this the following relationships for the half sine wave in Figure 3.11 are derived:

$$F_s = \int_0^S Pdx = P_{max} \int_0^S sin(\frac{x}{S}\pi)dx = \frac{2S}{\pi}P_{max} \tag{3.19}$$

Therefore:

$$P_{max} = \frac{\pi}{2S}F_s \tag{3.20}$$

where:

F_s = static load per unit length for stripe width S, as given
 by equation (3.1)
S = stripe width
P = pressure at point x
P_{max} = maximum pressure under static conditions
x = distance from nip entrance

Because it is being assumed that the static and dynamic loads are equal, the maximum pressure under static conditions, given by equation (3.20), can be taken as the maximum pressure generated under the dynamic condition where the entire surface of the roller is subjected to a sinusoidal displacement having a maximum value equal to the static penetration, p. Thus F_{max}, the corresponding force under dynamic conditions can be found by multiplying equation (3.20) by the appropriate area as in equation (3.21):

$$F_{max} = (Area) \bullet P_{max} = (\pi DL)\left(\frac{\pi F_s}{2S}\right)$$ (3.21)

where:

L = roller length

Thus the final form of the approximate roller heat generation equation is obtained by multiplying equation (3.16) by the duty cycle, α, and combining the result with equations (3.17), (3.18), and (3.21) and then substituting penetration, p, for Y_{max} to obtain:

$$Q = \left(\frac{\pi^2}{4}\right)\left(\frac{p}{S}F_s\right) LV \, sin\,\theta$$

$$Q = 2.465\left(\frac{p}{S}F_s\right) LV \, sin\theta$$ (3.22)

An examination of equation (3.22) in the light of the dynamic effects discussed above reveals that it underestimates the heat generation rate. That is, the actual force and the phase angle are known to increase as frequency or speed is increased. In addition, as shown in Figure 3.17, the stripe decreases somewhat with speed. All three effects, ignored in equation (3.22), act to give rise to a higher heat generation rate than predicted. Nevertheless, if this is kept in mind, this equation can be used to provide some sense of the magnitude of heat generation rates in actual rollers, and of how these rates are affected by the various nip properties.

Figure 3.20 shows how the calculated heat generation rate in a 40-inch-long, 3-inch-diameter, rubber roller varies with press speed, under four different sets of conditions. As can be seen, the heat generation at a given speed varies widely with both stripe and cover hardness. These curves also point out that heat generation rate is affected markedly by stripe setting, e.g., it is more than doubled by increasing the roller stripe from 3/16 inch to 1/4 inch. At the typical sheetfed press speed of 550 feet per minute, the worst case (35 durometer, 1/4-inch-wide stripe) heat generation rate is 73 watts or over three times the heat generation rate of 22 watts for the recommended combination of a 25 durometer cover and a 3/16-inch stripe setting. For the inker design shown in Figure 1.2 that has fifteen nips, the total predicted heat generation rate would be 1100 watts, or 3750 Btu/hour (950 kilocalories/hour) for the above worst-case conditions.

It can also be seen in Figure 3.20 that the heat generation rate varies directly with speed, even though the effects of speed on the stripe, load, and phase angle were not taken into account by equation (3.22). The

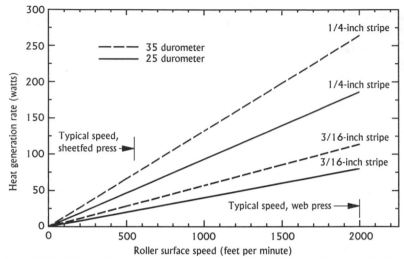

Figure 3.20 Calculated heat generation rate due to cyclic straining of the cover of a 40-inch-long-3-inch-diameter compliant roller running in contact with a single rigid roller of like diameter. Based on equations (3.4), (3.5), and (3.22) and a phase angle of 22 degrees.

calculated worst-case heat generation rate corresponding to the typical web press speed of 2000 feet per minute is 264 watts. For a typical web press ink roller train that has thirteen nips, the total calculated heat generation rate thus amounts to over 3.4 kilowatts, or 11,700 Btu/hour (2950 kilocalories/hour).

Before leaving this subject, the reader is reminded that the heat generation rates just discussed are due only to the mechanical working of the cover materials of the compliant rollers. The total generation rates in a printing unit also include contributions from the blanket and working the ink, and these are discussed in Section 4.7.

3.3 Fluid Transport to Nip

One of the two basic purposes of the roller assemblies used in printing presses is to transport ink, fountain solution, and paper from one point to another. In those locations where fluids are involved, transport is concerned with one of two tasks: lifting a relatively thick film from a reservoir, or in carrying a thin film from one nip to another. In this context, a thin film is defined as one that is immobilized or fixed in position relative to a point on the roller surface. Put another way, a thin film is one that maintains its thickness during transport due to the fact that the viscous forces greatly exceed the forces exerted on the fluid by gravity. In contrast, a thick film is one where fluid particles near the surface are affected by gravity, and hence

differ in velocity from those particles touching the roller surface. As a result, the thickness of a "thick film" changes during transport. In practice, thick films only exist on those printing press rollers that are used to lift a fluid from a reservoir to a nip.

The major point of interest in thin film transport is whether or not a stable film is formed on the roller surface. In thick film transport, the major point of interest is in the factors that govern film thickness. Accordingly, the subsequent discussion consists of separate sections that address these two interests.

3.3.1 Thin Film Transport. The films present in most press locations are defined as "thin" in that they are essentially unaffected by gravitational forces. Thus, in the ideal case, the thickness of such a film is found to be uniform throughout the region it is transported, i.e., from the upstream nip to the downstream nip and across the roller length. In theory, two different types of film non-uniformity or instability can be encountered: beading-up and ribbing. Beading-up refers to the consequences of poor wetting where there is a tendency of a fluid film to recede in randomly located areas, and ultimately form randomly spaced globules or drops on the surface. Ribbing, also called corduroying, refers to the formation of equally spaced ridges, parallel to the direction of travel. Ribbing is generated during film splitting at the nip exit, and for this reason is discussed in Section 3.5.

In practice, beading-up is rarely a problem because this type of film failure is due to the inability of the fluid in question to wet the roller surface in question. That is, because the materials used to cover rollers are carefully chosen to insure that they will be wet by the fluids they are designed to transport, wetting failures are rarely encountered. In those few instances where beading-up does occur in practice, it usually involves a water film on a dampening system roller. Invariably, the problem can be traced to a roller surface that has not been properly desensitized.

3.3.2 Fluid Lifting. Fluid lifting refers to the transport of a thick film of fluid by a roller from a reservoir to a takeoff point or nip where a portion of the fluid is moved or transferred. The phenomenon is of primary interest on lithographic presses because certain types of dampening systems utilize the relationship between the film thickness at the takeoff point and the speed of the roller as the basis for a metering system. Those systems are the brush type dampener described in Section 5.5, and the skim roller type dampener described in Section 5.6. Fluid lifting also takes place in overshot ink fountains, as shown in Figure 4.18. Here, however, metering is accomplished by a separate blade.

The principles of fluid lifting are well understood because of its importance in dip coating and single-roller coaters. Dip coating involves the constant speed withdrawal of a sheet or web of solid material from a quiescent liquid reservoir. The geometry of a single-roller coater is shown in Figure 3.21. In both cases, flow is given by the general relationship expressed in equation (3.23) as follows:

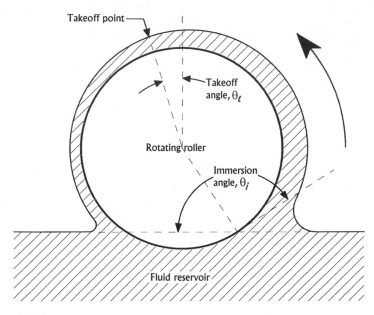

Figure 3.21 Geometry of single-roller coater.

$$q = QvLh^*$$ (3.23)

where:

 q = feedrate at some point above the fluid reservoir, in unit volume
 per second
 Q = a parameter to account for immersion angle, location above the
 reservoir, and the difference between actual and characteristic
 thicknesses
 v = characteristic velocity of the fluid film, i.e., web withdrawal rate
 or roller surface speed
 h^* = characteristic thickness of the fluid film
 L = web width or roller length

The characteristic film thickness is expressed by equation (3.24) as follows:

$$h^* = \left(\frac{\mu v}{\rho g}\right)^{1/2}$$ (3.24)

where:

μ = kinematic viscosity
ρ = density
g = acceleration due to gravity

For dip coating, it was found (Landau and Levich, 1942) that Q is a function of the capillary number, N_c, defined by equation (3.25). In the dampening applications of interest here, where the capillary number is much less than one, Q was found to follow the relatively simple relationship given by equation (3.26).

$$N_c = \frac{\mu v}{\sigma}$$ (3.25)

$$Q = CN_c^{1/6}$$ (3.26)

where:

C = constant
 = 0.93 for $N_c \ll 1$ and vertical withdrawal
N_c = capillary number
σ = surface tension

If the equations (3.24), (3.25), (3.26) are all substituted into equation (3.23), the final relationship for dip coating, equation (3.27), is obtained:

$$q = C v^{5/3} \mu^{2/3} \left(\frac{1}{\rho g}\right)^{1/2} \left(\frac{1}{\sigma}\right)^{1/6} L$$ (3.27)

In the case of the single-roller coater, which is analogous to some dampening system pan rollers, flow will also vary with the immersion angle θ_i and the takeoff angle θ_t, as defined in Figure 3.21. The form of the equation for flowrate will be the same as in equation (3.27), but the constant, C, will depend on the angles θ_i and θ_t. A theory that includes these additional variables has been developed (Tharmalingam and Wilkinson, 1978) that provides a straightforward, although cumbersome, method for evaluating flowrate. The accuracy of this method is illustrated by the plot of four different sets of data in the lower graph in Figure 3.22 as follows:

1. Experimental data from brush dampener pan roller (MacPhee,

1988) where $\theta_i = 138$ degrees and $\theta_t = 6$ degrees.

2. Corresponding calculated values for dip coating, e.g., equation (3.27) with $C = 0.93$.

3. Corresponding calculated values for roll coating based on the method of Tharmalingam and Wilkinson for $\theta_i = 138$ degrees and $\theta_t = 6$ degrees.

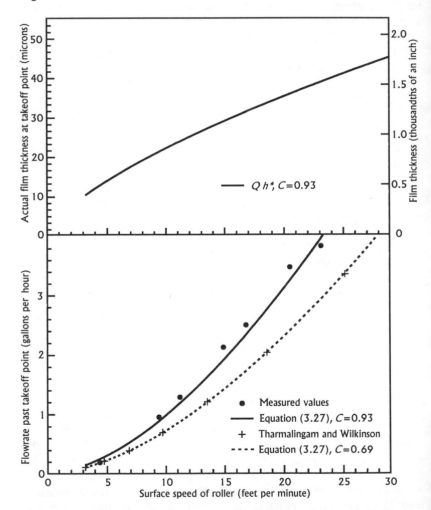

Figure 3.22 Flowrate and actual film thickness on roller for lifting of water. Roller is 3.625 inches in diameter, 36 inches long, and is immersed in reservoir to a depth of 0.47 inches. Corresponding immersion angle is 138 degrees. Both the measured data and the calculated data based on the method of Tharmalingam and Wilkinson are for a takeoff angle of 6 degrees.

4. Best fit of equation (3.27) to calculated values for roll coating, i.e., with $C = 0.69$.

From these plots, it can be seen that the method of Tharmalingam and Wilkinson, compared with measurements, underestimates flowrate by about 20 percent, at least in this range of capillary number (i.e., 0.00038 to 0.003). Fortuitously, the less appropriate dip coating theory (i.e., equation (3.27), with $C = 0.93$) agrees quite well with the measured data. Dip coating theory, however, does not take into account either the immersion angle, θ_i, or the takeoff angle, θ_t. Nevertheless, this is not a problem because the theory of Tharmalingam and Wilkinson predicts that flowrate is only a weak function of these two angles. Therefore, equation (3.27), along with $C = 0.93$, can be used to provide a good estimate of flowrate in dampening system applications of fluid lifting, as represented by the measured data in Figure 3.22. Equation 3.27 also shows how flowrate varies with both pan roller speed and fluid properties.

The actual film thicknesses corresponding to the flowrates calculated using equation (3.24) are shown in the upper graph in Figure 3.22.

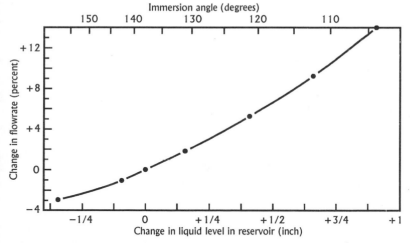

Figure 3.23 Effect of water level in reservoir on flowrate at takeoff point for system defined in Figure 3.22. Reference flowrate is 2.3 gallons/hour, corresponding to a roller surface speed of 16.7 feet/minute.

One other item of interest in such applications is the degree to which flowrate at the takeoff point varies with the liquid level in the reservoir, i.e., the dampening system water pan. For the system defined in Figure 3.22 at a pan roller speed of 16.7 feet per minute (flowrate of 2.3 gallons per minute at takeoff point), the effect of liquid level on flowrate was calculated using the method of Tharmalingam and Wilkinson. These results,

plotted in Figure 3.23, show that the flowrate is indeed weakly dependent on immersion angle, and hence also on liquid level in the reservoir or pan.

3.4 Fluid Behavior Within Nip

With few exceptions, all the nips in a printing press are formed by the conjunction of a rigid roller or cylinder with a relatively soft elastomeric-covered roller or cylinder. Fluid behavior within these nips is governed by three sets of properties: the properties of the rolling elements, the properties of the fluid, and the properties or conditions within the nip. The properties of the rolling elements that are pertinent are roller diameter, hardness, and thickness of the compliant roller cover. The important fluid properties are supply rate (i.e., film thickness delivered to the nip) and viscosity. The conditions within the nip that affect fluid behavior are roller surface speeds, squeeze or interference between the rolling elements, and the resultant load, pressure, and stripe width (i.e., width of nip). The film thicknesses delivered to a given nip are determined primarily by where in the press the nip is located, while fluid viscosity is determined largely by whether the fluid is ink or water.

Table 3.1 illustrates the range of nip characteristics found in a medium-size sheetfed lithographic printing press. It is based on standard practice for roller settings and recommended or typical values for resilient roller hardnesses. The most striking feature disclosed in Table 3.1 is that cylinder loads, whether measured in terms of average pressure or lineal load, are more than an order of magnitude higher than the roller loads in both the dampening and inking systems. The explanation for this is that relatively high pressures are needed in the printing nip to produce good transfer of the thin ink film from the blanket to the relatively rough-surfaced paper, and that relatively narrow nip widths are needed to avoid halftone dot spread and/or image elongation. These two requirements can only be achieved by using a relatively hard cover on the blanket cylinder. With such a hard blanket cylinder, a high pressure will also be developed between it and the plate cylinder because it is not practical to run at squeezes very much lighter than those in the printing nip. Another factor is the added squeeze in the printing nip due to the presence of paper; thus the pressures in the printing nip are always somewhat higher than in the plate-blanket nip.

Although some aspects of nip behavior are not yet well understood, many interesting facts have been learned recently from calculations based on modern elastohydrodynamic (EHL) theory (MacPhee, Shieh, and Hamrock, 1992, and Bohan, Lim, Korochkina, Claypole, Gethin, and Roylance, 1997). The reason that EHL theory is so useful is because nip behavior is, in many respects, analogous to fluid lubrication where a fluid is

Table 3.1 Characteristics of the nips found on medium-size sheetfed printing presses. Film thicknesses range from 3–30 microns (0.00012–0.0012 inches) in the inking system, 0.4–20 microns (0.000016–0.0008 inches) in the dampening system, and 1–3 microns (0.00004–0.00012 inches) on the printing cylinders.

Area on press	Properties of rollers/cylinders			Fluid properties	Settings		
	Diameter (inch)	Resilient cover thickness (inch)	Resilient cover hardness (Type A durometer)	Viscosity (poise) Note (a)	Stripe (inch)	Lineal load (pounds/inch)	Average pressure (pounds per square inch)
Inking system	3	3/8	25	35–450	3/16	0.9	4.8
Dampening system	3	3/8	25	0.01	3/16	0.9	4.8
Printing cylinders	10	0.07	Conventional blanket Note (b)	35–450	0.363	60	165
			Compressible blanket Note (c)	35–450	0.463	67	145

Notes: (a) From MacPhee and Wirth, 1989.
(b) Stripe based on 0.004-inch squeeze in printing nip. Load is extrapolated from data in Figure 2.8.
(c) Stripe based on 0.006-inch squeeze in printing nip. Load is extrapolated from data in Figure 2.8.

pumped between two surfaces for the purpose of separating them so as to prevent contact and resultant wear. Similarly, the fluid films carried by a contacting rigid and compliant roller join together at the nip entrance and are forced through the narrow passage between the rollers by the nip pumping action that is produced by the deformation of the compliant roller. In this regard, it is to be noted that the film thicknesses on printing press rollers are very small compared to the total indentations produced in the compliant rollers. From EHL theory, it has been learned that under these conditions fluid pressure within the nip is in essence a function only of the hardness of the compliant roller and the stripe setting. Thus pressure is essentially independent of fluid viscosity, roller speed, and film thickness and therefore can be assessed reasonably well using the equations given in Section 3.2.1 for dry rollers under static conditions. The reader is reminded, however, that the viscoelastic behavior of the compliant roller will produce some increase in nip pressure and decrease in stripe width under dynamic conditions, as illustrated in Figure 3.17.

Two other very important results have been shown by EHL calculations. The first is that fluid velocity is uniform throughout the nip. The second is that except for the case where the nip inlet is fully flooded the film thickness within the nip is simply equal to the sum of the thicknesses of the converging films entering the nip.

It has also been learned from EHL theory that, in general, three modes of nip operation are possible: totally starved, partially flooded, and fully flooded. This stems from two fundamentals. First, all of the fluid delivered to the nip, in the form of a thin film on each roller, must be carried away, either by passing through the nip as a result of the nip pumping action or by flowing back out of the nip entrance. Second, the pumping capacity of the nip increases significantly if fluid is allowed to fill, or pile up at, the nip inlet or entrance.

The three different modes of operation can thus be defined in terms of the balance achieved between the rates at which fluid is delivered and carried away. That is, if the pumping capacity of the nip proper exceeds the delivery rate, all of the fluid will be passed through and no inlet filling will occur. This is illustrated in Figure 3.24(a) and is defined as the totally starved mode.

If the delivery rate were now increased to a level slightly higher than the pumping rate, fluid would back up and fill the nip entrance to a distance where the pumping capacity would increase to equal the delivery rate. This partially flooded mode of operation is illustrated in Figure 3.24(b).

The third mode of nip operation, fully flooded, is shown in Figure 3.24(c). In this case, the nip is filled to or beyond the point where no further increases in pumping capacity are produced. Consequently, the delivery rate exceeds the pumping rate, and some fluid flows back out of the nip entrance.

 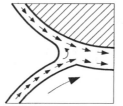 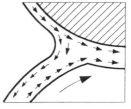

(a) Totally starved mode. Pumping capacity exceeds delivery rate. All fluid delivered passes through nip.

(b) Flooded mode. Inlet fills to extent needed to raise pumping capacity to level where it just equals delivery rate. All fluid delivered passes through nip.

(c) Fully flooded mode. Inlet fills to point where no further increases in pumping capacity occur. Delivery rate exceeds pumping capacity so some fluid flows back out of nip.

Figure 3.24 The three possible modes of nip operation.

It is obvious that the fluid will experience shear in both the partially flooded and fully flooded modes of operation (Figures 3.24(b) and (c)), because in these two cases some fluid is slowed down at the nip entrance. Although not so obvious, these same EHL calculations have shown that no shear exists in the totally starved mode, *provided that the surface speeds of the rollers are equal.* This condition is not met in practice due to slippage between rollers within the nip. (It was estimated in Section 3.2.2 that slippage is typically about one percent of roller surface speed.)

3.4.1 Maximum Attainable Film Thickness. The pumping capacity, measured in terms of the maximum attainable film thickness within a nip, is of great interest because it is a measure of the onset of the partially flooded mode and attendant fluid shearing.

The results of the above referenced EHL calculations show that, in the case of ink, the totally starved mode will be achieved if the ink film thickness entering the nip is less than 48 microns (0.002 inch) under the following reference conditions:

Diameter of both rollers	3 inches
Stripe setting	0.22 inches
Surface speed	500 feet/minute
Fluid viscosity	35 poise
Durometer of compliant roller	≈ 21 Type A

Based on the calculated values of ink film thicknesses given in Section 4.3, it can be seen that the above film thickness of 48 microns (0.002 inch) greatly exceeds the film thicknesses found on all inking rollers in printing presses with the possible exception of the ink fountain and ink ductor rollers. Further margin is provided in this regard by the fact that higher speeds and higher fluid viscosities than those listed above act to significantly increase the maximum attainable film thickness, while harder rollers have a

small effect in reducing film thickness. Therefore, it can be concluded that most nips in press inking systems operate under totally starved conditions when recommended roller materials and settings are being used. In contrast, the metering nip in squeeze roller type dampening systems is operated in the fully flooded mode. Thus, it is of interest to know how the various nip properties affect nip pumping capacity under these two extreme modes of operation.

Table 3.2 Dependence of nip pumping capacity on nip properties.

Mode of operation	Roller surface speed	Stripe setting	Roller hardness	Fluid viscosity
Totally starved	Increases with 1/3 power of speed	Increases with increasing setting	Decreases with increasing hardness	Increases with increasing viscosity
Fully flooded	Increases with 1/3 power of speed	Decreases with increasing setting	Decreases with increasing hardness	Increases with increasing viscosity

3.4.2 **Variables Affecting Attainable Thickness.** Table 3.2 summarizes what is presently known about the dependence of nip pumping capacity on four nip variables, under both the totally starved and fully flooded modes of operation. These dependencies are discussed in the paragraphs that follow.

1. **Roller Surface Speed.** EHL calculations revealed that in the totally starved mode, the maximum attainable film thickness varies as the 1/3 power of surface speed over the range of 100–3000 feet/minute for 3-inch-diameter rollers. This agrees very well with the 0.31 power obtained from measurements on a pair of dampening system squeeze rollers running under totally flooded conditions (Zavodny, 1973). Two other correlations of more comprehensive measured data for the fully flooded mode yielded the following exponents:

 0.49 (Coyle, 1988)
 0.583 (Smith and Maloney, 1966)

2. **Stripe Setting.** EHL calculations predicted that in the totally starved mode, over a range of stripe settings of 1/8 to over 5/8 inches, the maximum attainable film thickness increases as the 1.78 power of stripe width, as shown in Figure 3.25. This relationship is not a simple one, because when stripe setting is increased, two changes are introduced: the length of the nip is increased, and fluid pressure is increased. If only the pressure were increased (by increasing roller hardness as discussed in 3

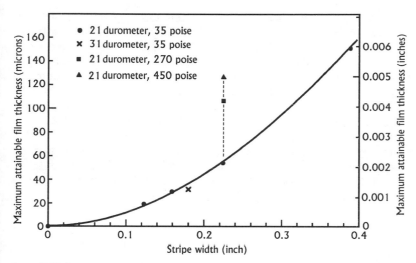

Figure 3.25 Dependence of nip pumping capacity on roller hardness, fluid viscosity, and roller setting at a press speed of 500 feet/minute (MacPhee, Shieh, and Hamrock, 1992).

below) the film thickness would decrease. Therefore the result obtained by increasing stripe width is thought to be due totally to the increase in nip length. This effect of stripe setting is just the opposite of that observed in nips operating in the fully flooded mode. For example, it is well known from operation of dampeners utilizing squeeze rollers that increasing the setting of the metering roller reduces the pumping capacity of the metering nip. The correlations of both Smith and Maloney, and of Coyle, referenced above, confirm this. The reason for this diametrically opposed behavior of these two modes is not understood at present. It is suspected, however, that when stripe width is increased in the fully flooded modes, only the pressure effect is manifested, because the flooded nip entrance negates the nip length effect that otherwise occurs in the totally starved mode.

3. **Roller Hardness.** Figure 3.25 shows that for given stripe, an increase in roller hardness acts to reduce pumping capacity in the totally starved mode. This is the same as observed under fully flooded conditions.

4. **Fluid Viscosity.** The limited data in Figure 3.25 suggest that the maximum attainable film thickness under totally starved conditions increases with the 1/3 power of fluid viscosity. This is a much weaker dependence than indicated by the correlations of measured data obtained from nips operated in the fully flooded mode. In this regard the exponents obtained by three different experimenters are as follows:

0.49	(Coyle, 1988)
0.64	(Smith and Maloney, 1966)
0.9	(Zavodny, 1973)

3.4.3 Effect of Inlet Flooding. In the above referenced EHL calculations, the effect of inlet flooding was investigated by varying the length of the flooded area over the range of from zero to one-half the stripe width. This was for the referenced conditions listed in Section 3.4.1. Figure 3.26 shows that filling the inlet has a tremendous effect on the pumping capacity, as measured by the maximum attainable film thickness. That is, the film thickness increases from 48 microns (0.002 inch) for the fully starved mode to over 1000 microns (0.042 inch), or over a factor of 20, for a flooded inlet length equal to one-half the stripe width. The fact that the curve in Figure 3.26 is still rising at a significant rate suggests that the fully flooded condition will be reached at an inlet length that is much larger than studied. Thus, the maximum pumping capacity in the fully flooded mode is much greater than the highest value given in this graph.

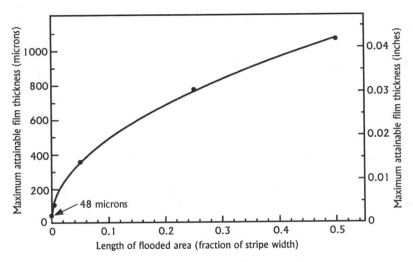

Figure 3.26 Dependence of nip pumping capacity on length of flooded area for a roller speed of 500 feet/minute, roller diameters of 3 inches, a 21 Type A durometer cover, a 0.224-inch stripe, and a fluid viscosity of 35 poise. See text for discussion of maximum pumping capacity.

3.5 Fluid Behavior at Nip Exit

The basic action carried out by a roller nip is to press together the films of fluid carried on the two contacting roller surfaces during their travel through the nip and to pull them apart at the nip exit. In Section 3.4, it was explained that the passage of the combined films through the nip is relatively tranquil. That is, the compliant roller deforms to produce a channel having a height equal to the sum of the two entering film thicknesses, and the combined film travels at a uniform velocity in the

absence of roller slippage. Because the roller surfaces diverge at the nip exit, the composite exiting film is pulled apart, or split, at some small distance beyond the nip exit. Although film splitting has been studied for many years by numerous investigators, there are many details about the process that are not yet understood. Nevertheless, a broad understanding of splitting has been obtained from these studies, and this will now be outlined.

3.5.1 Overview of Film Splitting. In general, it can be said that splitting occurs beyond the nip exit as a result of a viscous pumping action whereby fluid is drawn in separate directions by the diverging roller surfaces. This surface divergence, or pulling action, generates tensile forces in the composite ink film that are equivalent to negative pressures, i.e., pressures less than atmospheric. This region of negative pressure is predicted by theory (Coyle, Macosko, and Scriven, 1986) and has been observed experimentally (Zang, Aspler, Boluk, and DeGrâce, 1991). The maximum value of the negative pressure has been defined by the latter authors as the "tack" of the fluid. More detailed information on the dependence of the negative pressures on nip conditions is given in Section 3.5.2.

Figure 3.27 summarizes how the character of film splitting at a nip exit undergoes three marked changes as roller speed is increased. At very low surface speeds, the film exiting the nip splits in a very smooth and uniform manner, as shown in Figure 3.28.

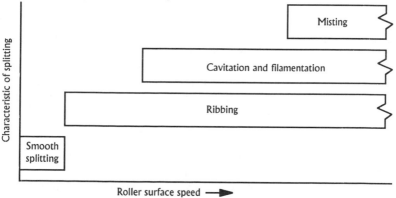

Figure 3.27 Change in character of film splitting at nip exit versus speed.

As roller surface speed increases, the character of splitting changes due to the onset of a type of hydraulic instability known as ribbing, or corduroying, the formation of equally spaced ridges, parallel to the direction of travel. This fluid instability is well known to hydrodynamicists and was first investigated on roller systems at least 30 years ago (Pitts and Greiller, 1961). It is taken up further in Section 3.5.3.

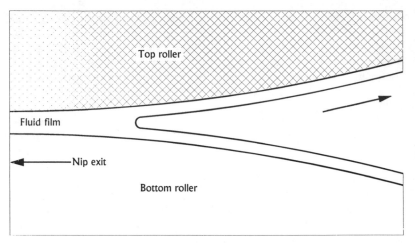

Figure 3.28 Portrayal of smooth film splitting that occurs at very low roller surface speeds.

A further increase in surface speed, well beyond the onset of ribbing, produces a second change in the character of film splitting, the occurrence of cavitation and filamentation. That is, when the negative pressure at the nip exit reaches some limiting level, closed-cell cavities are formed. These cavities become interconnected as the roller surfaces diverge, forming filaments of ink between the two surfaces. Thus, splitting is no longer smooth because final rupture of the ink occurs in the filaments and the ruptured filaments spring back to form a temporary pebbly, or orange peel, surface. This is described in more detail in Section 3.5.4.

At very high surface speeds, the character of film splitting is changed again by the onset of the undesired phenomenon of misting. This comes about when the filaments of ink rupture in two places, rather than one, thereby releasing particles of ink to the surroundings. This poorly understood but very important aspect of film splitting is discussed further in Section 3.5.5.

Before proceeding, there is one other very important aspect of film splitting that must be mentioned in this overview. This is the fractional transfer: the ratio of the thickness of the film retained on the downstream, or receptor, roller to the total thickness of the film traveling through the nip. The character of the fractional transfer is a function of the condition of the surface of the receptor roller and is taken up in Section 3.5.6.

3.5.2 Generation of Negative Pressures. With fluid present in the nip, the complete nip pressure distribution curve includes a region of positive pressure within the nip, and a region of negative pressure beyond the nip exit, as shown in Figure 3.29. For the film thicknesses encountered on press, the magnitude of the peak positive pressure is governed by roller stripe setting and hardness of the compliant roller. The magnitude of the

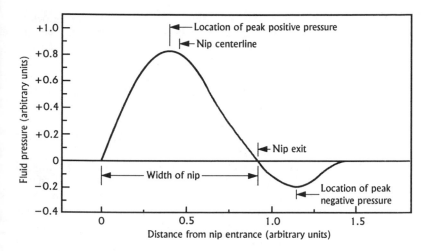

Figure 3.29 Pressure distribution within nip and in region beyond nip exit.

peak negative pressure depends on both roller surface speed and fluid properties. Interestingly, the magnitude of the peak negative pressure has only recently been measured directly (Zang, Aspler, Boluk, and DeGrâce, 1991). Nevertheless, its existence was known for many years previously from measurements of the forces exerted on the rider roller of tackmeters such as the inkometer invented at GATF (Reed, 1937) and the forces that delay the release of paper from the blanket and that sometimes cause picking of paper on press. In addition, Stefan, whose results have been cited often in the graphic arts literature, conducted a series of experiments over 100 years ago that demonstrated that a reactionary force, equivalent to a negative pressure, is generated when two flat plates containing a fluid between them are moved further apart (Stefan, 1874).

In spite of this breadth of information, there is relatively meager quantitative data on the magnitude of the negative pressures that are generated, and there is considerable uncertainty over how these pressures are affected by nip properties, especially the thickness of the fluid in the nip. To dispel this uncertainty, all of these information sources will be reviewed prior to summarizing the current state of knowledge.

1. **Direct Measurements.** The negative pressures existing at the nip exit have been measured directly, both for the case of ink transfer from a resilient roller covered with mylar to a stainless steel roller (Zang, Aspler, Boluk, and DeGrâce, 1991), and for the case of ink transfer to paper (Aspler, Maine, DeGrâce, Zang, and Taylor, 1994). In the former case, the negative pressures measured ranged from 29 to 58 pounds per square inch (0.2–0.4 MPa) at roller surface speeds of 236 and 690 feet/minute, and ink film thicknesses in the nip ranging up to 15 microns. For inks

containing dissolved polymer, the maximum negative pressure or fluid tack increased with increasing film thickness, whereas the tack of ink without polymer appeared to be independent of film thickness. Although data on speed effect was limited, it did show that tack increased with speed. These measurements were inconclusive regarding the effect of fluid viscosity. For the latter case of ink transfer to paper, the results were similar, with the added fact that observed ink tack was higher when printing on coated stock vis-à-vis newsprint. The most likely explanation for this is that there is a smaller area of contact in the case of the uncoated paper as demonstrated by the data in Figure 3.38 further on.

2. **Tackmeter Data.** The roller arrangement of the GATF-designed bench-type inkometer is shown in Figure 3.30. This also illustrates that it measures the torque exerted on the rider roller cradle by the pressures that are generated within and beyond the nip formed between the resilient rider roller and the polished driven roller (Reed, 1937). Inkometer readings are generally accepted as a measure of fluid tack, although no units are assigned to the measurements. The author has confirmed, however, that the readings obtained are in units of meter-grams of cradle torque. Measurements made by others (Plowman, 1989) and by the author show that inkometer reading increases as film thickness is increased over the range of 6 to 24 microns (0.00024 to 0.00096 inches). The author's data is plotted in Figure 3.31. In this regard, the calculated film thickness corresponding to the normal 1.3 cubic centimeter volume applied to the inkometer rollers is 0.00048 inches, or 12.3 microns (ASTM, 1989-3).

Inkometer measurements also indicate that tack or negative pressure increases with the square root of speed. For example, a black ink was found (Plowman, 1989) to have tacks of 12 at 400 revolutions/minute (314 feet/minute), 16 at 800 revolutions/minute (628 feet/minute), and 18.5 at 1200 revolutions/minute (942 feet/minute). Regarding the relationship between tack and viscosity, it has been found that the two are directly related in fluid systems having similar components (Cartwright and Lott, 1962 and Bassemir, 1980).

Some reservations have been expressed about equating the behavior of inkometer readings with the behavior of fluid tack, with respect to increasing film thickness. The main reason for this is the fact that the inkometer reading represents the sum of the torque produced by the positive pressure within the nip (which is asymmetrical, as shown in Figure 3.29) and the torque produced by the negative pressure beyond the nip exit. Therefore, it is argued, the response of the positive pressure may mask the response of fluid tack. This argument can be refuted by two facts. First, the torque due to the positive pressure within the nip is zeroed out when the cradle is balanced with no ink present. Second, the results of both EHL calculations (MacPhee, Shieh, and Hamrock, 1992), and the direct measurements discussed above, found that the pressure within the nip is independent of film thickness, over the range of film thicknesses of interest.

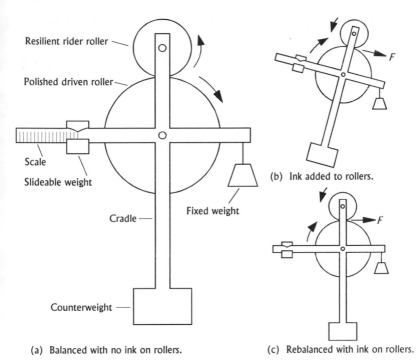

Resilient rider roller

Polished driven roller

Scale

Slideable weight

Cradle

Fixed weight

Counterweight

(a) Balanced with no ink on rollers.

(b) Ink added to rollers.

(c) Rebalanced with ink on rollers.

Figure 3.30 Schematic of GATF inkometer. Resilient rider roller is mounted on a cradle that is free to pivot about axis of driven polished roller. With rollers turning at desired speed, no ink on rollers, and slideable weight at zero point on scale, cradle is balanced by adjusting mass of fixed weight, as in (a). When ink is added to rollers, cradle is unbalanced by an equivalent force, F, generated by film splitting at nip exit, as in (b). Cradle is rebalanced by moving slideable weight to the left, as in (c). Magnitude of torque, created by force, F, is read from position of slideable weight, as in (c).

Thus, when ink is applied to the rollers of the inkometer, the only torque component that will change is the one due to negative pressure or fluid tack.

Some concern has also been expressed that inkometer behavior is not representative of what happens on press because the standard ink film thickness (12.3 microns) used on the inkometer is somewhat greater than the film thicknesses on press. This concern is allayed by the fact that comparable behavior was observed on press (Siebein, 1970) using an on-press inkometer that embodied the same principle as the GATF bench-type inkometer. In addition, the same increase in reading with increase in film thickness was observed using another type of on-press tackmeter on a press under idling conditions with no water present (Mill, 1970).

One other source of information on the behavior of fluid tack is the measurements made by Andries Voet on the rolling cylinder tackmeter that

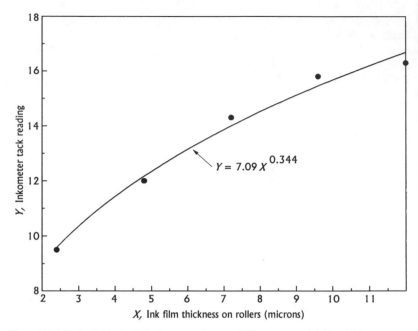

Figure 3.31 Tack of sheetfed ink after one minute at 800 rpm versus ink film thickness.

he appears to have invented with a colleague (Voet and Geffken, 1951). This device comprised a metal cylinder that was rolled down an inclined plane formed by a pair of rails and then upward again after passing the lowest point, much like a roller coaster.

A tack measurement comprised two passes of the cylinder: the first with the rails clear and the second with a small inked plate, equal in length to the circumference of the cylinder, placed in the path of the cylinder, just before the low point in the rails, so as to effect a transfer of some ink from plate to cylinder.

The difference in potential energy of the cylinder at the ends of the two passes was used to determine the amount of energy required to split the film. This was defined as tack energy by Voet and was expressed in ergs per square centimeter. The cylinder could be covered with different types of paper, and different inks and film thicknesses could be applied to the plate, so as to explore how these parameters affect tack energy.

Of interest here is the finding that, for a given fluid, tack energy increased linearly with film thickness. Voet also reported that there was a direct relationship between tack energy density measured in ergs per cubic centimeter and fluid viscosity.

3. **Paper Release.** This refers to the force necessary to separate or peel paper from a printing surface, as for example, to split the film of ink that is pressed between the paper and blanket as the paper passes through

the blanket-impression cylinder nip on a press. There have been many studies of paper release from blankets, based on three types of observations: paper picking, the degree of curl at the end of the sheets printed on a press (tail-end hook), and measurement of release distance on the blanket of an operating press.

Observations of picking when printing from a wedge plate (Fetsko, Schaeffer, and Zettlemoyer, 1963) showed that a maximum occurred at an ink film thickness of 5–7 microns (0.0002–0.00035 inches), with significant decreases occurring as ink film thickness was both decreased and increased. These observations have raised an uncertainty about whether the film splitting force increases or decreases with ink film thickness.

As for the effect of speed, there appears to be no question that picking on press is alleviated by reducing speed (Jorgensen and Lavi, 1973). This indicates that negative pressure increases with press speed.

It is the writer's opinion, however, that picking should not be taken as a measure of the film splitting force. This is because picking, the result of paper fracture, is not only a function of the applied force but also of the strength of the paper. Thus, for example, it is not possible to determine whether an increase in picking arose from an increase in force or a reduction in strength.

In a relatively recent study of release distance, using an acoustic approach (Iwasaki, Takahashi, Yukawa, and Okada, 1993), it was found that the release force increased with solid print density (and hence ink film thickness) in keeping with observations on the GATF inkometer.

4. Stefan's Law. This refers to a relationship based on an equation derived by J. Stefan to correlate measurements he made of the forces required to increase the gap between two glass plates immersed in a fluid (Stefan, 1874). The equipment used by Stefan consisted of two pairs of glass plates having diameters of 10.5 centimeters and 15.5 centimeters, i.e., about 4 and 6 inches respectively. (In his original paper, Stefan gives the diameter of the larger plate as 155 centimeters, but later comments that the ratio of the diameters was 3:2.)

The pair of plates used in a given experiment were immersed by placing them in a shallow glass pan containing either water, sodium chloride, alcohol, or air and were initially separated by sets of wires that ranged in diameter from 0.011 to 0.0573 centimeters (0.4 to 2.3 thousandths of an inch). A lifting force was applied to the top plate and the time required to reach a separation distance of 0.26 centimeters (about 0.1 inch) was measured. The measured times ranged from 8.5 seconds to more than three minutes, depending on initial separation, plate diameter, and fluid used. The relationship that he obtained is given by equation (3.28), which uses his terminology:

$$t = \frac{3\pi\eta R^4}{4qa^2} \tag{3.28}$$

where:

t = time for top plate to move to the final separation distance of 0.26 centimeters

a = initial separation distance as governed by the wire spacers

q = force applied to top plate

R = radius of plates

η = coefficient of internal friction (viscosity) of the liquid.

From this finding, the so-called Stefan's Law, relating film splitting force to nip properties, given by equation (3.29), was inferred by others:

$$F \propto \frac{\eta A V}{h^3} \tag{3.29}$$

where:

A = area where splitting occurs

h = ink film thickness

V = separation velocity

There is a question about equation (3.29) that must be asked: why isn't the area squared in keeping with R^4 in equation (3.28)? This question aside, there are several reasons why Stefan's experiments should not be invoked to qualitatively explain the behavior of fluid tack, i.e., the negative pressures generated beyond the nip exit. From the conditions of his experiments (plates totally immersed), it is clear that the results observed by Stefan were due to the flow of low-viscosity fluids into the capillary size channel formed between the two plates, and not to splitting. While it is thus obvious that the corresponding force varies inversely with some power of the width of the channel, the basis for equating this behavior to what happens at the exit of a roller nip containing ink does not follow, and has never been elucidated.

A second reason for discounting Stefan's observation in this context is the absence of cavitation in his experiments, for he surely would have observed cavitation if it had occurred. In contrast, film splitting on a printing press most assuredly occurs following cavitation, as brought out in Section 3.5.4. This alone precludes equating Stefan's results to what happens in nips on printing presses.

In summary, the most reliable source of information on how fluid tack varies with ink film thickness is the direct measurements made relatively recently (Zang, Aspler, Boluk, and DeGrâce, 1991). These clearly show that increasing the film thickness in a nip containing polymer-bearing fluids increases fluid tack, i.e., the maximum negative pressure generated beyond

the nip exit. Measurements obtained from various tackmeters, including the inkometer designed at GATF, confirm this. Measurements of paper release on press are also in agreement. Stefan's Law, often quoted in the literature, predicts otherwise, but it is not to be relied upon because it is based on experimental conditions that do not simulate film splitting.

Therefore, it is concluded by this author that there is sufficient appropriate experimental evidence available to demonstrate that fluid tack, or the maximum negative pressure generated at a nip exit, increases with increasing film thickness in the nip, over the range of film thicknesses on press for typical inks. The available pertinent evidence also seems quite clear in showing that increasing the viscosity of a given type of ink and increasing roller speed both increase fluid tack.

3.5.3 Ribbing. An exaggerated view of the hydraulic instability known as ribbing is given in Figure 3.32. It is an undesirable phenomenon because it results in streaks of a similar nature on the print, referred to as corduroying.

Figure 3.32 Exaggerated portrayal of the hydrodynamic instability known as ribbing. When ribbing has occurred on dampening system rollers, rib spacing has been about 1/8 inch.

Measurements of the conditions under which ribbing occurs on roller systems have been made by a variety of investigators over the past 30 years. All of their data appears to be consistent with a recently published correlation (Coyle, Macosko, and Scriven, 1990) that was computed using finite element methods. This correlation, plotted in Figure 3.33, shows that the onset of ribbing above a critical capillary number, N_c (product of

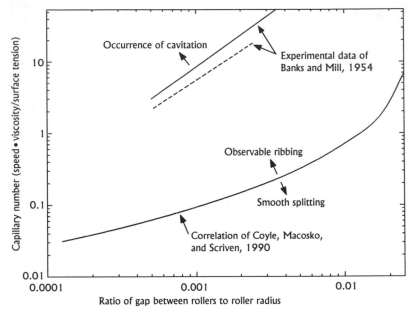

Figure 3.33 Comparison of onset of ribbing with onset of cavitation. Ribbing correlation
relates critical capillary number to gap-radius ratio. Data measured by Banks and
Mill on cavitation related critical roller speed to gap-radius ratio for castor oil
(solid curve) and paraffin (dashed curve). The critical speeds of Banks and Mill
were converted to capillary numbers using respective viscosities of 7.65 and 1.4
poise quoted by them and assumed surface tensions of 39 and 31.6 dynes/cm
respectively.

surface speed and fluid viscosity divided by fluid surface tension), that is a
function of the ratio of the half gap width between the rollers, to the roller
radius.

In lithographic inking systems, the capillary numbers range from the
hundreds to the thousands, while the gap to diameter ratios are in the
range of 10^{-5} to 10^{-4}. Thus it can be seen from Figure 3.33 that ribbing
is ever present at the speeds at which those inkers are run. To prevent
corduroying from showing up on the printed sheet, all such practical inking
systems include vibrating rollers dispersed throughout the train. It has been
stated (Mill, 1967) that the effect of the reciprocating action of a vibrating
roller is to randomize the ribbing pattern rather than to eliminate it. In any
case, ribbing on inking rollers is not a problem in practice.

The same cannot be said for lithographic dampening systems that
employ a metering roller, i.e., of the squeeze roller type. There are two
reasons for this. First, the capillary number of the dampening fluid in these
low-speed nips is in the range of 0.01 while the gap to diameter ratios are
the same order as in inkers. Thus, the correlation in Figure 3.33 predicts
that ribbing may well occur in those dampener locations. Second, there are

many such dampening system designs that do not employ vibrating rollers. As a result, corduroying was often times observed during the mid 1970's when alcohol substitutes were first tried on a large scale in such dampening systems.

On the face of it, these observations appear to be inconsistent with the correlation given in Figure 3.33. That is, an alcohol-substitute-based fountain solution has a lower viscosity than one using isopropyl alcohol (MacPhee, 1981), while surface tension, at best, is comparable and, more likely, is higher. Thus, it would seem that switching to a substitute-based fountain solution would reduce the capillary number and thus reduce the tendency of ribs to form.

There is another factor, however, that must be considered. The lower viscosity of the substitute requires that the squeeze rollers must be speeded up to achieve the same water feedrate. Feedrate is, however, proportional to the 0.72 power of roller speed and the 0.9 power of fluid viscosity, based on an unpublished analysis by the author of the operation of squeeze roller type dampeners. Thus if fluid viscosity is reduced by, say, 50 percent in going to a substitute, the feedrate will decrease by a factor of 1.87 as a result of this change. To return feedrate to its original level, roller speed must be increased by a factor of 2.38. Assuming no change in surface tension, the change in capillary number will be an increase of 2.38/1.87, or 27 percent. Therefore, ribbing is more likely to occur when using an alcohol-substitute-based fountain solution because, for the same feedrate, a higher capillary number will actually exist in the metering nip.

Although the problem of ribbing on dampening rollers has never been investigated in a systematic way, it is the author's opinion that there is more to the problem than indicated by the above rationale. Specifically, experience indicates that too narrow a stripe in the metering nip is a contributing factor. Currently, ribbing is not a major problem and the author attributes this to modern dampener designs wherein the upper speed limit of the metering roller has been increased, making it possible to run with a heavier stripe in the metering nip.

3.5.4 Cavitation and Filamentation. It has already been pointed out that the magnitude of the peak negative pressure generated in the fluid beyond the nip exit increases with roller speed under the condition of smooth or low-speed film splitting shown in Figure 3.28. At some speed, depending on fluid viscosity, film thickness, and roller diameter, the fluid is no longer able to sustain the negative pressure and cavities are formed. This leads to the totally different character of ink film splitting that is illustrated in Figure 3.34, and explained as follows:

1. At the level in negative pressure that the fluid is no longer able to sustain, closed-cell spherical cavities or bubbles are formed. (Closed cell refers to the fact that the cavities are not interconnected.) This phenomenon, referred to as cavitation, is well known in the field of fluid mechan-

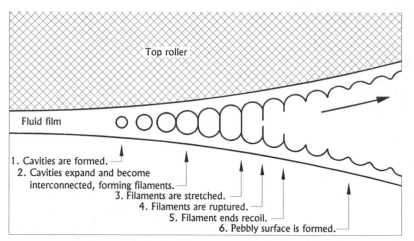

Figure 3.34 Stages in the formation of cavities and filaments during film splitting at high roller speeds. For contrast with smooth film splitting, in which cavitation does not occur, see Figure 3.28.

ics, as it often occurs in devices such as centrifugal pumps and the diverging sections of venturis where negative pressures are generated.

2. As the closed-cell cavities move away from the exit they expand, with the result that they become elongated and interconnected. Consequently, filaments are formed.

3. The filaments are stretched as they move further away.

4. When the limit of stretching is reached, the filaments rupture.

5. Following rupture, the filament ends recoil, or spring back toward their respective roller surfaces.

6. The recoiled filaments produce a temporary orange peel or pebbly-like surface on the two split films.

The occurrence of filamentation can be observed on a stopped press by manually indexing the ink fountain roller while the ductor roller is in contact with it. When the fountain roller is moved, filaments of ink, as shown in Figure 3.34, can be seen to appear between the split films, and these exiting films take on a pebbly or orange peel appearance beyond the filaments. When the roller is stopped, it will also be noticed that the orange peel appearance disappears after a short time has elapsed.

The limited data available on the onset of cavitation (Banks and Mill, 1954) confirm that it occurs well beyond the speeds at which ribbing becomes observable. This is illustrated in Figure 3.33 where the data of Banks and Mill on the onset of cavitation is contrasted with the data on the onset of ribbing. In this regard, it is to be noted that, for a given fluid such as the castor oil of Banks and Mill, the ordinate in Figure 3.33 is equal to roller speed times some constant. For this reason the comparisons of the

different data sets in Figure 3.33 are valid. A word of caution, however, is in order on this presentation: the plotting format used here was only chosen to show that the speed of the Banks and Mill roller rig at which cavitation occurred was much higher than the speed at which ribbing occurred. *It should not be inferred from this plot that cavitation, like ribbing, is correlated by a capillary number that is a function of the ratio of gap to roller radius.* While such a correlation is suggested, there is insufficient data to support one.

From a practical standpoint, cavitation is always present at the exit of nips of printing press rollers and cylinders that are carrying ink.

Photographic studies of splitting have revealed that there is a pattern to filamentation wherein the pattern becomes finer as roller speed is increased (Smith et al, 1956). Because the same is true of ribbing (Coyle, Macosko, and Scriven, 1990), this suggests that the pattern of filamentation may be an extension of the ribbing pattern. Further support for this suggestion is provided by the fact that the above referenced photographic studies revealed that the pattern of filamentation is also randomized by roller vibration.

3.5.5 Misting. The third change in the character of film splitting that occurs as roller speed is increased is misting. In the case of inking rollers, this phenomenon is also referred to as ink fly. It comes about when the filaments of fluid shown in Figure 3.34 rupture in two places, rather than one. As a consequence, very small strings of fluid are released to the surroundings. These strings contract due to surface tension to form spherical drops or globules. The status of knowledge on the factors that affect misting can be summarized as follows:

1. **Speed.** The volume of ink mist produced under a given set of conditions increases with roller speed. Furthermore, under a given set of laboratory conditions, it was found by Tasker that misting increased with the 2.2 to 2.8 power of speed (Christiansen, 1995). Thus, in practice, ink misting creates significant problems at very high speeds. For example, in the case of letterpress type newspaper presses, speeds exceeding 1500 feet/minute were hardly possible because of misting (Voet, 1952). On lithographic type newspaper presses, the speed where misting becomes excessive is somewhat higher, in the range of 2000 to 2500 feet/minute.

2. **Fluid Properties.** In practice, misting is primarily a problem associated with oil-based paste inks, as the misting of dampening fluid and water-based inks is rarely observed. It is thought that this is due primarily to the much higher electrical conductivity of the water-based fluids because it has been shown that misting could be eliminated by increasing the conductivity of an ink vehicle (Voet, 1956). Although it is thought that short inks (high ratio of yield value to viscosity) perform better (Kelly, Crouse, and Supansic, 1974; Eldred and Scarlett, 1990), shortness ratio per se does not appear to be the controlling property. For example, it was

found that reducing the viscosity of the vehicle of a given ink (increasing shortness ratio) increased misting (Voet, 1956).

3. Additives. Misting is decreased by the addition of certain additives, including pigments. For example, increasing both pigment loading and the size of the pigment particles have both been shown to reduce misting (Voet, 1956 and McKay, 1994). Another example, witnessed by the author, was of two test oils of the type used to calibrate viscometers (MacPhee and Wirth, 1989) that produced far more misting than did inks that had comparable viscosities. One explanation for the beneficial effect of additives in the form of particles is that they cause the filaments to break sooner (McKay, 1994).

4. Fluid Film Thickness. It has long been recognized that increasing fluid film thickness increases misting (Voet, 1952; Bisset, et al, 1979).

5. Temperature. It has been observed both in laboratory testing of inks on an inkometer (Evans, 1995), and in on-press tests (Traber, Has and Dolezalek, 1992), that higher temperatures cause an increase in misting.

6. Presence of Moisture. It would appear clear that the presence of moisture acts to retard or reduce ink misting. For example, Voet states that cold, dry weather promotes ink flying and that (letterpress) emulsion inks of the water-in-oil type showed a reduced tendency to flying (Voet, 1952). In addition, newspaper printers experienced far less misting after changing over from letterpress to lithographic type presses. There are two possible explanations for this beneficial effect on ink misting: the water globules may act in the same way as pigment particles and/or the effect that water has in increasing the dielectric constant of the water-in-oil emulsion may be significant.

7. Roller Diameter. Roller size also influences misting; smaller-diameter rollers have a greater tendency to produce misting (Bisset, et al, 1979). This is attributed to the higher speed of separation that occurs on smaller-diameter rollers.

8. Elasticity. This aspect of material behavior has already been brought up in Section 3.2.3 in connection with elastomers. There, it was pointed out that elastomers are viscoelastic materials, and therefore do not always respond to applied stresses in a simplistic manner, i.e., as ideal elastic solids. Printing inks are also viscoelastic materials, and thus, also, do not always respond simplistically in accordance with the characteristics of an ideal viscous fluid. In other words, under certain conditions, inks exhibit elastic behavior. This is particularly pertinent to the phenomenon of ink misting, as will now be discussed.

As in the case of elastomers, a mechanical analog is very helpful in providing insight into the dynamic behavior of inks under stress. Figure 3.35(a) is a simple mechanical analog proposed by Maxwell many years ago (Maxwell, 1867). In this model, the fluid under stress is likened to a system consisting of a spring in series with a dashpot.

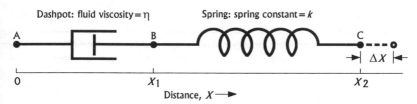

(a) Mechanical analog of a viscoelastic fluid, stretched instantaneously by an amount ΔX. Relaxation time of system, τ, is equal to ratio η/k.

(b) Response of mechanical analog in (a) to instantaneous stretching by an amount ΔX. Time for B to reach equillibrium position is determined by value of relaxation time, τ.

Figure 3.35 Diagrams used to explain how, under certain conditions, a viscoelastic ink can exhibit elastic behavior.

It will be understood, intuitively, that if the series system in Figure 3.35(a) is subjected to an instantaneous increase in length at Point C, equal to ΔX, i.e., is stretched as portrayed in the left plot in Figure 3.35(b), only the spring will immediately respond. Put another way, the dashpot will initially act as a rigid element and, therefore, Point B will not move. Eventually, of course, the dashpot, along with Point B, will move the same amount, ΔX, as Point C, as shown in the right-hand plot in Figure 3.35(b). In so doing, the spring tension will be relaxed. The response of the movement of Point B is characterized by a time constant equal to η/k. This time constant is referred to as the relaxation time of the fluid in question.

The importance of the analogy just discussed is that an ink will behave more like an elastic material when subjected to strains or movements that occur in times shorter than its relaxation time. This situation exists during film splitting, as pointed out by Aspler, et al (Aspler, Maine, DeGrâce, Zang, and Taylor, 1994). Specifically, their measurements indicate that the times required to split the ink film thicknesses normally found on press are well under 1 millisecond (0.001 seconds) at typical press speeds. This compares with findings by others that the relaxation times for typical news inks ranged from 0.02 to 0.4 milliseconds at shear rates the order of 1000 seconds^{-1} (Oittinen, Kainulainen, and Mickels, 1992).

Based on these considerations, it seems reasonable to conclude that misting may also depend on the elastic properties of the ink.

3.5.6 Fractional Transfer. Fractional transfer, usually expressed as a percent, defines how much of the film within a nip is retained by the receptor, or downstream roller. It is of great interest on rollers and cylinders that carry ink since the ultimate function of a printing press is to transfer ink to paper. This characteristic of film splitting is extremely difficult to measure on an operating press. Consequently, studies of it have been carried out almost exclusively on printability testers and proof presses, and the bulk of these studies has been concerned with ink transfer to paper.

Before proceeding to a detailed discussion of fractional transfer, it is important to review the ink states involved in joining and splitting:

1. Immobilized ink. This is ink that is adsorbed by or bonded to the roller surface.

2. Free ink. This is ink that can be made to move or flow and therefore is involved in the splitting process.

Because of this, there are two different sets of conditions under which fractional transfer occurs.

The first set is exemplified by press inking rollers where their surfaces are subjected to multiple-pass splitting. In this case, a semi-permanent layer of immobilized ink is established on the roller surfaces. Thus transfer of ink to and from such rollers is governed solely by how the free ink is split at the nip exit. That is, the system behaves as if the immobilized ink films were permanent roller coatings. There is every reason to believe that the fractional transfer of the free ink is 50 percent, and this has been shown to be true through experiments (DeGrâce and Mangin, 1987). This condition is illustrated in Figure 3.36(a).

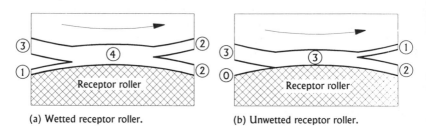

(a) Wetted receptor roller. (b) Unwetted receptor roller.

Figure 3.36 Diagrams that illustrate how fractional transfer is affected by wetting of receptor roller surface. Circled numbers indicate film thicknesses at respective locations. For wetted receptor roller in (a), percent transfer is 50. For dry receptor roller in (b), percent transfer is 66.7. Receptor roller is defined as roller with thinner film at nip entrance.

Under the second set of conditions exemplified by ink transfer to paper, i.e., single-pass splitting, the situation is quite different. Because the paper surface is unwetted, some fraction of the ink that is transferred will be immobilized. The remaining free ink does not split evenly for reasons

that are still being debated in the literature. Consequently, the fractional transfer can be different than 50 percent as shown in Figure 3.36(b).

This fundamental principle of ink transfer to paper was set forth in a landmark paper published over forty years ago (Walker and Fetsko, 1955) and is expressed by equation (3.30) for very thick ink films:

$$y = b + f(x-b) \qquad\qquad (3.30)$$
where:

x = ink film thickness in nip
y = average ink film thickness transferred to paper
b = immobilization capacity of paper surface (micron)
f = fraction of free ink that is transferred to the paper

It was also recognized that this equation is not valid for thin film thicknesses, for here the corresponding fractional transfer curve (y divided by x) is greater than 100 percent, as shown by the plots in Figure 3.37. Clearly this is physically impossible, and furthermore, actual fractional transfer curves were found to have the forms shown in Figure 3.37 (Fetsko and Walker, 1955). Thus it was recognized early on that equation (3.30) is inadequate to explain ink transfer to paper for several reasons, as follows:

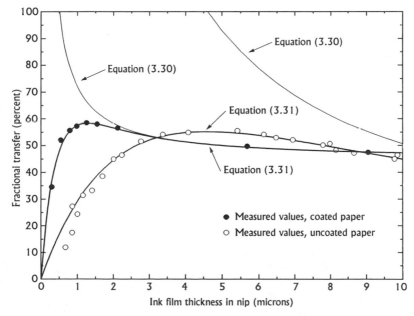

Figure 3.37 Comparison of actual fractional transfer curves and curves predicted by equation (3.31) for two widely different stocks. Fractional transfer is defined as that portion of the ink in the nip, in percent, that is transferred to the paper.

1. Area of contact between the paper surface and ink may not be 100 percent due to roughness of the paper surface.

2. At thin ink film thicknesses, the available ink film will be thinner than the immobilization capacity of the paper. This will result in a prediction of negative transfer.

To correct for these inadequacies, Walker and Fetsko reasoned that two additional terms were required in equation (3.30) to account for two conditions that exist at low ink film thicknesses:

1. $F(x)$, to account for incomplete contact between paper and ink (due to paper roughness).

2. $\phi(x)$, to account for the fact that the immobilization capacity of the paper may not be satisfied (due to the thickness of the ink in the nip being less than b).

The manner in which these two terms were incorporated, along with their definitions, is given in equation (3.31), the Walker-Fetsko equation:

$$y = F(x)\Big[b\phi(x) + f\big(x - b\phi(x)\big)\Big] \qquad (3.31)$$

where:

$$F(x) = \left(1 - e^{-kx}\right)$$
$$\phi(x) = \left(1 - e^{-x/b}\right)$$

$k =$ measure of paper smoothness, with higher values corresponding to smoother papers.

Typical values for b, f, and k for two widely different papers are listed in Table 3.3. These were obtained by fitting equation (3.31) to two sets of

Table 3.3 Experimentally determined values of b, f, and k in equation (3.31). Values were obtained by fitting equation (3.31) to measured amounts of ink transferred to paper versus amount of ink in nip, using a non-linear-least-squares method.

Type of paper	b, immobilization capacity of paper (micron)	f, fraction of free ink transferred to paper	k, measure of paper smoothness
Coated	0.498	0.445	1.84
Newsprint	4.61	0.0847	0.387

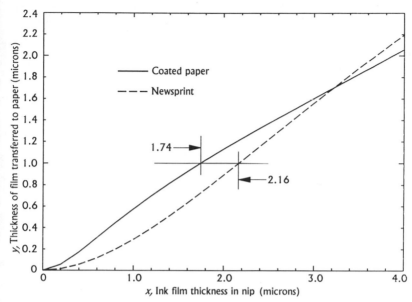

Figure 3.38 Amount of ink transferred to paper versus amount of ink in nip. Curves are non-linear-least-squares fit of equation (3.31) to measured data. To transfer a 1.0 micron thick film to paper, curves show that 1.74 and 2.16 microns must be present in the nip for coated paper and newsprint respectively.

actual measurements of x versus y using a non-linear-least-squares method. The set of measurements for a typical coated paper was taken from Table II in the Walker-Fetsko paper, while the set for a typical uncoated paper (newsprint) was taken as Sample B-STD in Table A-2 of a paper by Bery (Bery, 1981). The values listed in Table 3.3 were substituted in equation (3.31) to obtain the curves of fractional transfer, shown in Figure 3.37 and the corresponding curves of ink film thickness transferred to paper shown in Figure 3.38.

The latter curves are of interest because they show there is little practical difference in gross ink transfer to coated versus uncoated paper. That is, to transfer the one-micron-thick ink film that is typically needed requires a 1.74-micron-thick film in the nip in the case of coated paper, versus a 2.16-micron-thick film for uncoated newsprint. Thus the amount of ink that is carried on the inking rollers varies but little as a function of the paper being printed.

One might ask why so much attention has been paid to equation (3.31) over the years. The answer lies in the fact that this equation offers insight into the mechanism of ink transfer and offers the promise of correlating how paper and ink properties affect the transfer process.

With regard to the former, one example is provided by comparative plots of the function $F(x)$ for the two paper-ink combinations given in

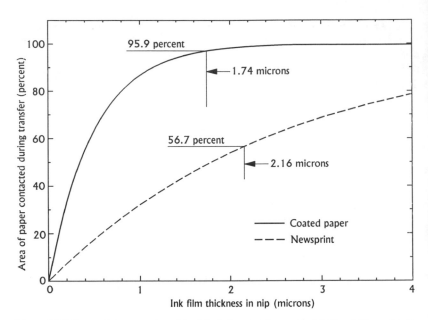

Figure 3.39 Area of paper contacted by ink during transfer versus ink film thickness in nip for two widely different stocks. During transfer of a one-micron-thick film to paper, curves reveal that area of contact is 95.9 percent for coated paper versus 56.6 percent for newsprint. Curves are plots of $F(x)$ in equation (3.31) based on parameters in Table 3.3.

Table 3.3. These plots, shown in Figure 3.39, reveal that the difference in smoothness of the two papers results in a smaller area of the newsprint being contacted, 56.7 percent, vis-à-vis 95.9 percent for the coated paper, when an average ink film thickness of one micron is transferred to the paper. This difference is consistent with microscopic examinations made by the author of coated and uncoated stock printed with a one-micron-thick ink film.

A second example is the relatively large immobilization capacity (4.6 microns) of the newsprint relative to that of the coated sheet (0.5 microns) as expressed by the values of b given in Table 3.3. Here again, this is consistent with the fact that in newspaper printing the ink is immobilized sufficiently such that further drying or curing is not necessary. In contrast, the low immobilization capacity of coated paper is reflected in the fact that ink transferred to coated paper must be dried in some way so as to prevent smearing when it is touched. Finally, the difference in smoothness represented by the values of k in Table 3.3 is of the same order as mechanical roughness measurements made on like papers (MacPhee and Lind, 1994). The former, however, may be a better indicator because it is obtained from printing tests, i.e., provides a measure of paper smoothness under printing conditions.

The promise that equation (3.31) would lead to the development of better correlations between the transfer process and ink and paper properties has not been fulfilled so far. Furthermore, serious questions have been raised about the usefulness of the Walker-Fetsko equation based on three shortcomings:

1. The fractional transfer curve $(y/x$ versus $x)$ calculated using the parameters b, f, and k, obtained from the fit of equation (3.31) to the experimental data $(y$ versus $x)$, showed poor agreement with the plot of the experimental values of y/x versus x (Karttunen, Kautto, and Oittinen, 1971; and Zaleski, Schaeffer and Zettlemoyer, 1969).

2. The parameters f and b cannot be estimated independently of each other, and fitted combinations are possible that make no sense physically, as for example a negative value of the parameter f (Mangin, Lyne, Page, and DeGrâce, 1981). In addition, the estimated values of these two parameters vary with the range of x, ink film thickness in the nip.

3. The imprecision noted in 2 seriously hampers any attempt to interpret the parameters in terms of paper or ink properties (Mangin, Lyne, Page, and DeGrâce, 1981).

The first shortcoming has been eliminated by the advent of the personal computer which, using non-linear curve-fitting methods, can be used to very quickly obtain accurate fits of experimental data, for example as shown in Figure 3.37.

Central to the second stated shortcoming is the fact that huge errors in the assessment of f, in equation (3.31), will be made if the Walker-Fetsko equation is fitted to a data set that only encompasses thin ink films, i.e., films whose thicknesses do not exceed the value of b in equation (3.31), the immobilization capacity of the paper. To avoid such errors it is essential to be aware of this problem and to observe the rule arising from it, i.e., to always insure that the range of experimental data extends to values of x that are 4–5 times the value of b.

The third shortcoming is more in the character of a reality in light of the fact that Walker and Fetsko discovered that the transfer process is accurately modeled by the parameters b, f, and k, and that these are not dependent on intrinsic properties of paper and ink. For example, the value of the immobilization capacity, b, is not only dependent on paper but is also dependent on ink viscosity, and dwell time or printing speed (Walker and Fetsko, 1955).

Thus, it is the author's opinion that these complaints are not valid and that there is still promise that fitting the Walker-Fetsko equation to measurements obtained on a printability tester can yield useful correlations between the transfer parameters b, f, and k, and ink and paper properties. These in turn could lead to useful correlations between printing material properties and print properties.

3.6 Summary

A printing press can be looked upon as an assembly of alternately rigid and compliant rollers running in contact with each other. The purpose of this assembly is to transport ink and/or water from one contact point or nip to another, and to effect or inhibit fluid transfer from one surface to another at each of the nips. The characteristics of rollers and the behavior of fluids resulting from rolling actions are as follows:

1. The requirements placed on printing press rollers include dimensional tolerances, surface finish, chemical compatibility, resistance to wear, structural stability, thermal characteristics, resistance to compression set, and cover hardness.

2. Hardness is a central roller property with two broad classifications: rigid and compliant. Rigid rollers are those with metal or hard plastic surfaces. The softest compliant rollers have surfaces corresponding to freshly cured silicone sealant, while the hardest correspond to a stack of office rubber bands 1/4 to 3/8 inches thick.

3. The type A durometer scale is the de facto measurement standard for specifying compliant roller hardness. This method is disadvantageous because there is no correlation between Type A durometer measurements and actual roller hardness or compliance. The Type A durometer of compliant rollers suitable for use on printing presses ranges from 20 to 40, with 20 being the softest.

4. Two basic configurations are used in the mechanical design of rollers: live shaft and dead shaft. Dead shaft rollers are less expensive to manufacture, but are disadvantageous because the heat generated in the bearings must be dissipated within the core envelope.

5. Another important roller property concerns the affinity of its surface for either ink or water. Thus, another important way of distinguishing a roller is by whether its surface is ink-receptive or water-receptive. Every roller in the train of an inking system must be ink-receptive. The converse is not true, however, in that every roller in the train of a dampening system need not be water-receptive.

6. The two most common materials used to cover rigid ink-receptive rollers are copper plating and Rilsan®, a compound of Nylon®. Copper is more expensive, but has better heat transfer characteristics. A wide variety of flexible polymer materials are available for covering compliant ink-receptive rollers.

7. The two most common materials used to cover rigid water-receptive rollers are hard chrome plating and ceramic compounds. The only time-proven cover materials for resilient rollers that are water-receptive are various woven and non-woven fabrics used as covers on rubber rollers. These materials are not ideal, however, because they must

be wetted first in order to be water-receptive. They are disadvantageous because they must be replaced rather frequently, and also increase dampening system response time. For these reasons, the majority of current dampening system designs utilize compliant rollers that have ink-receptive cover materials.

8. Calculation of the stresses and strains in compliant rollers cannot be carried out using traditional methods for three reasons: the layered structure does not conform to behavior predicated by the equations of Hertz, the compliant materials used are incompressible, and the modulus of elasticity of these covers has a large viscous component.

9. Equations (3.4) and (3.5) together with the correlation given in Figure 3.8 can be used to estimate load and penetration versus stripe width for a nip formed by the conjunction of a compliant and a rigid roller. Equation (3.4) shows that stripe width varies directly as the 0.412 power of load and as the 0.176 power of cover thickness. For 3-inch-diameter rollers set to a normal stripe of 3/16 inch, the corresponding load is about 0.85 pounds per inch for a 25 Type A durometer cover. The corresponding penetration is 0.01 inch.

10. The incompressibility of compliant roller covers causes them to exhibit a frictional drive diameter that is larger than the actual diameter. For typical conditions, this increase amounts to about three percent. The roller surface within the nip is subjected to a corresponding surface strain of about four percent. This implies that the corresponding circumferential slippage is about one percent, and this is in agreement with generally accepted values.

11. The visco-elastic behavior of compliant roller covers has the practical effect of reducing stripe width and shifting the location of the peak in nip pressure distribution under dynamic conditions, i.e., at press speed. The effect of the latter is to produce a resistance to rolling.

12. Work must be done on a compliant roller to cause it to rotate because of the resistance to rolling described immediately above. This work appears as heat generated in the compliant cover. Equation (3.22) provides a way of estimating heat generation rate, while Figure 3.20 contains different plots showing how heat generation rate varies with speed, stripe setting, and roller hardness. For a typical 3-inch-diameter rubber roller, increasing roller stripe from the recommended setting of 3/16 inch to 1/4 inch more than doubles the heat generated in the cover.

13. The calculated worst-case heat generation rate due to the mechanical working of the compliant rollers in a typical sheetfed press inking system is 1140 watts, or 3890 Btu/hour (980 kilocalories/hour).

14. In practice, fluid transport by press rollers is concerned with one of two tasks: lifting a relatively thick fluid film from a reservoir to a nip, or carrying a thin film from one nip to another.

15. Certain types of dampening systems utilize the relationships in fluid lifting as the basis for a metering system. That is, dampening feedrate

is changed by varying the speed of the fountain pan roller that lifts dampening fluid from the pan to the first nip in the system. The relationship between the fountain pan roller speed and the feedrate at the roller takeoff point is given by equation (3.27), which can also be used to calculate feedrate for a specific set of conditions. Figure 3.22 contains a plot of feedrate versus pan roller speed for a typical brush dampening system.

16. In thin film transport, two different types of film instability may, in theory, be encountered: beading-up and ribbing. In practice, beading-up is rarely encountered. Ribbing, or the formation of equally spaced ridges parallel to the direction of travel, is ever present on inking system rollers at practical roller speeds. To prevent corresponding print defects, vibrating rollers are dispersed throughout the inking system roller trains to randomize the ribbing pattern.

17. Fluid behavior within roller and cylinder nips is governed by the properties of the rolling elements (e.g., diameter and hardness), the properties of the fluid (e.g., viscosity), and the conditions within the nip (e.g., surface speed and stripe setting). Table 3.1 lists the characteristics of the nips found on a typical sheetfed press.

18. The pressures in nips formed by the conjunction of printing cylinders are about 30 times higher than the pressures in the nips formed by the conjunction of rollers under recommended conditions.

19. Fluid pressure within the nips on printing press rollers and cylinders is essentially independent of fluid viscosity, roller speed, and film thickness, and therefore can be assessed reasonably well using equation (3.4). It should be realized, however, that the actual stripe will be somewhat less and the pressure greater than predicted by equation (3.4) because of the viscoelastic behavior of the compliant roller cover under dynamic conditions. Fluid velocity is also uniform within such nips. Except for the case where the nip inlet is fully flooded, film thickness within the nip is simply equal to the sum of the thicknesses on the roller surfaces that converge to form the nip.

20. Three modes of nip operation are possible: totally starved, partially flooded, and fully flooded. Most nips formed by printing press rollers normally operate in the totally starved mode. An important exception is the metering nip in squeeze roller type dampening systems that operates in the fully flooded mode.

21. Table 3.2 summarizes the dependence of nip pumping capacity, or attainable film thickness within a given nip, on roller surface speed, stripe setting, roller hardness, and fluid viscosity for the extremes of the totally starved and fully flooded modes.

22. The diverging roller surfaces at the exit of a nip cause the composite film within the nip to be pulled apart or split at some point beyond the nip exit. This results in the generation of negative pressures beyond the point where the roller surfaces diverge. Direct measurements

have revealed that the peak pressures range as high as 58 pounds/square inch (0.4 MPa) at speeds of up to 690 feet/minute. The peak negative pressure generated is referred to as fluid tack, and the available pertinent evidence shows that it increases with increasing speed, film thickness, and fluid viscosity.

23. The character of film splitting undergoes three marked changes as roller speed is increased: from smooth splitting to ribbing, to cavitation and filamentation, and (at very high speeds) to misting.

24. The correlation defining the onset of ribbing is plotted in Figure 3.32. Some roller nips of squeeze roller type dampening systems are operated where the occurrence of ribbing is marginal. Thus ribbing is sometimes observed in dampening systems that are not equipped with a vibrating roller.

25. At some speed above that where ribbing occurs, the fluid at the nip exit is no longer able to sustain the negative pressure that is developed, and cavities are formed. As these cavities move away from the exit, they expand and become interconnected, forming filaments. Further divergence of the two roller surfaces causes the filaments to stretch and finally rupture. The ruptured filament ends recoil, producing a pebbly or orange-peel surface.

26. At relatively very high speeds, the filaments rupture in two places, thereby producing small strings that are released to the surroundings in the form of drops or globules. This phenomenon is referred to as misting, or ink fly, and poses a bar to printing at very high speeds, e.g., speeds above 2000 to 2500 feet/minute.

27. Although misting is not well understood, it is generally accepted that it is aggravated by shorter inks (lower ratio of yield to viscosity), thicker films, higher temperatures, less moisture, and smaller roller diameters. Misting is not as severe in lithographic printing vis-à-vis letter-press, and this suggests that the effect of emulsified water in reducing the dielectric constant of ink films may be important.

28. Fractional transfer defines how much of the film within a nip is transferred to the receptor or downstream roller. It is of great interest on rollers and cylinders that carry ink. In this context, it is important to make a distinction between immobilized ink, adsorbed or bonded to the roller surfaces, and free ink that is involved in the splitting process because it is free to move or flow.

29. In the case of inking system rollers, a semi-permanent layer of immobilized ink is established on the roller surfaces. Thus all of the ink involved in the transfer process is free ink, and the fractional transfer is 50 percent.

30. In the case of ink transfer to paper, the fractional transfer may be greater or less than 50 percent because a certain amount of the ink is immobilized by the paper and, for reasons still being debated in the literature, the remaining free ink may not be split evenly.

31. Ink transfer to paper is characterized by the Walker-Fetsko equation (equation (3.31) in the text) in terms of three parameters: b, the immobilization capacity of the paper; f, the fraction of free ink that is transferred to the paper; and k, a measure of paper smoothness. These parameters are dependent on more than one variable and therefore are not independent properties of the materials involved.

3.7 References

Aspler, J.S., Maine, J.H., DeGrâce, J.H., Zang, Y.H., and Taylor, S., "Printing Tack, Part 1: Influence of Paper Structure on Ink 'Tack' Measured in a Printing Nip," *22nd IARIGAI Research Conference Proceedings*, 1994, p 139.

ASTM, "Standard Test Method for Rubber Property—International Hardness," Specification D1415-88, Feb., 1989.

ASTM, "Standard Test Method for Rubber Property—Pusey and Jones Indentation," Specification D531-89, Mar., 1989.

ASTM, "Standard Test Method for Apparent Tack of Printing Inks and Vehicles by the Inkometer," Specification O4361-89, December, 1989.

ASTM, "Standard Test Method for Rubber Property—Durometer Hardness," Specification D2240-91, Feb., 1992.

Banks, W.H. and Mill, C.C., "Some Observations on the Behavior of Liquids Between Rotating Rollers," *Proceedings of the Royal Society* (London), Ser.A. Vol 223, No 1154 (May 6,1954), pp 414–419.

Bery, Y., "Three-Equation Ink Transfer Model," *16th IARIGAI Research Conference Proceedings*, 1981, pp 227.

Bisset, D.E., Goodacre, C., Idle, H.A., Leach, R.H., and Williams, C.M., *The Printing Ink Manual*, Northwood Books (London), 1979, 488 pp.

Bohan, M. F. J., Lim, C. H., Korochkina, T. V., Claypole, T. C., Gethin, D. T., and Roylance, B. J., "An Investigation of the Hydrodynamic and Mechanical Behavior of a Soft Rolling Contact," *Proceedings of the Institution of Mechanical Engineers* (London), Vol 211 (1997), Part J, pp 37–49.

Briscoe, B.J. and Sebastian, K.S., "An Analysis of the Durometer Indentation," *Rubber Chemistry and Technology*, American Chemical Society Rubber Division (Akron), Vol. 66, (1993) pp 827–836.

Christiansen, S., "Resins Are Gaining Weight," *American Ink Maker*, PTA Publications (Melville, N.Y.), Vol. 73, No. 10 (October) 1995, p 14.

Coyle, D.J. "Experimental Studies of Flow Between Deformable Rolls," AIChE Spring National Meeting (New Orleans), Mar., 1988.

Coyle, D.J.; Macosko, C.W.; and Scriven, L.E. "Film-splitting Flows in Forward Roll Coating," *Journal of Fluid Mechanics*, Cambridge University Press (Cambridge), Vol. 171 (Oct, 1986), pp 183–207.

Coyle, D.J., Macosko, C.W., and Scriven, L.E. "Stability of Symmetric Film-Splitting Between Counter-Rotating Cylinders," *Journal of Fluid Mechanics*, Cambridge University Press (Cambridge), Vol. 216 (July, 1990), pp 437–458.

De Grâce, J.H. and Mangin, P.J., "A Mechanistic Approach to Ink Transfer. Part II—The Splitting Behavior of Inks in Printing Nips," *19th IARIGAI Research Conference Proceedings*, 1987, pp 146–161.

Deshpande, N.V., "Calculation of Nip Width, Penetration and Pressure for Contact Between Cylinders with Elastomeric Covering," *TAPPI*, Vol. 61, No. 10 (1978), pp 115–118.

DIN, "Shore Hardness Testing A and D," DIN Specification 53505, June, 1987.

Eldred, N.R., and Scarlett, T., *What the Printer Should Know About Ink*, GATF, 1990, p 45.

Evans, B., personal communication, GATF, October, 1995.

Ferry, J.D., *Viscoelastic Properties of Polymers,* John Wiley & Sons, (New York), 3rd edition, 1980.

Fetsko, J.M., and Walker, W.C., "Measurement of Ink Transfer in the Printing of Coated Papers," *1955 TAGA Proceedings,* pp 130–138.

Fetsko, J.M., Schaeffer, W.D., and Zettlemoyer, A.C., "Sources of Differences in Picking Results Among Presses," *TAPPI,* Vol. 46, No. 3 (March, 1963), pp 157–162.

Gent, A.N. (Editor) *Engineering with Rubber,* Oxford University Press (New York), 1992, 334 pp.

Iwasaki, Y., Takahashi, Y., Yukawa, H., and Okada, H., "Study on Paper Releasing Phenomena in Offset Printing by Acoustic Approach," *1993 TAGA Proceedings,* p 238.

Jorgensen, G.W., and Lavi, A., *Lithographic Pressman's Handbook,* GATF, 1973, p 105.

Karttunen, S., Kautto, H., and Oittinen, P, "New Modifications of Ink Transfer Equations," *11th IARIGAI Research Conference Proceedings,* 1971, pp 33–52.

Kelly, E.J., Crouse, D.B., and Supansic, R.R., *Web Offset Press Operating,* GATF, 1974, p 153.

Landau, L.D. and Levich, V.G., "Dragging of a Liquid by a Moving Plate," *Acta Physiocochim* (USSR), Vol. 17, 1942, pp 42–54.

MacPhee, J., "Dampening Roller Covers," Lithographic Dampening Conference, GATF/R&E Council (St. Louis), Feb. 17–18, 1976, on tape.

MacPhee, J., "A Study of Roller Deformation Using Finite Element Analysis," *1996 TAGA Proceedings,* pp 505–522.

MacPhee, J., "Trends in Litho Dampening Systems Show Vast Improvements in Designs," *Graphic Arts Monthly,* Technical Publishing Company (New York), April 1981, pp 35–42.

MacPhee, J., "Interrelationship of the Variables and Parameters Which Affect the Performance of Brush Dampeners," *1987 TAGA Proceedings,* pp 306–330.

MacPhee, J. and Lind, J.T., "The Primary Paper Property That Affects Density Range," *1994 TAGA Proceedings,* pp 414–429.

MacPhee, J., Shieh, J., and Hamrock, B.J., "The Application of Elastohydrodynamic Lubrication Theory to the Prediction of Conditions Existing in Lithographic Printing Press Roller Nips," *21st IARIGAI Research Conference Proceedings,* 1992, pp 242–276.

MacPhee, J. and Wirth, D.M., "Measurements of the Axial Force Required to Drive an Oscillating Roller Under a Wide Range of Conditions," *1989 TAGA Proceedings,* pp 627–654.

Mangin, P.J., Lyne, M.B., Page, D.H., and DeGrâce, J.H., "Ink Transfer Equations— Parameter Estimation and Interpretation," *16th IARIGAI Research Conference Proceedings,* 1981, pp 180–205.

Maxwell, J.C., "On the Dynamic Theory of Gases," *Philosophical Transactions of the Royal Society* (London), Vol 157 (1867), pp 49–88.

McKay, R.C., "Effectiveness of Pigments in Suppressing Misting of Lithographic Printing Inks," *FATIPEC Congress* (Paris), Vol 22, No 3, 1994, pp 137–150.

McCrum, N. G., Buckley, C.P., and Buchnall, C.B., *Principles of Polymer Engineering,* Oxford Science Publications (New York), 1994, 391 pp.

Meijers, P., "The Contact Problem of a Rigid Cylinder on an Elastic Layer," *Appl. Sci. Res.,* 18, February 1968, pp 353–383.

Mill, C.C., "The Behavior of Liquids on Rotating Rollers," *9th IARIGAI Research Conference Proceedings,* 1967, pp 1–17.

Mill, C.C., "The Development of an Ink/Water Monitor for Lithographic Machines," *Papers from International Conference on Applied Lithographic Technology,* London, Oct. 7–9, 1970, PIRA (Leatherhead), 1971, pp 18:1–18:4.

Miller, R.D.W., "Theory of Impression and Rolling Contact," *The Penrose Annual,* Vol 54, 1960, p 111.

Oittinen, P.J., Kainulainen, J., and Mickels, J. "Rheological Properties, Setting, and Smearing of Offset Inks," *Graphic Arts in Finland,* 21, No 1 (1992), p 5.

Pitts, E. and Greiller, J., "The Flow of Thin Liquid Films Between Rollers," *Journal of Fluid Mechanics,* Cambridge University Press (Cambridge), Vol. 11, 1961, p 33.

Plowman, N., "Ink Tack—Part 2: Wet Film Thickness", *Graphic Arts Monthly,* Technical Publishing Company (NewYork), April, 1989, pp 126–127.

Reed, R.F., "Method and Apparatus for Measuring Properties of Inks and the Like," *U.S. Patent 2,101,322,* Dec 7, 1937.

RMA, *Roller Covering Handbook,* Rubber Manufacturers Association (Washington), 1989.

Roisum, D. R., " *The Mechanics of Rollers,*" TAPPI Press, 1996, 306 pp.

Scheuter, K.R., and Pfieffer, G., "The Influence of the Viscoelastic Properties of Covering Materials on the Rolling Process of Two Cylinders," *1969 TAGA Proceedings,* pp 326–350.

Siebein, W.A., "Present Developments with the GATF Press Inkometer," *1970 TAGA Proceedings,* pp 371–388.

Sites, B.L., "Transfer Method and Means," *U.S. Patent 2,036,835,* April 7, 1936.

Smith, D.L., Engle, L.S., Howard, J., and Jones, W., "Film Splitting on Rotating Rollers," *1956 TAGA Proceedings,* pp 147–151.

Smith, J.W. and Maloney, J.D., "Flow of Fluids Between Rotating Rollers," *TAPPI,* Vol. 49, No II (1966), pp 63A–66A.

Stefan, J., "Experiments on Apparent Adhesion" (in German), *Sitzungsberichte de Mathematisch-Naturwissenschaftlichen Classe de Kaiserlichen Akademie der Wissenschaften,* LXIX, Part II, 1874, pp 713–735.

Tharmalingam, S. and Wilkinson, W.L., "The Coating of Newtonian Liquids onto a Rotating Roll," *Chemical Engineering Science,* Pergamon Press Ltd. (Great Britain), Vol. 33, (1978), pp 1481–1487.

Traber, K., Has, M., and Dolezalek, F., *Thermal Balance of the Inking Systems of High-Speed Presses* (in German), Research Report 3268, FOGRA, 1992.

Voet, A., *Ink and Paper in the Printing Process,* Interscience Publishers (New York), 1952, 213 pp.

Voet, A., "Ink Misting and Its Prevention," *American Ink Maker,* PTA Publications (Melville, N.Y.), February 1956, p 32.

Walker, W.C. and Fetsko, J.M., "A Concept of Ink Transfer in Printing," *1955 TAGA Proceedings,* pp 139–149.

Zaleski, M., Schaeffer, W.D., and Zettlemoyer, A.C., "An Extended Application of the Walker-Fetsko Ink Transfer Equation," *10th IARIGAI Research Conference Proceedings,* 1969, pp 175–184.

Zang, Y.H., Aspler, J.S., Boluk, M.Y., and DeGrâce, J.H., "Direct Measurement of Tensile Stress (tack) in Thin Ink Films," *Journal of Rheology,* April 1991, Vol. 35, No. 3, pp 345.

Zavodny, E. N., "Roller Nip Behavior with Fountain Solution," *1973 TAGA Proceedings,* pp 211–223.

Chapter 4

Inking System Design

The inking systems employed on lithographic printing presses are distinguished by their use of a long train of rollers running at press speed. This is dictated by the heavy-bodied, or paste inks, that are used in lithography, as opposed to the much more fluid inks used in flexo and gravure. In addition, the majority of lithographic press inking systems in use today incorporate two other elements: an ink fountain assembly for storing a supply of ink and metering it out at low speed, and a ductor roller for transferring the metered film of ink to the head of the high-speed roller train. Thus, to gain an understanding of lithographic inker design and performance, it is necessary to learn why these three elements are used and to explain how they respond to different printing conditions. To begin, however, it will be helpful to review the requirements that an inking system must satisfy.

4.1 Requirements

The overall purpose of the inking system is to apply a film of ink to the image areas of the plate, and to replenish those areas on each revolution of the plate cylinder as printing progresses. To perform its job correctly, an inking system must satisfy four basic requirements as follows:

(1) The film of ink transferred to the plate must be uniform in thickness, in both the travel and across-the-press directions, regardless of ink coverage on the plate (i.e., fraction of plate area occupied by images). Typically, the thickness of the film of ink carried by the plate image areas is in the range of 2–3 microns (0.00008–0.00012 inches).

(2) The boundaries defining the areas of ink transferred to the plate must be sharp and correspond to like boundaries of the plate image areas. Thus, for example, the size of the inked halftone dots on the plate should be no greater or no less than the corresponding dot patterns on the plate.

(3) The inking system must include provisions that allow the operator to set the thickness of the ink film transferred to the plate. This is to enable the operator to adjust the printed ink film thickness and, hence, the print density. (Ideally, the controls provided to satisfy this requirement should be

calibrated to enable them to be preset, thereby reducing the need for makeready adjustments after the press has been started).

(4) The ink must be worked or kneaded sufficiently, prior to being transferred to the plate, to break down the heavy or gel-like structure that forms when a paste ink remains at rest. This is to insure transfer of an even film to the plate and thereby avoid a mottled appearance of the print.

4.2 Basic Behavior and Design Rationale

Almost all lithographic inking systems exhibit a number of common features. The reasons why this is so, along with basic inker behavior, will be explained in this section, as a prelude to the more detailed discussions contained in subsequent sections.

4.2.1 **The Ideal Inker.** When ink is transferred to the plate by a form roller, the roller surface exiting the plate-roller nip is left with an imprint, or ghost, of the pattern on the plate, as shown in Figure 4.1. (The reader is reminded that the term "form roller" is used to identify rollers that run in contact with the plate, i.e., the form.) This is due to the averaging process that occurs when the composite ink film is split at the nip exit. Thus, in passing through the nip, the film thickness is unchanged on those sections

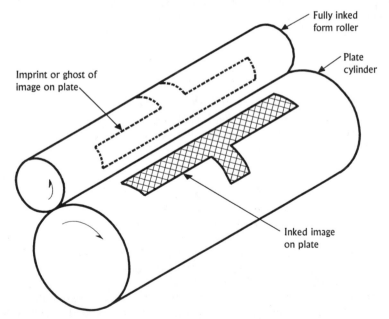

Figure 4.1 Formation of ghost image on form roller caused by zero ink transfer to nonimage areas of plate. Transfer of ink to image areas produces an imprint of those areas on the form roller surface.

of the roller that come in contact with nonimage areas because no ink is transferred. In contrast, a thinner film will exist in the regions on the roller that have transferred ink to the image areas of the plate. These patterns of nonuniform ink thickness are referred to as ghost images and are undesirable in that they can result in the printing of unwanted images, also called ghosts The phenomenon of ghosting is explained in more detail in Section 4.2.4.

One type of ideal inking system would avoid the above problem by metering a thin film of ink directly onto a single form roller, while at the same time erasing any ghosts or memories of previous images. One such ideal inker concept is shown in Figure 4.2. In the past, there have been a number of concerted programs to develop a practical inker based on this

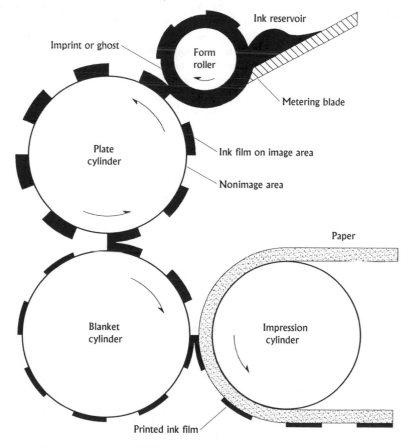

Figure 4.2 One concept of an ideal inking system. Ghost images on form roller are erased by passage through reservoir. Ink film thickness at entrance to nip with plate is constant and independent of coverage.

principle (Chevalier, 1976, and Dahlgren, 1982) but these efforts did not succeed. This may have been due to a problem that stems from the following properties exhibited by the paste inks used in lithography:

1. Resistance to flow is very high as exhibited by typical viscosities that range from 250–450 poise. (This compares with one grade of bee honey that was found [Evans, 1991] to have a viscosity of 225 poise, based on the same type of measurement used for ink.)

2. Ink viscosity is not constant but varies both with temperature and shear rate.

The specific problem that stems from these properties is that of controlling the thickness of the metered film. That is, considerable energy is required to meter such a thin film at high speeds. This high amount of energy is required to shear that portion of the ink that is accelerated from rest to the high surface speed of the form roller. Some energy is also expended to work or knead the ink. These two actions, kneading and shearing, produce significant changes in the viscosity.

Most metering methods are, however, dependent on viscosity—that is to say that the thickness of the metered film is some function of the viscosity of the fluid being metered. Thus, the act of metering induces changes in the properties that feed back to produce significant changes in the thickness of the metered film. A second factor that contributes to the problem is that the surface of the form roller must be compliant to enable it to transfer ink to the hard surfaced plate; thus its properties can and do vary during operation and therefore can produce additional variations in the thickness of the metered film.

4.2.2 Traditional Inker Design. Because paste inks are so difficult to shear at high speeds, traditional inking system designs incorporate some type of slow-speed metering device. Most often this comprises a V-shaped reservoir formed by the juncture of a slow-moving metal roller and some sort of doctor blade—the so-called ink fountain shown in Figure 4.3. Metering is accomplished by the action of the moving roller that carries a precise amount of ink through the gap formed between the fountain blade and roller. Thus, the thickness of the metered ink film is a function of the gap width. Uniformly spaced ink keys are provided so that gap width, and hence ink feed, can be adjusted in the across-the-press direction. In most traditional inker designs, the ink film thickness so metered is in the range of 50–250 microns (0.002–0.010 inches) for printing a solid the length of the plate. Because the metered film is much thicker than required, and is traveling at a relatively slow speed, some scheme must be devised to transfer a portion of it to the faster-moving roller train. Generally this is accomplished by using a roller that swings back and forth, to alternately contact the fountain roller, from which it picks up ink, and the first roller in the train, to which it delivers ink. In the U.S., this roller is called a ductor

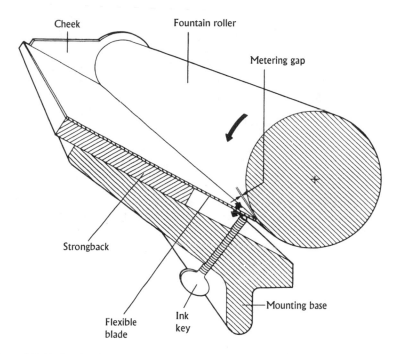

Figure 4.3 Typical ink fountain assembly. The V-shaped trough, formed by the junction of blade and roller, serves as a reservoir from which ink is metered through the gap whenever the fountain roller is rotated.

roller, and its action is shown in Figure 4.4. When the ductor is in contact with the fountain roller, both rollers are advanced a small increment at a very slow speed to produce two actions: metering of ink onto the fountain roller and transfer of a small sector or strip of ink to the ductor. When the ductor is subsequently swung into contact with the roller at the head of the roller train, it is accelerated up to press speed and some of the ink on it is transferred to the roller train.

On sheetfed presses, the common practice is to cycle the ductor every two plate cylinder revolutions, such that it dwells on the fountain roller for approximately one plate cylinder revolution, and on the roller train for 1–3 ductor roller revolutions, depending on roller stripe setting. This action of the ductor results in an uneven feed, and as a consequence a relatively long train of inking rollers must be used to smooth out the flow of ink to the plate. This smoothing action is elaborated on in Section 4.3.1.

Traditional inker designs are characterized by two additional features: vibrating rollers and multiple form rollers. With regard to the first, a certain number of rollers in the ink train must also be moved back and forth, or vibrated, in the axial direction to prevent ribs or ridges from forming in the

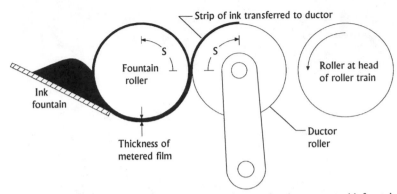

(a) During odd-numbered plate cylinder revolutions, ductor swings into contact with fountain roller. Fountain roller then slowly moves through sweep angle, S, to transfer strip of ink to ductor. Thickness of strip of ink is approximately one-half metered thickness.

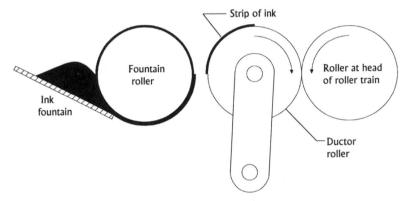

(b) At start of even-numbered plate cylinder revolutions, ductor swings into contact with roller at head of ink roller train and is accelerated up to press speed. Bulk of ink contained in strip is transferred to roller train.

Figure 4.4 Diagrams showing how ductor transfers ink metered by slow incremental movement of fountain roller to a roller in the ink train that is rotating continuously at the surface speed of the press.

around-the-roller direction. Multiple form rollers are employed to reduce spot ghosting. The reasons for their beneficial effect on ghosting is explained in Section 4.3 on roller train design.

In summary, most traditional lithographic inking systems are characterized by five features as follows:

1. A relatively long train of ink rollers, leading from the ink fountain to the plate, that travel at press speed.

2. A slow-moving fountain roller that works in conjunction with a fountain blade to generate a metered film of ink.

3. A ductor roller that transfers ink from the slow-moving fountain roller to the relatively fast-moving ink train.

4. A certain number of vibrating rollers in the ink train.

5. Multiple form rollers; usually four on a sheetfed press.

4.2.3 Basic Behavior. An understanding of the behavior of the relatively long roller trains that are characteristic of most traditional lithographic inking systems is essential to an understanding of the many aspects of their performance. Insight into such behavior can be obtained by considering the simplified model shown in Figure 4.5.

The transport of ink down this roller train to the plate is governed by the film splitting that occurs at the exit of each roller conjunction or nip. Conservation of volume requires that the total volume of ink exiting from a given nip must be equal to the total volume of ink entering that same nip. Because all the rollers are traveling at the same surface speed, it follows that

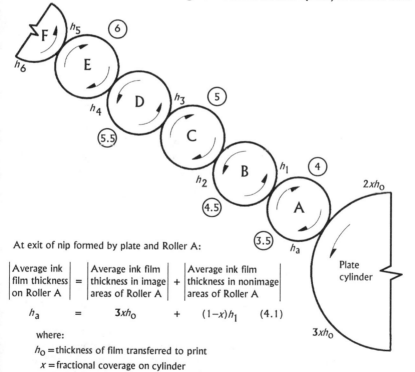

At exit of nip formed by plate and Roller A:

Average ink film thickness on Roller A	=	Average ink film thickness in image areas of Roller A	+	Average ink film thickness in nonimage areas of Roller A

$$h_a \quad = \quad 3xh_0 \quad + \quad (1-x)h_1 \qquad (4.1)$$

where:

h_0 = thickness of film transferred to print

x = fractional coverage on cylinder

Figure 4.5 Simple inking system having a single form roller. Circled numbers indicate required ink film thicknesses, in microns, to print a 1.0-micron-thick film at 50 percent coverage

the sum of the two ink film thicknesses, at a given nip exit, must be equal to the sum of the two film thicknesses at the entrance. This assumes, of course, that none of the ink is evaporated by the nip action.

This basic relationship was used many years ago to develop a model for calculating the steady-state ink film thicknesses throughout a roller train (Hull, 1968). Subsequently, computer calculations were made of the ink distribution and flows for a variety of inker configurations, using an expanded model to include ink coverages other than one hundred percent (Guerrette, 1985). In these later calculations, the effect of different split ratios at the nip exits was also explored.

Although this model is useful in providing insight, it is limited by the assumptions on which it is based. In addition to those already stated, the following assumptions must be kept in mind:

1. The inker is in steady-state operation.

2. Coverage on the plate is represented by a uniform screen of small dots. Therefore, the effect of a nonuniform layout of the image to be printed cannot be taken into account.

3. Under actual conditions at the nip between the form roller and plate, splitting of the ink film only occurs in the image areas on the plate, with no ink transfer to the nonimage areas. In this model, the film on the form roller at the nip exit is defined as a weighted average reflecting these two conditions. (See equation (4.1) in Figure 4.5.)

4. The roller just above the form roller(s) is a vibrating one, and its action is assumed to completely smooth out the uneven ink film left on the form roller after transfer to a plate with less-than-full coverage.

5. Conditions at zero coverage are taken as those corresponding to the values calculated for coverage of a single dot, i.e., a very small value for the variable x, defined in equation (4.1) in Figure 4.5.

A sample calculation will be described here, based on the simple single form roller ink train shown in Figure 4.5. Consider the nip formed between Rollers D and E. Based on the above principle, and a 50:50 film split ratio, the following equation can be written:

$$h_3 + h_5 = h_4 + h_4 \quad \text{or}$$

$$h_3 - 2h_4 + h_5 = 0 \qquad\qquad (4.2)$$

Four similar equations can be written for each of the other nips shown in Figure 4.5. After assigning values to the fractional ink coverage on the plate, x, and the ink film thickness transferred to the print, h_0, the set of five roller equations plus equation (4.1) can be solved simultaneously to yield the ink film thicknesses at all locations. One set of calculated values is given in Figure 4.5 and can be used to verify the truth of equation (4.2).

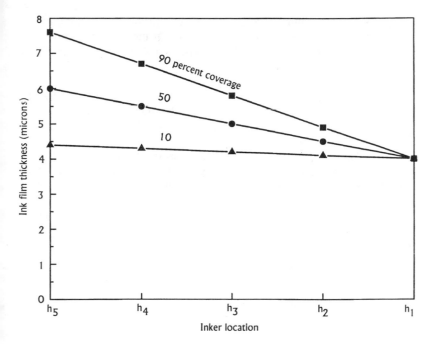

Figure 4.6 Required ink film thickness versus location in inker for various coverages. Data is for inker shown in Figure 4.5 and ink film thickness of 1.0 micron.

Figure 4.6 is a plot of the results of such calculations for three different ink coverages, for the case where a one-micron-thick film is transferred to the image area of the print, and assuming a 50:50 split in all nips. Examination of this plot reveals the following:

1. The ink film thickness on the downstream side of the form roller, h_1, is independent of coverage and is equal to four times h_0, the film thickness transferred to the paper. This is consistent with the requirement that the thickness of ink transferred to the plate must be independent of whether the plate consists of a single dot or a very large solid.

2. Ink film thickness increases back up the roller train in proportion to coverage. In this example, h_5 rises from 4.5 microns for 10 percent coverage to 6.0 microns for 50 percent, and 7.5 microns for 90 percent coverage. Because coverage equates to ink flow to the plate, it can be seen that larger flows require steeper gradients in ink film thickness back up the ink train. Conversely, for coverage approaching zero, ink film thickness will be the same on all rollers.

3. The increase in film thickness gradient with coverage is consistent with the fact that ink flow into the ink train must equal outflow to the plate. For example, in the system shown in Figure 4.5, outflow is

proportional to $3xh_O$ minus $2xh_O$, while inflow is proportional to h_6 minus h_5. Thus, an increase in coverage, x, requires an increase in outflow and that in turn requires an increase in inflow, and hence in ink film thickness at the head of the train.

This elementary behavior of the ink roller train, as portrayed by the data in Figure 4.6, is key to understanding why starvation ghosting poses such a problem to both the designers and users of inking systems. More will be said about this in the next section on ghosting.

4.2.4 Ghosting. In its broadest sense, ghosting refers to the unwanted phantom-like reproduction of either a pattern or a line that appears in another part of the form being printed. By definition, ghosts only occur in image areas. A distinction is made between chemical ghosting, due to changes in ink gloss, and mechanical ghosting, caused by abrupt changes in printed ink density. Mechanical ghosting can stem from faults in either the inking or dampening system, but it is inker-related ghosts that are to be discussed here.

The solid image pattern shown in Figure 4.7 displays three different types of a mechanical ghost: spot, runout, and starvation. It is not always recognized that the causes of spot and runout ghosts are the same, because runouts are frequently misdiagnosed as streaks, i.e. as being caused by a mechanical disturbance in the press.

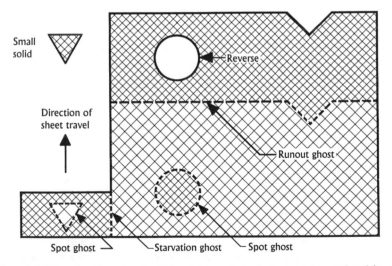

Figure 4.7 Form that illustrates the different types of ghosts that can be produced in an image area by an imperfect inking system. Ghosts are indicated by dotted lines. As shown, spot type ghosts can be generated either by a reverse in a large solid or by a small isolated solid or screen. Wider spaced cross-hatched lines indicate areas of lower ink density.

The mechanism whereby a spot or runout ghost is generated can be explained with the aid of the diagrams in Figure 4.8. Figure 4.8(a) shows the formation of a ghost on a form roller, due to a small non-image area of the plate. That is, ink transfer from form roller to plate is zero to the non-image area, resulting in an uneven or embossed film on the form roller. The height of the embossing is equal to the thickness of the ink film transferred to the image areas, and it is this height that defines the magnitude or thickness of the ghost image.

The magnitude of the ghost is attenuated each time it passes through a nip on its path to the paper. This is due to the averaging effect produced by the film splitting that occurs at a nip exit. Assuming a 50/50 split, the attenuation factor for each nip will be as follows: vibrator to form roller, 2, form roller to plate 1.33, plate to blanket, 1.5, and blanket to paper, 2. The attenuation factors in the plate cylinder nips are less than two because the ghost is transferred to the same location where a memory exists.

This is illustrated in Figure 4.8(b), where the magnitude of the ghost is attenuated to 1/8th of the original value by the time it is printed, as a consequence of passing through the four nips. The magnitude of the overall attenuation can be increased by the use of multiple form rollers and is also greatly influenced by roller train configuration, as will be explained in Section 4.3 on roller train design.

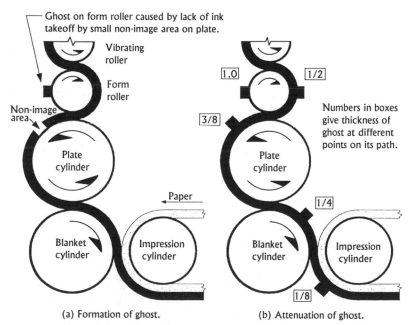

(a) Formation of ghost. (b) Attenuation of ghost.

Figure 4.8 Formation and propagation of spot and runout ghosts. In (b), attenuation is less than 2 in nips where ghost is always transferred to the same location.

The mechanism that accounts for the generation of a starvation ghost is quite different. This type of ghost occurs in forms containing abrupt changes in ink coverage in the across-press direction. This is illustrated in Figure 4.9(a) wherein a starvation ghost is identified as occurring along the boundary in the around-the-press direction, between Zone II that has a ten percent coverage, and Zone III, with a fifty percent coverage. The reason why such a ghost is generated can be traced to the inability of conventional inkers to produce the ink film thickness profiles that are required on the various rollers in the ink train to print a perfect reproduction.

Recalling the calculations displayed in Figure 4.6, it will be appreciated that the required ink film thicknesses in Zones I and IV are the same on all rollers, because no ink is fed to the plate. In Zones II and III, the required film thicknesses increase linearly with roller distance from the plate, and in proportion to ink coverage. Thus, for the simple inker shown in Figure 4.5, the required film thickness at h_5 is 6 microns for Zone III, as opposed to 4.4 microns in Zone II, and 4 microns for Zones I and IV. These ideal contours, plotted in the three-dimensional graph shown in Figure 4.9(b), provide the key to understanding why starvation ghosts are virtually unavoidable on traditional inkers.

Actually there are two limitations of traditional inkers that account for this inability. First, some degree of roller vibration, i.e., back and forth movement in the axial direction, is necessary and is always provided to prevent the formation of ribs, that in turn would produce streaks in the around-the-press direction. (Ribbing is discussed in more detail in Section 3.5.3 where it is pointed out that ribbing is always present at typical press speeds. Roller vibration does not eliminate ribbing but, rather, randomizes it so as to prevent streaks from appearing on the prints.)

Roller vibration in the axial direction is undesirable however, relative to starvation ghosting, because it will cause ink to be carried from high ink coverage zones into low coverage zones, thereby leading to thicker ink films being transferred to the print in low coverage zones. For the example shown in Figure 4.9, more ink than necessary would be carried into Zone II from Zone III by the action of roller vibration. Thus Zone II would be printed at a higher density than Zone III, at least along the boundary between the two.

The second inker limitation concerns the fact that ink feed adjustments in the across-the-press direction are limited to the zones defined by the ink fountain keys, that are described in detail in Section 4.4 on ink fountain design. For this reason, it is highly unlikely that the boundary between two ink keys will coincide with the boundary between zones on a form, as for example, the boundary between Zones II and III on the form shown in Figure 4.9(a). Thus in most cases, the press operator does not have the means available to adjust lateral ink feed in accordance with what is required to eliminate starvation ghosting. Even when he can, roller vibration acts to reverse the effect of his action.

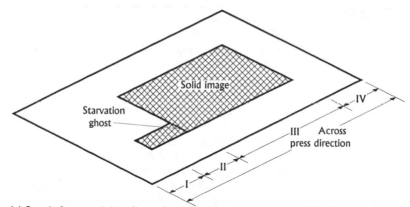

(a) Sample form consisting of zones I and IV with zero coverage, zone II with ten percent coverage, and zone III with fifty percent coverage. Starvation ghost is generated where large step change occurs in non-zero coverage between zones II and III.

(b) Three-dimensional graph of ink film thickness contours needed to print perfect reproduction of form shown in (a). Based on inker configuration shown in Figure 4.5.

Figure 4.9 Example that illustrates why starvation ghosting is unavoidable when using a traditional inker to print a form having a large step change in non-zero coverage in the across-press direction.

4.3 Roller Train Design

Ink roller train is the name given to the assembly of rollers, running at press speed, that is used in an inking system to transport ink from the metering system to the plate cylinder. Figure 4.10 is a more detailed diagram of the ink roller train on the typical press shown in Figure 1.2 in Chapter 1. The rollers are identified by capital letters and the nips by arabic numbers. The numbers in parentheses are the average film thicknesses at the respective locations, calculated using the method outlined in Section 4.2.3. The calculated values are based on a printed ink film thickness of 1.0 micron and a cylinder coverage of 83.3 percent, that corresponds to a plate coverage of 100 percent. The difference between plate and cylinder coverage is due to the presence of the gap in the plate cylinder that occupies 16.7 percent of the cylinder circumference.

The roller train in this example comprises rollers A through L (M is the feed roller), and can be characterized by three properties: the length of the shortest path to the plate, the number of form rollers, and the branch point location. In evaluating specific designs, there are other characteristics that are important as, for example, the total number of rollers in the train, the number of vibrating rollers in the train, and the type, number, and location of rider and bridge rollers. For the purpose of developing a basic understanding of how inkers work, however, the sections that follow will be concerned primarily with these three underlying characteristics and will use the design in Figure 4.10 as a reference.

4.3.1 **Length of Path to Plate.** This refers to the minimum number of nips through which ink must pass in traveling down the roller train to the plate. Alternately, it can be expressed as the corresponding number of rollers, which is the convention that is used in this book. For the system shown in Figure 4.10, the shortest path is six rollers, i.e. L, K, J, G, E, and A (or B). This number is typical for a modern sheetfed press. Ink trains that are very much shorter than this run the risk of two problems in operation as follows:

1. Feedback of water into the ink fountain.
2. Insufficient smoothing of the strip of ink delivered by the ductor.

It is well known that the first problem, feedback of water into the ink fountain, is more likely to occur with short ink trains. This is because there are fewer nips in the path back up the train and it is at the exits of ink roller nips where the bulk of the fountain solution is lost through flash evaporation.

The second problem arises because in practice ink feed is not continuous as indicated in Figure 4.10. Rather, a ductor is normally used and the relatively thick strips of ink delivered by the ductor roller generate

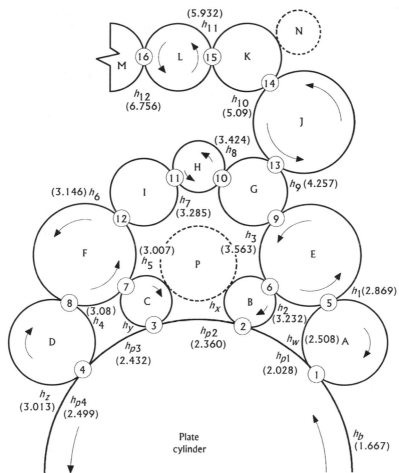

Figure 4.10 Reference ink train configuration. Dotted lines show optional rider roller N and optional bridge roller P. Numbers in parentheses are average ink film thicknesses, in microns, corresponding to a printed ink film thickness of 1.0 micron and a cylinder coverage of 83.3 percent (i.e., a plate coverage of 100 percent).

large disturbances in the ink film thicknesses throughout the train. The action of a long roller path in attenuating these disturbances can be illustrated by examining the behavior of the hypothetical single-form-roller ink train shown in Figure 4.11.

This configuration was developed by deleting rollers B, C, D, F, I, and H from the reference configuration in Figure 4.10. The dynamic behavior of this single-form-roller inking system was calculated for the hypothetical case of solid coverage around the plate cylinder, i.e., no gap in the cylinder, using a method developed by the writer (MacPhee, 1995), and

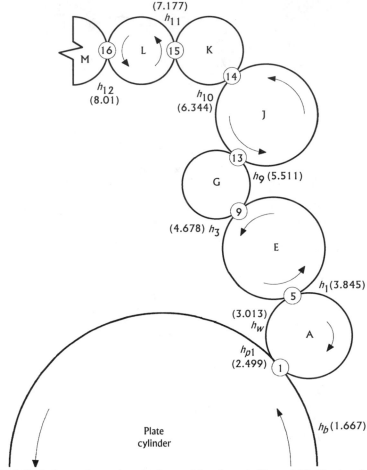

Figure 4.11 Single form roller version of reference inker shown in Figure 4.10. Numbers in parentheses are average ink film thicknesses, in microns, for 83.3 percent cylinder coverage (i.e., 100 percent plate coverage).

described in Section 4.6. The results are given in Figure 4.12 in the form of plots of the ink film thicknesses at various locations versus time.

Examination of the plot of h_{12} in Figure 4.12 shows that the initial magnitude of the disturbance, generated by the strip transferred by the ductor, is about 20.0 microns. As it travels down the roller train, its magnitude is reduced to 0.1 microns by the time it reaches the paper, i.e. by a factor of 200. This agrees quite well with the factor of 2^8, or 256, derived from the simple theory that the thickness of the ink strip will be reduced by one-half each time it passes through one of the eight nips that are in its path to the paper. Obviously, a longer roller path is desired from

Figure 4.12 Dynamic behavior of ink film thicknesses on single-form-roller train in Figure 4.11, with 100 percent cylinder coverage and ductor feed to roller L. The increase in printed ink film thickness due to strip delivered by ductor can be seen at the cylinder travel positions just before 1.75 and 3.75.

this aspect, in order to provide more attenuation. For example, a path of seven, or one additional roller, would reduce the magnitude of the ductor strip on the paper to about 0.05 microns.

Relatively long roller train paths are to be avoided, however, for reasons of cost and because of the adverse effect on ink system response time. This latter consideration is discussed in detail in Section 4.6 on that subject.

4.3.2 Number of Form Rollers. Experience has led most press builders to incorporate four form rollers in all but the very small sheetfed press models. The reason for having so many form rollers has already been explained as the need to reduce spot ghosting, generated by nonuniform coverage in the around-the-cylinder direction. The improvement in ghosting that is realized can be demonstrated by comparing the performance of the four-form-roller design shown in Figure 4.10 with that of the single-form design in Figure 4.11. This was done by calculating the

respective dynamic behaviors, assuming the following:

 1. The ductor roller is replaced by a hypothetical system that provides a constant continuous feed to roller L. (This is to eliminate ink film variations caused by the ductor.)

 2. 100 percent plate coverage (83.3 percent cylinder coverage).

The disturbances in ink film thickness generated throughout the roller train by the discontinuous coverage caused by the plate cylinder gap are illustrated in Figure 4.13. Figure 4.14 shows plots of similar ink film thickness calculations on four successive prints, for both the single- and four-form-roller trains. The magnitude of the worst ghost produced by the cylinder gap on the single-form-roller system is 0.11 microns versus 0.011

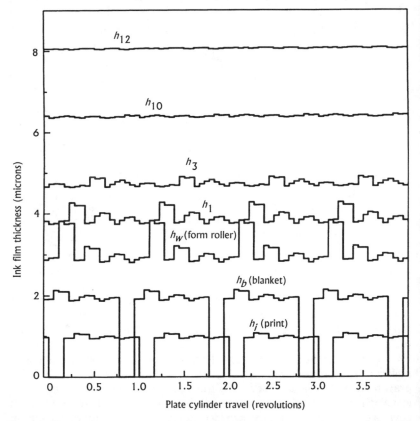

Figure 4.13 Dynamic behavior of ink film thicknesses throughout single-form-roller inker shown in Figure 4.11. Calculations based on plate cylinder with gap, 100 percent plate coverage, and continuous feed to roller L. Plots illustrate disturbances generated by plate cylinder gap.

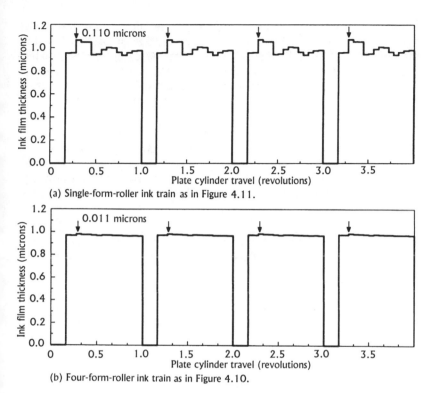

(a) Single-form-roller ink train as in Figure 4.11.

(b) Four-form-roller ink train as in Figure 4.10.

Figure 4.14 Comparison of worst ghosts in printed ink film, indicated by arrows, produced by presence of plate cylinder gap. Calculations based on 100 percent plate coverage and continuous feed.

microns for the four-roller system. The manner in which the four-roller system reduces ghosting vis-à-vis the single-form-roller system can be explained using the rationale on spot ghosting presented in Section 4.2.4, as follows.

This rationale predicts that the change in ink takeoff produced by the cylinder gap will generate a ghost of one micron at location h_W on the form roller of the single-form-roller design in Figure 4.11, and that it will be reduced by a factor of 2 each time it passes through a nip on its path to the paper. Because there are four nips in its path to the paper this would predict a total attenuation factor of 2^4 or 16. However, as explained in the discussion of Figure 4.8, in two of the nips the ghost is transferred to a location where a memory of the ghost exists. As a result, the total attenuation in these two nips will only be 2^1 rather than 2^2. Thus, in reality, the total attenuation factor will be 2^3, or 8, rather than 2^4. Therefore the predicted ghost magnitude is one micron divided by 8, i.e., 0.013 microns.

To determine the worst ghost magnitude in the four-form-roller design, it is necessary to first calculate the percentage of ink transferred to the plate by each form roller. This can be done by calculating the ink film thicknesses throughout the roller train under steady state, using the method described in Section 4.2.3. The film thicknesses so calculated are given in Figure 4.10, while the results of the percentage transfer calculations are given in column three of Table 4.1.

Table 4.1 Estimate of the magnitude of printed ghosts generated by each form roller in the first-down inker shown in Figure 4.10. Based on a printed ink film thickness of 1.0 micron and plate coverage of 100 percent. Rollers B and C have the same diameter as do A and D.

Form roller	Roller ID	Percentage ink transfer to plate	Attenuation factor	Magnitude of printed ghost (micron)
1	A	43.5	$2^6 = 64$	0.007
2	B	39.9	$2^6 = 64$	0.006
3	C	8.6	$2^5 = 32$	0.003
4	D	8.0	$2^3 = 8$	0.010

The next step is to determine the attenuation factor for each form roller, and this is done by counting the number of nips in the path from form roller to plate. For example, there are seven such nips for the first form roller, but only four for the fourth. Thus, the respective attenuation factors are 2^6 (64) and 2^3 (8), as given in column four of Table 4.1. Following the same logic, the calculated attenuation factors for rollers 2 and 3 that pass through six and five nips would be 32 and 16. These rollers, however, are small enough in diameter that they turn one full revolution while passing over the cylinder gap. Thus they pass through nips 6 and 7 twice, thereby producing an additional attenuation of two, for attenuation factors of 2^6 (64) and 2^5 (32) respectively.

The last step is to use the attenuation factors and percent transfers to calculate the magnitude of the various ghosts. Thus, for example, the ghost magnitude on the first form roller will be 0.435 microns, which will be attenuated by a factor of 64 to yield a ghost of 0.007 microns on the print or paper. The corresponding values of the printed ghosts for the other three form rollers are given in the last column of Table 4.1. Because rollers B and C have the same diameter, i.e., are commensurate, the ghosts

produced on them will be additive, as will the ghosts on A and D. Thus, the worst printed ghost, 0.017 microns from the first and fourth form rollers, is about one eighth that estimated for the single-form roller-inker, using the rationale of Section 4.2.4.

Table 4.2 summarizes the results of the two different methods just used to estimate the magnitude of the worst ghost for the two different designs. As can be seen, the predicted four-form-roller ghost is 10 to 13 percent that of the single-form-roller ghost, depending on the method of calculation used. Assuming that print density is proportional to ink film thickness, the change in density due to the single-form-roller ghost would be about 0.10 density units, which would be clearly visible.

Table 4.2 Estimate of ghost magnitude, in microns, on print for a printed ink film thickness of 1.0 micron and a coverage of 100 percent. Four-form-roller train data is as defined in Table 4.1.

	Rationale of Section 4.2.4	Dynamic calculation
Single form roller	0.130	0.110
Four form rollers	0.017	0.011

One other noteworthy consequence of utilizing multiple form rollers is that the ink film thicknesses that must be carried on the rollers are reduced, compared to a single form roller train. This is evident from the ink film

(a) Single form roller as in Figure 4.11. (b) Four form rollers as in Figure 4.10.

Figure 4.15 Ink film thickness on roller train rollers versus coverage. Plots show that one effect of multiple form rollers is to reduce the ink film thickness required at a given location.

thicknesses given in Figures 4.10 and 4.11. A direct comparison is provided in Figure 4.15 by the plots of ink film thickness versus coverage at identical locations on the two roller trains. This characteristic has the beneficial effect of partially counteracting the effect that additional form rollers have on increasing the system response time. Further details on this are given in Section 4.6.

4.3.3 Branch Point Location. An obvious consequence of using multiple form rollers is that there are as many paths for the ink to take to the plate as there are form rollers. The location of the first branch in this travel path is important in characterizing ink train design, in that it influences which form roller will transfer the greatest amount to the plate. For example, Table 4.1 shows that the first form roller in the reference inker of Figure 4.10 transfers the largest fraction (43.5%) of the total amount of ink transferred to the plate. (This inker would be referred to as "first-down" where this notation refers to the form roller that transfers the most ink to the plate. Using one alternate notation, it would be referred to as "front-heavy," while with another it would be termed a 44/40/9/8 inker.)

Table 4.3 Estimate of the magnitude of printed ghosts generated by each form roller in the inker shown in Figure 4.16. Based on a printed ink film thickness of 1.0 micron and plate coverage of 100 percent. Rollers B and C have the same diameter as do A and D.

Form roller	Roller ID	Percentage ink transfer to plate	Attenuation factor	Magnitude of printed ghost (micron)
1	A	26.9	$2^6 = 64$	0.004
2	B	24.7	$2^6 = 64$	0.004
3	C	25.2	$2^5 = 32$	0.008
4	D	23.2	$2^3 = 8$	0.029

If the rollers were rearranged so that the branch point of the reference inker were shifted from roller G to roller I, as shown in Figure 4.16, there would be a change in both ink flow distribution to the plate and ghosting. This is demonstrated by the data in Table 4.3, wherein the distribution is more even, although it is still the first form roller that transfers a maximum of 26.9 percent to the plate. Thus while the design in Figure 4.16 might appear to be "last-down," it is in fact a "first-down." The magnitude of the

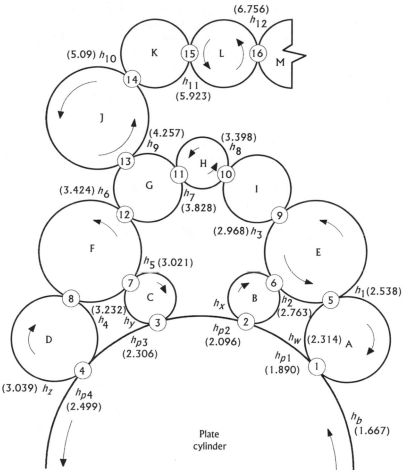

Figure 4.16 Alternate layout of rollers used in reference inker. In this arrangement, more ink
is delivered to the last two form rollers, C and D, as compared to the layout in
Figure 4.10.

worst ghost is generated on the first and last form rollers and amounts to
0.033 microns, which is two times higher than for the first-down inker in
Figure 4.10.

Based on the above analyses, it might appear that the ideal inker
would have a branching that would produce a distribution that is
proportional to the attenuation factors, i.e., 53.3, 26.7, 13.3, and 6.67
percent, assuming large incommensurate form rollers. In such a case,
ghosting would be minimized in that the printed ghosts from all form rollers
would equal 0.008 microns, a slight improvement over the performance of
a comparable (incommensurate) reference design. Aside from the practical

design problems that would be encountered in trying to achieve the above distribution, it is not desirable based on considerations other than ghosting. Chief among these is the take-up and distribution of water in the inker, a subject that is considered in detail in Volume II of this work.

Another factor that must be considered is that the distribution of ink flow to the plate can, depending on roller train design, change drastically with plate coverage. This has been amply demonstrated by the results of steady-state calculations made on eight different inker designs (Guerrette, 1985). Another example is provided by the designs in Figures 4.10 and 4.16 wherein both of their distributions change from the values in Tables 4.1 and 4.3 for 100 percent plate coverage to almost the above ideal distributions for a coverage of 5 percent.

4.3.4 Rider and Bridge Rollers. Very often it is necessary to use rollers that are not in one of the direct paths leading to the plate. These are of two types, riders and bridges.

The term "rider" is used to describe a roller that contacts the main roller train at a single point, e.g., Roller N in Figure 4.10. One purpose for using such a roller is to further attenuate abrupt changes in the thickness of the stream of ink being transported to the plate. Rider Roller N shown in Figure 4.10 would, in theory, provide an additional attenuation factor of two to the disturbance generated by the strip of ink, fed by the ductor, as it travels to the plate. In reality, the improvement achieved is even greater as illustrated by the comparative plots in Figure 4.17.

As the name suggests, bridge rollers are used to provide an alternate (and often more direct) path between two rollers. Very often such a roller provides a direct connection between the second and third ink form rollers, as shown in Figure 4.10 by Roller P. For this roller train layout, such a bridge produces a negligible change in flow distribution to the plate, and hence ghosting. It is still often used, however, because it enhances the flow of water to the back end of the ink train.

4.4 Ink Fountain Design

During the past twenty years, ink fountain designs for medium and large-size presses have become much more sophisticated than the simple design illustrated in Figure 4.3. The driving force behind this advance stemmed from the dual desires to provide remote ink key controls and to enable the ink keys to be preset, so as to improve press productivity by reducing makeready time. Because different press manufacturers took different approaches during this period to improve ink fountain performance, there is considerable variation in the design of ink fountains on modern presses. This is not surprising in light of the many requirements now placed on ink fountain design. These are listed in the first section below. This is followed by a section that describes the characteristics that

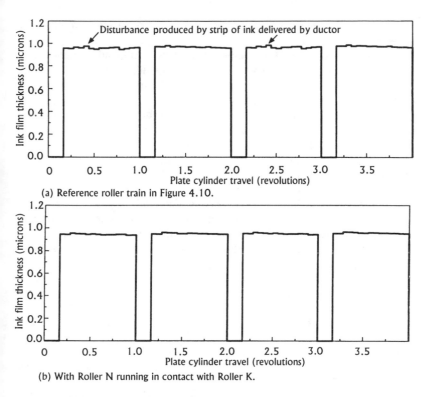

(a) Reference roller train in Figure 4.10.

(b) With Roller N running in contact with Roller K.

Figure 4.17 Calculated printed ink film thicknesses that show one benefit of using a rider roller.

distinguish one design from another and a section that describes principles of operation.

4.4.1 Design Requirements. The requirements that an ideal ink fountain must satisfy can be summarized as follows (MacPhee, 1980):

1. The thickness of the metered ink film must be adjustable from the minimum needed when running zero coverage to the maximum needed when running full coverage. As shown in Figure 4.15(b) for a printed ink film thickness of one micron, the minimum corresponds to 3 microns (0.00012 inches). The maximum should be in the range of about 200 microns (0.008 inches) as brought out in Section 4.5 on ductor rollers.

2. Random variations in metered ink film thickness, once the keys have been set, must be in the range of plus or minus 5 percent in order to limit variations in print density to acceptable levels.

3. It must be possible to make ink adjustments in discrete zones across the width of the press. Zone width must be in the range of 1–1.5 inches, depending on press design. Such lateral adjustments are needed to

accommodate changes in coverage in the across-press direction, as explained in Section 4.2.4.

4. There should be no interaction between zone adjustments, i.e., adjusting one ink key should have no effect on the adjacent key settings.

5. Readouts of ink key settings must be provided to make it possible to preset the ink keys or zone adjustments.

6. The metered ink film thickness should be independent of press speed, volume of ink in the fountain, and ink properties.

7. Fountain must be easy to clean and must not leak.

8. Ink storage capacity must be adequate for several hours of operation between fillings.

4.4.2 Distinguishing Characteristics. Generally a given ink fountain design can be described quite well in terms of four characteristics. Because these characteristics provide a means for distinguishing the important differences between specific designs, they are listed and discussed as follows:

1. **Overshot versus Undershot.** This refers to whether the metered film flows over or under the fountain roller, as determined by the location and orientation of the metering element or blade. The difference between these two types of fountain is illustrated in Figure 4.18. Overshot fountains are not bothered by leakage and are therefore favored for use with relatively liquid inks. Consequently, overshot fountains are seldom if ever found on sheetfed presses.

2. **Metering Angle.** This refers to the angle formed between the wetted surface of the metering element and the tangent to the roller, as shown in Figures 4.20(a) and (b). Classical lubrication theory teaches that if this angle is made very small, such that the metering element becomes almost parallel to the roller tangent, very high pressures will be generated in the wedge of ink entering the metering nip. Such large pressures are undesirable, of course, because the forces developed by them can deflect

(a) Undershot orientation (b) Overshot orientation

Figure 4.18 The two basic ink fountain layouts.

the metering element, producing changes in the metered film thickness. This has long been recognized by press designers (Hantscho, 1977). As a result, there are many designs that use a metering angle of 90 degrees in order to completely eliminate such forces.

3. **Type of Metering Element.** Basically, three types of metering elements are used: continuous blade, segmented blade, and discrete elements, illustrated in Figure 4.19. The continuous blade is simple In construction and relatively easy to clean. It has, however, a major drawback: the adjustment of a given key often affects the settings of adjacent keys, due to the "oil canning effect." The use of a segmented blade or discrete metering elements eliminates this drawback, but may impose other disadvantages, such as difficulty in cleaning. In the case of the blades, the width of the metering gap is changed by moving the tip of the blade or segments in a direction normal to the blade surface. With discrete elements, normal practice is to vary the gap by moving the elements in the direction that is parallel to their wetted surface to simplify sealing. As shown in Figure 4.19(d), fountains utilizing discrete elements may also incorporate a rigid plate that forms the ink reservoir and that covers all but the tips of the metering elements. In one singularly unique design that is

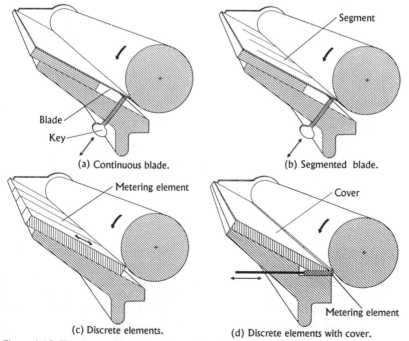

(a) Continuous blade. (b) Segmented blade.

(c) Discrete elements. (d) Discrete elements with cover.

Figure 4.19 The three basic types of metering elements used in ink fountain design. The directions in which the different metering elements are moved to adjust gap width are indicated by double-headed arrows.

widely used (Jeschke and Junghans, 1984), the rigid plate is covered by a thin sheet of plastic that also completely covers the metering elements, thereby shielding them from ink. The idea of using such a thin sheet was first suggested by Hull (Hull, 1968).

4.4.3 **Principles of Operation.** Ideally, the metering elements of an ink fountain should be oriented such that the sides of the channel, through which ink flows, are parallel. In such a case, lubrication theory predicts that a very thin layer of ink will adhere to the metering element surface and have zero velocity. A very thin layer of ink will also adhere to the surface of the moving roller and have the same velocity, V, as the surface of the roller. If the distances between the two surfaces are small enough, the velocity gradient will be linear; thus the average velocity of the ink will be $V/2$. As a result, the metered film thickness adhering to the roller at the gap exit will be equal to one half the width of the metering gap and will be independent of roller speed. Actual measurements of a fountain with just such a geometry (MacPhee, 1980) yielded a film thickness to gap width ratio of 0.65. Taking into account the potential for experimental error, the agreement is considered fairly good.

Figure 4.20 Analogy between slipper bearing and ink fountain metering element.

In many practical ink fountain designs, the metering element forms an angle, θ, with the roller tangent, such that a wedge-shaped channel is formed. This is analogous to the slipper bearing shown in Figure 4.20. If the metering angle, θ, is very small, say 5 degrees or less, quite a high pressure can be developed in the ink, as indicated in Figure 4.21. In addition, this pressure will increase as roller speed increases and metering gap decreases.

The effect of this pressure is to produce a viscous pumping action that results in a metered film that is thicker than the gap width. This action has been confirmed by measurements on an actual ink fountain of the type shown in Figure 4.3 (MacPhee, 1980). Thus, if the angle θ is made too small, changes in the speed of the roller will result in changes in the metered ink film thickness.

There are several other aspects of ink fountain performance that deserve mention here. First is the circulation of ink within the reservoir, as illustrated in Figure 4.22. This was first explained on theoretical grounds by

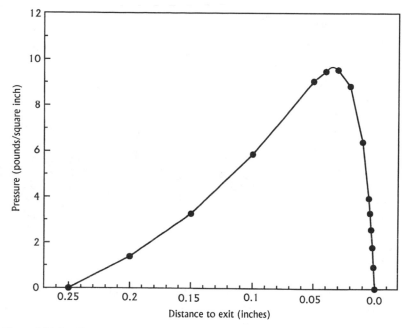

Figure 4.21 Profile of pressure developed in a metering gap with an angle, θ, of 5 degrees and a gap opening, W, of 100 microns (0.004 inches). Ink viscosity is 200 poise and roller surface speed, V, is 6.25 feet/minute.

Mill (Mill, 1961-1), who also verified the phenomenon experimentally (Mill, 1974). Mill showed through analysis that a neutral plane is created beyond the point of maximum pressure wherein the ink velocity is zero. Between the neutral plane and the roller, the ink moves in the same direction as the roller, but on the other side of the plane, the direction of flow is reversed, thereby producing the circulation shown in Figure 4.22.

 Another aspect of fountain performance is related to the relatively small opening or gap between the edge of the metering element(s) and the fountain roller. Foreign particles in the ink that are larger than the gap opening can and do become lodged in the entrance to the gap. They can be quite troublesome in causing starvation and/or impeding closure of the gap. These problems are much more likely to occur when printing on uncoated papers because paper lint is picked up by the ink and transferred back up the train and into the fountain. One method used by press designers to avoid this problem is to provide a single-turn spiral groove in the fountain roller. Thus, as the groove passes by the metering edge, the gap is momentarily enlarged, thereby allowing any obstructing particles to pass through. Another solution to this problem is to replace the ink fountain with a device, called an ink rail, that pumps ink directly onto the

Figure 4.22 Streamlines showing circulation of ink, caused by movement of fountain roller.

roller train. Such devices are widely found on web presses used for newspaper work, because newsprint is so linty. Ink rails are described in more detail in Chapter 6 on web presses.

4.5. The Ductor Roller

The purpose of the third component of an inking system is to transfer a portion of the slow-moving film of metered ink on the fountain roller to the roller train that travels at press speed. Virtually all sheetfed presses manufactured today utilize a ductor roller for this function. Many alternate devices, however, have been proposed over the years. Two of these, eccentrically mounted rollers, and skimming rollers, are used on some models of web presses and are described in Chapter 6, that discusses the unique features of web printing.

The principle of operation of a ductor roller has already been explained in Section 4.2.2, and is shown in Figure 4.4. Normally, the ductor mechanism is so designed that its stripe to the topmost roller in the train can be adjusted by the press operator. Because of this, the dwell time in this position can be varied somewhat, although it is primarily established by the geometry of the cam used to actuate it. At the other position, touching the fountain roller, the ductor is normally held in position by springs. The dwell time here can be adjusted by the operator's sweep control, generally in the range from zero to 90 degrees of fountain roller travel. In this way, the sweep adjustment enables the pressman to adjust

total ink feed rate, while the fountain keys allow him to adjust ink feed at specific lateral positions.

Many modern presses also include an adjustment that enables the pressman to change the timing of the ductor motion. By changing the timing, it is sometimes possible to further attenuate the change in print density produced by the strip of ink delivered to the ink train by the ductor. Figure 4.23(a) is a plot of printed ink film thickness on which the change in thickness produced by the strip of ink has been identified. The smoothing effect of changing ductor timing so that the strip of ink arrives at the plate cylinder gap is illustrated in Figure 4.23(b).

The method mentioned earlier for calculating inker dynamic behavior was used to determine how ductor performance affects the required ink film thickness on the ink fountain roller. For the reference ink train shown in Figure 4.10, the effect of dwell time in the roller train position is given in Table 4.4, while the effect of coverage is shown in Figure 4.24. From this figure, it can be seen that the maximum required film thickness on the fountain roller is 70 microns (0.0028 inches) for a ductor sweep of 90

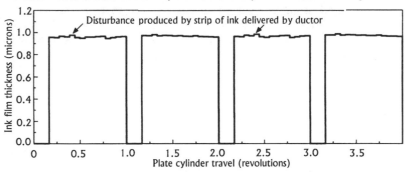

(a) Reference roller train in Figure 4.10.

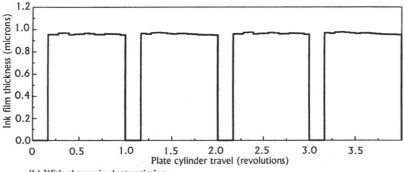

(b) With change in ductor timing.

Figure 4.23 Calculated printed ink film thicknesses that illustrate the benefit of changing ductor timing to cause ductor-delivered strip to arrive at the plate cylinder gap.

degrees. Many pressmen prefer to run with less sweep, in which case an even greater film thickness would be needed.

Table 4.4 Effect of ductor dwell time, in ink train position, on ink film thickness required on fountain roller, for 100 percent plate coverage and 90 degree sweep in ink fountain position.

Dwell time (ductor roller revolutions)	Required ink film thickness on fountain roller (microns)
1	116 (0.0046 inches)
2	82 (0.0033 inches)
3	70 (0.0028 inches)

The required thickness will be greater still if the required printed ink film thickness is more than the 1.0 micron on which Figure 4.24 is based. Thus, it would seem prudent to design the ink fountain to deliver a maximum metered film thickness in the range of at least 200 microns (0.008 inches) so as to provide a margin of three over the maximum

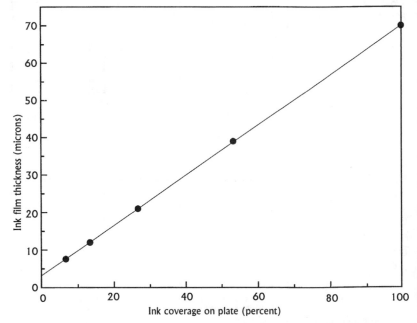

Figure 4.24 Relationship between plate coverage and required ink film thickness on fountain roller. Based on reference inker and 90 degree ductor sweep in ink fountain position and three revolution dwell in ink train position.

predicted in Figure 4.24. In practice, even greater margins are provided, as evidenced by the fact that the maximum gap openings on current press designs are in the range of 300–500 microns (0.012–0.020 inches).

4.6 Dynamic Behavior

The factors that affect the dynamic behavior of inking systems are of great interest to both the designers and users of printing presses. Two types of dynamic behavior are of interest: short-term and long-term. Short-term behavior concerns the response of printed ink film thickness under quasi-steady-state conditions, where the only disturbances are periodic ones produced within the press. The resultant variations in ink film thicknesses throughout the roller train are of interest in predicting unwanted print density variations due, for example, to the gap in the plate cylinder and the action of the ink ductor roller. Long-term variations are of interest in learning how quickly the inking system responds to operator adjustments to ink feedrate. Quick response to operator adjustments is, of course, desirable to reduce makeready time and waste. In this context, time is measured in terms of plate cylinder revolutions. Thus short-term behavior is concerned with press response during periods of a few plate cylinder revolutions, whereas long-term behavior is concerned with press response during tens of plate cylinder revolutions.

4.6.1 Short-Term Behavior. Examples of the short-term response of various inking system designs are shown in Figures 4.14, 4.17, and 4.23. In all of these cases, the response of interest is the variation in printed ink film thickness over one or two plate cylinder revolutions, due to the non-uniformity (gap) in the plate cylinder. In all three examples, the independent variable, time, is represented by plate cylinder travel. Another example, plotted in Figure 4.12, shows the response of the ink film thicknesses throughout the roller train to the uneven feed produced by the action of a ductor roller.

4.6.2 Long-Term Behavior. Measurements of the long-term dynamic behavior of lithographic presses (Mill, 1961-2 and Neuman and Almendinger, 1978) have demonstrated that the time-dependent relationship between print density (and/or printed ink film thickness) and ink feedrate can be described by a first-order differential equation of the form:

$$\tau \frac{dH(t)}{dt} = C_1 F - H(t) \tag{4.3}$$

where:
C_1 = a constant
F = ink feedrate

$H(t)$ = printed ink film thickness as a function of time
t = time
τ = system time constant

Accordingly, for a step change in feedrate from F_0 to F_1 at time zero, the response of ink film thickness with respect to time should be in accordance with equation (4.4) as follows:

$$H(t) = H_o + \Delta H \left(1 - e^{-t/\tau} \right) \tag{4.4}$$

where:

H_0 = film thickness at $t = 0$
ΔH = change in ink film thickness at equilibrium after ink
feedrate has been changed from F_0 to F_1.

The actual behavior, as measured by Neuman and Almendinger, includes a delay, D, between time zero when feedrate is changed, and the time when a change in printed ink film thickness (i.e., print density) is first observed. This typical behavior, illustrated in Figure 4.25, is commonly referred to as an exponential response wherein the output variable (in this case printed ink film thickness) gradually approaches its final value, H_1 on an exponential curve. The system time constant, τ, is of importance because it

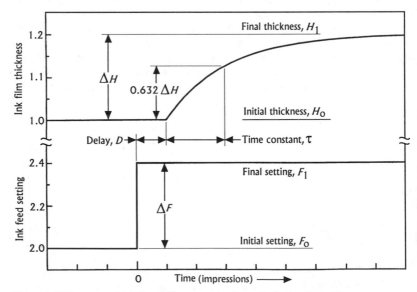

Figure 4.25 Response of ink film thickness to step change in feed setting at time zero.

determines how rapidly the final value is approached. For example, the output variable will change by 63.2% of the final change, $\Delta H,$ in a time equal to one time constant, and by 95% in three time constants. In printing, the significance of this is that printed sheets are wasted during the time required to reach equilibrium following a change in ink feed. Thus, short system time constants are desirable and important.

In his experimental work, Mill showed that system response time increases as ink coverage on the plate decreases. In addition, he developed a method for predicting the relationship on a given press, but it is not easy to implement. Subsequently, it was suggested that mean ink residence time can serve as a good stand-in for time constant, where mean residence time is defined as the volume of ink stored on the rollers and cylinders, divided by ink flow to the plate (MacPhee, 1985). These two properties of a given system are relatively easy to calculate on a small computer, using the method outlined in Section 4.2.3.

More recently, calculations of the dynamic behavior of inking systems (MacPhee, 1995) have shown that mean residence time represents an upper limit to the value of the time constant, and that the actual value of the time constant can be somewhat lower, depending on how ink is fed to the roller train. The results of such calculations for the reference inker shown in Figure 4.10 are given in Figure 4.26, in the form of plots of both

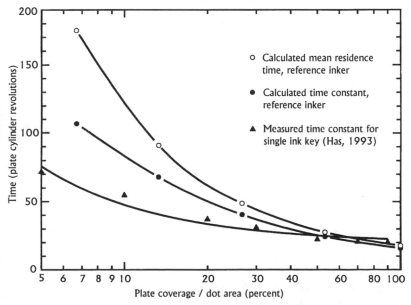

Figure 4.26 Relationships of mean residence time and time constant to coverage. Based on reference inker, 90 degree ductor sweep, and ductor dwell time in ink train position of three roller revolutions. Plot of measured time constant versus dot area, for changes in a single ink key, is included for comparison.

mean residence time and time constant, versus coverage on the plate. These show that for the given ductor operating conditions, agreement is fairly good at high coverages, but diverges significantly at low coverages. For example, at a coverage of 7.5 percent, the mean residence time is 157 impressions, or plate cylinder revolutions, versus a time constant of 100. The reason for this can be explained by the fact that with ductor roller feed, the rate of inflow of ink to the roller train is much greater during the initial stages of the change than it is during the end, i.e., at steady state. This is because ink flow is a function of the difference in the ink film thicknesses on the ductor and the top roller in the train, and this difference is significantly greater initially, for the lower coverages. The validity of this explanation was proven by repeating the calculations under the assumption of a constant feed to the ink train, in which case the calculated time constants matched the corresponding residence times.

An interesting aside is the effect that the number of form rollers have on response time. When the four-form-roller train in Figure 4.10 is compared with the single-form-roller version in Figure 4.11, it might be expected that the time constants would be approximately in proportion to the total number of rollers, 12 to 6, or 2 to 1. This is because it might be expected that the amount of ink stored on the rollers would be proportional. This is not the case, however, as shown by the plots of ink film thickness on the various rollers, versus plate coverage, given in Figure 4.15. This disproportionality results from the fact that less ink is carried by the four form rollers because less ink is transferred per roller. (This can be seen clearly by comparing the ink film thicknesses given in Figures 4.10 and 4.11). Thus, for example, for 7.5 percent plate coverage, a mean residence time of 157 impressions, is calculated for the four-form-roller inker versus 118 for the single-form-roller inker.

4.6.3 Calculational Method. Because the method employed here (MacPhee, 1995) for calculating both short- and long-term dynamic behavior can be quite useful, a brief description of it is included in this section. The method is based on three presumptions that are explained as follows:

1. The dynamic response of the ink film thicknesses throughout the ink roller train and printing cylinders can be represented by the results of sets of sequential steady-state calculations that are carried out at small equal intervals of time. In each such set of steady-state calculations, the film thicknesses at the exit of each nip in the system are calculated, assuming conservation of volume, i.e., that outflow from the nip is equal to inflow at that instant. A percentage of film splitting must also be assigned. The film thicknesses at the nip entrances are taken as being equal to the exit thickness of the corresponding upstream nip at some previous instant in time, corresponding to the travel time between nips. For example, at any given instant in time, the ink film thicknesses at the exit of Nip 5 in the

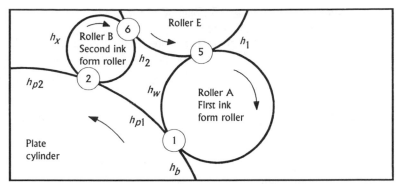

Figure 4.27 Nips 1, 2, 5, and 6 in reference inker shown in Figure 4.10.

reference ink train, shown in Figure 4.27, can be expressed by equation (4.5) as follows, assuming a 50:50 film split:

$$2h_1(t_n) = h_2(t_n - \Delta t_{65}) + h_w(t_n - \Delta t_{15}) \qquad (4.5)$$

where:

film thicknesses, h, are defined in Figure 4.27
t_n = given instant of time
Δt_{65} = travel time of roller E from Nip 6 to Nip 5
Δt_{15} = travel time of roller A from Nip 1 to Nip 5

For nips involving the plate cylinder, two equations are needed to account for changes in ink coverage around the cylinder. For example, the equations describing the ink film thicknesses at the exit of Nip 1 in Figure 4.27 are derived by considering the volume of ink carried away from the exit of Nip 1 by Roller A, per incremental travel under steady-state conditions:

$$
\begin{vmatrix} \text{Total} \\ \text{volume on} \\ \text{Roller A} \end{vmatrix}
=
\begin{vmatrix} \text{Volume on} \\ \text{image area} \\ \text{of Roller A} \end{vmatrix}
+
\begin{vmatrix} \text{Volume on} \\ \text{nonimage area} \\ \text{of Roller A} \end{vmatrix}
$$

$$h_w = xH_{p1} + (1-x)h_1 \qquad (4.6)$$

where:

h_b = average film thickness on plate at Nip 1 entrance
h_{p1} = average film thickness on plate at Nip 1 exit

h_W = average film thickness on Roller A at Nip 1 exit
x = fractional coverage on plate
H_b = film thickness in image area on plate at Nip 1 entrance
H_{p1} = film thickness in image area on plate at Nip 1 exit

Then, by definition:

$$h_b = xH_b \tag{4.7}$$

$$h_{p1} = xH_{p1} \tag{4.8}$$

From conservation of volume:

$$h_W + h_{p1} = h_1 + h_b \tag{4.9}$$

Substituting equations (4.6) and (4.8) in (4.9) yields:

$$h_{p1} = \left(\frac{x}{2}\right)h_1 + \frac{h_b}{2} \tag{4.10}$$

Substituting equations (4.8) and (4.10) in (4.6) yields:

$$h_W = \left(1 - \frac{x}{2}\right)h_1 + \frac{h_b}{2} \tag{4.11}$$

It is then an easy matter to convert equations (4.10) and (4.11) to the time-dependent forms given by equations (4.12) and (4.13) as follows:

$$h_{p1}(t_n) = \left(\frac{x}{2}\right)h_1(t_n - \Delta t_{51}) + \frac{h_b(t_n - \Delta t_{b1})}{2} \tag{4.12}$$

$$h_W(t_n) = \left(1 - \frac{x}{2}\right)h_1(t_n - \Delta t_{51}) + \frac{h_b(t_n - \Delta t_{b1})}{2} \tag{4.13}$$

where:

Δt_{51} = travel time of roller A from Nip 5 to Nip 1
Δt_{b1} = travel time of plate cylinder from Nip b to Nip 1

The interval of time between each set of sequential steady-state calculations must thus correspond to some unit circumferential travel time of a point on a roller or cylinder.

2. The circumferential distance between all nips can be approximated by a multiple of the unit length of travel, which of course is related to the unit circumferential travel time.

3. The circumferences of all rollers and cylinders can be approximated by some multiple of the unit length. In practice it has been found that good results are obtained when the plate cylinder circumference is divided into 16 to 18 unit lengths. The roller circumferences generally will then fall in the range of 3 to 6 unit lengths, and nip-to-nip travel lengths in the range of 1 to 4 unit lengths.

If the interval between each set of steady-state calculations is looked upon as a unit length of travel, rather than a unit travel time, the independent variable can be converted directly to units of plate cylinder revolution; thereby enabling the results to be expressed as functions of plate cylinder revolutions or impressions. Thus the results are independent of press speed.

There is a very important implication to the implementation of these presumptions. This is that the roller-cylinder layout used in the calculations will not be an exact replica of the press under study. This, of course, is due to the changes that must be made in the diameters and nip-to-nip distances to satisfy presumptions 2 and 3 above. The major practical problem that arises as a consequence is that the calculated magnitude of spot ghosting may be greater than actual because some of the form rollers may have to be made commensurate, i.e., have the same diameter.

One very positive feature of this model is that plate cylinder coverage need not be constant in the around-the-cylinder direction, because each increment of plate cylinder travel can have a unique coverage. (For all of the calculations given in this book, incremental coverage is either zero or one. Thus for 50 percent cylinder coverage, one half of the plate cylinder increments are assigned a coverage of one and the other half a coverage of zero.)

When this model is utilized, the task of calculating dynamic response is reduced to a series of sequential tasks wherein each sequential task consists of solving a group of simultaneous equations. Although the individual equations are quite simple, the overall job would be daunting if it had to be carried out manually because of the large number of calculations required. For example, twenty-two simultaneous equations must be solved at each interval for the reference inker shown in Figure 4.10, while the number of intervals required can easily reach 5000. Thus over 100,000 calculations may be necessary to produce an answer to a single problem. For film splits other than 50:50, the number of calculations will be almost doubled. Fortunately, the calculations can be carried out very quickly on a personal computer using any one of a number of currently available spreadsheet programs. The results cited in this book were obtained using a 486 personal computer and the spreadsheet program Excel (Microsoft, 1992).

The heart of this program is a table or spreadsheet that can contain as many as 256 columns, identified by letters, and 16,384 lines or rows, numbered in sequence. The intersection of a column and a row is referred to as a cell. A cell may contain a fixed number or an instruction (an equation) to calculate a given variable. In utilizing the program for these calculations the overall concept is to have each row represent a discrete sequential time (or sequential travel), while columns are assigned to specific nips. (The first two columns are used to identify the time sequence and plate coverage.) The last nip in the chain, blanket to paper, is assigned to the last column on the right while the first nip at the head of the roller train is assigned the first nip column on the left. This method is capable of simulating either a constant feed or feed by a ductor roller. Additional information on this is given in the primary reference (MacPhee, 1985).

The equations governing each nip are entered into assigned columns such that the calculation of film thickness in a given nip is performed sequentially in each cell in the column to which it is assigned. This is illustrated in Figure 4.28. The input film thicknesses required in each cell calculation are automatically read from the appropriate cells in preceding rows.

	A	B		R	S	T
1	Time, t	Coverage, x		h_1	h_2	h_w
2	-2			0	0	0
3	-1			0	0	0
4	0	1.0		0	0	0
5	Equation A	1.0		Equation R	Equation S	Equation T
6	Equation A	1.0		Equation R	Equation S	Equation T
7	Equation A	1.0		Equation R	Equation S	Equation T
8	Equation A	1.0		Equation R	Equation S	Equation T
9	Equation A	1.0		Equation R	Equation S	Equation T

Figure 4.28 Layout of spreadsheet for calculating dynamic response. For example, equation (R) would correspond to equation (4.5) in the text and equation (A) would advance time in each succeeding cell by one unit. The values of h_2 and h_w, required in equation (R), would be taken from the appropriate preceding cells in columns S and T.

The computation of dynamic response for a given set of conditions proceeds from zero time through as many time intervals as specified. The entire computation takes but a few seconds once the problem has been set up or entered into the spreadsheet program. Setup time, however, can

range from a few minutes for minor changes to existing computations to hours or days for a completely new problem.

4.7 Heat Generation

The heat generated in ink roller trains is significant and can give rise to troublesome temperature changes over the course of a press run if adequate means for its removal are not provided. For example, it is known from experience (Kurz, 1995) that about 3.3 kilowatts (11,300 BTU/hour) is needed to cool the printing unit of a typical 40-inch-wide sheetfed press when printing waterless at 12,000 impressions per hour, or 550 feet per minute. If this amount of cooling is sufficient to keep the press at room temperature, it can be assumed that the heat generation rate is about the same, i.e., 3.3 kilowatts. The various sources of this heat are discussed in Section 4.7.1. This is followed by a section that contains sample calculations for the printing unit.

4.7.1 Sources. There are five sources of the heat generated in an ink train, and these are identified and explained as follows:

1. Ink Splitting. In Section 3.5.1, it was pointed out that work must be done on a film in order to effect splitting, and that this work appears as heat.

2. Vibrating Roller Action. Because a certain number of rollers in the ink train are made to oscillate in the axial direction, a certain number of nips are subjected to axial sliding. To produce this action, work must be done on a roller by the mechanism that generates the vibratory motion, and this work appears as heat.

3. Circumferential Roller Slippage. Because most of the compliant rollers on a press are friction driven, some circumferential slippage must occur within the nip. This slippage results in the generation of heat.

4. Cyclical Straining of Compliant Roller Cover. The viscoelastic behavior of the materials used to cover compliant rollers produces a resistance to rolling. The net effect is that work must be done on the roller to cause it to rotate, and this work appears as heat.

5. Roller Bearings. Although some heat is generated in the roller support bearings, its magnitude is comparatively small, and therefore it is not addressed here.

Based on these definitions, an equation describing total heat generation rate in an ink train can be written as follows:

$$Q_t = Q_{fs} + Q_{va} + Q_{sl} + Q_{cs} \qquad (4.14)$$

where:

Q denotes heat generation rate
t denotes total in all rollers and nips
fs denotes component due to film splitting
va denotes component due to vibrating action
sl denotes component due to circumferential slippage
cs denotes component due to cyclical straining

Methods for calculating the magnitude of each component are given in the next section, along with sample calculations for a typical sheetfed press.

4.7.2 Sample Calculations. To the writer's knowledge, the only prior published report on calculations of heat generation in ink roller trains is one published by FOGRA in 1992 (Traber, Has, and Dolezalek, 1992). In this report, the same five sources of heat generation listed above are identified, and methods for calculating the magnitude of each source are outlined. The results given are for a typical web press and are based on ink properties measured in the laboratory. The sample calculations given here are for a typical sheetfed press and utilize data from on-press measurements to a large extent. The reader must realize, however, that neither the methods presented here nor the ones given in the FOGRA report can be expected to yield accurate results because the data needed on ink properties under the conditions of interest in the calculations is not available. Thus, the best to be expected is some sense of the relative contribution of these various sources to the total rate of heat generation.

The sample calculations that follow are all based on the reference inker, shown in Figure 10, including optional Rollers N and P. Other assumptions are a press width of 40 inches, a speed on 12,000 impressions/hour, or 550 feet/minute, and a fractional slippage of 0.01. The effects of dampening fluid on ink properties are ignored so as to allow a direct comparison of the total calculated value with the figure of 3300 watts for cooling a typical sheetfed press when printing waterless, known from experience and cited above.

1. Heat Generation Due to Film Splitting, Q_{fs}. This component of the total heat generation rate is given by equation (4.15) for a single nip:

$$Q_{fs} = VD_{fs} \qquad\qquad (4.15)$$

where:

D_{fs} = drag force produced by film splitting
V = roller surface speed

D_{fs} in equation (4.15) represents the drag on the roller pair forming the nip in question. It is the reaction to the equivalent tangential force, F, shown, for example, in Figure 3.30, that is generated by film splitting at

the nip exit. The magnitude of D_{fs} can be estimated from inkometer readings because the inkometer scale is in units of gram meters of torque. For example, a tack reading of 20 on a bench-type inkometer corresponds to a torque of 20 gram meters on the polished driven roller (shown in Figure 3.30). The diameter of this roller is 3 inches; therefore the equivalent tangential force, F, and drag D_{fs} are equal to 1.16 pounds (525 grams). Thus, if the on-press tack were also 20, the corresponding force on a 40-inch-long roller vis-à-vis the 6-inch-long inkometer roller would be 7.73 pounds. The corresponding heat generation rate per nip is 4252 foot pounds/minute, or 96 watts, and the total heat generation rate, for the reference inker having 18 nips, is 1728 watts.

2. **Heat Generation Rate Due to Vibrating Action, Q_{va}.** The forces necessary to produce the oscillatory motion of vibrating rollers have been measured under typical press conditions, (MacPhee and Wirth, 1989). Therefore, a relatively straightforward calculation is all that is needed to estimate the heat generated by this action. In most presses, the oscillatory motion is harmonic such that both the axial speed of the roller and the force necessary to produce it are sinusoidal functions of time. Therefore, it can be shown that the average heat generation rate is given by the following expression:

$$Q_{va} = (1/2) \, F_{max} \, V_{max} \tag{4.16}$$

where

F_{max} = peak value of sinusoidally varying force
V_{max} = peak value of sinusoidally varying axial velocity

For a 48-7/8-inch-long, 35-durometer roller, set to a 3/16-inch stripe, the worst case or maximum force needed to generate vibrating action was measured to be 45 pounds at a maximum axial velocity of 1.44 inches/second (MacPhee and Wirth, 1989). For a 40-inch-long roller, this force becomes 37 pounds. For the reference inker, assume that the stroke of the three vibrating rollers, Rollers E, F, and J, is one inch. Typically the frequency of vibration would be one cycle for every two plate cylinder revolutions, or 100 cycles/minute. The corresponding maximum axial velocity would therefore be 5.23 inches/second. Figure 13 in the above reference shows that the driving force varies as the 0.25 power of speed. Thus the measured value of 37 pounds at a maximum speed of 1.44 inch/second extrapolates to 51 pounds at 5.23 inch/second. To determine heat generation rate for the reference inker, the appropriate values to be used in equation (4.16) are therefore F_{max} = 51 pounds, and V_{max} = 5.23 inch/second. The corresponding heat generation rate is 15 watts/nip. Since the reference inker has 8 nips that experience vibratory action, the total heat generation rate is 120 watts.

3. Heat Generation Due to Slippage, Q_{sl}**.** An expression similar to equation (4.15) can be written to describe this component in a single nip, as follows:

$$Q_{sl} = V_{sl}D_{sl} \qquad (4.17)$$

where:

D_{sl} = drag force produced by roller slippage
V_{sl} = relative speed of rollers, i.e., slip velocity

To the author's knowledge, the only measurement of the power necessary to overcome slippage is contained in an unpublished report that showed that 597 watts of power (298 watts per nip) were needed to drive the first ink form roller on a 40-inch-wide sheetfed press at a speed 15.5 percent slower than the plate cylinder (Wirth, 1977). This form roller was 2.95 inches in diameter, was slipping at a relative velocity of 48 feet/minute, and formed two nips. To extrapolate this to the slippage of interest here of one percent (5.5 feet/minute), it will be assumed that the drag, D_{sl}, varies with velocity in the same manner as F_{max} in equation (4.16), i.e., as the 0.26 power of velocity. Thus, equation (4.17) can be rewritten as follows:

$$Q_{sl} = C \; V_{sl}^{1.26} \qquad (4.18)$$

where:

C = some constant

Based on this relationship the corresponding power for the reference inker would be 20 watts per nip. The total heat generation rate for the reference inker due to roller slippage is 18 times 20 watts, or 360 watts.

4. Heat Generation Due to Cyclic Straining, Q_{cs}**.** A method for obtaining some sense of the magnitude of heat generation from this source is described in Section 3.2.3, and calculated values for some typical roller pairs are given in Figure 3.20. According to these calculations, the heat generation rate in a 40-inch-long, 35-durometer roller, set to a stripe of 3/16 inch, is 33 watts per nip. Total heat generation in the reference inker is therefore 594 watts.

The results of these sample calculations, listed in Table 4.5, show that the total calculated heat generation rate for the ink roller train is 2.8 kilowatts. There is, however, one other source of heat generation that must be considered: the blanket. The heat generated by it can be estimated using equation (3.22) and the typical values of penetration or squeeze, stripe

width, and lineal load, for a typical compressible blanket given in Table
3.1. The resultant calculated heat generation rate for each blanket cylinder
nip is 400 watts for the same press speed of 550 feet/minute and width of
40 inches.

The total heat generation rate for the rollers and cylinders of the
printing unit assumed in this example is thus 3.6 kilowatts. This is about 10
percent higher than the required cooling rate of 3.3 kilowatts when
printing waterless, cited at the beginning of this section. This difference is
not surprising in view of three considerations: the uncertainties in the
material property values used in the calculations, the possibility that some
heat is transferred to the ambient air (if temperatures in the press are
higher than ambient), and the possibility that some heat is removed by the
paper. Recent measurements indicate that the latter possibility is indeed
both very real and significant on a heatset web press (WOA, 1997).

Table 4.5 Approximate magnitudes of the four major sources of heat
generation in a typical ink train on a sheetfed press. Based on a
40-inch-wide press, with the roller arrangement shown in Figure
4.10, running at a speed of 12,000 impressions/hour (550
feet/minute).

Source	Rate of heat generation per nip (watts)	Number of nips	Total heat generation rate	
			(watts)	(percent of total)
Ink splitting	96	18	1728	62
Vibrating action	15	8	120	4
Roller slippage	20	18	360	13
Cyclic straining	33	18	594	21
Total			2802	100

It is also of interest to examine the effects of dampening on required
cooling capacity. From experience, it is known that much less cooling
capacity is required when printing with dampening, i.e., about 0.8
kilowatts versus 3.3 kilowatts when printing waterless. This difference is
attributed by the author to the evaporative cooling provided by the
dampening solution.

For example, for the inking system defined above, Figure 5.1 in
Chapter 5 predicts a water consumption rate of 0.97 gallons/hour (3.7
liters/hour). If all of this water is evaporated, it will produce a cooling rate
of about 2.4 kilowatts. This compares very well with the difference of 2.5
kilowatts between the two cooling requirements given in the previous
paragraph.

Based on these numbers it can be inferred that there is very little
difference in the total amount of heat generated in a printing unit when

printing waterless, as compared to printing with dampening fluid. The big difference is the cooling effect of the fountain solution.

4.8 Summary

Lithographic inking systems are called upon to meter out a thin film of paste-type ink and transfer it to the image areas of the plate cylinder. Most practical inking systems are characterized by five elements: a long train of rollers, an ink fountain comprising a slow-moving roller and adjoining blade, a ductor roller, a certain number of vibrating rollers in the train, and multiple form rollers. The salient characteristic and functions of these elements are as follows:

1. The ink fountain roller and adjoining blade comprise a V-shaped reservoir for storing a supply of ink. Metering is accomplished by the action of the slow-moving roller that carries a precise film of ink through the gap formed between the blade and roller. The roller moves at a slow speed so as to minimize the force required to shear the paste-type inks used. The thickness of the film of ink so metered typically ranges from 4 to 70 microns (0.00016–0.0028 inches) depending on the fraction of the plate covered by ink.

2. The fountain blade is designed so that the press operator can adjust the thickness of the metered film in discrete zones across the width of the press. The devices used to effect these adjustments are called fountain keys.

3. A ductor roller is normally used to transfer the metered film of ink from the slow-moving fountain roller to a roller at the head of the train of inking rollers that runs at press speed. It accomplishes this by swinging back and forth, to alternately contact the fountain roller, from which it picks up ink and the first roller in the train, to which it delivers ink. When the ductor is in contact with the fountain roller, both rollers are advanced a small increment at a very slow speed to produce two actions: metering of ink onto the fountain roller and transfer of a small sector or strip of ink to the ductor. When the ductor is subsequently swung into contact with the roller at the head of the roller train, it is accelerated up to press speed and some of the ink on it is transferred to the roller train. On sheetfed presses, the common practice is to cycle the ductor every two plate cylinder revolutions, such that it dwells on the fountain roller for approximately one plate cylinder revolution, and on the roller train for 1–3 ductor roller revolutions.

4. The action of the ductor roller produces an uneven feed. Therefore, a relatively long train of inking rollers must be used to smooth the flow of ink to the plate.

5. Ink roller trains are characterized by three properties: the length of the shortest path to the plate, the number of form rollers, and the location of the branch points in the path to the form rollers. The path length to the

plate affects the degree to which the uneven feed of the ductor is smoothed out and the feedback of water into the ink fountain. The location of the branch points and the number of form rollers affect the magnitude of certain types of mechanical ghosts that are generated by the inker in image areas, i.e., unwanted phantom-like reproductions of a pattern or line.

6. The extent to which mechanical ghosts occur is a function of ink train design. Spot and runout ghosts are caused by uneven ink takeoff by the plate in the travel direction, and are mitigated by using multiple form rollers and by judicious selection of branch point locations. Starvation ghosts are caused by abrupt changes in ink coverage in the across-the-press direction. There is relatively little that the press designer or operator can do to mitigate this latter type of ghosting.

7. A certain number of rollers in the ink train are oscillated back and forth along their axes. These vibrating rollers prevent ribbing and also help to mitigate ghosting. Typically, vibrating rollers are cycled every two plate cylinder revolutions.

8. The dynamic behavior of an inking system can be modeled quite accurately by a first-order differential equation. The corresponding system time constant is a function of the length of the roller train, the total number of inking rollers, and the fractional ink coverage on the plate. For a typical ink train, the time constant ranges from about 25 impressions for 50 percent plate coverage to over 100 impressions for a coverage of 5 percent.

9. A significant amount of heat is generated in the printing unit of a printing press. Although accurate data on the pertinent material properties is not yet available to make accurate calculations possible, current estimates predict that approximately three-fourths of the total heat generated is generated in the ink roller train while the balance is generated in the two nips formed with the blanket cylinder.

4.9 References

Chevalier, J. "A New Approach to Fast Proofing," *1976 TAGA Proceedings*, p 116.

Dahlgren, H. "New Dahlgren Photo-Mechanical Printing System," brochure distributed during TAGA tour in May 1983, Dahlgren Manufacturing Company (Dallas), April 20, 1982, 11 pp.

Evans, B., personal communication, GATF, January 19, 1990.

Guerrette, D.J., "A Steady State Inking System Model for Predicting Ink Film Thickness Distribution," *1985 TAGA Proceedings*, p 404.

Has, M., "Ink Control in Sheetfed Offset Printing," *22nd IARIGAI Research Conference Proceedings*, 1993, pp 414–432.

Hantscho, W., "Ink Fountain for Printing Presses," *U.S. Patent 4,058,058*, Nov. 15, 1977.

Hull, H., "The Theoretical Analysis and Practical Evaluation of Roller Ink Distribution Systems," *1968 TAGA Proceedings*, p 288.

Jeschke, W. and Junghans, R., "Ink Duct for Offset or Letterpress Printing Machines," *U.S. Patent 4,480,547*, Nov. 6, 1984.

Kurz, H.J., personal communication, Baldwin-Gegenheimer GmbH (Augsburg), May 15, 1995.

MacPhee, J., "A Unique Solution to the Problem of Ink Fountain Design," *1980 TAGA Proceedings,* p 122.

MacPhee, J., "A Relatively Simple Method for Calculating the Dynamic Behavior of Inking Systems," *1995 TAGA Proceedings,* pp 168–183.

MacPhee, J., Kolesar, P. and Federgun, A., "Relationship Between Ink Coverage and Mean Ink Residence Time," *18th IARIGAI Research Conference Proceedings,* 1985, p 297.

MacPhee, J. and Wirth, D.M., "Measurements of the Axial Force Required to Drive an Oscillating Roller Under a Wide Range of Conditions," *1989 TAGA Proceedings,* pp 627–654.

Microsoft, *Microsoft Excel User's Guide 1,* Microsoft Corporation , 1992, p 93.

Mill, C.C., "The Behavior of Printing Ink on Rollers," *OCCA Journal,* Oil and Colour Chemists' Association (Middlesex), September 1961, p 596.

Mill, C.C., "An Experimental Test of a Theory of Ink Distribution," *5th IARIGAI Research Conference Proceedings,* Vol. 1, p 183, 1961.

Mill, C.C., "Ink Distribution Systems," *The British Ink Maker,* Aug. 1974, p 172.

Neuman, C.P. and Almendinger, F.J., "Experimental Model Building of the Lithographic Printing Process III," *1978 GATF Annual Research Department Report,* March, 1979, p 181-207.

Traber, K., Has, M., and Dolezalek, F., *Thermal Balance of the Inking Systems of High-Speed Presses* (in German), Research Report 3268, FOGRA, 1992.

Wirth, D. M., *Installation and Initial Testing of the Miehle 40 Inch Hydrostatic Delta System,* internal Baldwin Report No. SP-5223 (unpublished), Apr 5, 1977, 3 pp.

WOA, "Productivity & Quality Thru Temperature Control—The Program Continues," panel discussion, Web Offset Association Annual Conference, May 5–7, 1997, WOA, to be reprinted.

Chapter 5

Dampening System Design

Modern dampening systems exhibit considerable diversity in design characteristics for two reasons. First, the designer has much greater latitude in the choice of those system parameters that affect performance, compared to inking systems. Second, the relative importance of the various requirements placed on a dampening system vary from one printing segment to another, e.g., from commercial to newspaper printing. Thus, the tradeoffs made in developing a dampening system design for commercial applications are quite different from the tradeoffs (and resultant design) made for, say, a newspaper application. For these reasons it is important to begin this chapter with a listing of the many demanding requirements placed on a dampening system, along with a discussion of the implications they have on design. This is followed by a section that discusses basic dampener behavior, a section that identifies and discusses the important characteristics that distinguish one dampening system design from another, and sections that describe the five major types of dampening systems in current use: conventional or ductor type, squeeze roller, brush, skimming roller, and spray.

5.1 Requirements

The requirements placed on the dampening system of a lithographic press are both many and demanding. Thus, the first step in gaining insight into the many different configurations in use today is to set forth those requirements as follows:

1. Deliver fountain solution to the plate so as to maintain a very thin uniform film on the nonimage areas.
2. Prevent feedback of ink into the components used to supply and meter fountain solution.
3. Minimize the time and resultant paper waste required to reach equilibrium or balanced conditions following press startup.

These requirements, along with their implications, are discussed in the sections that immediately follow.

5.1.1 **Maintain Thin Film of Water on Plate.** For the lithographic process to succeed, it is absolutely essential to maintain a uniformly thin film of fountain solution on the nonimage areas of the plate, over the entire speed range of the press. The task of doing this is assigned to the dampening system, and it accomplishes this by delivering a web-like stream of fountain solution to the plate. A more or less continuous feed of fountain solution or water is necessary because water is being continuously removed in three ways: by take-up into the ink, by transfer to the paper, and by evaporation.

A series of 26 water consumption measurements (MacPhee, 1985) made prior to 1985 on a wide variety of presses with different type dampening systems indicated that the required makeup rate is equivalent to a sheet of water about 0.4 microns (0.000016 inches) thick, that is the width of the press, and that is traveling at press speed. (The measured film thicknesses at the lowest press speeds were found to be somewhat less, 0.32 microns, due probably to less evaporation from dampening roller surfaces.) This data set, plotted in Figure 5.1, exhibited good correlation with a linear best fit, also shown.

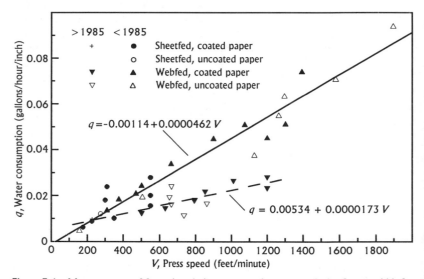

Figure 5.1 Measurements of fountain solution consumption rate per inch of press width for a wide variety of dampening systems. Straight-line best fit of data obtained before 1985 has slope equal to 0.38 micron and correlation coefficient of 0.97. Thickness of equivalent sheet of water is 0.32 micron for measurement at lowest speed and 0.40 micron for measurement at highest speed.

A second series of 14 measurements on four different presses (MacPhee, 1989, 1990-2, 1991, and 1995, and Goodman, 1992) made subsequently indicate a makeup rate half as great, i.e., about 0.2

microns versus 0.4 microns from the earlier set. This second set of measurements is also plotted in Figure 5.1.

At present there is no explanation for the factor of two difference in these results. A systematic error in measurement is not considered to be a likely cause because five different methods of measurement were used. It is possible that changes made in inks and fountain solutions subsequent to 1985 are the cause, but this also seems unlikely. One other possible explanation is that six of the post-1985 measurements were made under test conditions where the pressman was instructed to set water feed at just above the level that produced scumming, but there is no correlation between data obtained under this condition and low water usage.

It has also been found that the rate of water loss or consumption is not always uniform across the press, i.e., more or less water may be needed at the ends of the rollers, depending on the type of dampening system employed. In addition, the rate of feed must be accurately controlled for reasons explained in Section 5.2.1.

It is often asked if water usage varies with ink coverage on the plate. The measurements of water consumption discussed in Section 5.2.1 in connection with Figure 5.4 indicate no dependence. Evidence to the contrary, however, was seen in an experiment conducted by the author on a high-speed web press equipped with a plate-feed film-type dampening system. The dampener was equipped with a unique water supply system that only fed enough water to fill the metering nip (MacPhee, 1997). When running a plate with uniform coverage, the pattern of water rivulets draining away from the nip was as shown in Figure 5.2(a). Subsequently, when running a four-page-wide plate having one page with heavy coverage, the region in the nip corresponding to that page became starved, as shown in Figure 5.2(b). This provided clear evidence that more water is needed for heavy coverage, at least for this type of dampening system.

There are several very significant design implications to the requirements just discussed. Foremost is that a sophisticated metering system is needed to produce an extremely thin film of water that can be controlled very accurately. In addition, lateral control of feedrate is highly desirable to compensate for different requirements at the roller ends, and the feedrate should automatically track press speed.

5.1.2 **Prevent Ink Feedback.** This requirement arises from the fact that ink deposited on components used to supply and meter fountain solution can create a wide range of printing problems and increase the need for press maintenance. The implication of this requirement is that one or more barriers must be provided to prevent the passage of ink back up the dampening system while allowing for the passage of fountain solution in the reverse direction.

5.1.3 **Minimize Time to Reach Equilibrium.** This last requirement, to minimize the time to reach balanced conditions following press startup, stems from the need to maximize press utilization and minimize the wastage

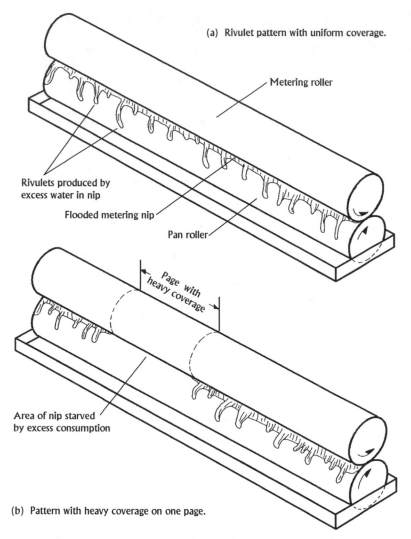

(a) Rivulet pattern with uniform coverage.

Metering roller

Rivulets produced by
excess water in nip

Flooded metering nip

Pan roller

Page with
heavy coverage

Area of nip starved
by excess consumption

(b) Pattern with heavy coverage on one page.

Figure 5.2 Experiment with press equipped with film-type dampener and unique water
supply system that only fed enough water to keep metering nip filled.

of ink and paper. Unless attention is paid to this requirement, the time to reach equilibrium can be 100 or more impressions.

The reason for this is that at startup a certain amount of water must be transported to and taken up by the ink, which resides on the inking system rollers, to establish the equilibrium condition that some water is carried by the ink in the form of emulsified droplets. Therefore, a higher water feed is required initially; otherwise the plate will scum, i.e., take on

smudges of ink in the nonimage areas, and subsequently require a relatively long time to clean up the scummed areas. The implication of this requirement is that one or more of the following features must be incorporated into the design of the dampening system.

1. Means for momentarily and automatically increasing water feedrate at startup.

2. A device, such as a bridging roller, or a common form roller, for feeding water into the inker just prior to startup.

3. Some type of accumulator (fountain solution storage device) in the dampener that is capable of momentarily feeding more water when demanded by the plate. A fabric-covered form roller or a rider roller helps in this regard, but is disadvantageous in that it increases system response time to changes in water feed settings.

4. A return path from plate to metering system such that excess fountain solution can be returned by the plate. Such a path acts to make the system self-regulating so as to respond automatically to water demands by the plate.

5.2 Basic Behavior

There are certain behavioral aspects of the dampening process that are common to all methods of dampening. These include ink/water balance, the water film thickness required on the plate, and dampening related ghosting. All of these topics are discussed in the sections that immediately follow.

5.2.1 Ink/Water Balance. One unique feature of the lithographic process is that a second fluid, water, must be fed to the plate along with ink Thus, the press operator must juggle two feedrates to achieve a satisfactory print. The term "ink/water balance" describes any given combination of ink and water feedrate settings. The complexity of the press operator's task of finding and maintaining the correct combination, i.e., the proper/ink water balance, is quantified by the diagram in Figure 5.3. Here it can be seen that nine different combinations are possible and that only one of them is correct: the pair that produces the desired print density with a minimum water feed.

A detailed discussion of the consequences of ink and water deviations from the correct or proper settings has been reserved for Volume 2. For now it is enough to point out that, at the proper water feed setting, too much ink will result in a higher-than-desired print density, while too little ink will result in too low a density. Alternately, at the proper ink feed setting, too much water will cause small washed out areas to appear on the print, while too little water will cause scumming, i.e., the appearance of ink smudges in nonimage areas on the print. Excessive water feed will also

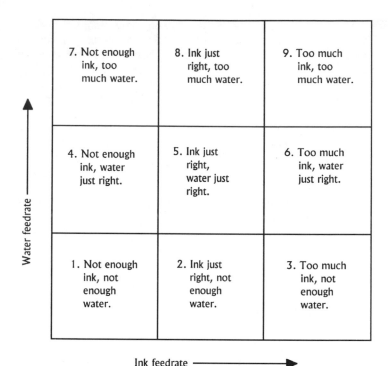

Figure 5.3 The nine different combinations of ink and water feed settings, or ink/water balances, that are possible in lithographic printing.

aggravate dampener related ghosting, as explained in Section 5.2.3.

The lower limit on water feedrate, i.e., where scumming just occurs, is weakly dependent on the ink film thickness on the plate (and hence on printed ink film thickness). That is, more ink requires more water, as shown by the data in Figure 5.4, which were obtained during a series of carefully controlled printing tests run with water feed set at just above the scumming level (MacPhee, 1985). Interestingly, these data, obtained on a press with an inker-feed dampener, also show that the lower limit on water feedrate is more or less independent of plate coverage, which is contrary to the dependence indicated in Figure 5.2.

The data plotted in Figure 5.4 also lend support to the theory that most of the water consumed is lost through evaporation in the press, as opposed to being carried away on the paper or in the printed ink film. This is because the data show two things as follows:

1. The decrease in water consumption when running the press without paper (wherein a like amount of ink was removed from the plate by stripping wheels) was about 15 percent. This behavior indicates that the

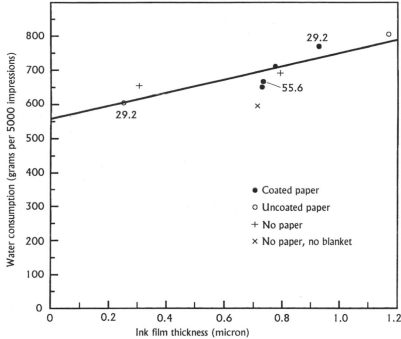

Figure 5.4 Measured water consumption rates on a sheetfed press with an inker-feed dampener, running at a surface speed of 227 feet/minute (MacPhee, 1985). Ink coverage was 8.3 percent except for three runs where coverage was 29.2 or 55.6 percent, as indicated by numbers next to data points.

fraction of consumed water carried away on unprinted areas of the paper was very small, i.e., about 0.15.

2. The amount of water (711 grams per 5000 impressions) consumed in a typical light coverage printing run was over seven times the corresponding amount of ink consumed (97.8 grams per 5000 impressions). These data show that it was physically impossible for the printed ink to have carried away a significant fraction of the water consumed.

Further support for this theory is provided by the measurements plotted in Figure 5.5. These indicate that no water below a threshold in water consumption of about 2 grams/square meter was transferred to the newsprint used. This threshold is equal to an equivalent water film thickness of 2 microns and corresponds to the second set of water consumption measurements plotted in Figure 5.1, i.e., those obtained after 1985. The conclusion suggested by this data is that out of the total amount of water supplied when printing on newsprint, the amount *not transferred to the paper* is 2 grams/square meter (2-micron-thick film). Of course, when

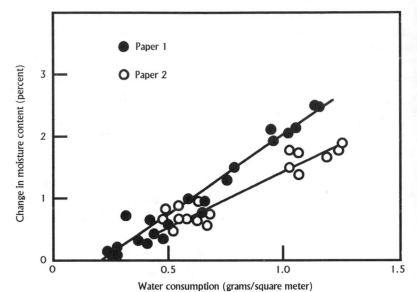

Figure 5.5 Measurements of water consumption when printing on newsprint and the corresponding increase in moisture content of paper. Reproduced with permission from TAPPI from the paper "Determination of Time Dependence of Dimensional Changes in Newsprint" (Trollsas, Eriksson, and Malmqvist, 1992).

printing on less-absorbent coated stock the amount of water not transferred to the paper may be higher.

A number of other investigators have reached different conclusions on the subject of the fate of water, based on measurements of the fate of tracer compounds dissolved in fountain solution. These conclusions are considered suspect, however, because the fate of the tracers will not parallel the fate of water where significant evaporation occurs.

5.2.2 Water Film Thickness on Plate. The data plotted in Figures 5.1, 5.4 and 5.5 lead to the following conclusions regarding water consumption on press:

1. Measurements made prior to 1985 show that water consumption under production conditions is equivalent to a press-wide sheet of water leaving the press, at press speed, that has a thickness of 0.3–0.4 microns (0.000012–0.000016 inches). More recent measurements, however, indicate that water consumption can be equivalent to a sheet of water as thin as 0.2 microns. The reasons for this difference are not understood.

2. Consumption is independent of the type of dampening system used.

3. Consumption is essentially the same when printing on uncoated paper, on coated paper, or on no paper at all.

Given this information on water usage, one might expect that the water film thickness on the nonimage areas of the plate can be ascertained with a reasonable degree of accuracy. Unfortunately, this is not true because the two methods that have been used to assess water film thickness on plate give quite different results, as will now be explained.

As noted in Section 1.1.3, several investigators have reported water film thicknesses on the plate of about one micron, based on reflectance type measurements.

The second method used for assessing water film thickness is to calculate a value using a measured consumption rate as the starting point, based on the following assumptions:

1. The film of water is split equally in all nips beyond the inking rollers, i.e., the plate-to-blanket and blanket-to-paper nips.

2. The fraction of total usage that is lost or transferred to the paper can be specified with reasonable accuracy.

For example, in the series of press tests referred to in Figure 5.4, the typical consumption rate was 0.22 gallons per hour, equivalent to an exiting water sheet thickness of 0.32 microns, at a press speed of 227 feet per minute. If the assumed fractional loss to the paper is taken as 87.5 percent, the calculated water film thicknesses are as given in Figure 5.6(a).

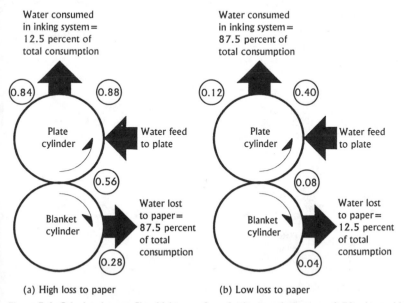

(a) High loss to paper (b) Low loss to paper

Figure 5.6 Calculated water film thicknesses for a feedrate equivalent to a 0.32-micron-thick sheet of water and two different assumed rates of consumption in the inker. Circled numbers are calculated thicknesses in microns.

The film thicknesses on the plate before and after passing under the ink form rollers (0.84 and 0.88 microns) coincide very well with the above reported reflectance measurements of about 1.0 micron.

If, in contrast, only 12.5 percent of the water consumption is assumed lost to the paper, a quite different result is obtained as shown in Figure 5.6(b). Here, the calculated water film thickness on the plate ranges from 0.12 to 0.4 microns, well below the measured value of 1.0. This latter result is quite plausible, however, given the data in Figures 5.4 and 5.5, which indicates water loss to paper is quite small.

Given these conflicting results, one can only conclude that there is a great uncertainty over the water film thickness on the nonimage areas of the plate, with the best estimated values ranging from a high of about 1.0 micron down to as low as 1/8th that value. Although resolution of this uncertainty must await additional experimental data, the lower estimate, as portrayed in Figure 5.6(b), will be taken as the correct value throughout the remainder of this volume, based on the above mentioned experimental evidence that shows a small loss to the paper.

5.2.3 **Dampener-Related Ghosting.** There are two ways that a dampening system can generate printed ghosts. In the first, an existing inker-related ghost can be aggravated or made worse if too much water is fed to the plate. This stems from the fact that the thin film of dampening fluid is applied to both nonimage and image areas of the plate. The unneeded film on the image areas interferes with the ink transfer necessary to replenish ink on the image areas. Thus, if there is more water at the front of the inking system than at the back, as is to be expected due to progressive evaporation, the percentage of ink transferred by the first form roller will decrease and this decrease will aggravate many ghosts.

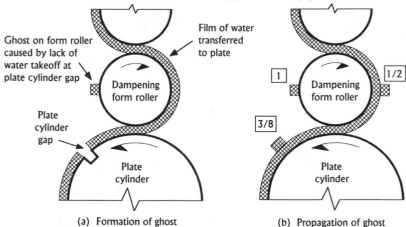

(a) Formation of ghost (b) Propagation of ghost

Figure 5.7 Explanation of formation and propagation of a water ghost generated by the gap in the plate cylinder. Numbers in boxes give magnitude of ghost relative to the thickness of the film transferred to the plate.

The second way that a dampening system can cause a ghosting problem is by generating a runout ghost in a manner very similar to the behavior explained in Figure 4.8 for inker-related runout ghosts. In the case of a dampener, there is zero water transfer from the dampening form roller to the plate during the time the plate cylinder gap passes under it. As a result, a water ghost is produced on the dampening form roller, as shown in Figure 5.7(a). This ghost is subsequently transferred to the plate, attenuated by its passage through two nips, as shown in Figure 5.7(b). If the region on the plate where the water ghost has been transferred is an image area, a printed ghost will be generated because ink transfer to the water ghost area by the ink form rollers will be impaired. Such dampener related runout ghosts are not uncommon (MacPhee and Lester, 1986) and are proof that water does indeed interfere with ink transfer.

5.3 Distinguishing Characteristics

A dampening system is defined by four major properties or characteristics: the type of metering method used, and the type, directionality, and path of the fountain solution flow to the plate. The chart in Figure 5.8 lists the four major dampening system characteristics and identifies the workable alternatives for each. Given these various alternatives, there are, theoretically, a total of 48 possible different dampening system configurations. Certain features are, however, mutually exclusive, either by definition or on practical grounds. For example, a

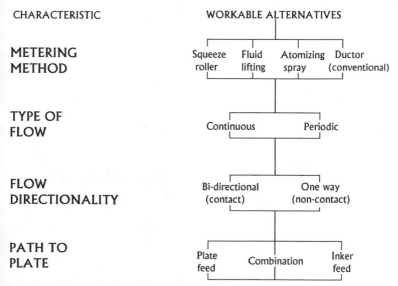

CHARACTERISTIC	WORKABLE ALTERNATIVES			
METERING METHOD	Squeeze roller	Fluid lifting	Atomizing spray	Ductor (conventional)
TYPE OF FLOW	Continuous		Periodic	
FLOW DIRECTIONALITY	Bi-directional (contact)		One way (non-contact)	
PATH TO PLATE	Plate feed	Combination		Inker feed

Figure 5.8 Characterization of dampening systems.

ductor-type is not continuous by definition, while continuous-type spray dampeners have generally proved impractical. When these so-called impossible and impractical configurations are deleted, the maximum theoretical number of configurations is reduced to 15. In practice, however, there are less than ten fundamentally different configurations in actual use.

All of the alternatives listed in Figure 5.8 are discussed qualitatively in the following sections, while quantitative descriptions of currently used dampener designs are given in Sections 5.4 through 5.9.

5.3.1 **Metering Methods.** This refers to the techniques employed to generate the required thin stream of water. Two of the four methods identified in Figure 5.8, squeeze roller and fluid lifting, generate a thin continuous web of water. For this reason, dampeners that utilize these methods are often referred to as film-type, or continuous dampeners.

The squeeze roller method of metering is a common choice on both sheetfed and web heatset presses. This concept utilizes a pair of squeeze rollers (one of which is resilient) to meter out the dampening fluid. The two rollers are geared together and driven by a variable-speed motor at a lower surface speed than the other press rollers, i.e., in the range from zero to not more than about 150 feet per minute.

One of the rollers also serves as a fountain roller. Figure 5.9 shows two different configurations. In Figure 5.9(a), the resilient or metering roller serves as the fountain roller whereas in Figure 5.9(b), the hard surfaced chrome roller serves as the fountain or pan roller. The fountain roller carries more water than is needed to the metering nip, thus flooding it. The amount of fluid that passes through this metering nip is thus limited and in practice is no more than a few microns. Figure 5.14, discussed further on, gives the calculated value for a typical small sheetfed press. As

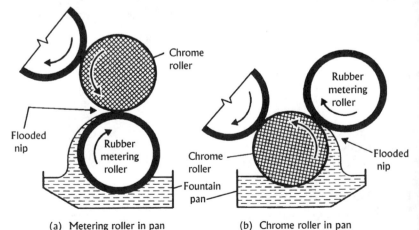

(a) Metering roller in pan (b) Chrome roller in pan

Figure 5.9 The two different configurations used in the squeeze-roller method of metering.

explained in Section 3.4.2 in Chapter 3, the exact amount of fluid that passes through the metering nip is governed by four factors as follows:

1. Roller speed
2. Hardness of the resilient roller
3. Roller setting, i.e., pressure
4. Viscosity of the dampening fluid

Water feedrate is adjusted by adjusting the speed of the roller pair. Dampening systems utilizing this metering method of necessity also employ a slip nip, because of the difference in speed between the roller pair and the other press rollers. This method is well proven and possesses the advantage that water feed at the roller ends can be increased by skewing, i.e., by cocking one of the rollers so that the axes of the two rollers are no longer parallel.

Figure 5.10 illustrates two different variations of the fluid-lifting method of metering. This concept also utilizes a pair of rollers, a chrome pan roller and a take-away roller that travel at quite different speeds, compared to the squeeze-roller method. The chrome fountain roller is driven by a separate variable-speed motor at a relatively low surface speed, i.e., in the range of from zero to no more than about 20 feet per minute in sheetfed applications. At these slow speeds, the maximum film thickness on the chrome roller is shown in Figure 3.22 in Chapter 3 to be about 30 microns (0.0012 inches), and to vary as the two-thirds power of roller speed. This relationship between water film thickness on the fountain roller and fountain roller speed constitutes the principle on which this metering

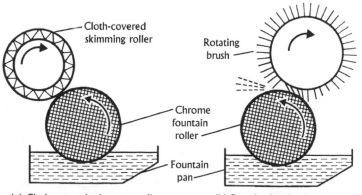

(a) Cloth-covered take-away roller. (b) Rotating-brush take-away roller.

Figure 5.10 Two different variations of the fluid-lifting method of metering. In the skimming roller system, shown in (a), the take-away roller is fabric covered while in the brush system, shown in (b), fluid take-away is carried out by a rotating brush.

method is based. This is because, for all practical purposes, all of the water that reaches the nip formed between the chrome fountain roller and the take-away roller is carried away by the much faster moving take-away roller. In effect, the fountain roller surface is wiped clean by the take-away roller. Thus, water feed rate is determined by the amount of water delivered by the fountain roller and can be adjusted by changing the speed of the fountain roller. One disadvantage of this method is that it is not possible to increase feedrate at the roller ends by skewing.

The spray-type metering method can be thought of as constituting a subgroup of metering methods that utilize the atomization process. (In this context, atomization is the process wherein a fluid is disintegrated into small particles.) As shown in Figure 5.11, there are in general three types of fluid atomizers: rotary, ultrasonic, and sprayers. Sprayer-type atomizers utilize a nozzle to generate a relatively high velocity between the fluid to be atomized and the surrounding air or gas, with the result that the fluid breaks up into drops. In single-fluid sprayers, the fluid is discharged from the nozzle under high applied pressure to produce the high velocity. Twin-fluid sprayers discharge the fluid under low applied pressure into a high-velocity air stream to achieve atomization (Lefebvre, 1989).

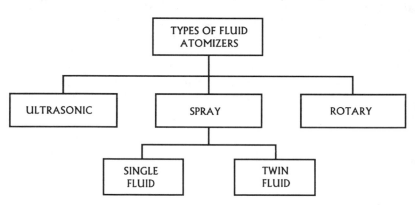

Figure 5.11 Classification of fluid atomizers.

Sprayers produce drops that range in size from about 0.001 to 0.010 inches (25–250 microns). Figure 5.12 illustrates how these drop sizes compare with naturally occurring precipitation (Delavan, 1987; and Fraser and Eisenklam, 1956). Thus, a given nozzle design can also be characterized by the mean size of the drops it produces. However, for dampening applications, it is important to know that such nozzles actually produce a range of drop sizes, and attention must be paid to both the largest and smallest drops produced. Very large drops can cause water marks, while very small drops will drift away and land in unwanted areas.

To achieve the desired dispersion pattern, the spray nozzle opening is

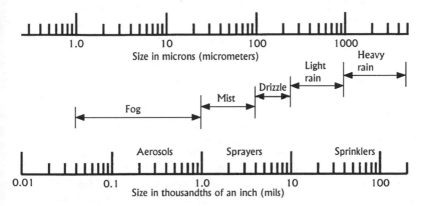

Figure 5.12 Drop sizes of natural occurring precipitation.

shaped to give the fluid jet a particular form, such as a flat sheet, in the case of nozzles used in spray dampeners. Because a line of nozzles is needed to span the width of a press, nozzles for dampening system applications are designed to produce a pattern with tapering ends so as to produce a uniform flow where the patterns of adjacent nozzles overlap. A major advantage of the spray method of metering is that the use of an independent flow control for each nozzle enables the press operator to adjust flowrate in the across-the-press direction.

It is interesting to note that the rotary-brush metering method also utilizes the atomization process and is of the rotary type, according to the classification of Figure 5.11. In general, rotary types produce more uniform drops of much smaller size, as evidenced by the fact that the stream of drops produced by a spiral brush dampener is not visible to the human eye.

To date, dampeners using ultrasonic atomizers have been limited to developmental prototypes. This type of atomizer produces a relatively uniform and small drop, but suffers from the fact that the delivery velocities are quite low—with the result that a good portion of the drops produced simply float away (MacPhee, 1990).

The last method of metering to be described here is the one employed by the ductor or conventional-type dampening system. The operation of the ductor roller employed in such dampeners is the same as for the ink ductor roller. Therefore, the principle of operation will not be explained here because it is assumed that the reader is already familiar with the basic ductor roller motions as set forth in Figure 4.4 and the text that accompanies it in Chapter 4.

5.3.2 Type of Flow. The second way that dampening systems can be classified is by whether the flow of fountain solution through the dampener is continuous or periodic. Continuous flow is preferable for printing reasons

but is not essential. Therefore, a system with periodic flow may offer an important tradeoff. For example, one advantage gained in a spray-type (periodic) system is excellent lateral control because of the ability to adjust feedrate across the width of the press.

5.3.3 Flow Directionality.

A third way of describing a dampening system is whether the flow path to the plate is bi-directional or one-way. For example, squeeze-roller dampeners are bi-directional because there is a return flow path from plate to metering system. In contrast, brush dampeners are one-way because fountain solution cannot be returned to the brush by the plate. Bi-directional flow type dampeners have also been referred to as contact-type dampeners (MacPhee, 1981). One-way flow, achieved by having a physical gap in the flow path, insulates the metering components and fountain solution supply system from ink feedback. This greatly reduces the frequency at which these items must be cleaned.

5.3.4 Path to Plate.

The last method of classification is in terms of the flow path that the fountain solution takes in traveling from the metering system to the plate. Three possibilities exist. The first, labeled plate-feed, refers to dampening systems that employ a separate dampening form roller isolated from the inking system, as exemplified by the system shown in Figure 1.6 in Chapter 1. In contrast, fountain solution is fed to the plate via an inking form roller in inker-feed or integrated systems, while combination-type systems utilize a separate dampening form roller that is connected to the inker by a bridge roller.

Inker-feed dampeners have very quick startup response, but can aggravate dampener-related ghosting, for reasons explained in Section 5.2.3. Many users also believe that ink feedback into the dampener is significantly worse with inker-feed dampeners of the contact type, but this assessment is probably due more to the fact that the majority of contact-type inker-feed dampeners have been of the three-roller type. As explained in Section 5.5.3, squeeze-roller type dampeners that use only three rollers produce more ink feedback than do four-roller configurations. Platefeed dampeners are thought to be superior by many users for printing light coverage forms. The rationale for this view is that less water is fed to the inker, thereby reducing the risk of excessive ink emulsification.

One advantage of combination-type dampeners is that the bridge roller can be lifted when printing light coverage forms, thus achieving the advantages of both plate- and inker-feed systems.

5.4 Ductor-Type Dampeners

Ductor-type dampening systems were dominant until the advent of film and brush types in the 1960's. A major reason for their loss of favor is the requirement that one or more of the rollers must be covered with some type of fabric as shown in Figure 5.13.

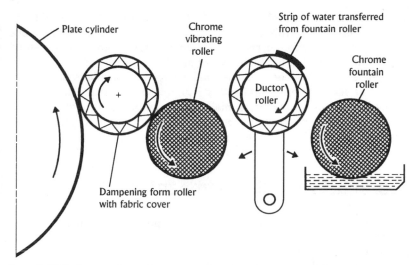

Figure 5.13 Ductor-type dampening system. Also referred to as a conventional dampener.

There are two reasons why fabric covers are required. First is the fact that the ductor provides an intermittent feed of water to the dampening system rollers that are traveling at press speed. (In general, ductor-type systems are designed to feed a strip of water to these rollers every other plate cylinder revolution.) Unlike the train of inking rollers, the train of dampening rollers that run at press speed in a ductor system generally consists of only two rollers: a chrome vibrating roller and a single dampening form roller. As a consequence, the strip of water delivered to them by the ductor cannot be smoothed out enough, or evenly distributed, before it reaches the plate. Thus, to overcome this shortcoming, the form roller is equipped with a replaceable fabric covering to provide a reservoir of water. Over the years, there have been attempts to run ductor dampeners bareback, i.e., without a cover on the form roller, but this approach has not caught on, except on some very small presses.

A fabric cover must also be installed on the ductor roller to prevent water slinging that would otherwise occur when the ductor is rapidly accelerated to press speed, each time it swings into contact with the vibrator. In the past, fabric covers were sometimes installed on the fountain roller as well, but this is hardly ever done now.

The disadvantage of fabric coverings is that they increase press response time, and require more operator skill and maintenance than barebacks do. Because of the former, startup time and waste is greater than on presses with film-type dampeners. Woven covers can also generate unwanted patterns on the print and be a source of lint.

Another very important disadvantage of ductor-type dampeners is that water builds up on the sides of the plate in the areas that are beyond

the edges of the paper being printed. This buildup results in water slinging and can only be controlled through the use of water stops that reduce water feed in the affected regions. Obviously, excess water is prevented from being returned to the fountain pan in this type dampener.

These disadvantages notwithstanding, conventional dampeners are capable of achieving print quality that is comparable to that achieved with film-type dampeners. In fact, some proponents of ductor systems claim superior quality, and this is probably true if the comparison is made with an inker-feed film dampener. (The ductor type is a plate-feed dampener, and therefore less likely to aggravate ghosting.)

5.5 Squeeze-Roller Dampeners

This type of dampener is of great importance because it is the dampener of choice on a very large majority of the presses that are currently used to print on coated paper. The ascendancy of the design is a relatively recent phenomenon in that it is only in the past twenty-five years that it has relegated the once dominant ductor-type dampener to obscurity.

5.5.1 Evolution. This class of dampening system derives its name from a metering method that probably saw its first application in printing on flexographic presses. The use of the squeeze-roller method in a dampening system appears to have been conceived independently in the late 1930's by J.G. Goedike of San Antonio, Texas, and an unknown Danish inventor (Goedike, 1938; and Larsen, 1939). It is H.P. Dahlgren, however, who is generally credited with reducing this concept to practice (Dahlgren, 1965), and for this reason, dampeners of this type have been referred to as Dahlgrens in the past. This generalization is unfortunate and misleading, because there has been great diversity in the design of squeeze-roller dampeners for many years. Dahlgren's original stock in trade was a three-roller design using the inker-feed concept. Although this was widely accepted by the industry, four-roller designs of other manufacturers, utilizing both the plate-feed and combination configuration, are now in widespread use. The four-roller design was conceived at least by 1965 but did not appear in the market until five years later (Greiner, 1970). Four-roller designs possess several attractive features, as will now be explained.

5.5.2 Principles of Operation. A squeeze-roller dampener is distinguished by two unique features: a relatively low speed metering nip and (as a consequence) a slip nip somewhere in the train of rollers leading to the plate. These nips are identified in the diagram of a typical three-roller design shown in Figure 1.6 in Chapter 1. The behavior of the metering nip has already been described in Sections 3.4.2 of Chapter 3 and 5.3.1 of this chapter. The important aspects summarized here are that the metered film thickness is proportional to the following, assuming no slip in the metering nip:

1. The one-third power of roller surface speed
2. Roller setting or pressure
3. Hardness of the metering roller
4. Viscosity of the fluid being metered

From this, it might seem necessary for the speed of the two separately driven rollers to track press speed. It might also be thought that water feedrate will vary with the 1.33 power of metering roller speed, because the metered film thickness varies as the one-third power of roller speed as brought out in Section 3.4.2. In actuality, neither is true because of the presence of the slip nip, as will now be shown.

Figure 5.14(a) identifies the different water film thicknesses throughout the dampening system shown in Figure 1.6 in Chapter 1, while equations (5.1) through (5.5) describe the dependencies of these film thicknesses on roller speeds and each other.

$$h_m = CV_m^{1/3} \tag{5.1}$$

$$\frac{h_1}{h_2} = \left(\frac{V_p}{V_m}\right)^{1/2} \tag{5.2}$$

$$V_p h_p + V_m h_m = V_p h_1 + V_m h_2 \tag{5.3}$$

$$h_p(1-\alpha) + h_1 = 2h_p \tag{5.4}$$

$$h_p = \frac{CV_m^{4/3}}{\left[\left(\dfrac{V_p^{3/2} + V_m^{3/2}}{V_p^{1/2}}\right)(1+\alpha) - V_p\right]} \tag{5.5}$$

where:

h = film thickness as defined in Figure 5.12(a)
V_m = surface speed of metering roller
V_p = surface speed of press
C = a constant
αh_p = amount of water consumed

Equation (5.1) describes the relationship between the metered film thickness, h_m, and the surface speed, V_m, of the metering roller. Equation (5.2) defines how the slip ratio V_p/V_m governs the splitting of the film exiting from the nip between the dampening form roller and the chrome

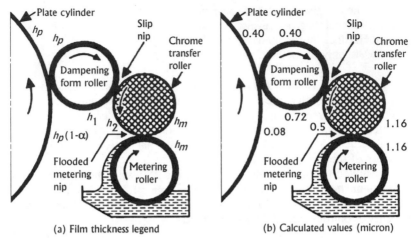

(a) Film thickness legend (b) Calculated values (micron)

Figure 5.14 Typical film thicknesses on a squeeze-roller dampener. Water consumption, expressed as the thickness of an equivalent sheet of water, is equal to αh_p.

transfer roller (Zavodny, 1973). Equations (5.3) and (5.4) describe the conservation of the volumes entering and leaving the slip nip and the form roller plate cylinder nip respectively. When combined, these four equations yield equation (5.5) that expresses the water film thickness on the plate, h_p, as a function of the roller speeds and α, the amount of water consumed by the press, expressed as a fraction of h_p. These equations can be used to calculate the various film thicknesses provided, of course, that experimental data is available to evaluate the constant C. The previously referenced tests (MacPhee, 1985), along with the value of α assumed in Figure 5.6(b), provide just such data as follows:

V_p = 227 feet per minute, measured speed
V_m = 110 feet per minute, measured speed
$\alpha \, h_p$ = 0.32 micron, measured consumption expressed as the
 thickness of the sheet of water fed to the press
h_p = 0.4 micron, based on assumed value of 0.8 for α.

The value of C thus obtained, 0.242, was used along with equations (5.1)–(5.4) to calculate the various film thicknesses given in Figure 5.14(b). The two effects of the slip nip on the performance of this type of dampener can be illustrated by two series of calculations based on equations (5.1) and (5.5). In the first, the film thickness h_p is calculated as a function of metering roller speed. Roller speed is then converted to its equivalent, the setting of the water control dial (that is used by the press operator to adjust water feedrate) using the measured relationship given by equation (5.6):

$$V_m = 2.768(X-2.032) \tag{5.6}$$

where:

X = setting of water control dial

The product αh_p can then be converted to feedrate (in gallons per hour) given the knowledge that the press speed was 227 feet per minute and the test press width was 25 inches. The resulting calculated values, plotted in Figure 5.15, can be approximated quite well by the simple power law relationship given by equation (5.7):

$$q = (0.0156)(X-4.65)^{0.722} \tag{5.7}$$

where:
 q = water feedrate in gallons per hour at a constant press speed of
 227 feet per minute, or 6000 impressions per hour.

This demonstrates that the first effect of the slip nip is to transform the four-thirds power law relationship between metered flowrate and metering roller speed to a 0.72 power law relationship between feedrate and setting of the water control dial as given by equation (5.7).

The second contribution of the slip nip can be illustrated by using equation (5.5) to calculate feedrate as a function of press speed, at a given

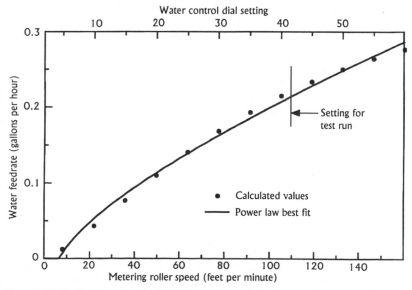

Figure 5.15 Feedrate versus metering roller speed and water control dial setting for the squeeze-roller dampener shown in Figure 5.12. Fitted curve is a 0.72 power law relationship defined by equation (5.7).

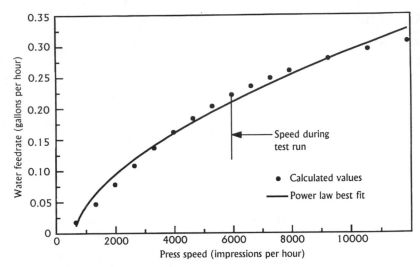

Figure 5.16 Calculated behavior that illustrates how well feedrate automatically tracks press speed in a typical squeeze-roller dampener.

water control dial setting, and hence metering roller speed. This series of calculations is plotted in Figure 5.16, and shows that feedrate automatically tracks press speed to a great extent. That is, feedrate increases as press speed is increased even though no increase has occurred in the metered film thickness. This is explained by the fact that the slip ratio, V_p/V_m, in equation (5.2) increases with press speed, thereby changing the split ratio, h_1/h_2 This, of course, results in more water being transferred to the form roller from the chrome transfer roller. Thus, the second effect of the slip nip is of major importance, because it transforms the seemingly constant feed performance of the squeeze rollers into a behavior that is somewhat self-regulating. The resultant behavior is not completely self regulating because feedrate is not linear, but instead follows an approximate 0.587 power law as given by equation (5.8) and illustrated in Figure 5.16.

$$q = 0.00136(I-622)^{0.587} \tag{5.8}$$

where:

I = press speed in impressions per hour.

Even so, this partial self-regulating behavior is so satisfactory that it is seldom necessary to provide a control link between the press and this type of dampener for the purpose of improving the tracking of press speed.

5.5.3 Location of Slip Nip. Two broad categories of squeeze-roller dampeners exist, based on the location of the slip nip. In the first, the slip

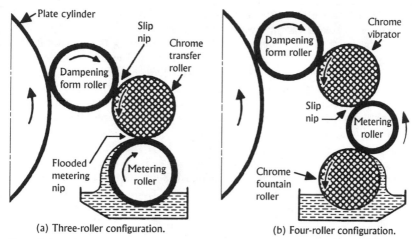

(a) Three-roller configuration. (b) Four-roller configuration.

Figure 5.17 Comparison of the three- and four-roller configurations used in squeeze roller dampeners.

point is located at a nip between a roller carrying some ink, and a water-carrying roller, as shown in Figure 5.17(a). This arrangement is sometimes referred to as a three roller configuration, or alternately, as an emulsion dampener (Blanchard, 1993). The latter term is based on the fact that an ink-water emulsion is produced in a nip upstream of the plate, i.e., by the shearing action on the films of water and ink in the slip nip. This dampener concept results in a relatively simple mechanical design because the two squeeze rollers can be mounted together and be moved as a unit out of engagement with the form roller when the form roller goes off impression with the plate cylinder. For this reason, it is much easier to retrofit this type of continuous dampener to an existing press.

There are some drawbacks, however, to placing the point of slippage between an ink-carrying and a water-carrying roller. The resulting emulsifying action produces more ink feedback into the dampening system and its associated fountain solution supply system. The additional emulsifying action of the slip nip may account for the need to run with alcohol in the fountain solution, and for the opinion of many that it is much more difficult to run this type of dampener with an alcohol substitute. (In the inks in use at the time that this type of dampener was introduced, the addition of alcohol to fountain solution greatly reduced water pickup, as measured by the Surland test discussed in connection with Figure 1.9. Thus, to some extent, alcohol counteracted the emulsifying effect of the shearing action of the slip nip.)

Another shortcoming of this configuration is that the absence of a vibrating roller makes it more susceptible to unwanted water streaks in the around-the-cylinder direction.

The other location used for the point of slippage is in a nip formed between two rollers carrying water only, as shown in Figure 5.17(b). The great advantage of this arrangement is that the shearing that occurs in the slip nip does not act on a composite layer of ink and water, and therefore does not contribute to emulsification. The longer roller train is also a benefit in smoothing out the variations in water film thickness generated by the plate cylinder gap. (This can be demonstrated by calculating the water film thickness on the plate as a function of time using the technique described in Section 4.6 for an inking system.)

The four-roller configuration shown in Figure 5.17(b) is more complex mechanically because of the desire to separate the chrome vibrator from the form roller when going off impression. This is to prevent ink transfer from the form roller to the chrome vibrator, when off impression, that would otherwise occur as the vibrator surface dries off (because the squeeze roller also separates from the vibrator). Similarly, when going on impression, it is desirable for the metering roller to contact and wet the vibrator prior to its engagement with the form roller.

5.5.4 Configurations Encountered in Practice. It has already been mentioned that some type of squeeze-roller dampener is the major choice on presses used to print on coated paper. Most of the designs in current use employ one of the five roller configurations diagrammed in Figure 5.18. The three-roller, inker-feed configuration shown in Figure 5.18(a) was the first to be used extensively, and became known as a Dahlgren, because of H.P. Dahlgren's work in developing and marketing this design (Dahlgren, 1965, and 1967). A plate-feed version of this configuration was developed by Miehle-Goss-Dexter, Inc., and became known as the Miehlematic Dampener (Nothman, 1967).

In the Dahlgren design, the first ink form roller, which also serves as the dampening form roller, is friction-driven by the adjoining ink vibrator and the plate cylinder. The stripe settings in both of these nips are critical because the drag in the slip nip tends to slow down the form roller. Thus, to insure that the form roller does not generate a streak due to a change in roller speed (slow down) especially when it is in the plate cylinder gap, it is necessary to maintain a relatively heavy stripe between it and the vibrating roller. A heavy stripe is undesirable, however, because it can interfere with ink transfer, increase roller heating, and aggravate emulsification. This need for a heavy stripe, plus the presence of so much water on the first ink form roller, probably accounts for the complaint of users that ghosting is aggravated with this dampener (Kist, 1976). In the Miehlematic design, the problem of roller slowdown was solved by equipping the separate dampening form roller with a gear drive.

Both the Dahlgren and Miehlematic dampener represented a great advance over the ductor-type systems they replaced. Their many advantages included very fast response, greatly reduced waste, and less demands on operator skill.

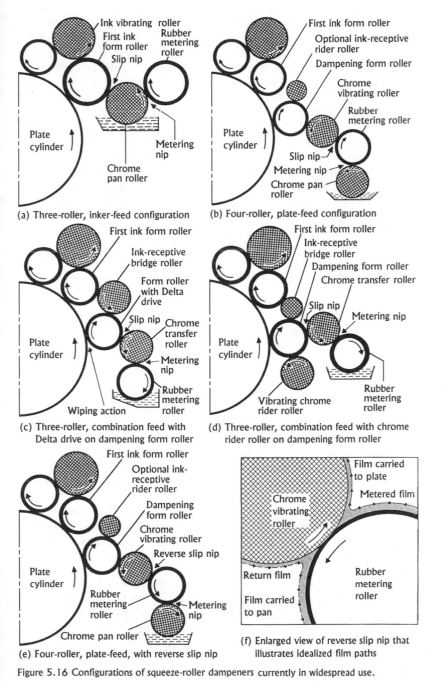

(a) Three-roller, inker-feed configuration

(b) Four-roller, plate-feed configuration

(c) Three-roller, combination feed with Delta drive on dampening form roller

(d) Three-roller, combination feed with chrome rider roller on dampening form roller

(e) Four-roller, plate-feed, with reverse slip nip

(f) Enlarged view of reverse slip nip that illustrates idealized film paths

Figure 5.16 Configurations of squeeze-roller dampeners currently in widespread use.

The four-roller plate-feed configuration, shown in Figure 5.18(b), is widely used on both sheetfed and webfed presses. The pioneering model developed by MAN Roland for use on sheetfed presses is called the Rolandmatic, while the equally pioneering model developed by Heidelberg Harris for use on webfed presses is known as the Duotrol. Similar designs are to be found on other models of web presses. The advantages of this very successful configuration include good compatibility with alcohol substitutes. On webfed presses, the most commonly encountered problem (perhaps due to their higher speeds) is ink buildup on the form and metering rollers. Excessive ink buildup on the dampening form roller can cause gap streaks. (These will be explained in more detail in Volume 2.) Excessive ink buildup on the metering roller, or slip roller, as it is sometimes called, can result in ink toning in nonimage areas of the print.

The configuration in Figure 5.18(c) is distinguished by the use of a Delta® drive, so named because the dampening form roller is driven at a different (in this case slower) surface speed, relative to the plate. The resultant wiping action insures that hickeys will not become lodged on the plate. (The subject of hickeys and the mechanisms that account for their generation and removal is taken up in Volume 2.) The important advantage gained is the virtual elimination of hickeys, a fact that has been documented by users (MacPhee, 1994, and Folkes, 1994). Users have also reported that the Delta action reduces water consumption—based on their observation that scumming appears if the Delta drive is disengaged so as to let the form roller run at press speed. Tests run by the author during the development of this dampener also showed that ghosting is reduced, and on some forms eliminated, when the Delta drive is engaged. The Delta Dampener, shown in Figure 5.18(c) is a patented design (MacPhee and Lester, 1988) that is manufactured by Epic Products International for both new and retrofit press installations.

Figure 5.18(d) is a diagram of the Alcolor (Beisel, 1982), manufactured by Heidelberger Druckmachinen AG for their line of sheetfed presses. This dampener is unique in employing a vibrating chrome rider roller in contact with the dampening form roller. This eliminates the water streaks that sometimes occur on the three-roller configuration dampeners shown in Figure 5.17(a). Another advantage is that the bridge roller can be retracted to allow for operation as a plate-feed dampener. Many users prefer to do this when running light coverage forms.

The configuration diagrammed in Figure 5.18(e) is distinguished by the use of a reverse slip nip, whose principle is illustrated in Figure 5.18(f). The basic idea of employing reverse rotation is to produce a wiping action that minimizes the amount of fluid that actually passes through the slip nip. Thus, essentially all of the metered film is carried to the plate, and all of the return film is carried to the pan. A major advantage of this design, at the time it was introduced, was that it required less alcohol in the fountain solution, but this has since been made moot by the widespread use of

alcohol substitutes. It has also been claimed that the reverse slip nip changes the relationship between feedrate and metering roller speed to a linear one (MacPhee, 1984). This claim is at odds with the measurements (Zavodny, 1973) discussed in Chapter 3 that indicate a 4/3 power law relationship between feedrate and roller speed in the absence of slip nip effects. The dampener shown in Figure 5.18(e), named the Komorimatic, is made by Komori Printing Machinery for their sheetfed presses.

5.5.5 Performance Attributes. On balance, squeeze-roller dampeners give excellent performance. They have very quick response and low startup waste, due to the absence of the fabric covers used in the ductor-type dampeners they succeeded. The absence of fabric covers also makes this class of dampeners easy to operate and relatively maintenance free. Although it is generally agreed that the print quality achieved is extremely good, some users believe that a small penalty in print quality, vis-à-vis ductor types, is paid in exchange for the above advantages.

One potential problem arises because some of the water in the flooded nip leaks out at the roller ends. While most of this leakage drains back into the pan, a portion finds its way around the flat ends of the rollers and into the exit side of the metering nip. As a result, excess water is

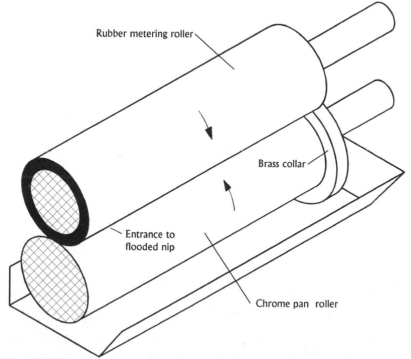

Figure 5.19 Scheme for preventing leakage around the ends of flooded nip used in squeeze-roller dampeners (Guaraldi and Skowron, 1991).

metered out at the very ends of the rollers. One common way of avoiding this problem is to make the squeeze rollers longer than the press rollers; thus the strips of heavy water do not transfer in the slip nip. Another solution to this problem is illustrated in Figure 5.19. Here a brass collar, affixed to the chrome roller, runs in contact with the flat end of the rubber roller. This seals off the end of the flooded nip and prevents fluid from bypassing around the roller ends to the nip exit.

Feedrate in these dampeners is sensitive to temperature; a rise in fluid temperature of 10 degrees Fahrenheit reduces feedrate by 13 percent. This is due to the dependence of feedrate on fluid viscosity, which in turn decreases as temperature goes up.

The main problem, or complaint, about performance on sheetfed presses is the need to use isopropyl alcohol in the fountain solution and/or the difficulty of achieving comparable performance with alcohol substitutes. On webfed presses, this type of dampener runs on alcohol substitutes with relative ease. There, the most commonly encountered problem is ink feedback that manifests itself as ink buildup on ink-receptive dampening rollers, and ink contamination of the fountain solution. Excessive ink buildup on the dampening form roller is undesirable because it can cause gap streaks while excessive buildup on the slower-moving rollers can cause toning. Excessive contamination of fountain solution produces an accumulation of ink scum on circulator components and can produce changes in fountain solution chemistry.

5.6 Brush Dampeners

Brush dampeners are now only used on heatset and non-heatset web presses. Nevertheless, they are included here because they were originally conceived for use on sheetfed presses.

5.6.1 Evolution. The idea of using a brush to deliver fountain solution was conceived in the early 1950's by H.P. Dahlgren (Dahlgren, 1954), who described a system very much like the one shown in Figure 5.8(b) for flicking water directly onto the plate of a sheetfed press. This was succeeded in a few years by a design using the same brush and pan roller configuration, but located so as to flick water onto the first ink form roller (Dahlgren, 1961). Both of these Dahlgren designs showed a spirally-wound brush. An alternate configuration was developed by Miehle-Goss-Dexter, Inc. for use on newspaper presses (Dunbar, 1967). In this design, a brush with evenly distributed bristles dipped into the fountain pan, and segmented blades were used to flick the water off the bristles onto a distributor roller. The use of segmented blades made it possible to adjust flow rate across the press, which was a big advantage over the spiral-brush designs. This design was succeeded by a two-roller configuration because, when running a narrow web, the brush bristles beyond the web became

fouled with ink. Thus, brush dampeners have evolved such that today all designs utilize a spiral brush in a configuration much like the one shown in Figure 5.20.

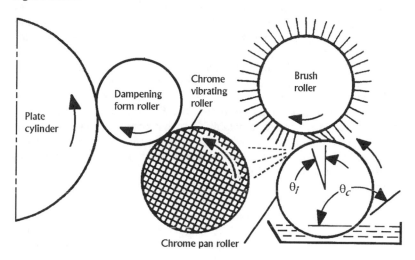

Figure 5.20 Typical brush dampener configuration. Brush is driven at a constant surface speed of 700 feet/minute. Feedrate is varied by varying pan roller speed over the range of 0–25 feet /minute. Feedrate is also weakly dependent on contact angle, θ_c, and takeoff angle, θ_j.

5.6.2 Principles of Operation. As shown in Figure 5.20, the two components that distinguish the spiral-brush dampening system are a relatively low-speed chrome fountain roller and a relatively high-speed spiral brush roller. The bristles of the brush are made of a relatively stiff and springy material, like nylon. The two rollers are mounted such that they come in contact with slight interference to form a nip. The chrome roller is immersed in a pan such that when it turns it delivers a thin film of fountain solution (water) to the common nip. Because of the interference at the nip, the brush bristles are bent in passing through it. When the bristles leave the nip, they quickly spring back to their relaxed position. The springing action of the bristles, combined with the centrifugal force generated by the rotary motion, propels and atomizes the water that they have picked up. The latter process is so effective that the water particles in the resultant stream are of a size that is invisible to the human eye.

In practice, the brush roller is driven at a sufficiently high speed such that most of the water delivered to it is propelled away by the flicking action of the brush bristles. Thus, feedrate is determined by the rate at which the pan roller delivers water to the nip formed by its junction with the brush. To permit changes in feedrate, a variable-speed motor is used to drive the fountain roller, while the brush roller is driven at a constant speed of less than 1000 rpm. This dampener derives its name from the fact that

it employs a long thin brush, wound into a coil, that is then mounted on a cylindrical core to produce a roller with bristles extending in the radial direction along a spiral path around the roller axis. In order to produce a rational design of such a dampening system, a knowledge of two relationships is needed. The first stems from the requirement that feedrate should track press speed. That is, the controller for the separate pan roller drive motor must be programmed to automatically increase its speed as press speed is increased. To determine the required relationship between pan roller speed and press speed, the relationship between feedrate and pan roller speed must be known. The second relationship that must be understood is how the properties of the brush roller affect performance. This, of course, is necessary to establish at what constant speed the brush roller should be driven, and at what stripe the brush should be set to the pan roller. It is important not to drive the brush roller any faster than necessary so as to minmize misting.

Although the performance of brush dampeners has been analyzed in some detail (MacPhee, 1987; MacPhee and Cerro, 1989), correlation between theory and actual performance is relatively poor for two reasons. First, as explained in Section 3.3.2, and illustrated in Figure 3.22, the appropriate theory of Tharmalingam and Wilkinson governing the amount of water delivered by the pan roller to the nip it forms with the brush underestimates flowrate. Second, the theory presented by MacPhee and Cerro, which explains spiral brush performance, correlates poorly with experimental data. Nevertheless, these theories are worth reviewing because they provide useful insight into the behavior of this type of dampener and therefore do provide some guidance in design.

To analyze the brush dampener, one needs to consider two actions: the amount of water delivered by the fountain or pan roller to the brush, and the amount of water removed from the pan roller by the flicking action of the brush.

The relationship between pan roller speed and feedrate has been taken up in detail in Section 3.3.2, and is summarized by equation (5.9).

$$q = CV^{5/3}(\mu\rho/g)^{1/2}(\mu/\sigma)^{1/6}L \qquad (5.9)$$

where:

C = a constant determined by the contact and takeoff
 angles defined in Figure 5.20
g = acceleration due to gravity
L = length of roller
q = rate fluid is delivered to takeoff point
V = surface speed of roller
μ = fluid dynamic viscosity
ρ = fluid density

σ = fluid surface tension

The importance of this equation is that it shows that feedrate varies in accordance with the 5/3 power of pan roller speed. Thus, to track press speed, the pan roller controller should be programmed to increase pan roller speed in proportion to the 3/5ths power of press speed.

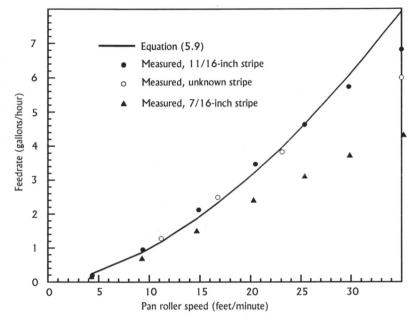

Figure 5.21 Feedrate data for brush dampener in Figure 5.20. Brush length is 36 inches, contact angle is 138 degrees, and takeoff angle is 6 degrees.

For the roller arrangement shown in Figure 5.20 and the corresponding angles, the value of the constant, C, in equation (5.9) has been found to be 0.93. Thus, equation (5.9) can be used to evaluate the rate at which water is delivered by the pan roller to its junction with the brush. The values of feedrate versus roller speed so calculated are plotted in Figure 5.21.

To analyze the flicking action of the brush, it is first necessary to determine the effect of the spiral geometry used, i.e., the effect of the non-uniform coverage of the brush roller by the spirally-wound bristles, as shown in Figure 5.22(a). It has been shown (MacPhee and Cerro, 1989) that the spirally-wound brush is equivalent to an axial brush roller having a straight strip of brush parallel to the roller axis, with a circumference length B_b, as shown in Figure 5.22(b). The relationship between the properties of the two equivalent rollers is given by equations (5.10) and (5.11).

$$B_b = \left(\frac{D_b}{D_c}\right)\left(\frac{a}{\sin\phi}\right)$$ (5.10)

$$\phi = \arctan(p / \pi D_c)$$ (5.11)

where:

a = width of spiral brush
B_b = circumferential length of equivalent brush
D_b = diameter of spiral brush
D_c = diameter of spiral-brush roller core

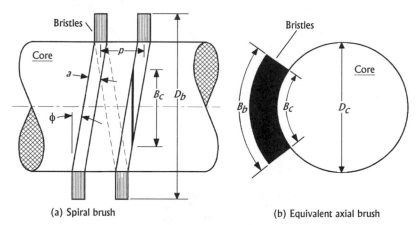

(a) Spiral brush (b) Equivalent axial brush

Figure 5.22 Important properties of spiral brush and equivalent axial brush.

When the equivalent brush roller is viewed in context with the pan roller, as shown in Figure 5.23, it becomes evident that, depending on the relative speeds, there can be periods where sections of the pan roller will pass through the nip without ever being contacted by the axial brush. In fact, there are, in theory, three different possible interactions between the axial brush and the fountain roller, as follows (MacPhee and Cerro, 1989):

1. A flicking action that occurs as the bristles leave the nip. This results in a steam of fluid being flung from the bristles and atomized, as portrayed in Figure 5.20.
2. A wiping action that occurs as the bristles pass over the roller within the nip. This results in fluid being transferred from the pan roller to the bristles prior to their exit from the nip.
3. An absence of contact between the brush and the pan roller.

The measured data that is plotted in Figure 5.21 indicates that, with a

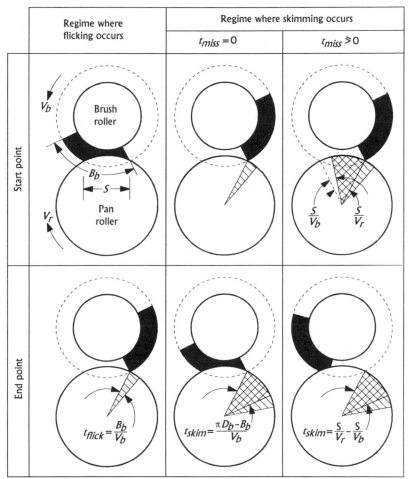

Figure 5.23 Derivation of times in brush roller cycle occupied by flicking and skimming.

heavy enough stripe, essentially all of the fluid on the pan roller is removed during the first two types of interactions. Thus, in practice it appears that it is only the third interaction, absence of contact, that affects how much fluid is removed by the brush. The fraction of the time when there is no contact can be evaluated by considering a cycle consisting of one brush roller revolution that has a time duration, t_{cycle}, defined by equation (5.12):

$$t_{cycle} = t_{flick} + t_{skim} + t_{miss} \qquad (5.12)$$

If one observes the pan roller surface as it exits from the nip over this time

period, three different surface regimes will be seen, corresponding to the three different interactions. The time durations of the first two regimes, derived in Figure 5.23, can be used in conjunction with equation (5.12) to derive the time duration of the third regime. These relationships are summarized by equations (5.13) through (5.16) that provide the following insight: at very low speeds of the pan roller, every region of the pan roller is touched or contacted by the brush so that t_{miss} is zero and the other times are constant, as given by equations (5.13), (5.14) and (5.15):

$$t_{cycle} = \pi D_b / V_b \qquad (5.13)$$

$$t_{flick} = \frac{B_b}{V_b} \qquad (5.14)$$

For $t_{miss} = 0$

$$t_{skim} = \frac{\pi D_b - B_b}{V_b} \qquad (5.15)$$

For $t_{miss} \geq 0$

$$t_{skim} = \frac{S}{V_r} - \frac{S}{V_b} \qquad (5.16)$$

where:

t_{cycle} = time for brush roller to travel one revolution
t_{flick} = time of pan roller travel during flicking regime
t_{skim} = time of pan roller travel during skimming regime
t_{miss} = time of pan roller travel during zero contact regime
S = stripe setting of brush to pan roller
V_b = surface speed of the brush roller
V_r = surface speed of the pan roller

As the pan roller speed is increased, however, a point will be reached where small sections of the pan roller start to miss contact with the brush. Further increases will cause t_{skim} to decrease in accordance with equation (5.16). From a performance standpoint, this is undesirable because the relationship between feedrate and pan roller speed will change. This region of operation can be avoided, however, by setting the brush roller speed high enough relative to the maximum speed at which the pan roller is to be operated. A recipe for determining this speed can be obtained by noting that the values of t_{skim} defined by equations (5.15) and (5.16) are equal

at the pan roller speed where the onset of the non-contact region occurs. Thus, the lower limit on brush roller speed can be found by combining equations (5.15) and (5.16) and rearranging the result as follows:

$$V_b \geq V_{r_{max}} \left(\frac{\pi D_b - B_b + S}{S} \right) \tag{5.17}$$

Alternately, an expression for the minimum stripe, S, necessary for a given set of roller speeds can be obtained by rearranging equation (5.17) to yield equation (5.18):

$$S \geq \frac{V_r \left(\pi D_b - B_b \right)}{V_b - V_r} \tag{5.18}$$

The ability of equations (5.17) and (5.18) to accurately predict the onset of the non-contact region can be checked using the measured data plotted in Figure 5.21. A more effective format for displaying the onset is obtained by converting the measurements to dimensionless flowrates using equation (5.19).

$$Q = q/V_r h^* L \tag{5.19}$$

where:

$h^* =$ characteristic film thickness
 $= (V_r \mu / \rho g)^{1/2}$
$Q =$ dimensionless flowrate
$q =$ volumetric flowrate

When plotted, as in Figure 5.24, both curves of dimensionless flowrates exhibit an inflection point that presumably represents the onset of the non-contact region. A comparison of the actual stripes with the stripes calculated using equation (5.18), as given in Table 5.1, indicates that equation (5.18) underestimates the minimum stripe needed by a factor of 2 to 3.

Table 5.1 Effective stripes, calculated using equation (5.18) and pan roller speeds at inflection points, versus actual stripes.

Actual stripe	0.44 inches (7/16 inch)	0.69 inches (11/16 inch)
Calculated stripe	0.19 inches	0.24 inches

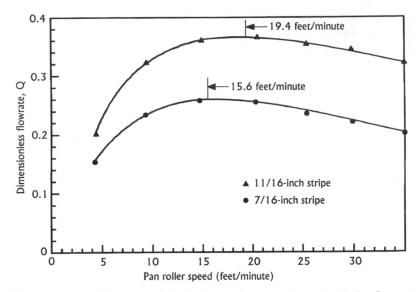

Figure 5.24 Plots of the measured data in Figure 5.21 converted to dimensionless flowrates in accordance with equation (5.15). Inflection points are thought to indicate onset of the non-contact region.

Using equation (5.17) to calculate the minimum required brush roller speed at these points yields results that are too low by similar factors. This poor agreement is most likely due to the fact that the effective or active stripe is much smaller than the measured stripe. Until more experimental data is obtained, however, equations (5.17) and (5.18) should be used only for insight.

5.6.3 Configurations Encountered in Practice. The roller configuration shown in Figure 5.20 is representative of a very large majority of the brush dampeners in current use. (It was mentioned earlier that these dampeners are only used on web presses.) When used for commercial printing on coated stock, a common practice is to use a fabric cover on the dampening form roller to reduce startup waste. In newspaper applications, the dampening form roller is more often run without a cover, but separate dampening roller trains with as many as four rollers have been specified (Schneider, 1993). In some newspaper applications, a brush dampener is used to feed fountain solution into the ink train, thereby eliminating the dampening roller train altogether. More is said about this in Chapter 7 on non-traditional forms of lithography.

5.6.4 Performance Attributes. Brush dampeners are used in significant numbers on both commercial (heatset) and non-heatset web presses. One of the main reasons for opting for them is that there is no ink feedback to contaminate the fountain solution supply system. Proponents claim that print quality equal to that of squeeze-roller dampeners can be

achieved, although much greater demands are placed on operator skill to do so. In order to achieve low startup waste, some sort of fabric cover must be used on the dampening form roller and this increases dampener response time.

Feedrate with this dampener is temperature-sensitive, and it has been found to decrease 7 percent for an increase in fountain solution temperature of 10 degrees Fahrenheit (MacPhee, 1987). Very little heat is generated in such dampeners, however, and therefore less cooling capacity is needed to maintain constant temperature, compared to squeeze-roller dampeners.

One disadvantage of the brush concept is that lateral control of feedrate can only be achieved through the use of water stops, wiper devices placed along the pan roller to thin out the film of water delivered to the brush. One method used to supply more water at the roller ends is to double the brush pitch at the ends by adding a second short length of brush to each end of the core. For this concept to work, however, stripe setting must be carefully controlled. This is because a relatively heavy stripe causes the single-pitch section to be just as effective as the double-pitch end sections in flicking water off of the pan roller.

The biggest problem with brush dampeners is contamination of the brush by ink fly. This reduces the springiness of the bristles, thereby causing random reductions in feedrate and corresponding print defects. To avoid this problem, the brushes must be cleaned on a regular basis. Brush dampeners do not automatically track press speed. Therefore, some link must be provided between press speed and the controller for the pan roller drive motor.

5.7 Skimming-Roller Dampeners

Although relatively little has been written about skimming-roller dampeners, they are in wide use today, mostly on web presses. As evidence of this, it is estimated that there are over 20,000 units installed throughout the world. As noted in Section 5.3.1 his type of dampener is similar to a brush dampener, in that it employs a chrome pan roller to achieve the fluid-lifting method of metering, but differs by using a fabric-covered skimming roller, in place of a brush roller, to carry away the metered amount of fountain solution.

5.7.1 Evolution. It would appear that this type of dampener was developed concurrently in the early 1960's by the Goss Division of MGD Systems (a predecessor of Goss Graphic Systems) for single-width newspaper web presses (Bruno, 1962), and by the Miller Printing Machinery Company for sheetfed presses (Saul, 1963). The roller arrangements of the two designs are the same, and it is shown in Figure 5.25. Although the design of the system has remained unchanged over the years, it is now only produced by Goss.

5.7.2 Principles of Operation. This type of dampener works on the principle that essentially all of the dampening fluid lifted or delivered by the chrome pan roller to the slip nip, formed with the skimming roller, is wiped off or transferred to this roller, which travels at press speed. This follows because the speed differential between the two rollers is very large. To demonstrate, consider the following approximate conditions for a typical 40-inch-wide sheetfed press traveling at 550 feet/minute (12,000 impression/hour):

1. Water consumption: ~1.0 gal/hour, from Figure 5.1
2. Equivalent water sheet thickness: 0.32 microns, from Figure 5.1
3. Pan roller speed: ~10 feet/minute, from Figure 5.21
4. Water film thicknesses on plate: as in Figure 5.14(b).

If is assumed that equation (5.2) applies to the slip nip and that the film split is 50:50 in all other nips, the film thicknesses throughout the roller train can be calculated. The results, given in microns by the numbers in Figure 5.25, show that a film 17.6 microns thick must be lifted to the slip nip, and that only 0.18 microns, or one percent of this, remains on the roller after it has passed through the nip. Feedrate is controlled in exactly the same way as in the brush dampener, by varying the speed of the chrome pan roller. Thus feedrate can be calculated using equation (5.9) or read from Figure 5.21 (if it applies).

5.7.3 Configurations Encountered in Practice. So far as is known, all dampening systems of this type have used the roller configuration shown in Figure 5.25, with no connecting roller to the inker. The design for sheetfed presses developed by Miller is called the Miller-Meter Dampener,

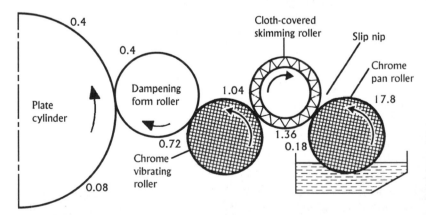

Figure 5.25 Roller arrangement used in the skimming-roller dampening system. Numbers indicate calculated water film thicknesses, in microns, for a typical 40-inch-wide press running at a speed of 12,000 impressions/hour.

while the Goss design for web presses is named Continuous Feed Dampener. In both designs, the vibrating chrome roller is gear-driven at press speed, and in turn drives the dampening form and skimming rollers by friction, also at press speed.

A separate variable-speed motor and controller is used to drive the chrome pan roller, thereby making it possible to vary the speed of this roller and, hence, water feedrate. In order for feedrate to track press speed, the controller for the pan roller drive motor must be programmed to automatically increase its speed as press speed is increased. All four rollers in this dampening system remain in contact when the dampening form roller goes off impression with the plate cylinder. Although it has been stated that it is possible to run the form roller bareback (Tyma, 1976), the author is unaware of any current installation that does not use some type of fabric cover on this roller.

5.7.4 Performance Attributes. Overall, this dampening system design gives very good printing performance. In sheetfed applications its advantages were documented 20 years ago (Kist, 1976) as follows, vis-à-vis squeeze-roller types:

1. Less ghosting
2. Less emulsification
3. Does not require alcohol

The accompanying drawbacks were also given as:

1. More waste at startup
2. Fabric covers must be replaced periodically
3. Pan roller cannot be skewed

In current web press applications, the major appeal of this design is its excellent print performance. Its major drawback is that the fabric roller covers used have unpredictable lives, and therefore are the source of unscheduled press downtime when they fail during a run.

5.8 Spray Dampeners

This type of dampener is of interest because it is widely used on newspaper presses and on web presses for printing forms. Like the brush dampener, it is seldom if ever found on sheetfed presses.

5.8.1 Evolution. The idea of using an array of some type of atomizing nozzles for delivering fountain solution to the rollers of a lithographic press dates back to at least the 1930's. For example, in one early concept, water was sprayed onto the dampening fountain roller (Schultz, 1935) presumably to gain the ability to adjust feedrate laterally.

A second concept envisioned spraying water directly onto the plate (Grembecki, 1940), while in a third, water was sprayed directly into the ink train (Larsen, 1939).

The first design to be adopted on a significant scale, however, was developed in the late 1960's (Smith, 1972) for use on forms presses. This was a twin-fluid sprayer with rather closely spaced nozzles, i.e., on the order of one inch spacing. Fluid to each nozzle was supplied by its own variable-displacement pump. All of the pumps for a given spraybar were driven by a common variable-speed motor. Lateral control of flowrate was achieved by adjusting the displacement of the individual pumps, while total flow from the bar was caused to track speed by varying the speed of the common drive motor accordingly. The fluid was discharged from each nozzle under a relatively low applied pressure (about 5 pounds/square inch) and a separate high-velocity stream of air was also discharged from the nozzle to effect atomization. Experience with this design apparently disclosed the need for an enclosure to contain overspray (Smith, 1977).

Beginning in the early 1970's a variety of atomizing type metering methods were devised for use in dampening systems. These included several porous-shell water pan rollers, with a row of air nozzles inside for atomizing the water picked up by the roller. The major reason why many of these early atomizing types did not catch on was the many problems that stemmed from the use of gum in fountain solution, and the low fluid delivery pressures employed. That is, gum left in the system at shutdown dried up and caused malfunctioning of the low-pressure water delivery system on subsequent startups.

The turnaround in acceptance of spray dampening systems began with the introduction of two design features: the use of relatively high pressure single-fluid nozzles and the adoption of a control scheme in which average flow rate is controlled by periodically pulsing the opening of the valves that control flow through the nozzles (Schwartz and Yamagata, 1984). Thus, all of the current spray systems operate at a constant fluid pressure in the range of about 40–100 pounds/square inch, and control average flowrate by varying the relative amount of time the nozzle control valves are open and closed.

5.8.2 Principles of Operation. The principles of fluid atomization and the various type of devices used to achieve it are described in Section 5.3.1. Figure 5.26 illustrates the principles of operation of a modern pulsed spray dampener. The key element is a spraybar consisting of an array of uniformly spaced atomizing nozzles and control valve assemblies. Each nozzle produces a more or less oval spray pattern with a flow distribution that is relatively flat except near the ends, where it falls off quite rapidly, as shown in Figure 5.26(b). For this reason, the spray patterns of adjacent nozzles must overlap to produce a uniform flow distribution across the press. In this regard, the nozzle spacing is critical because too large a spacing will result in not enough water feed at the

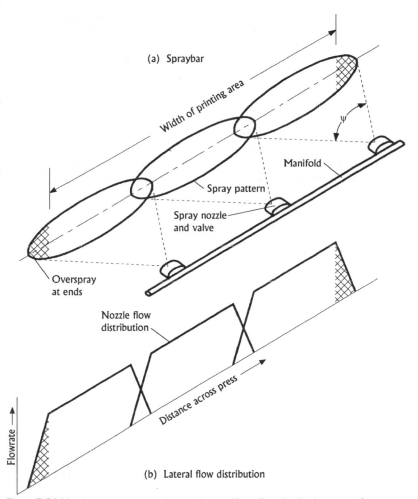

Figure 5.26 Nozzle arrangement used to produce uniform flow distribution across the press.

overlap points, while too small a spacing will result in overfeed at the overlaps. In addition, the spray patterns of the end nozzles must extend beyond the width of the press printing area to insure flow uniformity at the edges of the plate. Thus, there is overspray at the ends that must be collected and drained away.

Additional drainage is generated because all of the atomized particles that strike the target roller are not adsorbed on its surface; a small number bounce off and are scattered over a wide angle of trajectory. If these scattered particles strike a stationary surface, fluid will build up to a degree where large drops will form. If these drops are in turn allowed to drip back

onto a roller, unwanted water marks may appear randomly on prints. To prevent this, the entire spraybar must be shrouded. In addition, the shroud must be oriented so that any fluid particles that strike the shroud and coalesce on its inside surfaces can be collected and drained away. This does not pose a significant problem, however, because the drainage can be recycled by returning it to the fluid supply system.

A major advantage of a pulsed sprayer stems from the fact that the instantaneous flowrate from every nozzle can be the same. Consequently, it is only necessary to perfect a single nozzle geometry. For a given applied pressure, this in turn fixes the spray angle, ψ, shown in Figure 5.26(b). Given a fixed spray angle, it is a relatively simple task to configure a spraybar for any given width press in accordance with the following procedure:

1. Select the number of nozzles to be used in the spraybar. This establishes the spacing between nozzles.

2. Calculate the nozzle-to-roller distance, based on the spacing and spray angle.

A typical nozzle-to-roller distance is 4 inches for a spacing of 9 inches.

The special solenoid valves used to control nozzle flow make it possible to use turn-on times with durations as low as 0.02 seconds (Hultberg and Hansson, 1991). Depending on the control scheme used, average flowrate is increased either by decreasing off-time, increasing on-time, or some combination of both. The pulse frequencies used in practice equate to turning the spray nozzles on about once every plate cylinder revolution.

5.8.3 Configurations Encountered in Practice. Spray dampeners have utilized a variety of roller configurations. In many instances they have replaced brush systems on both newspaper presses and on very wide presses running commercial work. In the latter case, the separate train of dampening rollers (a dampening form and a chrome vibrator) generally has been retained. On forms presses, a separate roller train consisting of as many as four rollers has been specified (Smith, 1977). On newspaper presses, there are also many retrofit installations of ink train dampeners where the spray bar feeds water directly into the inking system. (More is said about this in Chapter 7 on nontraditional forms of lithography.) When spray systems are specified on new newspaper presses, however, the overwhelming preference has been for systems that utilize a separate train of dampening rollers (MacPhee, 1990-1). Normal practice on such systems is to use a three-roller train that includes a chrome roller. This trend is indicative of an industry consensus that better print quality is achieved with a spray dampener if a separate dampening roller train is used.

5.8.4 Performance Attributes. The atomized spray method of dampening possesses two very significant advantages: feedrate can be adjusted laterally (because nozzles can be controlled individually) and there

is no ink feedback into the fountain solution supply system. Another very important advantage vis-à-vis brush dampeners is the ability to momentarily increase feedrate when restarting a press. This is extremely valuable to newspaper printers because it results in significant savings in startup waste.

The ability to adjust feedrate across the press results in using less water to print, again vis-à-vis brush dampeners. Presumably this stems from the fact that more water is needed on the roller ends, and with a spray system this need can be fulfilled without having to run excess water in the middle. The resultant benefits that accrue to web printers are extremely worthwhile: fewer web breaks caused by baggy webs, and less web fanout; both due to less water delivered to the web. Many users also report savings in ink consumption, but to date, limited data has been produced to support this claim. The major problem with spray dampeners is the perception that they exact a tradeoff in print quality. The jury is still out as to whether this perception is simply a carryover from the problems encountered with the early (and imperfect) systems of the 1970's, or whether it is indeed a limitation of the concept.

5.9 Rotary-Atomizer Dampeners

Two different designs of rotary-atomizer dampening systems are in use today: the Turbo dampener, developed by MAN Roland, and the WEKO dampener, manufactured by the company of the same name. Both of these designs are used exclusively on web presses and therefore are described in Chapter 6.

5.10 Summary

Lithographic dampening systems are called upon to meter out a precise amount of fountain solution so that it can be delivered to the plate in the form of an equivalent thin sheet 0.3–0.4 microns (0.000012–0.000016 inches) thick that is the width of the press and is traveling at press speed. In doing so, ink must be prevented from feeding back into the dampener and fountain supply system. In addition, the dampening system design should enable the press to quickly reach equilibrium conditions. Because different industry segments have different priorities on the various aspects of press performance, a wide range of dampening system configurations are currently found in practice. The characterization of dampening systems and the unique features of current designs can be summarized as follows:

1. Dampening systems can be characterized in terms of four properties: metering method, type of flow, flow directionality, and path to

plate. The type of metering used, however, is the most common way of characterizing a given design.

2. Conventional dampeners utilize a ductor roller to transfer water from a slow-moving fountain roller to a chrome vibrator running at press speed. Although once widely used on both sheetfed and web presses, this type of dampener has been largely replaced by more modern designs. Very high print quality is achieved with this type of dampener but at the expense of the disadvantages of using fabric-covered rollers.

3. Most sheetfed presses currently sold come equipped with a dampening system that utilizes the squeeze-roller method of metering. This group of dampeners is also referred to as the continuous or film type.

4. Four different types of dampeners are used on web presses: squeeze roller, spiral brush, skimming roller, and spray.

5. Squeeze-roller dampeners use a pair of rollers to meter out the dampening fluid. The rollers are geared together and driven by a variable-speed motor over a speed range of from zero to 100–150 feet per minute. Because the press rollers travel at much higher speeds, slippage must occur at some nip in the train leading to the plate. Both three- and four-roller trains are used. Although there are many older plate-feed systems in use, the majority of current designs are of either the plate-feed or combination type. This type of dampener is easy to use, has quick response and low maintenance, and produces very good print quality. The biggest complaint on sheetfed presses is about the need to use isopropyl alcohol in the fountain solution, or the difficulty of achieving comparable performance with alcohol substitutes. On web presses, the most commonly encountered problem is ink buildup on ink-receptive dampening rollers, and ink feedback into the fountain solution supply system.

6. Spiral-brush dampeners utilize a high-speed rotary brush to flick water off of a slow-moving fountain roller and onto a roller moving at press speed. On commercial web presses, water is normally delivered by the brush to a separate train of dampening rollers that includes a fabric-covered form roller. On non-heatset presses, as used, for example, in newspaper printing, fabric covers are not used. Also, on some newspaper presses, the water is flicked into the ink train. Brush dampeners are easy to operate, and avoid ink feedback into the fountain solution supply system by virtue of the physical gap that exists between the brush and the press rollers. The biggest complaint about brush dampeners is the need to periodically clean the brush of contamination by ink fly, which otherwise would degrade print quality.

7. Skimming-roller dampeners utilize a train of four rollers in series. Metering is carried out by a slow-moving chrome fountain roller that delivers fountain solution to a fabric-covered roller traveling at press speed. From there fountain solution is transferred to a vibrating chrome roller and hence to the plate via a fabric-covered dampening form roller. This type of dampener is widely used on single-width newspaper presses, and has a

reputation for excellent print performance. Its major disadvantage is that the fabric roller covers on the form rollers have unpredictable lives, and therefore are the source of unscheduled press downtime when they fail during a run.

8. Spray dampeners use an array of nozzles to direct a stream of atomized water particles onto a press roller. Where it is desired to maximize print quality, a separate train of dampening rollers is utilized. The major advantages of spray dampeners are the elimination of ink feedback into the dampen fluid supply system, the ability to adjust water feedrate in the across-the-press direction, and the ability to momentarily increase feedrate at startup. These result in less startup waste, fewer web breaks, and less fanout vis-à-vis brush dampeners. The major disadvantage of spray dampeners is the current perception that they extract a tradeoff in print quality. This perception may be a carryover, however, of the poor performance of the early (and imperfect) spray dampeners of the 1970's.

5.11 References

Beisel, H., "Dampening-Inking Unit for Offset Printing Machines," *U.S. Patent 4,440,081,* Nov 19, 1984.

Blanchard, A. "Film Dampening System for a Rotary Offset Press," *U.S. Patent 5,191,835,* Mar 9, 1993.

Bruno, M.H., "The Dampening Problem in Lithography," *Proceedings of Seminar on Lithographic Dampening Systems,* joint R&E Council/LTF meeting, Feb 8, 1962, pp 17.

Dahlgren, H.P., "Lithographic Offset Press Plate Dampening Device," *U.S Patent 2,868,118,* Jan 13, 1959.

Dahlgren, H.P., "Dampening Device and Method for Lithographic Offset Printing Plate," *U.S. Patent 2,972,944,* Feb 28, 1961.

Dahlgren, H.P., "Means for Dampening Lithographic Offset Printing Plates," *U.S. Patent 3,168,037,* Feb 2, 1965.

Dahlgren, H.P., "Lithographic Dampener with Skewed Metering Roller," *U.S. Patent 3,343,484,* Sept 26, 1967.

Delavan, *Catalog of Industrial Nozzles and Accessories,* Delavan Industrial Products Operation (Lexington, Tennessee), 1987, p 2.

Dunbar, R.V., "The Goss Brush Dampening System," *Papers Presented to the Lithographic Dampening Conference,* Dec. 7–8, 1967 (GATF and R & E Council), 1968, pp 37–41.

Folkes, N.L., *A Study of the Epic Delta Dampening System's Ability to Eliminate Plate-Caused Hickeys,* RIT Master's Thesis, Nov 1994, 33 pp.

Fraser, R.P., and Eisenklam, P., "Liquid Atomization and the Drop Size of Sprays," *Transactions of the Institution of Chemical Engineers,* Vol. 34, 1956, pp 301.

Greiner, H.M., "Development of Modern Dampening Systems," *Proceedings of Pira/IARIGAI International Conference on Applied Lithographic Technology,* London, Oct. 7–9, 1970, PIRA (Leatherhead) 1971, pp 37:1–37:5.

Grembecki, E.C., "Dampener for Printing Presses," *U.S. Patent 2,196,412,* Apr 9, 1940.

Goedike, J.G., "Dampening System for Lithographic and Analogous Presses," *U.S. Patent 2,126,768,* Aug 16, 1938.

Goodman, R. M., "Basic Lithography and Offset Printing Plates: Impact on Printing Problems," *Proceedings of 1992 International Printing & Graphic Arts Conference,* TAPPI Press, Oct 18–21, 1992, p 302.

Guaraldi, G.A. and Skowron, M., "Apparatus for Preventing Undesired Fluid Flow Past a Flow Control Location," *U.S. Patent 5,027,705,* Jul 2, 1991.

Hultberg, S. and Birger, H., "Control Method and Apparatus for Spray Dampener," *U.S. Patent 5,038,681*, Aug 31, 1991.

Kist, K., "The Miller-Meter System," *Lithographic Dampening Conference Proceedings*, GATF, printed illustrations and taped presentations, 1976, Part II, p33.

Larsen, C.E., "Process and Arrangement for Dampening the Flatbed Printing Forms of a Printing Press, Particularly in Offset Printing," *German Reich Patent 678,543*, Jul 17, 1939 (in German).

Lefebvre, A.H., *Atomization and Sprays*, Hemisphere Publishing Corporation (New York), 1989, p 4.

MacPhee, J., "Trends in Litho Dampening Systems Show Vast Improvements in Designs," *Graphic Arts Monthly*, Technical Publishing Company (New York), April 1981, p 35.

MacPhee, J., "Recent Trends and Developments in Lithographic Dampening," *Graphic Arts Monthly*, Technical Publishing Company (New York), Sept 1984, p 76.

MacPhee, J., "Further Insight into the Lithographic Process—With Special Emphasis on Where the Water Goes," *1985 TAGA Proceedings*, pp 269–297.

MacPhee, J., "Interrelationship of the Variables and Parameters Which Affect the Performance of Brush Dampeners," *1987 TAGA Proceedings*, pp 306–330.

MacPhee, J., Internal Baldwin company report, Nov 21, 1989.

MacPhee, J., "Update on Dampening," *Graphic Arts Monthly*, Technical Publishing Company (New York), March 1990, p 63.

MacPhee, J., Internal Baldwin company report, July 16, 1990.

MacPhee, J., Internal Baldwin company report, Oct 10, 1991.

MacPhee, J., Internal Baldwin company report, Feb 21, 1995.

MacPhee, J., "New Insights into the Behavior and Elimination of Hickeys," *American Ink Maker*, PTN Publications (Melville) May 1994, p 32.

MacPhee, J. "Fountain Solution Supply System," *U.S. Patent 5,619,920*, Apr 15, 1997.

MacPhee, J. and Cerro, R.L., "Performance Analysis of Brush Dampeners," *Chemical Engineering Science*, Pergamon Press, (New York), Vol. 44, No. 4, pp 841–849, 1989.

MacPhee, J. and Lester, L.E., "Some New Ideas on Pinpointing the Cause of Horizontal Printing Streaks," *1986 TAGA Proceedings*, p 89.

MacPhee, J., and Lester, L.E., "Dampening System," *U.S. Patent 4,724,764*, Feb. 16, 1988.

Norton, R.K., "Mechanism for Applying a Coating to a Plate," *U.S. Patent 3,433,155*, Mar 18, 1969.

Nothman, G. A., "The Miehlematic Dampening System," *Papers Presented to the Lithographic Dampening Conference*, Dec. 7–8, 1967, GATF and R & E Council, 1968, pp 17–23.

Saul, A.A., "Dampener for Printing Presses," *U.S. Patent 3,106,154*, Oct 8, 1963.

Schneider, G., "Dampening System," *U.S. Patent 5,123,346*, Jun. 23, 1992.

Schultz, J., "Dampening Device for Lithographic Offset Presses and the Like," *U.S. Patent 1,991,961*, Feb 19, 1935.

Schwartz, M. A. and Yamagata, T., "Fluid Dispensing Apparatus Such as Spray Dampener for Printing Press and Method of Dispensing," *U.S. Patent 4,469,024*, Sept 4, 1984.

Smith, R.R., "Spray Dampening System with Individual Metering Pumps for Offset Press," *U.S. Patent 3,651,756*, Mar 28, 1972.

Smith, R.R., "Spray Dampening System for High Quality Offset Printing," *U.S. Patent 4,044,674*, Aug 30, 1977.

Trollsas, P. O., Eriksson, P. J., and Malmqvist, L., "Determination of Time Dependence of Dimensional Changes in Newsprint," *Proceedings of International Printing & Graphic Arts Conference*, TAPPI Press, Oct 18–21, 1992, p 345.

Tyma, L. "The Goss Brush and Miehle-Matic/Roland-Matic System," *Lithographic Dampening Conference Proceedings*, GATF, printed illustrations and taped presentations, 1976, Part II, p 34.

Zavodny, E. N., "Roller Nip Behavior with Fountain Solution," *1973 TAGA Proceedings*, pp 211–223.

Chapter 6

Unique Features of Web Printing

A web press derives its name from the fact that printing is carried out on a continuous strip of paper supplied from an unwinding roll at the infeed end of the press. The printed web is either rewound onto a roll or else is fed to a sheeter or folder where it undergoes a finishing process, that includes cutting, to produce either sheets or folded pieces called signatures.

Web presses that utilize the lithographic process are important because, in the U.S. at least, they produce a significant amount of printing vis-à-vis sheetfed presses. The data in Table 6.1 on annual ink consumption provides a measure that the volume of printing done on web presses is over six times the volume done on sheetfed presses. The same table also contains a comparison of the value of the ink used, which is a measure of the value of printed products produced on the two types of presses. This indicates that the value of printing produced on web presses is not quite twice that of sheetfed presses, i.e., that the unit printing costs on web presses are lower than sheetfed. A third measure of the importance of web printing is the estimate by printing press manufacturers that over 47 percent of all the money spent to purchase offset printing presses worldwide in 1985 was for web presses (Porter, 1990).

Table 6.1 Annual ink usage on sheetfed and web offset presses in the U.S. for the year 1992 (U.S Dept. of Commerce, 1995).

Printing sector	Ink usage	
	Consumption in pounds	Value in U.S. dollars
Sheetfed offset	107 million	425 million
Heatset web offset	287 million	486 million
Non-heatset web offset	398 million	341 million

Offset printing on a webfed press involves the same basic steps outlined in Chapter 1 for a sheetfed press, and the major press elements, cylinders, plates, blankets, rollers, and inking and dampening systems, are

much the same. Nevertheless, web presses possess several features that are so unique as to warrant this separate chapter on the subject.

The first two sections in this chapter take up the relative merits of web presses, as compared to sheetfed, and describe overall web press design. These are followed by sections on web tension, cylinders, blankets, and plates, and on the inking system design variations found on web presses. A section has also been included that identifies the dampening system designs that are unique to web presses and the designs that are most commonly used on web presses. Readers whose sole interest is in web printing may be disappointed by the cursory treatment given in this chapter to the paper handling and finishing equipment which are an integral part of any web press. The limit in treatment is, however, in keeping with the intent of this work to address the mechanics of *printing*.

6.1 Relative Merits of Web Presses

6.1.1 Advantages. The popularity of web presses stems from the many advantages they possess over sheetfed presses. The advantages are listed and described as follows:

1. **Speed.** Web presses are capable of running at speeds as high as 3000 feet/minute (164 meters/second) as compared to a top speed of about 700 feet/minute (38 meters/second) for a sheetfed press. These speeds equate to an even greater difference in productivity, 100,000 versus 15,000 impressions/hour, due to the smaller diameter of the printing cylinders used on web presses.

2. **Perfecting Capability.** The strict definition of a perfecting press is one that prints on both sides of a web of paper and then cuts and folds it to form a product ready for use, as in the case of a newspaper press. The industry, however, has come to adopt a broader meaning of perfecting, i.e. the capability to print on both sides during one pass through the press. Thus, certain sheetfed presses are called perfecters because they have the ability to turn the sheet over after it passes through a printing unit such that the other side can be printed in subsequent units. Web presses, however, have the ability to print on both sides in the same printing unit due to the fact that the impression cylinder can also serve as a blanket cylinder for the bottom side of the paper. Thus, a web press is a more efficient system for perfecting and this enhances its productivity. The way that the cylinders are arranged on a web press to achieve this capability is described in Section 6.4.2 below.

3. **In-line Finishing.** Finishing describes the various operations such as folding, trimming, and cutting to length that are performed following printing to create the final product. Web presses are such that a wide variety of these operations can be carried out in-line, i.e., during passage

Figure 6.1 Types of signatures commonly produced on commercial web presses. Arrows indicate folding sequence; dotted lines location of subsequent fold. Oftentimes webs are slit into ribbons prior to folding.

through the press. Foremost of these operations is folding and cutting the printed web to produce a signature. Figure 6.1 illustrates the most common types of signatures delivered by web presses. It is to be understood that these are just a few of the many types of products that can be produced in-line.

Other operations that can be performed in-line include cutting to length, trimming, scoring, coating, numbering, pasting, stitching, and

punching. It is obvious that these features greatly enhance productivity depending on the form of the final product. For example, newspapers are produced completely on-press with the finished product delivered ready for shipment. (It is somewhat incongruous that a newspaper in the traditional format, such as the *New York Times,* is folded into tabloid signatures. The tabloid newspaper format, such as used by the *New York Daily News,* is also a tabloid signature and is obtained by slitting the ribbon along its centerline as it enters the former board.)

4. **Paper Cost.** The cost of a given grade of paper is 15–20 percent lower in roll form than in sheet due to the additional expense and waste in sheeting and the larger lot size inherent in rolls. Although the net cost difference is less because the percentage of waste on a sheetfed press is less, the cost difference is still significant.

5. **Range of Substrates.** It is much easier to print lower grade papers, such as newsprint, and very thin papers on web presses. Therefore it can be said that web presses have the ability to print on a wider range of substrates.

6. **Spray Powder.** A major bane of sheetfed printing is the need on many jobs to spray a minute amount of powder (usually cornstarch) on each sheet as it is delivered. This is to separate the sheets so as to prevent them from sticking together in the delivery pile before the ink dries. The powder is objectionable because it roughens the printed surfaces and contaminates press components and nearby equipment. Thus, another advantage of a web press is that the need for spray powder is eliminated because different ink setting processes are used, as described in Section 6.2.2.

6.1.2 Disadvantages. Because of their makeup, web presses also possess certain drawbacks vis-à-vis sheetfed presses and these are recounted in the following paragraphs.

1. **Complexity.** The various components needed to feed, guide, process, and finish the web of paper used add considerably to the complexity of a web press. (These components are identified and described in Section 6.2.1.) This greater complexity affects both capital and operating costs, as discussed below. In addition, compared to sheetfed printing, it results in longer job setup or makeready times, and the requirement for a larger operating crew.

2. **Capital Cost.** The perfecting capability of web presses, together with their greater complexity, results in significantly higher capital costs for a given size and number of units. This difference can easily amount to over a factor of two.

3. **Operating Costs.** The hourly operating cost of a web press is generally much higher than for a sheetfed press of comparable size. This is due primarily to the higher capital cost of the web press.

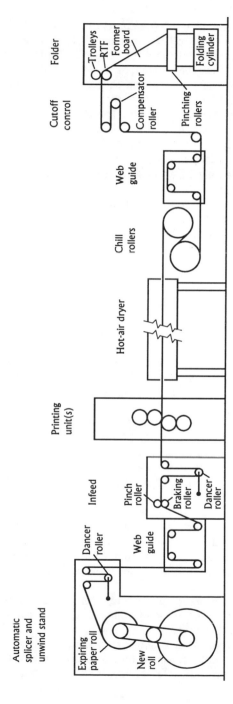

Figure 6.2 Makeup and arrangement of components on a typical heatset web offset press. Generally at least four printing units are provided. In addition to the folder shown here, three other types of delivery devices are used: rotary cutters, sheeters, and rewind stands.

4. Sheet Length. The cutoff or repeat length of most web presses is fixed. As a result, a fixed amount of paper must be fed through the press for each rotation of the plate cylinder. This in effect freezes the length of sheet that must be printed to avoid excessive paper waste. In contrast, sheetfed presses can print on sheets that range anywhere from about 50 percent to 100 percent of the maximum allowable sheet length.

5. Ink Setting Processes. The two main ink setting processes used on web presses (described further in Section 6.2.2) differ from the oxidation curing process used most often on sheetfed presses. These differences are extremely important because most web inks are never truly dried, but instead are only set or immobilized on the paper. Consequently the ink on the printed web has a greater potential to rub off in the case of newspapers, and to smear in handling (due to exposure to the oil from one's skin) in the case of higher quality products, like magazines. In contrast, sheetfed inks dry like paint and therefore are much more permanent. (Drying by oxidation requires time, which explains why this drying process cannot be used on web presses.)

6.2 Web Press Design

It has already been mentioned that the additional components used on a web press to control the web and to dry and finish the printed product result in a more complex system relative to a sheetfed press. There are four other broad web press characteristics that set them apart from sheetfed presses: two different ink curing processes are used; press designs are more specialized and hence can be grouped into at least six broad categories; the paper is held in tension; and the cylinders are usually configured in a way to allow perfecting. The first three of these differences are addressed in the sections that follow immediately. The fourth, web tension, is discussed at length in Section 6.3 while the fifth, perfecting, is elaborated on in Section 6.4.2, which includes a description of the roller and cylinder arrangements found in typical web presses.

6.2.1 **Key Components.** Web presses most often include a multitude of major components beyond the printing units. This is brought out in Figure 6.2 that illustrates a typical single web heatset press, and Figure 6.3 that illustrates a typical double-width newspaper press. The various components portrayed are described below.

1. **Automatic Splicer and Reel Stand.** The web paper is supplied to the press in the form of rolls 42 to 50 inches (107 to 127 cm) in diameter that weigh up to 2500 pounds (1134 kilograms) for 35-inch-wide (89-cm) presses, and over twice as much on very wide presses. A roll to be printed is mounted in a reel stand where it unwinds as the web is payed out. Most reel stands have provisions for mounting two, and

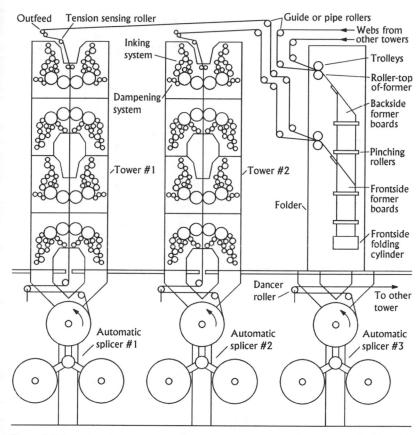

Figure 6.3 Layout and arrangement of components on a typical tower-type double-width newspaper press. Press may have additional towers not shown.

sometimes three, rolls of paper and are designed for on-the-fly splicing of the lead end of a new roll to the tail end of the expiring roll, hence the name automatic splicer. Automatic splicers thereby eliminate the need to shut down the press to change a roll, since an expired roll can also be removed and replaced with a fresh one while the press is running.

Two types of automatic splicers are currently in use: match-speed and zero-speed. These names stem from the fact that in the former, splices are made at press speed, while in the latter the tail end of the web is momentarily stopped to make the splice. Two designs of match-speed splicers are used: turret and in-line. In the turret design, shown in Figure 6.2 and 6.3, each roll is installed on the ends of a pair of parallel arms or spokes that radiate from a common shaft. During an automatic splice, the new roll of paper is accelerated to press speed and the shaft on which the arms are mounted rotates so as to position the new roll where it can be

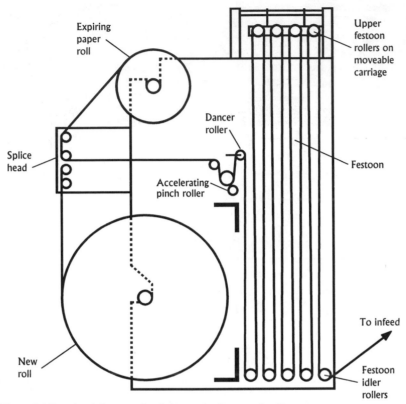

Figure 6.4 Functional diagram of typical zero-speed automatic splicer.

spliced to the running web, while at the same time the expired roll is severed from it. Further movement of the arms places the expired roll in a position where its core can be removed and replaced with a new roll.

In the zero-speed or festoon type of automatic splicer, shown in Figure 6.4, the web passes up and down and over two rows of rollers spaced 12 or more feet apart. In this way, as much as 200 feet (60 m) of web length is stored in the festoon or labyrinth that is formed.

When it becomes necessary to splice on the new roll, the expiring paper roll is momentarily brought to a stop by a brake. This causes the web to stop moving at the splice head, located upstream of the festoon, thereby making it possible to effect the splice with the web at rest. While the splice is being made and the expiring web is severed, the top row of festoon rollers starts to move down, or collapse, toward the lower set thereby providing an uninterrupted supply of web to the press.

Once the splice is made, the web from the new roll is brought up to speed by the driven accelerating roller and the collapsed row of festoon

rollers is slowly returned to its normal position to await the next splice.

Both types of splicers include systems for controlling the amount of pull or tension that is exerted on the web in unwinding the paper roll. A tension of about one pound per inch (1.8 N/cm) of web width is typically maintained at this location in the press. This relatively low tension is chosen so as to minimize web breaks due to overstressing of the splice. Most of the current systems for controlling web pullout or roll tension, referred to as roll tension controllers, employ the dancer roller principle shown in Figures 6.2, 6.3 and 6.4. The principle of operation of the dancer roller is described in the section below on infeeds.

The preceding descriptions make it clear that festoon-type splicers differ from turret-types in two respects: the rolls of paper are in fixed positions, and the splice is made on a stationery section of the web. Because of these differences, festoon type splicers are less expensive to build and the task of preparing the splice is much more straightforward. The advantages of the turret type, which predates the festoon type, are its ability to operate at much higher web speeds and the much smaller floor space occupied by it. Also, less time is required to change rolls in a turret type because the paper rolls are not mounted on through shafts, that in contrast must be installed in new rolls and removed from expired rolls on a festoon type.

2. Web Guides. Because the mechanical properties of the web may vary in the across-web direction, the web may have a tendency to wander toward one side or the other of the press. Therefore, some type of web guiding device is required at both the infeed and delivery ends of the press to keep the web centered in its path. The type shown in Figure 6.2 is the four-roll steering box in which the top pair of rollers can be canted either way in the horizontal plane so as to move the web sideways in either direction. In all designs, some type of sensor is required to measure the lateral position of the web. When web movement to one side or the other of the desired lateral position is detected, a corrective signal is generated. In the four-roll steering box design shown, the top pair of rollers is canted in the appropriate direction, in response to the corrective signal, thereby causing the web to return to the desired lateral position.

3. Infeed. Some web presses are also equipped with web tensioning devices, called infeeds. The basic purpose of this device is to establish the magnitude of web tension into and out of the printing units. Tension in this region of the press is normally maintained at a level of 1 to 5 pounds per inch of web width (1.8 to 8.8 N/cm) depending on the grade of paper. This tension, which is well below the rupture strength of the corresponding typical papers, is necessary for proper passage through the printing cylinder nips, as explained in Section 6.3.

The infeed system for controlling tension consists of two elements: an assembly of two or three pinch rollers and a downstream device for sensing web tension. In the tension sensing device generally used, the web is led

around a movable (dancer) roller to form a U-shaped loop. Tension in the web therefore results in a pull on the roller. This pull is resisted by air cylinders that push against the pivoted roller hangers. With the dancer roller in its mid position, web tension is proportional to air pressure and can be varied by adjusting the air pressure in the cylinders.

The hangers supporting the dancer roller are also equipped with a device for sensing roller position and generating a corresponding signal. Thus, for the dancers shown in Figure 6.2, a roller movement in the upward direction produces a signal indicating an increase in tension. Conversely, a roller movement in the downward direction produces a signal indicating a decrease in tension. Web tension is thus regulated at the desired level (set by the air pressure) by varying the speed of the pair of pinch rollers located upstream, in response to changes in the web tension signal. More is said about web tension in Section 6.3.

As shown in Figure 6.3, infeeds are not needed or provided on many newspaper presses. This is because the tension necessary in the printing units (about one pound per inch of web width) is comparable to the pullout or tension maintained by the roll tension controller. Thus, a single tension control system serves both needs.

4. Printing Units. The heart of a web press is made up of one or more printing units, depending on the type of press. Typical web printing units are described in more detail in Section 6.4.2.

5. Outfeed. The outfeed, like the infeed, is a web tensioning device. Its name is derived from the fact that it is located on the exit side of the printing units, as shown in Figure 6.3. It is installed only on non-heatset presses because the chill rollers on a heatset press act as an outfeed. More on its use is given in Section 6.3, on tension.

6. Dryer. Web presses of the heatset type are so called because the printed film of ink is cured by evaporating off the solvent component of the ink vehicle. To accomplish this, it is necessary to heat the web as it emerges from the last printing unit and to exhaust the ink solvent vapor that is driven off. This is the job of the dryer. The vast majority of dryers used today on heatset offset web presses are of the hot air type, shown schematically in Figure 6.5 (MacPhee and Gasparrini, 1984). In this type of dryer, jets of high velocity hot air are directed toward both printed surfaces of the web, producing two results as follows:

(a) The ink and paper are heated to a temperature of about 275 degrees Fahrenheit (135 degrees Celsius), thereby causing most of the ink solvent to evaporate.

(b) The ink solvent vapor emerging from the printed films is carried away by the swiftly moving air.

Two main fluid circuits are provided in such a dryer: a recirculating system and an exhaust system. The former, consisting of a blower, burner,

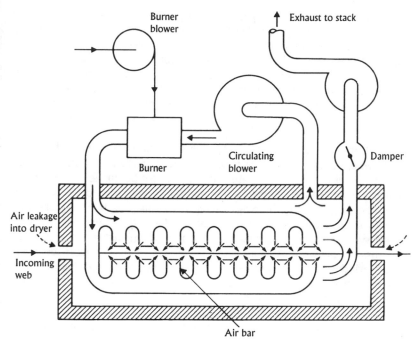

Figure 6.5 Functional diagram of hot-air dryer used on heatset web presses.

and air jet bars, performs three important functions as follows:

(a) Heats the air in the dryer to 300–400 degrees Fahrenheit (149–204 degrees Celsius) in order to evaporate the ink solvent.

(b) Generates high velocity air jets that impinge on the web to enhance heat transfer and carry away the ink solvent.

(c) Provides thorough mixing of the air and vapors in the dryer volume thereby minimizing dead spots where high concentrations of vapor might accumulate.

The exhaust system consists of a blower, damper, and stack. Its purpose is to provide a known rate of discharge over a known and safe exit path for the combustible vapors that are evaporated from the film of printed ink. This is accomplished in two ways. First, the exhaust blower creates a negative pressure in the dryer enclosure, thereby insuring that any uncontrolled leakage will be into the dryer. Second, the blower generates a flow of the air-vapor mixture from the dryer enclosure to the outside by way of an exhaust stack. Before it is discharged to the environment, the exhaust passes through either a catalytic converter or a thermal incinerator to reduce the amount of volatile organic compounds to acceptable levels.

7. **Chill Rollers.** After passing through the dryer, the warm ink is quite soft and must be hardened or set to prevent smearing during finishing. This is accomplished by passing the web over water-cooled rollers, referred to as chill rollers, that rapidly cool both the ink and paper substrate. The chill rollers are coupled to the main press drive through a positive, variable-speed transmission, usually of the harmonic drive type. The controls of the transmission can be used by the pressman to vary web pullout from the printing units and thereby vary tension (and set relaxed print length), as explained in Section 6.3.

8. **Cutoff Control.** In most web presses, the web is fed either to a sheeter where it is cut into sheets, or to a folder where it is folded and cut to form signatures. In both cases, the cut must be made at the point between the end of a given impression and the beginning of the subsequent impression, i.e., the point corresponding to the plate cylinder gap area. In order to control the register or location of the cut, some type of cutoff control system is required. Generally such a system includes a moveable compensator roller that is located so that the length of web path, between the last printing unit and the pullout rollers in the folder (or sheeter), will change when it is moved. For example, as shown in Figure 6.2, the web travel may form a "U" around the compensator roller such that a roller move to the left shortens the web path. The cutoff control system also includes an encoder that generates a pulse for every plate cylinder rotation, and an electro-optical device for detecting variations in the printed image along the web. The electro-optical detector is locked onto a particular repetitive point of the printed image enabling the controller to measure the interval between the encoder pulse and a pulse corresponding to the locked-on point. This interval provides a measure of the register of the cutoff point. Thus, when a change in this interval is detected, a corresponding signal is generated to cause the compensator roller to move in the direction necessary to correct the change in register.

9. **Delivery Device.** The printed web is most frequently delivered to a folder, as illustrated in Figures 6.2 and 6.3. Although a wide variety of folder types are used, most include a former board for making the first fold along a line parallel to web travel. The way in which this is accomplished is shown in Figure 6.6. Additional folds can be made in either direction using other types of folders that employ cylinders and/or rollers. One such example, used primarily on newspaper presses, is also shown in Figure 6.6. It employs a folding cylinder equipped with three different devices located around its circumference: cutting cushions, cam-operated folding pins, and retractable tucker blades. The folding cylinder, equal in diameter to the press plate cylinder (that has two newspaper pages around), runs against a cutting cylinder half its diameter. The cutting cylinder has a knife extending the length of the cylinder that alternately comes into contact with the two cutting cushions of the folding cylinder, thereby making cuts equal to the length of one page.

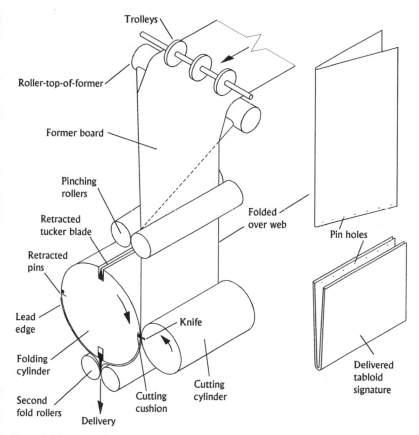

Figure 6.6 Diagram showing how two common folds are made on web presses.

Simultaneously with a cut, the pins in the folding cylinder extend to maintain a hold on the lead edge of the folded-over web exiting from the pinching rollers. When the middle of the just-cut tabloid signature reaches the second fold rollers, the tucker blade extends, forcing the middle of the page into the nip of these rollers. At the same time, the pins holding the lead edge of this signature retract, thereby permitting the signature to be drawn through the nip of the rollers where the second fold is made.

On commercial presses, second fold rollers are not normally used. Rather, a second cylinder, equipped with jaws, is used instead. These jaws receive the signature from the tucker blades and grasp the signature along the second fold so that it can be transferred to either another folding device or to the delivery. Thus, on commercial presses, this type of second fold is referred to as a jaw fold.

The cutting cylinder also has a set of pins that can be extended on alternate cuts. In so doing, every other signature is stored or "collected"

for one revolution on the cutting cylinder. In this way, every two consecutive signatures can be collated to form a single larger signature.

The folder just discussed is but one of a great variety of types used on web presses that include double former (with and without pins), combination, jaw, and ribbon (Kelly, Crouse, and Supansic, 1974). It also is representative of one of the four different devices to which the printed web may be delivered. The other three are a sheeter, a rotary cutter, and a rewind stand. The form of products created by each of these devices is given in Table 6.2, along with the distance between cuts. From this table it is obvious that the type of delivery device needed on a particular press is dependent on the requirements of the particular jobs to be run on that press. For example, on newspaper presses where the same type of job is run day in and day out, a single type of delivery device, a folder, is normally all that is installed. On commercial presses, however, where a wide variety of jobs is run, it is not uncommon for two or three different types of delivery devices to be installed such that the web travel path can be switched to whichever device is appropriate for a given job.

Table 6.2 Characteristics of products created by the various types of delivery devices used on web presses. A signature is defined as a printed sheet that has been folded one or more times. In most cases, press cutoff is equal to either the circumference (repeat length) of the plate cylinder or one half that amount.

Delivery device	Form of product	Distance between cuts
Folder	Signature	Press cutoff
Rotary cutter	Signature or sheet	Adjustable
Sheeter	Sheet	Press cutoff
Rewind stand	Continuous roll	Length on roll

6.2.2 Ink Setting Processes. Drying, as applied to the curing of a wet film of ink, is taken here to mean the chemical conversion of an ink to a solid. In traditional sheetfed printing, the inks used contain vegetable oils that dry by oxidation. Most often a catalyst or drier is included in sheetfed ink formulations to speed the process. The inks used in a vast majority of web presses employ oils that are non-drying. (Exceptions are the small number of web presses that use UV or EB cured inks.) Thus these inks do not dry in the above sense, but rather are cured by setting, i.e., by a physical process that immobilizes the printed film. Two different setting processes are employed: heatset and coldset, although the latter is more often referred to as non-heatset. The principles of these two methods of curing are outlined in the following paragraphs.

1. **Heatset.** In the heatset process, the printed ink film is immobilized by increasing its viscosity to that of the resin that is used, along with an oil, to form the vehicle that carries the ink pigment particles. This is accomplished by first heating the ink film and substrate in a hot-air dryer to evaporate the ink oil. This heating softens the resin that is left behind, so it is necessary to harden the resin by cooling it. This second step is accomplished by passing the printed web over the chill rollers located at the dryer exit, shown in Figure 6.2. Strictly speaking, the cured ink film is not dry because the remaining resin that bonds the pigment particles to the paper has not been chemically converted, and can thus be resoftened by reheating or by adding oil to it. The latter point explains why a heatset ink film can be smeared by rubbing it with the oil exuded by a person's skin.

2. **Coldset.** The coldset (non-heatset) process is limited to printing on uncoated paper such as newsprint. Here, the printed ink film is immobilized by penetration of the vehicle, which contains mostly non-drying mineral or soy oils, into the paper. The fluid is entrapped in the interstices between the paper fibers and thus is largely immobilized. If not all of the vehicle can penetrate, then some of the ink can be rubbed off in handling the product, a not uncommon problem with newspapers.

6.2.3 Categorization of Web Presses. Web presses are, to a far greater extent than sheetfed presses, tailored to produce specific products, such as newspapers or books. Consequently, there are enough differences that they can be divided into groups or categories that have distinguishing characteristics, as shown in Table 6.3. The reader is cautioned that this categorization is a general one, and therefore exceptions can be found. For example, while a very large majority of double-width newspaper presses have vertical webs, some such presses have been made with a horizontal web configuration. More information about each category is given in the paragraphs that follow.

1. **Commercial Heatset Presses.** This group of presses is used to print annual company reports, magazines, catalogs, and the like. A typical press has a single web, 35 to 38 inches wide, and is equipped with six printing units. There are, however, many presses in this group that have two webs and a total of eight to nine units. As indicated in Table 6.3, presses in this category range in width from 18 up to 57 inches. Such presses must be equipped with a dryer to set the ink that is used. This need favors a horizontal web because the web can be led directly into the dryer, thereby avoiding turning rollers that would smear the undried ink. A typical commercial heatset press is illustrated in Figure 6.2.

2. **Commercial Non-heatset Presses.** This category, which also includes single-width newspaper presses, encompasses a rather narrow range of web widths (27 to 36 inches), but a wide range in the number of webs per press (1–12), and the number of printing units per web (1–4). This is

Table 6.3 Broad categorization of web presses. Characteristic data listed applies to the majority, but not all, of presses in the U.S. that make up the given group or type.

Type of press	Web characteristics		Max width (inch)	Number of printing units/web	Perfecting or Non-perfecting	Type of ink
	Attitude	Number per press				
Commercial, heatset	Horizontal	1–2	18–57	4–6	Perfecting	Heatset
Commercial, non-heatset and Newspaper, single-width	Horizontal and Vertical	1–12	27–36	1–4	Perfecting	Non-heatset
Newspaper, double-width	Vertical	1–10	50–60	1–4	Perfecting	Non-heatset
Forms	Horizontal	1	17–21	2–8	Non-perfecting	Heatset and Non-heatset
Book	Horizontal	1–2	23–66	1–4	Perfecting	Heatset and Non-heatset
Directory	Horizontal	1–2	65–80	1–4	Perfecting	Non-heatset

because the commercial presses in this group tend to have only one or two webs per press, and four printing units per web, whereas the newspaper presses have more webs and a higher incidence of a single printing unit per web.

3. **Double-Width Newspaper Presses.** These presses are unique in that a very large majority have vertical webs. The roll stand is located at the bottom, and provides the support for the 1 to 4 printing units mounted above it. Given the large number of webs used and the wide webs employed, these presses can be extremely large. The almost universal selection of the vertical web configuration by newspaper printers is attributed to the better access provided to the plate and blanket cylinders, with the web in place. This access is important because many daily papers require frequent plate changes during printing to supply regional editions. The use of non-heatset ink in these presses permits the many webs that are often run to be routed over guide rollers to a common folder. A typical tower-type double-width newspaper press is illustrated in Figure 6.3. Another typical double-wide newspaper press configuration that utilizes a single unit with a half deck is illustrated in Figure 7.2 in Chapter 7.

4. **Forms Presses.** As the name suggests, this group of presses was originally developed to print business forms of the type used for orders, invoices, expense reports and the like. Consequently, the web was printed on only one side (non-perfecting) and relatively few printing units were needed per web. In the last ten years of so, however, the range of products has been expanded to include commercial products such as mailers and multicolor envelopes. The number of printing units provided per web has thus increased to as many as eight, to permit printing of four colors on both sides of the web. This is accomplished by also providing turning bars that enable the web to be turned over after passing through the first half of the press such that the bottom side can be printed in passing through the second half of the press. Thus, forms presses are unique in utilizing relatively narrow webs and non-perfecting printing units.

5. **Book Presses.** Traditionally, book presses printed a single color, black, and thus were equipped with a single printing unit per web. With the growth in color printing, more and more book presses are being installed with four printing units per web.

6. **Directory Presses.** This group derives its name from the product printed: telephone directories. Directory presses are characterized by wide horizontal webs and (usually) the absence of a dryer.

6.3 Web Tension

An absolutely essential condition to the success of web printing is that the web must be held in tension. The reasons for this, along with the principles that govern tension and their reduction to practice, are described in this section.

6.3.1 **The Need for Web Tension.** In order for printing to succeed on a web press, the web must be tensioned. There are two reasons why this is necessary. First, some tension is required to overcome the bending resistance of the paper to insure that the web follows a consistent path as it is unwound from the roll and then pulled over the various rollers, bars, and boards in the reel stands and delivery section of the press. Second, considerable force is required to peel, or separate, the web from the blanket at the exit of each printing nip, i.e., for blanket release, in a manner that does not adversely affect register. The magnitude of the tension needed to accomplish these two tasks depends on the stiffness, or bending resistance, of the paper, the tack of the ink, and the amount of ink coverage on the plate.

As noted in Section 2.3.5, blanket release forces as high as 4 pounds per inch of paper width have been measured off press. Thus it is not surprising that the tensions typically required in the web spans following printing units range from between 1.0 pounds per inch of paper width (1.75 N/cm) for newsprint to as high as 5 pounds per inch (8.86 N/cm) for thicker coated stocks. In comparison, most standard 32-pound (47-g/m^2) newsprint has a tensile strength of about 10 pounds per inch of paper width or 17.5 N/cm (Gunning, 1972). The tensile strength of coated stock varies considerably, depending on thickness. For example, a typical 32-pound (47-g/m^2) coated paper with 0.0019 inch (0.05 mm) thickness exhibited a tensile strength of 16 pounds per inch (28 N/cm), while a typical 70-pound (104-g/m^2) coated paper with 0.0037 inch (0.094 mm) thickness exhibited a tensile strength of 36 pounds per inch or 63 N/cm (Hung, 1984).

The tensions required in the reel stand and delivery section of the press are somewhat lower, ranging from less than one up to a few pounds per inch.

Accurate control of web tension is important to many aspects of web printing, including the maintenance of color-to-color registration and reliable folder operation. Because of this, it can be seen that web tensioning devices are key elements of a web press.

6.3.2 **Governing Principles.** Web tension is generated through the use of a capstan, i.e., a roller capable of exerting either a pulling or a retarding force on the web. In practice, this is achieved by virtue of the friction force that can be developed between web and roller if the web is pressed against the roller. Pressure between the web and roller can be generated in one of two ways: by a compliant pinch roller, as shown in Figures 6.2, 6.3, and 6.4, or by arranging the web path to produce a finite angle of contact, or wrap, between a tensioned web and the capstan roller. The explanations that follow are based on the latter method for developing the pressure, but it is to be understood that the principles outlined below also apply where a pinch roller is used to increase the pressure.

Figure 6.7 illustrates the three possible modes of operation of a

capstan where the web is assumed to be divided into equal increments along its length and where:

L_o = length of equal increments of web with zero tension
ΔL_e = stretch of each increment in exit span due to exit span tension
ΔL_i = stretch of each increment in inlet span due to inlet span tension
V_e = web surface speed in exit span
V_i = web surface speed in inlet span

In Figure 6.7(a), no torque is exerted on the capstan by its support shaft, i.e., it is free to rotate and act as an idler roller. In this case, the capstan surface will travel at the same speed as the web and the inlet and exit web speeds will be equal. The tensions must also be equal as indicated by the equal lengths of ΔL_i and ΔL_e. In this case, no friction force (save for the small amount needed to overcome roller bearing drag), is generated between capstan and web.

In Figure 6.7(b), the capstan support shaft is caused to rotate so as to speed up or drive the web. Inlet tension will thus be greater than the outlet tension, as indicated by the relative magnitudes of ΔL_i and ΔL_e. This difference in tension is just balanced by the friction forces that are generated between web and capstan.

In Figure 6.7(c), the capstan is caused to rotate so as to slow down or brake the web. In this case, the inlet web speed will be less than web speed in the exit span. Again, a difference in tension will exist, with the higher tension in the exit span, and an equivalent friction force will be generated.

The maximum difference between inlet and exit span tensions, i.e., the friction force, that can be sustained on or by the capstan without the occurrence of slippage, is given by equation (6.1), usually referred to as the capstan equation:

$$F = T_h - T_l = T_h\left(1 - e^{-f\alpha}\right) \tag{6.1}$$

where:

f = coefficient of friction
F = friction force (pounds)
T_h = higher tension (pounds)
T_l = lower tension (pounds)
α = wrap angle (radians)

Of course, if a pinch roller is employed to press the web against the capstan roller, a much greater tension difference can be sustained before slippage will occur.

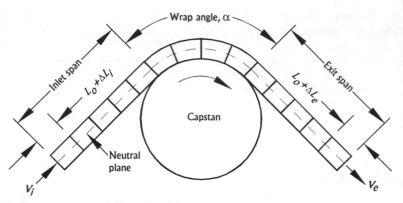

(a) Capstan serves as web idler roller. Inlet span tension and exit span tension are equal.

(b) Capstan serves as web driving roller. Inlet span tension is greater than exit span tension.

(a) Capstan serves as web braking roller. Exit span tension is greater than inlet span tension.

Figure 6.7 Three possible modes of operation of a capstan. Amount of elongation of each web increment, ΔL, in a given span is proportional to the corresponding web tension. In all three modes web inlet velocity, V_i, is essentially equal to circumferential velocity of capstan.

For the case of zero slippage, there are two principles governing tensioned web spans between capstan rollers that are important in understanding the steady-state interactions between the various speeds and tensions. These principles are explained and set forth as follows:

1. The relationship between velocity and tension in each span of web between any two capstans is governed by the principle of conservation of mass. The exact relationship is obtained by considering that at every point on the web path, the rate, q, at which the equally spaced web increments shown in Figure 6.7 pass the point is the same. The web velocity is given by equation (6.2) while equation (6.3) relates web elongation to tension.

$$V_n = q\,(L_n + \Delta L_n) \tag{6.2}$$

$$(\Delta L_n\,/L_n) = CT_n \tag{6.3}$$

where:

C = web compliance (inch stretch/pound)
L_n = length of web increment at zero tension (inch)
ΔL_n = amount increment is stretched due to tension (inch)
q = web flowrate (increments/minute)
T_n = web tension (pounds)
n indicates nth web span

Given that q is the same in every span under steady state conditions, equation (6.2) can be rearranged to yield:

$$q = \frac{V_n}{(L_n + \Delta L_n)} = \frac{V_{n-1}}{(L_{n-1} + \Delta L_{n-1})} = \cdots = \frac{V_1}{(L_1 + \Delta L_1)}$$

$$q = \frac{V_n}{L_n\left(1 + \dfrac{\Delta L_n}{L_n}\right)} = \frac{V_n - 1}{L_{n-1}\left(1 + \dfrac{\Delta L_{n-1}}{L_n - 1}\right)} = \cdots = \frac{V_1}{L_1\left(1 + \dfrac{\Delta L_1}{L_1}\right)} \tag{6.4}$$

Because L_n, L_{n-1}, and L_1 are all equal, the exact relationship is obtained by combining equations (6.3) and (6.4) to yield:

$$L_o q = \frac{V_n}{1 + CT_n} = \frac{V_{n-1}}{1 + CT_{n-1}} = \cdots = \frac{V_1}{1 + CT_1} \tag{6.5}$$

where:

$$L_o = L_n = L_{n-1} = \cdots = L_1$$

Equation (6.5) thus constitutes Principle 1 governing the relationship between velocity and tension in each span of web.

2. Figures 6.7(b) and (c) illustrate that web elongation (ΔL) changes from capstan inlet to exit for the cases where the capstan acts either as a driving or a braking roller. Consequently, web creep will take place over the region where web and capstan are in contact. Assuming there is no slippage, it can be seen that there will be one point of contact where web and capstan surfaces are traveling at the same velocity. If the difference between the velocity of the surface and of the neutral plane of the web is neglected, and regardless of the mode of operation, creep between the web and capstan surface will always be zero at the inlet point of contact and maximum at the exit point of contact. (Note that creep differs from slip wherein with slip there is relative movement between web and capstan over the entire area of contact.) Thus, Principle 2 governing the relationship between velocity and tension in each span of web is as follows: the velocity of the web in a given span is, for all practical purposes, always equal to the circumferential speed of the downstream capstan. (To be precise, velocities should be specified as those of the neutral plane of the web, because the velocity of the web surface in contact with the capstan will be slightly lower due to the compression resulting from the web being bent around the capstan. For the purpose of this discussion, however, this difference can be neglected.)

The derivation of the two principles just set forth was based on the assumption of no slip between web and capstans. Although this assumption is realistic in many cases, there are nipping rollers on press that are driven at relatively high constant speeds such that the web must slip in order not to break. (Examples are the roller at the top of the former board in the folder (RTF) and the nipping rollers downstream of the former board.) In these situations where there is slip, web speed in a given span is still governed by the speed of the downstream capstan. Thus for the general case, Principle 2 becomes: the velocity of the web in a given span is equal to the web velocity at the inlet to the downstream capstan.

Armed with the above principles, the response of a web system to different capstan actions can be deduced. To do this, consider the simple web system shown in Figure 6.8, consisting of three web spans established by two capstans. For the initial conditions, assume the following:

T_i, the tension in the inlet span, is held constant
V_e, the velocity in the exit span, is held constant
V_A and V_B, the circumferential speeds of Capstan A and Capstan B are equal to V_e

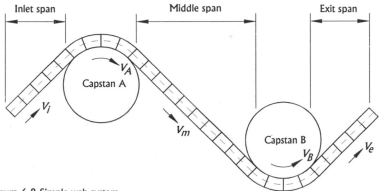

Figure 6.8 Simple web system.

Based on these assumptions, web tension is equal to T_i in all spans, while web velocity is equal to V_e in all spans.

Consider now what happens if the speed of Capstan A is increased by a small amount. According to Principle 2, above, the inlet velocity, V_i, will increase a corresponding amount. According to Principle 1, equation (6.5), this in turn will cause q to increase because T_i is assumed to be held constant. Equation (6.5) also predicts that T_m and T_e will decrease. If the speed of Capstan A is decreased, the opposite changes will be effected.

By applying the same principles, the response of the web system in Figure 6.8 to changes in the speed of Capstan B also can be deduced. From Equation (6.5), it can be seen that a change in the speed of Capstan B does not affect web speed in the inlet span and hence web flowrate. Thus, the only response produced by a change in the velocity of Capstan B is to change the web tension and velocity in the span preceding Capstan B, i.e., the middle span. These responses are listed in Table 6.4, along with the responses to speed changes in Capstan A, set forth above.

The theoretical responses given in Table 6.4 can be summarized as follows, assuming no slippage:

1. For the case of a web span where tension is maintained constant, the effect of changing the speed of the capstan immediately downstream is to change the tension in all of the downstream spans.

2. For the case of a capstan where the velocity of the exiting web is maintained constant, the only response to changing the speed of the capstan is to change the speed and tension of web in the span immediately upstream.

These theoretical steady-state responses will be compared to actual practice in the next section as a way of checking on the validity of the principles set forth above.

Table 6.4 Theoretical response of the variables of system shown in Figure
6.5 to changes in V_A, the speed of Roller A, and V_B, the
speed of Roller B. Inlet span tension, T_i, and exit span velocity,
V_e, are held constant at all times. NC indicates no change, ↑
indicates increase, and ↓ indicates decrease.

Change at zero time	Resultant steady state response				
	Web flowrate q	Inlet span velocity V_i	Mid span velocity V_m	Mid span tension T_m	Exit span tension T_e
V_A ↑	↑	↑	NC	↓	↓
V_A ↓	↓	↓	NC	↑	↑
V_B ↑	NC	NC	↑	↑	NC
V_B ↓	NC	NC	↓	↓	NC

6.3.3 Tension Control in Practice. Based on the above assumptions,
it will be realized that Capstan A in Figure 6.8 is analogous to the infeed
brake roller, and Capstan B is analogous to the chill rollers of the web press
shown in Figure 6.2. This is because tension in the web span upstream of
the infeed roller is held constant by the roll tension controller in the paster,
while web velocity downstream of the chill rollers is maintained constant by
the folding cylinder.

Given this analogy between the web system shown in Figure 6.8 and
the web press shown in Figure 6.2, Table 6.4 should provide a prediction
of how the tensions in various spans of the web press are affected by
changes in the speeds of the infeed braking roller and the chill rollers. For
example, based on the behavioral effect of Capstan A, one would predict
that varying the speed of the infeed braking roller will vary web speed in
the span upstream of the braking roller and hence web flowrate, q. In turn
the change in web flowrate will vary the tension in all the web spans
downstream from the braking roller, i.e., the span between it and the
printing unit, the span between printing unit and the chill rollers, and the
span between the chill rollers and folder. This prediction is in accord with
both experience and the intended use of the infeed.

The behavioral effect of Capstan B, as also set forth in Table 6.4,
predicts that changing the speed of the chill rollers will have no effect on
web flowrate, q. Thus, only the tension in the web span preceding the chill
rollers will be affected. This prediction flies in the face of experience in that
it is common practice to adjust web tension on the former board in the
folder, i.e., a web span following the chill rollers, by adjusting the speed of
the chill rollers. On the other hand, the theory as expressed in Table 6.4 is

supported by experimental data obtained from the inlet and outlet spans of an on-press drag roller on a non-heatset press (Lin and Hudyma, 1991). This suggests that the anomalous effect of changing chill roller speed may be tied to changes in the physical properties of the web produced as a result of passing through the dryer.

This is indeed the case, in that the high temperature to which the paper is raised in the dryer, while being constrained by tension, results in some permanent elongation, or stretch in the direction of travel (Hung, 1984). (This can be verified by comparing the length of printing on sections of web removed from before and after the dryer). Consequently it cannot be assumed that the untensioned length of the web increment, L_n, will be the same in the web span following the dryer as in the web span preceding the dryer. To account for this, Principle 1 (equation (6.5)) must be rewritten as follows:

$$q = \frac{V_n}{L_n(1+CT_n)} = \frac{V_{n-1}}{L_{n-1}(1+CT_{n-1})} = \cdots = \frac{V_1}{L_1(1+CT_1)} \qquad (6.6)$$

Assume that the web span following the chill rollers is designated as the nth span. Thus, for the case where, for instance, the speed of the chill rollers is increased, the following equality holds:

$$q_{n-} = q_{n+} = \frac{V_{n-}}{L_{n-}(1+CT_{n-})} = \frac{V_{n+}}{L_{n+}(1+CT_{n+})} \qquad (6.7)$$

where:

L = length of web increment at zero tension
V = web velocity
C = web compliance
q = web flowrate
T = web tension
$n-$ denotes value before speed increase
$n+$ denotes value after speed increase

According to Principle 2 in Section 6.3.2, web velocity in the span following the chill rollers, V_n will be unaffected by a change in chill roller speed. Thus V_{n-} and V_{n+} will be equal. Also, it is known that L_{n+} will be greater than L_{n-} due to added overstretching caused by the increase in tension in the web span in the dryer that occurs as a result of the speedup in the chill rollers. Therefore, to preserve the equalities in equation (6.7), T_{n+} must decrease, relative to T_{n-}. As a result, it is seen that the modified theory, as represented by equation (6.6), correctly predicts the

Table 6.5 Response of web variables to changes in the speed, V_C, of the chill rollers shown in Figure 6.1. Folder span web velocity, V_f, is held constant by folder pinch rollers. NC indicates no change, ↑ indicates increase, and ↓ indicates decrease.

Change at zero time	Resultant steady state response				
	Web flowrate q	Dryer span velocity V_d	Folder span velocity V_f	Dryer span tension T_d	Folder span tension T_f
$V_C\uparrow$	NC	↑	NC	↑	↓
$V_C\downarrow$	NC	↓	NC	↓	↑

response to changes in chill roller speeds that are summarized in Table 6.5. Of course, the key factor in applying the theory is the knowledge that the length of the web increment, at zero strain, is increased as a result of being heated and stretched in the dryer.

The reader is again reminded that all of the above discussions of the interactions between web speed and tension are for steady-state conditions. In order to predict web behavior during the transient following a sudden change, more complex theory is required (Smith, 1974, Montgomery, 1984, and Lin and Hudyma, 1991).

On the typical vertical web newspaper press, shown in Figure 6.3, the pressman has several means available for adjusting tension: the control for roll tension, the outfeed, the trolleys above the roller-top-of-former (RTF), the pinching rollers downstream of the former board, and the bands on the folding cylinder.

The system for controlling roll tension is analogous to the infeed on heatset presses in that tension in the span leading to the printing units is controlled by braking the paper supply roll, in response to signals from a dancer roller. In accordance with theory, changing this tension will affect web flowrate and, hence, the tensions in all of the downstream nips.

The outfeed is a closed-loop tension controller consisting of a pair of non-slipping nipping rollers, a preceding roller that senses web tension (achieved by using gauges to sense strain in the roller mounts), and a controller. The speed of the nipping rollers is automatically adjusted by the controller to maintain a preset tension, as measured by the sensing roller. In accordance with theory, this system does not affect web flowrate and, hence, only affects the tension in the span leading from the last printing unit.

At the folder, tensions can be adjusted in three ways. First, the amount of slip at the roller-top-of-former (RTF) can be varied by changing the pressures exerted by the trolleys. According to theory, this will only

affect tension in the span before the former board. Tension on the former board can be varied by varying the pressure between the nipping rollers, located below the former board. Bands on the folding cylinder provide the third means for adjusting web tension in the folder. These bands, in effect, vary the diameter and hence the surface speed of the folding cylinder. Because of slippage in the preceding folder nips, web speed and hence tension in all spans back to the outfeed will also be affected by changing the bands. Therefore, adjusting the bands adjusts tension in all the spans back to the outfeed. (This is also true of adjustments to the pressure of the nipping rollers.)

6.4 Cylinders, Plates, and Blankets

In general, the plates and blankets used on web presses are like those described in Chapter 2 for use on sheetfed presses. In contrast, web printing cylinders differ markedly from those on sheetfed presses in four respects: gap width (including lack thereof), arrangement, design, and packing practice. On web press printing cylinders, it is not necessary to provide space for grippers. Therefore the gaps are made as narrow as possible (on the order of 1/4 inch or 6 mm) to minimize paper waste and reduce print disturbances due to cylinder vibration. This also introduces the possibility of using gapless plates and blankets, a concept that has been given great attention in recent years and which will now be discussed.

6.4.1 **Gapless Blankets and Plates.** To the best of the author's knowledge, the first presses to use a gapless blanket were those manufactured by Gormley Manufacturing and Levy in the 1960's. Both designs were disadvantageous because the blanket could not be removed from the cylinder by the press operator. Therefore, it was necessary to replace the entire cylinder when it came time to install a new blanket.

More recently, a number of removable sleeve-type plates and blankets have been developed, as exemplified by the many patents on the subject that have issued in the period from 1989 to the present. Heatset web presses that utilize such plates and blankets have also been developed and are now being manufactured and sold.

The key to the current success of gapless plates and blankets for web presses is the ability to install and remove them quickly. This is accomplished through the use of three innovations: (Köbler, 1989; Hollis, 1978; and Bass and Kirby, 1964):

1. A moveable bearing support on one end of the cylinder that can be quickly retracted to provide clearance for sliding the sleeve onto and off of the cylinder.

2. Means for preventing the cylinder from sagging when the moveable bearing support is retracted.

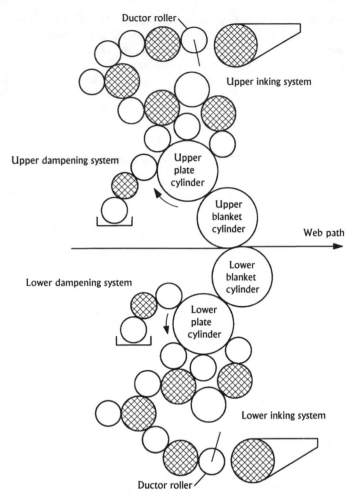

Figure 6.9 Cylinder and roller arrangement in a typical web press with a horizontal web.

3. Means for passing compressed air through radial holes in the cylinder so as to expand the sleeve to facilitate mounting it on and dismounting it from the cylinder.

Fabrication of a gapless blanket is carried out on a mandrel to form the different layers needed (see, for example, Vrotacoe, Guaraldi, Carlson, and Squires, 1994). These layers are similar to those described in Section 2.3 on blankets. The supporting structure for the blanket layers consists of either a thin internal metal shell, usually made of nickel, or one of fiberglass.

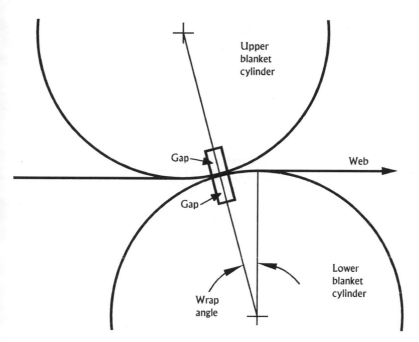

Figure 6.10 Web wrap achieved by canting the line connecting blanket cylinder centers.

Fabrication of a gapless plate is accomplished through the use of a standard type aluminum plate as described in Section 2.4 on plates. After the plate has been exposed and developed in the flat, it is formed into a cylinder utilizing a machine that bends it into a cylindrical shape, trims the leading and trailing ends to produce the required circumferential length, and then joins the two abutting ends using a laser welding process (Hoffman, Winterholler, Prem, and Stöckl, 1995).

6.4.2 **Cylinder Arrangement.** In section 6.2.3, it was pointed out that most web presses are perfecters, i.e., both sides of the web are printed on as it passes through a printing unit. Thus, a typical web printing unit consists of pairs of blanket and plate cylinders, along with their associated ink and dampening systems, arranged in more or less mirrored locations on either side of the web, as illustrated in Figure 6.9. In general, the ink and dampening systems are much like those described in Chapters 4 and 5 for sheetfed presses. Differences that do exist are described in Sections 6.5 and 6.6 below.

Probably the most noticeable difference in the cylinder arrangement in Figure 6.9, vis-à-vis a sheetfed press, is the absence of an impression cylinder. This is because the lower blanket cylinder serves as the impression cylinder for the upper blanket cylinder and vice versa. A very important requirement of the arrangement of the blanket cylinders on web presses is

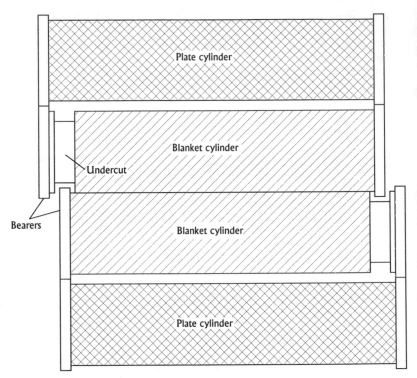

Figure 6.11 Staggered blanket cylinder arrangement used to permit packing in accordance with the true rolling principle.

that it should be such that contact with the web is not lost when the two blanket cylinder gaps meet. This, of course, is to prevent web slippage and changes in register that would occur as a result. To accomplish this, the centers of the blanket cylinders are located on a line that is canted from the normal to the web path. As shown in Figure 6.10, this produces a certain amount of web wrap around both upper and lower cylinders. Common practice is to provide a wrap angle of 10–15 degrees.

Interestingly, a comparable wrap angle is also provided on at least one design of a press equipped with gapless blankets (Guaraldi and Geary, 1994). Another interesting practice is that no wrap is provided on many vertical non-heatset web presses. This does not seem to create any printing problems on double-width newspaper presses, due probably to the use of two blankets across the cylinder with staggered gaps. On single-width presses with no blanket wrap, problems apparently do occur sometimes on four-color presses. This is said because idler rollers between units are employed by some users to bend the web path and thereby create some wrap on the blanket cylinders.

Another unique feature of some of the double-width newspaper presses manufactured by Goss Graphic Systems is that of not running blanket cylinders bearer to bearer. This is achieved by providing undercuts at one end of each blanket cylinder so as to allow the cylinders to be staggered, as illustrated in Figure 6.11. More is said about this in Section 6.4.4 on packing practice on web presses. Aside from this one exception, most web press cylinders run bearer to bearer.

6.4.3 Cylinder Design In the U.S. at least, commercial presses utilize plate cylinders with a circumference of a little over 22 inches (56 cm), the length of two 8-1/2 x 11 pages. This is due to a long-standing conviction by many users that unacceptable color variations will occur in the direction of web travel if longer length plates are employed. This is contrary to the thinking in Europe where plate cylinders double that size are often found, and U.S. practice on newspaper presses where plate cylinders double that size are common. The larger cylinders are advantageous in allowing more pages to be printed on a given job. The larger-diameter cylinders are also stiffer and therefore can be run at higher speeds for reasons explained below.

On commercial presses, blanket cylinders are made either the same diameter as the plate cylinder, or twice the diameter of the plate cylinder. The adoption of the double-diameter blanket cylinder was a landmark development in web offset press design conceived in the 1960's by the Cottrell division of Harris Intertype Corporation, nee Harris, now Heidelberg-Harris. The advantage of the double-diameter, or two-around, blanket cylinder is its much higher speed capability, while the disadvantage is having two impressions per revolution that may differ, i.e., the so-called A-B problem. On newspaper presses, current practice is to use blanket and plate cylinders of the same diameter.

Most web press cylinders are made of cast steel or forgings and then plated for protection against corrosion by fountain solution. In some cases, cylinders have been made of stainless steel to avoid corrosion. Generally, the cylinders are solid, but very heavy-walled shells have been used for cylinders on some press models.

The rationale for using a heavy-walled cylinder rather than a solid one is to increase the cylinder's natural frequency of vibration. This frequency is an important factor governing the press speeds at which certain printing disturbances occur. (That is, streaks perpendicular to web travel that are produced by the shocks of cylinder unloading and loading that occur when two adjacent cylinder gaps meet.) As a practical matter, the natural frequency of a given size cylinder cannot be changed by more than about 15 percent by using a heavy walled in lieu of a solid design. Nevertheless, making, say, the plate cylinders thick-walled and the blanket cylinders solid, detunes the cylinder assembly sufficiently to produce a significant benefit in performance.

Further improvement in this regard is realized by double-diameter

blanket cylinders referred to above. In addition to increasing cylinder stiffness, this raises the natural frequency of the blanket cylinder by 40 percent and further detunes the assembly. Consequently, single width presses (38 inch, or 96 cm wide) with double-around blanket cylinders (with gaps) are capable of speeds up to about 2500 feet/minute (12.5 m/sec), whereas similar single-around presses are generally limited to speeds of 1200–1600 feet/minute (6–8 m/sec).

6.4.4 Packing Practice. It was pointed out in Section 2.2.5 and 2.2.7 that the common practice on sheetfed presses is to pack the blanket to the bearer, and pack the plate over the bearer by an amount equal to the desired squeeze, i.e., in accordance with the true rolling principle. This practice cannot be followed on most web presses because the blanket cylinders are run bearer to bearer, and this packing scheme would result in zero squeeze between the two blankets. Thus, plates are generally packed to the bearers and blankets are packed over the bearers by an amount equal to the desired squeeze. The fact that print quality comparable to that of sheetfed presses can be achieved on web presses is further evidence that there is no significant difference between the two methods of packing.

An exception to the above stated packing practice on web presses is the ability of Goss double-width presses to utilize the true rolling method. This is made possible by offsetting one pair of blanket and plate cylinders with respect to the other, as illustrated in Figure 6.11. Also shown in this figure are the cylinder body undercuts needed to provide clearance for the opposing bearer. (On bearerless models, these undercuts are obviously not necessary.)

6.5 Inking Systems

The description of the traditional inking system design, given in Section 4.2.2, can also serve as an introduction to the inking systems used on web presses. It must be recognized, however, that the latter differ in several significant ways, and often incorporate features that are unique to web presses.

The ink roller trains used on web presses, as a rule, have fewer form rollers than their sheetfed counterparts. To be specific, heatset web presses most often have three form rollers, and many newspaper presses have only two, in contrast to the four normally found on a sheetfed press. Newspaper presses also generally have relatively shorter ink trains compared to both sheetfed presses and heatset web presses.

The most striking differences found between the two types of presses are in the alternate sub-systems, sometimes used to meter the ink and to transfer the metered ink to the head of the roller train. Three such sub-systems, unique to web presses, are described in the remaining paragraphs of this section.

6.5.1 Ink Rail. An ink rail is a device used on double-width newspaper presses to meter out ink and feed it to a pickup roller at the head of the ink train. Thus, it takes the place of the combination of an ink fountain and ductor roller. The ink rail, invented early in this century (White, 1917), is designed to feed strips of ink the width of a newspaper column, i.e., a little over 2 inches (5 cm) wide, directly onto a roller running at press speed.

There are two central elements to the ink rail system: an ink reservoir containing individual positive-displacement pumps that supply ink to the rail, and the ink rail itself that is mounted next to the ink roller to be supplied with ink. All of the pumps serving a given rail are usually driven from the same shaft. The speed of the pump shaft is synchronized with the speed of the press, and yet can be varied so as to vary the amount of ink supplied by all of the pumps. In addition, each pump has an adjusting screw, analogous to the ink key on an ink fountain, for adjusting the ink supplied by each pump. The discharge ports of the ink pumps are connected to lines that carry ink to the individual discharge slots in the rail.

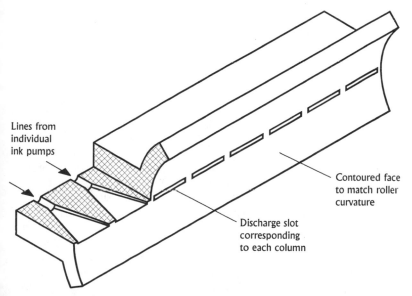

Lines from individual ink pumps

Contoured face to match roller curvature

Discharge slot corresponding to each column

Figure 6.12 Schematic of an ink rail with section cut away to show geometry of ink nozzles.

The principle of the ink rail can be explained with the aid of the schematic shown in Figure 6.12. It contains a row of fan-shaped nozzles that have discharge ports in the shape of thin slots, slightly shorter than the width of the newspaper column to be printed. The face of the rail is contoured to match the roller surface to be supplied with ink, and is mounted adjacent to the roller with a clearance of 0.01 inch (0.25 mm).

In operation, ink is pumped from the ink reservoir by the individual pumps to each fan-shaped nozzle in the rail. The ink is forced through the nozzles and discharged onto the adjacent ink roller through the slots in the contoured rail face. The main advantage of an ink rail system is that ink feedrate to individual nozzles is independent of adjustments to the feedrate in adjacent columns, i.e., no interaction between key settings as in the typical ink fountain shown in Figure 4.3. Another significant advantage is that feedrate is much more uniform, compared to a ductor roller system. This is especially beneficial on the shorter ink roller trains found on newspaper presses. Ink rails also provide better tracking of ink feedrate to press speed, avoid the problem of ink contamination by paper dust that occurs in open fountains, and eliminate the problem of ink leakage that often occurs with undershot fountains, when they are filled with relatively thinner news inks.

As might be expected, ink rails have their drawbacks. The major one is that ink rails are difficult to clean. Years ago when only black ink was used on newspaper presses, this was not a problem. Currently, with much color printing done, this drawback has become more important because changing color rotation on a multicolor press is often necessary, and on presses equipped with ink rails this becomes a messy job.

Another drawback of ink rails that has come to the fore in recent years is the difficulty of presetting its keys in accordance with ink coverage data obtained during prepress operations, such as scanning the film or plate. This is due to the difficulty in calibrating the keys or individual ink pump adjustments. To correct this problem, a so-called digital ink rail was developed (Niemiro and Whiting, 1991). In this device, constant speed, continuously operating, positive-displacement (e.g., gear type) pumps replace the piston type pumps used earlier. Flow to the ink nozzles is controlled by valves that are opened at periodic intervals for accurately timed periods. This mode of operation makes it possible to preset ink feed to each nozzle very accurately and thus achieve faster makereadies.

6.5.2 Film Feed System. The film feed system that dispenses with the need for a ductor roller is another unique web press innovation that has been used for many years on certain single-width newspaper and commercial heatset web press models. In this concept, shown in Figure 6.13, ink is fed from the ink fountain roller directly to a pickup roller at the head of the ink roller train. The ink fountain roller rotates continuously at a speed in the range of 0–10 revolutions/minute, while the pickup roller rotates at press speed. Most often the pickup roller is made of steel and has a knurled surface. This roller also is mounted on a throwoff so it can be disengaged from the fountain when the press is off impression and for washup.

There are two very significant advantages to the film feed concept. First, ink feed to the ink roller train is continuous, thereby eliminating the disturbances in ink film thickness, and hence print density, caused by the

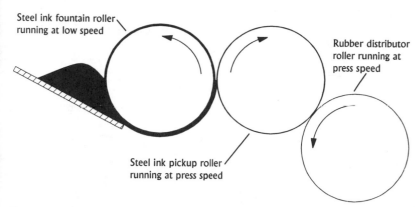

Steel ink fountain roller running at low speed

Rubber distributor roller running at press speed

Steel ink pickup roller running at press speed

Figure 6.13 Roller diagram of the film feed system concept that dispenses with the need for a ductor roller. A common practice is to provide a knurled surface on the pickup roller.

strips of ink delivered intermittently by the operation of a ductor roller, as illustrated in Figure 4.12. This is particularly valuable on newspaper presses because ductor disturbances in the print are more likely to be seen due to the shorter ink roller trains used on such presses.

The second advantage of the film feed concept is that it eliminates the torsional shocks to the inker drive system, produced each time the ductor roller swings into contact with the roller at the head of the ink roller train. These shocks can cause print disturbances at very high press speeds.

A drawback of the film feed concept is that considerable heat may be generated by the high rates of shear that occur in the nip formed between the ink pickup and fountain rollers, depending on ink viscosity. Thus, to avoid variations in ink metering on heatset presses, due to fountain roller heating, this roller should be temperature controlled.

6.5.3 CUIM Roller. The CUIM roller was developed about forty years ago as an alternate to the ductor roller (Aller, 1962). Since then it has been used on commercial heatset web presses made by Baker Perkins Limited (now part of Goss Graphic Systems). The key element of this concept, illustrated in Figure 6.14, takes its name from Continuously Undulating Inking Mechanism. This ingenious roller is made up of side-by-side free-running rubber-covered disks, approximately 2 inches (5 cm) in width. All the disks are identical and are fitted with ball bearings that have eccentric hexagonal-shaped bores. The disks are mounted on a hexagonal shaft such that each disk has an eccentricity that is advanced 60 degrees relative to the preceding one. Thus, every sixth disk is located on the same centerline.

The hexagonal CUIM roller shaft is driven continuously by a separate variable speed motor, but the speed is normally held constant in the range of 50–100 revolutions/minute. This ink fountain roller is also driven

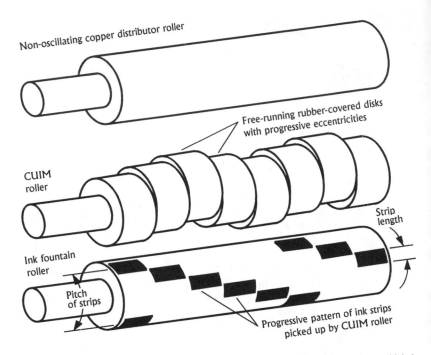

Figure 6.14 Arrangement of CUIM roller relative to the ink fountain roller, from which it picks up ink, and the copper distributor roller, to which it delivers ink.

continuously by another variable-speed motor that tracks press speed. At a press speed of 2000 feet/minute (10 m/sec) the fountain roller rotates about 80 revolutions/minute.

The rotation of the hexagonal CUIM shaft causes the individual disks to move back and forth to alternately contact the fountain roller, where the disks slow down to pick up ink; and the copper distributor roller, where the disks speed up, to transfer ink to the roller train. Because of the progressive eccentricity of the disks, the back and forth motions of each group of six disks are out of phase. Thus the pattern of ink pickup along the fountain roller is progressive, as shown in Figure 6.14.

In practice, the rate of ink feedrate can be changed in a useful way by changing the speed of either the ink fountain roller or the CUIM roller shaft (Bohen, Claypole, and Gethin, 1996). Increasing the speed of the CUIM roller reduces the pitch of the ink strips picked up (increasing ink feed) while at the same time reducing the strip length (decreasing ink feed). The net effect is to increase ink feedrate, although not in direct proportion to CUIM roller speed. Increasing the speed of the ink fountain roller increases strip length and hence increases ink feed. Both of these strip properties are identified in Figure 6.14.

The advantages of the CUIM roller are similar to those of the film feed system. These are, relative to a ductor roller, a reduction in both the printing disturbances generated by discontinuous feeding, and the torsional mechanical shocks to the inker drive system. The major drawback of the CUIM roller is its higher cost, both to manufacture and to recover.

6.6 Dampening Systems

A relatively wide variety of dampening system types are being fitted to new web presses. This is in contrast to sheetfed presses, where some version of a film-type dampener has become almost the universal choice on new presses. The most likely reason for this is that the two different ink setting processes used on web presses (heatset and non-heatset) work in conjunction with significantly different papers and inks. Support for this explanation is provided by the fact that squeeze-roller dampeners are the overwhelming choice of users of heatset presses, whereas a large segment of the non-heatset press population is equipped with some type of non-contacting dampener, i.e., brush, spray, or rotary atomizer type. Nevertheless, the following discussion of web press dampeners is divided into two different groups: those designs in common with dampeners used on sheetfed presses, and those designs unique to web presses.

6.6.1 **Designs Common to Sheetfed Presses.** The dampening system designs that are found on both sheetfed and web presses are all of the film, or continuous type, save for a few ductor-type dampeners on older web presses. The two most common continuous types are described in the following paragraphs.

1. **Squeeze-Roller Type.** The type of dampener most frequently used on heatset web presses is the four-roller, plate-feed, squeeze-roller design illustrated in Figure 5.18(b). The optional rider roller shown in the same figure is almost never used on web presses. Web printers often refer to this design as the Duotrol type, because this is the name given to it by its originator, Harris-Intertype Corporation, nee Harris, now Heidelberg-Harris. The reader is referred to Sections 5.5.1 through 5.5.3 for detailed information on squeeze-roller dampeners and to Sections 5.5.4 and 5.5.5 for more detailed information on this particular configuration.

2. **Skimming-Roller Type.** An interesting and surprisingly little known fact is that there are more web press units equipped with skimming-roller dampeners than with any other type. This dampening system design, shown in Figure 5.25, uses the skimming-roller method of metering. It was named Continuous Feed by its originator, Goss Graphic Systems, and has been widely used on single-width newspaper presses manufactured by that company. Although this type of dampener was also installed on Miller sheetfed presses, the only new presses on which it is now installed are non-

heatset webs. More information on this dampening system design is given in Section 5.7.

6.6.2. Designs Unique to Web Presses. Currently there are three types of dampening systems that, with minor exceptions, are used exclusively on web presses: brush, spray, and two versions of rotary atomizers. Interestingly, all of these are one-way, or non-contacting, designs, and find their greatest application on presses used for non-heatset work. This is perhaps explained by the fact that, as a group, the biggest advantage of these dampeners is the elimination of ink feedback into the dampening system, which otherwise is a major problem when using non-heatset inks. Another advantage perceived by users is the ability of these dampeners to deliver more water, as is thought required when printing on uncoated stock. Each of these dampener types is described in the remaining paragraphs of this section.

1. **Spiral-Brush Dampeners.** This type of dampener, illustrated in Figure 5.20, was originally developed for sheetfed presses (Dahlgren, 1959), but never found any significant application there. It has been widely used on both heatset and non-heatset web presses, and is described in detail in Section 5.6.

2. **Spray Dampeners.** This type of dampener was originally developed for use on forms presses (Smith, 1972), and is still used there today, although on a modest scale. Currently, spray dampeners find their greatest application on double-width newspaper presses, including tower or four-high models designed for process-color printing, and shown in Figure 6.3. Their use on single-width non-heatset and heatset presses has only gained favor in the last few years. More details on the evolution and principles of operation of spray dampeners are given in Section 5.8.

Most spray dampeners in use today are of the single fluid type wherein an oval-shaped spray pattern of atomized water particles is generated by forcing a stream of water under high pressure through a nozzle. Because the atomized particles or water droplets produced by these nozzles have a diameter on the order of 0.004 inches (100 microns), some portion of the stream is deflected by, or bounced off, the roller surface toward which the stream is directed. In addition, the spray pattern must extend beyond the ends of the roller for reasons explained in Section 5.8.2. Thus, as much as 10 percent of the total volume sprayed appears as overspray, i.e., water particles that end up on surfaces other than the press roller being sprayed.

The need to contain this overspray accounts for the form of the typical spraybar used today. Figure 6.15 shows a typical spraybar design for a 35–38 inch (89–96.5 cm) wide press. A row of four nozzles, placed on about 9-inch (23-cm) centers, are mounted along the length of a support channel. This assembly is surrounded by an enclosure with

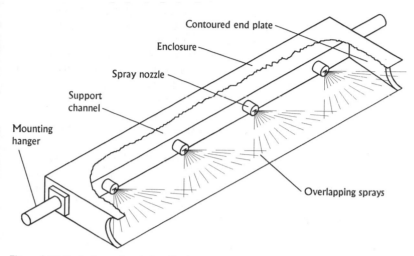

Figure 6.15 Typical spraybar design. Enclosure is partially cut away to show nozzles.

contoured end plates to enable it to be located with a small clearance next to the press roller to be sprayed. In this way, overspray is confined to the inside of the enclosure. As a result, droplets of water will gradually form on the interior surfaces of the enclosure. If the spraybar location is such that it can be tilted upward, these droplets will run toward the back of the enclosure where they can be collected in a drain for reprocessing and return to the fluid supply system for reuse.

When operated continuously, the smallest commercially available spray nozzle produces a flowrate of about 3.6 gallons per hour (13.6 liters/hour) at the pressures required to achieve the spray pattern desired for dampening. Thus, the bar shown in Figure 6.15 would have a total flowrate of 14.4 gallons/hour (54.5 liters/hour) if operated continuously. In contrast, the best fit curve of the data in Figure 5.1 predicts that the fountain solution consumption rate of one dampener on a 38-inch (96.5-cm) wide press will be 4.4 gallons per hour (16.7 liters/hour) when printing at a speed of 2500 feet per minute (12.5 m/sec).

Thus, the only practical way to apply a spray dampener is to use a pulsed mode wherein flow to the nozzles is turned off and on periodically. Based on the above flowrates and press speed, the nozzles would have to be turned on 30.6 percent of the time. Assuming that an "on time" as small as 10 milliseconds can be achieved, this equates to a corresponding "off time" of 22.6 milliseconds. For a press with a 22-inch (56-cm) cutoff, this works out to about one and one-third "on pulses" for every revolution of the plate cylinder. This is frequent enough to insure that no printing problems result from the discontinuity in water feedrate.

The pulsed mode of operation has the advantage that feedrate can be

varied simply by varying the "off time." Thus, spray dampeners not only can be programmed to track press speed, but can also be programmed to follow any required curve of feedrate versus press speed.

In some early single-color newspaper press applications of spray dampeners, the spray bars were located so as to feed water directly into the ink train. With the advent of four-color double-width tower-type newspaper presses, practice has shifted to spraying onto a separate train of dampening rollers as illustrated in Figure 6.3. Also, in many retrofit installations on both heatset and non-heatset presses, a spray bar has simply replaced the spiral-brush and chrome pan roller pair shown in Figure 5.18.

3. Rotary-Atomizer Dampeners. In Section 5.3.1, fluid atomization was identified as one of the methods used in dampening systems to meter out and distribute the required thin stream of water. In this context, atomization is the process wherein a fluid is disintegrated into small particles. In general, this is accomplished by generating a high velocity between the fluid to be atomized and the surrounding air, with the result that the fluid breaks up into small drops. One method of doing this is to discharge water under high pressure through a small orifice or nozzle, as in the case of spray-type dampeners described in the previous paragraph. A second method is to utilize centrifugal force to generate high fluid velocities. This latter principle is employed in two different dampener designs for web presses: the Turbo dampening system and the WEKO dampening system.

The Turbo dampening system (Rau, 1987), conceived and manufactured by MAN Roland, is illustrated in Figure 6.16. Its key element is the turborotor, a metal roller spirally wrapped with a strip of grater-like material, i.e., a strip of sheet metal containing a uniform pattern of protrusions produced by perforations, as in a vegetable grater. The axis of the turborotor is located parallel to the axis of the roller to be dampened. A fluid reservoir is provided with a constant level such that the protrusions on the turborotor just touch the water surface.

When the turborotor is driven at a high speed, water is picked up by the protrusions, and then flung off by centrifugal force. This produces high-velocity streams of water droplets that emanate in paths tangent to the turborotor surface and in the direction of its travel.

As in the case of spray dampeners, the unit must be enclosed to contain the overspray. The enclosure also has a slotted opening to enable a narrow stream of droplets to reach the target roller.

To achieve the desired droplet velocity, the turborotor is driven at a relatively high constant speed. Control of water feedrate is achieved through the use of a series of shutters that are moved up and down by remotely controlled actuators to vary the effective width of the slotted opening in the enclosure. Each shutter is equal in length to some increment of press width, e.g., the width of a page in the case of a double-width newspaper press.

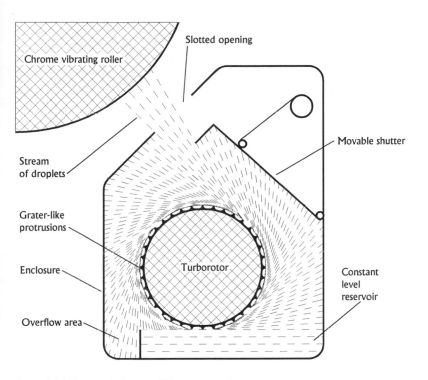

Figure 6.16 Functional diagram of Turbo dampening system.

The WEKO dampening system, introduced in 1972 (Voas, 1978), is based on the same principle as the Turbo dampening system. It differs, however, in that each spray bar consists of a row of rotors on approximately 4-inch (10-cm) centers, with their axes perpendicular to the axis of the roller to be dampened, as shown in Figure 6.17. The rotors reportedly rotate at a speed of 5000 revolutions per minute to produce a stream of water particles 30–40 microns (0.0012–0.0016 inch) in diameter (Rau, 1987). These particles are much larger than those produced by a brush dampener which, as noted in Section 5.6.1, are invisible to the human eye. (A 30-micron particle, in contrast, can be readily seen.)

Individual lines deliver water to the center of the cup-shaped rotors causing the water to be flung out in all directions. Each rotor is surrounded by a circular shroud that is open over an arc of about 45 degrees, thus limiting the stream of water particles to a similar spray angle. (Particles blocked by the shrouds are carried to a drain and returned to the water supply system for reuse.) The spray bar is located from the roller to be dampened at a distance that results in some overlapping of adjacent streams. The enclosure surrounding the row of rotors is equipped with

Figure 6.17 Functional diagram of WEKO dampening system.

adjustable shutters to enable the width of each stream to be varied. In this way, the width of the streams are set on press to butt together. It is claimed that this adjustment need only be done once, at initial installation.

Controls are provided for adjusting the relative water flow to each rotor. In this way, the operator can adjust feedrate across the press in approximately 4-inch (10-cm) increments. Total flow to each dampening unit or line of rotors can also be adjusted, thereby making it possible to have feedrate track press speed. Early on, the WEKO dampening system was used on both sheetfed and web presses. Currently, it is used almost exclusively on forms presses. In this application, it reportedly performs very well (Sanger, 1991).

6.7 Summary

Web presses derive their name from the fact that printing is carried out on a continuous strip of paper supplied from an unwinding roll at the infeed end of the press. In terms of sales, at least half of all products produced by the lithographic process in the U.S. are printed on web presses. Because of this, an understanding of web printing is important. This is not to say that the mechanics of web printing are basically different from those of sheetfed printing. Rather, the unique features that are described in this chapter and summarized in the following paragraphs are more in the

nature of variations made necessary by, or to take advantage of, those characteristics that are peculiar to printing on a web.

1. Web presses possess at least six important advantages: very high production rates (e.g., 100,000 impressions/hour), the capability to perfect, the relative ease of finishing in-line, lower paper costs, the ability to print on a wide range of substrates, and the elimination of spray powder.

2. On the debit side, web presses possess certain disadvantages: greater complexity, a higher capital cost for a given number of printing units, higher operating costs, fixed cutoff (generally), and the use of inks that are less permanent with respect to curing.

3. In addition to the printing units, a web press can comprise a multitude of other major components for controlling the web and processing the printed product. These include an unwind, or reel stand, an automatic splicer, web guides, an infeed, an outfeed, a dryer, chill rollers, a cutoff control, one or more folders, and/or a sheeter, and/or an in-line finishing system and/or a rewind stand.

4. Generally, web printing employs either heatset or coldset inks. These are quite different from the drying inks normally used on sheetfed presses in that they are cured by an immobilization process.

5. Heatset inks are immobilized, or hardened, by first heating the printed web to evaporate most of the petroleum-based ink oil contained in the ink. This increases the viscosity of the ink that remains. The web is then chilled to harden the remaining ink vehicle.

6. Coldset inks as used, for example, in newspaper printing, become immobilized by penetration of the ink vehicle into the interstices between the paper fibers. For this reason, coldset printing is limited to uncoated paper.

7. Web presses are frequently tailored to print specific products. Because of this tailoring, they can be grouped into at least six different types wherein each type has its own unique set of characteristics: commercial heatset, commercial non-heatset, double-width newspaper presses, forms presses, book presses, and directory presses. The major characteristics of each type are given in Table 6.3.

8. An essential condition to the success of web printing is that the web must be held in tension. This is to insure that the paper follows a consistent path through the many components of the press, and to peel the web from the blankets in a manner that does not adversely affect register.

9. Accurate control of web tension is important to many aspects of web printing, including the maintenance of color-to-color registration and reliable folder operation.

10. The interaction between web speed and tension in the various spans of a web press are governed by two principles. The first is given by equation (6.5), while the second is that web speed in any given span is equal to the web speed at the entrance of the downstream capstan or nip.

Barring slip and neglecting creep, this latter speed equates to the speed of the downstream capstan.

11. The plates and blankets used on web presses are similar to those used on sheetfed presses in composition, but not always in form. This is because of the relatively recent development of web presses with gapless plate cylinders and gapless blanket cylinders. For those presses, cylindrical rather than flat plates and blankets are needed.

12. To date, gapless plates have been made by forming a conventional plate into a cylinder and welding the adjoining ends. Gapless blankets are fabricated in the round on a mandrel.

13. Most web presses print on both sides of the paper at the same time (i.e., perfect). For this reason, each printing unit usually is made up of pairs of blanket and plate cylinders, along with their associated ink and dampening systems, in more or less mirrored locations, as shown in Figure 6.9.

14. The line between the centers of opposing blanket cylinders in a horizontal web printing unit is generally canted from the normal so as to produce an angle of web wrap on the cylinders. This is to prevent web slippage when the gaps in the blanket cylinders pass through the common nip.

15. The maximum speed at which printing can be carried out on a web press is frequently limited by printing disturbances produced by the shocks of cylinder unloading and loading that occur when a cylinder gap passes through a nip.

16. A cylinder configuration developed in the 1960's by the Cottrell division of Harris, now Heidelberg Harris, utilizes blanket cylinders twice the diameter of the plate cylinders. This landmark innovation raised the speed at which web presses are limited by printing disturbances.

17. The cylinders on web presses are normally made of cast or forged steel and generally are solid. In some instances, heavy-walled plate cylinders are used so that their natural frequency will differ from that of the solid blanket cylinder. This is to raise the speed limit described in 15 above.

18. Most blanket cylinders on web presses are run bearer to bearer. Consequently, the true rolling method of packing cannot be used. This does not appear to impose any penalty on print quality. To permit the use of the true rolling principle of packing, however, some double-width newspaper presses use a staggered blanket cylinder arrangement wherein the blanket cylinders are not run bearer to bearer.

19. The inking systems used on web presses are similar to the designs on sheetfed presses. Some minor but significant differences do exist, and there are features sometimes employed that are unique to web presses.

20. Heatset web presses most often have only three form rollers, while many newspaper presses have only two. This is in contrast to the four form rollers normally found on sheetfed presses.

21. A device unique to web presses, called an ink rail, is often used in

place of an ink fountain and ductor roller on double-width newspaper presses. An ink rail eliminates interaction between ink keys, produces a more uniform ink feed, provides better tracking of press speed, avoids the problem of ink contamination in open fountains, and eliminates the problem of ink leakage. A major disadvantage is that they are difficult to clean, which makes changing colors a messy job.

22. Another unique inking system design variation is the film feed system. Here, ink is fed directly to the ink roller train from the ink fountain roller, thereby eliminating the ductor roller. This system provides a continuous ink feed and eliminates the torsional shocks to the inker drive produced by the action of a ductor roller.

23. An alternate to the ductor roller, found only on web presses, is the CUIM roller, developed and used by Baker Perkins (now part of Goss Graphic Systems) on their heatset presses. Its advantages are similar to those of the film feed system given in 22.

24. A wider variety of basic dampening system types is found on web presses, compared to sheetfed presses. These can be grouped into two types: those common to sheetfed presses and those unique to web presses.

25. A web press dampener that is also common to sheetfed presses is the four-roller squeeze-roller type, configured independent of the inking system. This type of dampener is used almost exclusively on heatset web presses.

26. The dampening system used most widely on web presses is the Goss Continuous Flow design, a skimming-roller dampener, i.e., a film or continuous type dampener. It is used almost exclusively on non-heatset web presses. Although new installations are now unique to web presses, a dampener of this type was also installed on sheetfed presses at one time. A full description of the skimming roller dampening system is given in Section 5.7 of Chapter 5.

27. There are three other dampening system types that are also unique to web presses: spiral brush, spray, and rotary atomizer. All of these non-contacting systems find their major use on non-heatset presses. Spiral-brush dampeners are fully described in Section 5.6 of Chapter 5.

28. Spray dampeners, originally developed for forms presses, are now widely used on double-width newspaper presses. A row of nozzles supplied by high-pressure water is used to produce a uniform spray of water particles. Flow is not continuous, but instead is pulsed (turned on and off periodically). This makes it an easy matter to vary flow rate, to track press speed, and to compensate for different papers. The entire spray bar must be enclosed to contain the overspray so that it can be collected and reused. Additional information on spray dampeners is given in Section 5.8.

29. Two different designs of rotary atomizer type dampeners are current: the Turbo dampening system and the WEKO dampening system. These two designs differ from spray dampeners in that the flow of water particles is continuous rather than pulsed.

6.8 References

Aller, C.B., "Ductor Roller for Use in Distribution Systems for Liquid and Semi-liquid Substances," *U.S. Patent 3,037,449*, June 5, 1962 (Re-examined issue RE25,881, Oct. 12, 1965).

Bass, W.E. and Kirby, J.F., "Method and Apparatus for Mounting Printing Sleeve," *U.S. Patent 3,146,709*, Sept 1, 1964.

Bohan, M.F.J., Claypole, T.C., and Gethin, D.T., "Factors Affecting the Process Stability of a Heatset Web Offset Press," *1995 TAGA Proceedings*, Vol. II, pp 1077–1094.

Dahlgren, H.P., "Lithographic Offset Press Plate Dampening Device," *U.S Patent 2,868,118*, Jan. 13, 1959.

Guaraldi, G.A. and Geary, J.W., "Printing Unit with Skew and Throw-off Mechanism," *U.S. Patent 5,301,609*, Apr. 12, 1994.

Gunning, J.R., "Predicting the Performance of Newsprint," *GATF Conference Proceedings (Paper Performance)*, Oct. 11–12, 1972, pp 5–14.

Hoffman, E., Winterholler, J., Prem, W. and Stöckl, H.; "Welded Tubular Printing Plate, and the Method of Making," *U.S. Patent 5,379,693*, Jan. 10, 1995.

Hollis, J.H., "Printing Press with Removable Printing Roll Sleeve," *U.S. Patent 4,119,032*, Oct 10, 1978.

Hung, J.Y., "Paper Fluting—Results of TEC Studies," *GATF Technical Forum Proceedings (Controlling the Lithographic Process)*, Oct. 1–3, 1984, pp 21-1 to 21-18.

Kelly, E.J., Crouse, D.B., and Supansic, R.R., *Web Offset Press Operating*, GATF, 1974, 180 pp.

Lin, P. and Hudyma, E., "Modeling of Web Tension Response and Its Application to Newspaper Printing," *1991 TAGA Proceedings*, pp 588–606.

Köbler, I., "Adjustable Bearing Arrangement for a Printing Machine Cylinder," *U.S. Patent 4,856,425*, Aug. 15, 1989.

MacPhee, J. and Gasparrini, C. R., "Tests Run to Determine the Effect of Blanket Washing on the Concentration of Combustible Vapor in the Dryer of a Heatset Web Offset Press," *1984 TAGA Proceedings*, pp 505–520.

Montgomery, R.M., "Tension and Register Model for a Multiunit Web Press," *1983 TAGA Proceedings*, pp 286–299.

Niemiro, T.A. and Whiting, F.J., "Press Inking System," *U.S. Patent 5,027,706*, July 2, 1991.

Porter, M., *The Competitive Advantage of Nations*, The Free Press, a Division of MacMillan (New York), 1990, p 180.

Rau, G. "Dampening Systems for Newspaper Presses," *Newspaper Techniques*, IFRA, July/August, 1978, pp 22–25.

Senger, K. T., "Letter to the Editor," *Forms Manufacturing* (Arlington, Virginia), Vol 5, No 5, May, 1991, p 6.

Smith, R.R., "Spray Dampening System with Individual Metering Pumps for Offset Press," *U.S. Patent 3,651,756*, Mar. 28, 1972.

Smith, R.E., "Approximate Analysis of Oscillatory Tension Effects on Register Error," *1974 TAGA Proceedings*, pp 60–72.

U.S. Department of Commerce, *Census of Manufacturers, Miscellaneous Chemical Products*, U.S. Government Printing Office (Washington, D.C.), Report No MC92-1-28H, March, 1995, p 18.

Voas, D. R. "The WEKO System," *Lithographic Dampening Conference Proceedings*, GATF, February 17-18, 1978, Tape.

Vrotacoe, J.B., Guaraldi, G.A., Carlson, J.R., and Squires, G.T.; "Method of Making a Gapless Tubular Printing Blanket," *U.S. Patent 5,304,267*, Apr. 19, 1994.

White, B.C., "Inking Mechanism," *U.S. Patent 1,214,856*, Feb. 6, 1917.

Chapter 7

Non-traditional Forms of Lithographic Printing

The preceding chapters of this book have all been concerned with one or more aspects of the traditional form of lithographic printing. The term "traditional" is used here to define the form that has been practiced over the past 100 years and that features the following:

1. A heavy-bodied or paste ink with grease-like chemical properties (ink viscosities that range from 35–450 poise).

2. A water-based fountain solution applied to the nonimage areas of the plate to prevent ink transfer thereto.

3. The reproduction of gradations in tone through the use of small equally spaced dots of varying size, i.e., conventional halftones.

4. An operational sequence wherein water is applied to the plate first, followed by the application of ink which adheres only to the image areas. (This is referred to as the water-first mode of the ink-water sequence.) Following these applications, the inked image on the plate is transferred to the substrate being printed, either directly, or via offsetting to a blanket.

5. An inking system comprising a relatively long train of rollers and an ink fountain equipped with keys for adjusting ink feedrate in the across-the-press direction. This feature is also referred to as zone control of inking.

Over the years, a great deal of research and development work has been carried out with the objective of improving upon various features of this form of lithographic printing. The net result of this work has been to produce a remarkable number of improvements that involve a departure from the traditional form of lithographic printing just described. It is the objective of this chapter to describe twelve of the more technically interesting of these departures, identified in Figure 7.1. From this chart, it is seen that the twelve variations can be categorized in terms of dual-fluid processes, single-fluid processes, and alternatives to conventional halftones, and this is the sequence in which they will be taken up here. The reader should understand that, while all of the variations or non-traditional forms of lithographic printing described here were at one time or another used in production, many of them either did not achieve or sustain commercial success, and therefore have not survived.

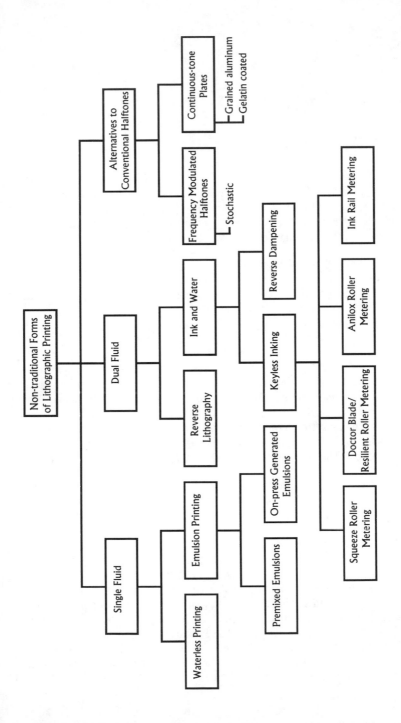

Figure 7.1 Classification of non-traditional forms of lithographic printing.

7.1 Reverse Dampening

A long-held tenet of lithography is that the plate must be dampened before applying ink to it. This is the so-called water-first mode of the ink-water sequence. The necessity for it would appear to be entirely reasonable, given the rudimentary explanation in Chapter 1 of how lithography works. Therefore, it may be surprising to hear that the opposite ink-water sequence, water last, or reverse dampening, was accidentally discovered to be viable over twenty-five years ago, and has been used routinely ever since on many double-width newspaper presses (Tyma, 1996). The sequence of events that led to this accidental discovery occurred during initial operation of the half deck for the double-width Metro newspaper press, manufactured by Goss Graphic Systems.

The half deck is an assembly consisting of a single printing couple and a common impression cylinder, designed for mounting on top of a Metro printing unit, as shown in Figure 7.2(a). (In newspaper parlance, a printing unit is made up of two opposing couples, where each couple consists of a blanket and a plate cylinder along with their associated inking and dampening systems.)

The purpose of the half or color deck is to make it possible to print additional colors on a web previously printed in black in either the supporting unit or in a separate unit. Two of the many web lead possibilities for doing this are shown in Figure 7.2, along with the number of colors printed on the webs. The wide variety of web leads is made possible by incorporating two features into the press design as follows:

1. The blanket cylinders in the supporting unit can be operated in two different positions: in contact with each other for perfecting, as shown in Figure 7.2(a), or in contact with the common impression cylinder, as shown in Figure 7.2(b).

2. The cylinders and rollers of both the half deck and one of the couples in the supporting unit can be run in either direction, i.e., can be reversed.

The fact that two of the plate cylinders can be reversed has the obvious result of also reversing the ink-water sequence. Thus for the web leads shown in Figure 7.2(a), the two couples in the printing unit are running water first, as is the couple in the half deck. In contrast, for the web lead shown in Figure 7.2(b), the half deck couple and the one beneath it are reversed and are running water last.

The Metro press was originally equipped with Goss Continuous Feed dampeners. At the time the press was designed, conventional wisdom taught that it was not possible to print using the water-last mode. For this reason, two dampening systems were installed on all half decks and

(a) Blanket cylinders of printing unit are in normal position that permits printing on two different webs.

(b) Blanket cylinders of printing unit are moved to contact common impression cylinder (CIC) to print on single web.

Figure 7.2 Roller diagram of Goss Metroliner unit and half deck with two different web leads. Numbers indicate number of colors printed on the respective sides of the web.

reversible press unit couples (Tyma, 1996). In this way, water could always be run first, by engaging the appropriate dampener, regardless of cylinder direction.

Following installation of the first Metro, the dampener on the arch side of the half deck developed a chattering type of roller vibration that set up waves in the water pan. This lead to spilling of water onto the couple below. More or less in desperation, operation was switched to the "wrong" dampener and, much to the surprise of everyone, it printed quite well (Tyma, 1996). It was soon learned that some colors would not run well, or at all, with reverse dampening. Following discussions with ink makers, this problem was overcome by making modifications to the affected ink vehicles. The problem dampener in the color deck was subsequently removed leaving the aisle unit as in Figure 7.2. When brush dampeners were subsequently introduced on the Metro, the dampeners were located as shown in Figure 7.2.

Although quantitative assessments of the merits of water first versus water last have only been published for keyless inking systems (Fadner, 1995), there is a consensus among users that fewer printing problems are encountered when running in the water-first mode. Thus, although time has proven that reverse dampening is viable, it is not an equal of the traditional mode of water first and has therefore lost favor.

7.2 Reverse Lithography

Reverse lithography is an alternate process developed in the early 1960's to get around the problem of the objectionable odors given off by traditional lithographic inks. The specific market segment targeted was the printing of packaging materials for food where such odors cannot be tolerated. The concept was founded on a two-part strategy:

1. Solve the problem of ink odor by using a water-based ink (Greubel, 1967).
2. Utilize an oily fountain solution made of a volatile aliphatic hydrocarbon with a preferred boiling point in the range of 247–287 degrees Fahrenheit (119–142 dgrees Celsius) (Greubel, 1965-1).

The lithographic process was preserved in the sense that two fluids were used and that one of the surfaces of the plate (the nonimage) was made oil-receptive, while the other (the image) was made water-receptive. Fountain solution was applied to the plate first, to form a thin film on the nonimage areas. Thus when ink was next applied, it only stuck to the image areas and not to the nonimage areas The term reverse arose, of course, because the lithographic properties of ink and fountain solution were reversed.

In addition to the unique ink and fountain solution, reverse lithography was characterized by a number of other features that are highlighted on the roller diagram in Figure 7.3. Perhaps of greatest interest is the plate, because it foreshadowed the plates developed just a few years later for waterless lithography.

Two plates were developed for use in reverse lithography. The first design (Greubel and Russell, 1966) consisted of a zinc or aluminum plate coated with a silicone compound in the nonimage areas. The stages in the preparation of this plate are illustrated in Figure 7.4(a) to 7.4(d). This negative-working plate employed a "deep-etch" light-sensitive coating that was in common use at the time in the preparation of conventional lithographic plates of the chemically etched type. This coating was exposed and developed to create a mask over the image areas, as shown in Figure 7.4(b).

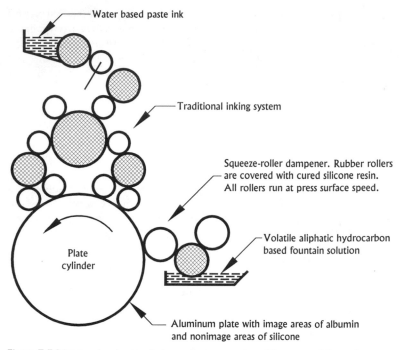

Water based paste ink

Traditional inking system

Squeeze-roller dampener. Rubber rollers
are covered with cured silicone resin.
All rollers run at press surface speed.

Volatile aliphatic hydrocarbon
based fountain solution

Plate
cylinder

Aluminum plate with image areas of albumin
and nonimage areas of silicone

Figure 7.3 Diagram showing key features of a press equipped for reverse lithography.

The plate was then treated with a strong acid (a deep-etching solution) that attacked and ate away part of the exposed metal in the nonimage areas. This was to provide better adhesion of the silicone coating that was wiped on with a cloth and then air-dried for 5 to 15 minutes, as depicted in Figure 7.4(c). After the silicone had dried, the plate was immersed in warm water and scrubbed with a hard brush. Owing to its water solubility, the hardened coating remaining on the image areas was thus dissolved and removed, carrying with it any silicone coated over it, as shown in Figure 7.4(d). The final step in the preparation of this original-design plate Involved hardening the silicone by baking the entire plate. Thus, in its finished form, the original-design plate consisted of nonimage areas of silicone and slightly recessed image areas of aluminum.

A problem of image area blinding was encountered in using this plate, and to correct it, an improvement was made (Greubel, 1965-2). (Although the patent application for the improved plate was filed later than the application on the original-design, the patent on the improved design was issued first.) The improvement involved covering the image areas of an original design plate with a hardened albumin-type coating, and this was accomplished as shown in Figures 7.4(e) and 7.4(f), and explained as follows.

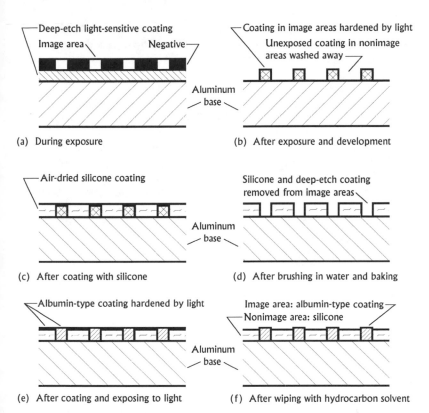

Figure 7.4 Schematics of original and improved plate designs, used in reverse lithography, in various stages of preparation. Finished form of original-design plate is shown in (d) and of improved design in (f).

After preparing an original-design plate, shown in Figure 7.4(d), a light-sensitive coating containing albumin and ammonium bichromate was applied at about the same dry thickness as the silicone resin film, i.e., 0.0004 inches (10 microns). The plate was then exposed to an arc light for 4 to 5 minutes to harden the albumin. Next, as shown in Figure 7.4(f), the plate was wiped or rubbed with a rag soaked in an aliphatic hydrocarbon solvent having a boiling range of 145 degrees Fahrenheit (63 degrees Celsius). The hardened albumin coating was readily removed from the surface of the silicone by this action, but remained bonded to the aluminum in the image areas. This produced the finished form of the improved-design plate consisting of silicone resin nonimage areas and image areas of an albumin-type compound.

Performance on press showed significant improvement in that no blinding occurred after printing 100,000 impressions, versus an original design plate that began to exhibit blinding after 27,000 impressions.

The fourth feature of reverse lithography, illustrated in Figure 7.3, is the squeeze-roller dampener (Greubel and Ely, 1966). This dampener was unique in two respects:

1. The two resilient rollers were first covered with rubber in the normal way, and then coated with a silicone compound ranging in thickness from 0.0002 to 0.002 inch, or 5 to 50 microns (Milton and Greubel, 1965). The roller was then baked to cure the silicone coating.

2. All of the rollers in the dampening system were run at press speed. It is assumed that this was made necessary by the relatively low viscosity of the aliphatic hydrocarbon fountain solution, which is about 0.5 centipoise at room temperature (Shell, 1991). As a consequence, fountain solution feedrate could only be varied by adjusting roller squeeze. This necessitated a rather elaborate mechanism for doing this, as described in the above referenced Greubel and Ely dampener patent.

Reverse lithography was used successfully in production for printing ice cream cartons with four color process inks (Savageau, 1996). The process did not survive, however, and one can only speculate on the reasons why. Certainly one contributing factor was the improvements made to reduce the odor of conventional inks. At this late date, it is easy to second guess the use of a volatile aliphatic hydrocarbon as a fountain solution and to think that this contributed to the demise of the process. In the context of the times, however, it probably seemed no worse than the isopropyl alcohol that was then widely used in fountain solutions, and that had a much lower boiling point (180 degrees Fahrenheit versus 247–287 degrees Fahrenheit for the aliphatic hydrocarbon). It is also possible that the process was difficult to control, and that this may have been a contributing factor. The available literature is silent on this and, again, it must be remembered that traditional lithography also had its own problems of control in the 1960's.

Although reverse lithography has not survived, its reduction to practice is a testament to the creativity and resourcefulness of the group at Interchemical Corporation (later Inmont) that developed it.

7.3 Keyless Inking

In the introduction it was pointed out that traditional lithographic inking systems are characterized by a relatively long train of inking rollers and the use of multiple form rollers. It was also pointed out that the use of a long train of inking rollers makes it necessary to provide some means (e.g., ink keys) to adjust ink feedrate in the across-the-press direction, so as to match ink feedrate to the ink demand of the form being run.

Such an inking system possesses three significant disadvantages, as follows:

1. The ink keys must be adjusted at the beginning of each new job in order to achieve a uniform print density in the across-the-press direction. This adds considerably to the time needed for press makeready.

2. Starvation type ghosting, explained in Section 4.2.4, cannot, as a general rule, be completely eliminated.

3. The multiplicity of inking rollers increases both the amount of heat generated in the train, and the response time of the press to changes in ink feedrate.

The main advantages sought by keyless inking systems are the elimination of the first and second above listed drawbacks of traditional inking systems. In addition, many keyless concepts have embodied short ink trains, thereby eliminating the third disadvantage as well. Thus, keyless inking systems are akin to the ideal inker described in Section 4.2.1.

Since the 1960's, a considerable amount of money has been invested in programs aimed at developing keyless inking systems for both newspaper and commercial lithographic presses. It is only within the past ten years, however, that designs have been perfected for use in double-width newspaper printing applications. For example, it was reported in 1989 that 99 newspaper press units around the world were printing with some type of keyless inking system, although none were in the U.S. (Fadner and Bain, 1989). Today, there are at least six manufacturers of systems for double-width offset newspaper presses, and the number of printing units installed and on order has risen to well over 1000 worldwide.

The main reason why success has been so long in coming is that there are four very significant potential obstacles, due to the presence of water and the high viscosity of the inks, that must be overcome in designing a keyless inking system for a lithographic press as follows:

1. The high speeds at which the paste ink is metered pose a challenge to the achievement of consistent metering and low wear rates of the metering elements. This obstacle is compounded by the potentially high rates of heat generation arising from these high speeds.

2. Excessive free water may be released beyond the nip formed between the plate cylinder and inking roller. If this occurs, the free water can impede ink transfer as a result of stripping, interfere with metering, and produce a washed-out appearing print (Dahlgren, 1984 and Corse, 1980).

3. Very high rates of shear can exist between metering elements (depending on the method used), with the result that free water may be released at the metering point. Such water can interfere with ink metering and cause simultaneous scum and washed-out areas (Chou and Bain, 1995).

4. The amount of water emulsified into the ink may build up to excessive levels, resulting in unacceptable water spots and/or ghosting in the printed product.

In the course of developing systems that avoid these potential problems, the designers of keyless presses have produced a wide variety of concepts. In fact, there are almost as many concepts as there are manufacturers. Thus, to obtain a complete picture of keyless technology it is necessary to review each of the designs that have actually been used in production. This review will be divided into two groups: early designs no longer extant, and designs currently offered for sale. Prior to embarking on this review, the characteristics that distinguish one design from another will be identified and discussed as necessary.

7.3.1 **Metering Methods Employed** Three different types of devices have been employed to meter ink in keyless systems: a squeeze roller, a doctor blade or rod, and a digital ink rail. The principles of operation of many of these devices are described in other parts of this book. For example, the metering principles of a squeeze roller are given in Section 3.4, those of a doctor blade in conjunction with a smooth roller are in Section 4.4.3, and ink rails are described in Section 6.5.1. Further information on the use of a doctor blade used in conjunction with a resilient roller to meter extremely thin films of paste ink is included in the description of the Dahlgren design for commercial printing, contained in Section 7.3.4. Similarly, the use of a rotating doctor rod in conjunction with a resilient roller to meter extremely thin films of paste ink is included in the description of the Chambon design for commercial printing, also contained in Section 7.3.4.

A number of keyless designs utilize a doctor blade in conjunction with an anilox roller to meter ink, a concept that has been used with success for many years on flexo presses. This type of roller was given the name anilox in the late 1930's, when it was developed, because, at that time, flexo was known as aniline printing. (Anilox was formerly registered as a trademark by Inmont). It would appear that the idea of using it on lithographic presses was an offshoot of a program at the ANPA Research Institute to adapt the keyless flexo process to newspaper printing (Jaffe, 1980).

In the flexo process, a roller having a surface engraved with a uniform array of cells, i.e., an anilox roller as in Figure 7.5(a), delivers ink directly to a compliant relief plate. The roller is also partially immersed in a pan of ink and thus picks up an excess amount of ink as it rotates. A doctor blade, pressed against the roller surface, rides on the lands between the cells and thereby scrapes off the excess ink, leaving only the ink contained in the cells. In this way, the same average film thickness is always presented to the flexo plate and there is no need for lateral adjustments of ink feed.

Print density is a function only of cell volume, ink viscosity, and ink pigment concentration. To avoid having to change anilox rollers (i.e., to

(a) Typical flexo design (b) Roller with composite cover

Figure 7.5 Two types of rollers used in anilox-roller-type keyless inking systems.

change cell volume), print density is normally controlled in the flexo process by controlling ink viscosity. This is accomplished by controlling the concentration of the solvent or solvents used in the vehicle.

One of the early problems encountered in utilizing this concept on litho presses was excessive wear of the anilox roller, which reduced the volume of the engraved cells and, hence, print density. This gave rise to a tremendous amount of research by many different groups to develop longer lived rollers.

One of many of the resultant improvements (Ijichi, 1993) was to replace the anilox roller, shown in Figure 7.5(a), with one having a composite cover, illustrated in Figure 7.5(b). The composite cover consists of very hard particles, randomly dispersed in a softer matrix. The hard particles are made of aluminum oxide or the like, and have a grain size of approximately 20 microns (0.0008 inch). The action of the doctor blade preferentially wears away the softer matrix, causing a portion of the hard particles to protrude from the nominal surface. Because the doctor blade only contacts the tips of the protruding particles, the spaces in between act as cells, as in an anilox roller.

The long life of this roller is due to the fact that, as the hard particles protruding from the surface are worn away, they are replaced by newly emerging particles from successively lower levels. The matrix also wears away, with the result that new cells are formed continuously as the old cells are worn away. A secondary effect of these particles is to grind the doctor blade to a smooth finish, thereby prolonging its life as well.

7.3.2 Size and Number of Form Rollers. Many keyless inkers utilize a single large ink form roller, the same diameter of the plate cylinder. The purpose of such a roller is to eliminate ghosts generated by the narrow gap in the plate cylinder as, for example, illustrated in Figure 4.14 in Chapter 4. The use of such a roller is not essential, however as there are a number of designs, both past and present, that use multiple form rollers of smaller diameter.

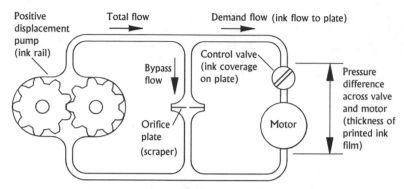

Figure 7.6 Fluid circuit analogy used to explain regulating action in a keyless inking system that utilizes an ink rail to feed a greater amount of ink than is required, and a scraper to remove the excess ink.

7.3.3. Use of an Ink Bypass Path.

Some keyless designs include a separate ink scraper or doctor blade for bypassing a portion of the ink on the rollers back to the reservoir. This is based on a principle for regulating ink film thickness that was proposed over thirty-five years ago for use on a letterpress newspaper press (Chase and Doyle, 1961).

In accordance with this principle, much more ink is fed to the ink

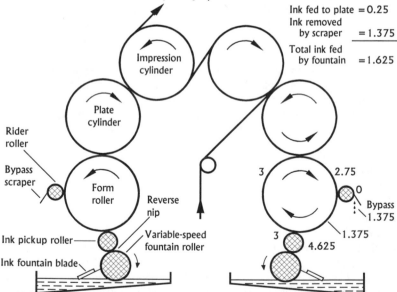

Figure 7.7 Roller diagram of keyless letterpress design that incorporates a scraper blade for bypassing ink back to the fountain (Chase and Doyle, 1961). Numbers on right indicate ink film thicknesses in microns at a coverage of 25 percent and a printed ink film thickness of 1.0 microns.

roller train than is demanded by the plate. The excess flow is bled off at some point on the roller train and returned to the reservoir. Because total flow is made up primarily by this bypass flow, the film thicknesses on the rollers, and hence the thickness of the ink film transferred to the paper, does not vary greatly in response to changes in the ink demanded by the plate, i.e., for different ink coverages on the plate.

This regulating action can be explained in terms of the analogous fluid circuit shown in Figure 7.6, where the total flow is large compared to the flow demanded by the motor. In such a case, it will be realized that the pressure rise across valve and motor will not vary greatly as the demand flow is changed by varying valve opening. In this example, valve opening is analogous to ink coverage on the plate, demand flow is analogous to ink flow to the plate or paper, total flow is analogous to ink flow to the roller train, and pressure rise is analogous to printed ink film thickness.

The design proposed by Chase and Doyle is shown in Figure 7.7. The large flow of ink to the roller train is supplied by an overshot fountain that is set to provide a uniform feed of ink in the across-the-press direction. The bypass flow is achieved by removing all of the ink from a roller, located in the return path to the ink rail, and returning it to the reservoir.

The ink film thicknesses given in Figure 7.7 were calculated using the method outlined in Figure 4.5. These calculations show that, for an average plate coverage of 25 percent, the volume of ink removed by the scraper blade is over five times the volume of ink delivered to the plate.

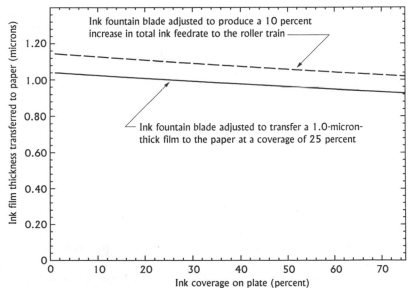

Figure 7.8 Calculated thickness of ink film transferred to the plate versus ink coverage on plate for keyless system shown in Figure 7.7.

The solid curve in Figure 7.8 is a plot of calculated ink film thickness transferred to paper versus plate coverage for the condition where the ink fountain has been adjusted so that a 1.0-micron-thick film is transferred to the paper at a coverage of 25 percent. This illustrates the good regulation achieved with this concept in that the thickness of the printed film rises by only four percent at a coverage of one percent and drops by only seven percent at a coverage of 75 percent.

The calculated values of printed ink film thickness for a 10 percent increase in total feedrate, given by the dashed curve in Figure 7.8, also show that the printed ink film thickness is proportional to the setting of the ink fountain.

When applied to a lithographic press, this system for achieving keyless inking possesses three very important advantages, as follows (Chou and Bain, 1995):

1. The shear rate at the metering elements is low because of the metered film is thicker (due to the lower relative speed of the elements). As a result, the problem of water release at the metering elements can be avoided with proper ink formulation.

2. Removal of ink by the scraper in the return path eliminates the problems created by excess water carried back to the metering elements.

3. Overall print density can be adjusted by varying feedrate from the ink fountain.

7.3.4 Early Designs No Longer Extant. There were four early keyless inker designs, no longer extant, that were advanced to the stage where units were installed in printing plants and used in production: the previously mentioned ANPA design for double-width newspaper presses, one developed by the Dahlgren Manufacturing Company for converting letterpress newspaper units to lithography (Dahlgren Manufacturing Company, 1978), one developed by Chambon Machinery for use on presses for proofing and packaging printing (Chevalier, 1976), and one developed by the Dahlgren Manufacturing Company for commercial sheetfed printing. All four are described in the following paragraphs, in chronological order.

1. **Chambon Design.** The Chambon keyless inking system used a unique squeeze-roller metering system (Corse, 1980) based on principles set forth in an earlier patent (Chambon, 1966). Shown in Figure 7.9, the Chambon system was featured by a compliant form roller the same diameter as the plate cylinder, and a metering device that consisted of a small-diameter ink doctor rod that was captured by a vee groove in the fountain block. The doctor rod was pressed against the form roller by the fountain block and rotated by a separate drive motor in the direction shown. In theory (Corse, 1980, and Chevalier, 1976), the metered ink

film thickness leaving on the form roller is governed by equation (7.1):

$$t_f = \frac{t_n}{2}\left(1 - \frac{V_d}{V_f}\right)^2 = \frac{1}{2}\left(1 - \frac{V_d}{V_f}\right)^2 \left(\frac{R}{p}\right)^{0.5}\left(\frac{h\mu V_f}{2E}\right) \qquad (7.1)$$

for: p much larger than t_n

where:

E = modulus of elasticity of compliant cover on form roller
h = thickness of compliant cover on form roller
p = depth of penetration of doctor rod into form roller cover
R = radius of doctor rod
t_f = metered ink film thickness on form roller
t_n = total metered ink film thickness in nip
V_d = surface speed of doctor rod
V_f = surface speed of form roller
μ = ink viscosity

Thus, this system also possesses the advantage that the operator can adjust overall print density by adjusting the speed of the doctor rod.

The problem of excessive water release beyond the plate nip was addressed by adding a barrier rod, a device similar in principle to the ink doctor rod. The pressure and speed of the barrier rod was adjusted to allow

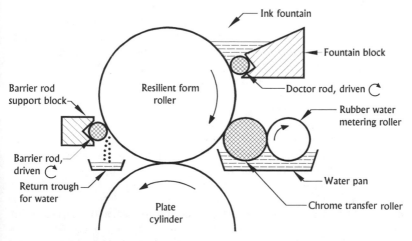

Figure 7.9 Chambon keyless inking system for commercial printing utilized a squeeze roller metering system (Corse, 1980). Barrier rod is designed to remove water, but not ink.

the film of ink, but not the water, to pass through the nip it formed with the form roller. It was claimed that the film of water remaining on the form roller was less than 1/50th the thickness of the ink (Corse, 1980).

If Figure 7.9 is compared with Figure 4.2, it will be seen that the Chambon design approaches that of the ideal inker in that the imprint, or ghost of the plate image, that is left on the form roller, is erased when the form roller surface is refreshed by passing through the ink fountain. This is an advantage that not all keyless inking systems possess.

There are three major questions about this design that are not answered in any of the literature available to the author. The first concerns how much heat is generated by the metering action, and whether the resultant temperature changes adversely affect operation. The second question has to do with the life of the form roller. It seems quite likely that excessive form roller wear, requiring frequent replacement, would occur because of the high rates of slippage between this roller and the doctor and barrier rods. The third is what was done to cope with water release and collection in the ink fountain.

So far as is known, only a few installations of this design were made and none have survived.

2. **Dahlgren Newspaper Design.** The Dahlgren keyless inking system for newspapers is described in a brochure, two patents, and a TAGA paper (Dahlgren Manufacturing Company, 1978; Dahlgren, 1980; Dahlgren, Sullivan, Gardiner, and Taylor, 1983; and Fadner and Bain, 1989). The configuration set forth in the Fadner and Bain TAGA reference, shown in Figure 7.10, is the one that will be described here because it presumably represents the final version of the design that Fadner and Bain reported was run on four press units in the U.S. from 1980 to 1985.

The squeeze-roller system used for ink metering in this design is very much like the one employed in squeeze-roller dampening systems. (See Section 5.5.2 for a detailed description of this type of dampening system.) Ink is metered in the nip formed between a rubber metering roller (located in the ink reservoir) and a copper ink transfer roller. These two rollers are geared together and driven separately by a variable-speed motor at less than press speed. Thus ink feedrate, and hence print density, can be varied by changing the speed of this roller pair.

A friction-driven rubber ink transfer roller is placed between the copper ink transfer roller and the rubber form roller, which is driven at press speed. Roller slippage may occur at two points: the nip between the two ink transfer rollers, and the nip between the rubber ink transfer roller and the form roller. More likely, however, the rubber transfer roller will run at press speed, resulting in a single slip nip between the two transfer rollers.

As can be seen in Figure 7.10, the problem of excessive water release beyond the nip formed with the plate cylinder was addressed by installing a wiper blade to remove some of the ink and water transferred to a

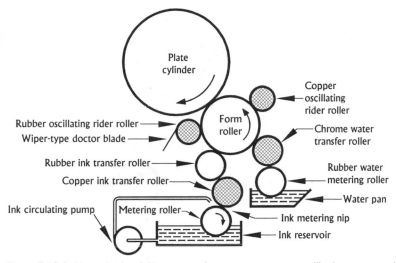

Figure 7.10 Dahlgren keyless inking system for newspaper presses utilized a squeeze-roller
metering system. Installed at Green Bay Post Gazette in 1980 (Fadner and Bain,
1989).

(presumably hard) rubber oscillating roller riding on the single ink form
roller. Removal of ink at this point no doubt also helped to reduce
ghosting. The ink and water thus removed was drained back into the ink
reservoir for reuse. This device is not shown in either the Dahlgren
brochure or patents, so it is not known when it was added and by whom.
In any case, it was reported that free water tended to appear in the ink
circulation system (Fadner and Bain, 1989). It is assumed that this posed a
problem, because it was also reported that the ink volume in the reservoir
was allowed to decrease near the end of a run such that the next day's run
could begin with substantially fresh ink.

In summary, the Dahlgren keyless inking system for newspaper presses
possessed the advantage of having provisions for the pressman to adjust
overall ink feedrate and hence overall print density. On the debit side, the
problem of excess free water release at the metering point appears not to
have been solved at the referenced installation, and it was reported that the
system was finicky and too sensitive to control (Fadner and Bain, 1989).

So far as is known, few if any installations of this design have survived.

3. **Dahlgren Commercial Concept.** The concept employed by
Dahlgren Manufacturing Company, to develop a keyless inking system for
commercial applications, differed significantly from the Dahlgren design for
newspaper applications, described in the previous section. Shown in Figure
7.11, the Dahlgren commercial design utilized a single compliant form
roller, the same size as the plate cylinder, and a doctor blade for metering
(Dahlgren, Taylor, and Gardiner, 1984). Like the Chambon design in

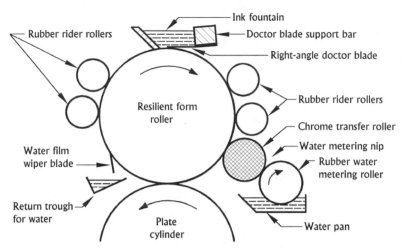

Figure 7.11 Dahlgren keyless inking system for commercial printing utilizing doctor blade and resilient roller for metering (Dahlgren, Taylor, and Gardiner, 1984).

Figure 7.9, it incorporated the ideal inker feature of erasing the imprint or ghost of the plate image left on the form roller by passing the surface of the form roller through the ink fountain.

The problem of excessive water release beyond the plate nip was addressed by adding a wiper-type scraper blade to remove the water. The additional use of air jets to evaporate some of the water may also have been used, in that both devices were the subject of a separate patent (Dahlgren, Taylor, and Peters, 1985).

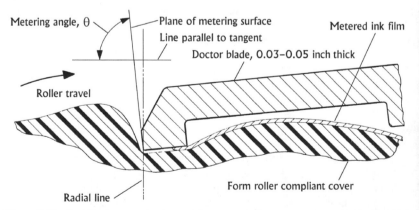

Figure 7.12 Detail of doctor blade used in keyless inking system shown in Figure 7.11 (Dahlgren, 1985). Doctor blade acts as a spring-loaded cantilevered beam. Radial force exerted on the form roller is in the range of 4 pounds per inch of press width.

The distinguishing feature of this concept, however, was the design of the doctor blade. Shown in Figure 7.12, a thin flexible doctor blade was mounted more or less tangent to the roller so that the narrow surface at its end served as the metering surface, where metering surface refers to the wetted surface adjoining the roller. The thickness of the metered ink film was established by adjusting two blade parameters: the radial force exerted by it on the compliant form roller, and the metering angle. (Metering angle, also discussed in Section 4.4.2, and identified in Figure 7.12, is defined as the angle formed between the metering surface and the tangent to the roller.)

Adjustment of the two blade parameters was achieved by mounting the blade support bar, shown in Figure 7.11, so that its ends could be both moved up and down and rotated. Because the doctor blade acted as a spring-loaded cantilevered beam, the up and down movement varied beam deflection and, hence, radial force. Rotating the bar changed the metering angle.

The up and down movement was achieved using manually operated screws, located at each end of the bar. Dial indicators were used to obtain readouts of bar position at each end. In the one test reported, density changed from 1.21 to 1.87 density units when the bar position was moved 0.025 inches (Dahlgren, Taylor, and Gardiner, 1984).

Rotation of the bar, to adjust metering angle, about a nominal value of 90 degrees, was accomplished by supporting the bar ends in bearings and using a remotely controlled motor drive to position a crank arm attached to the bar. This positioning system was equipped with a digital readout corresponding to metering angle.

The relationship between metered ink film thickness and the two doctor blade parameters, radial force and metering angle, is illustrated in Figure 7.13 (Dahlgren, 1985). For a given metering angle, it is seen that film thickness initially decreases as radial force is increased. A minimum is reached, however, at some value of force such that a further increase in force causes film thickness to increase. Figure 7.13 also shows that film thickness increases with decreasing metering angle, in keeping with the principles set forth in Section 4.4.3.

It was found that consistent metering along the entire length of the doctor blade (i.e., width of the press) was obtained when the doctor blade was operated in the region to the right of the minimum values of ink film thickness in Figure 7.13 (Dahlgren, 1985). The manual adjustments of radial force were used for coarse control of print density, while fine control was effected by using the remotely operated positioning system to change the metering angle.

It was claimed that metered ink film thickness, and hence print density, did not vary with press speed, and that the heat generated by the metering system was not excessive. Cooling means were specified, however, for both the doctor blade support bar and the form roller. This made it

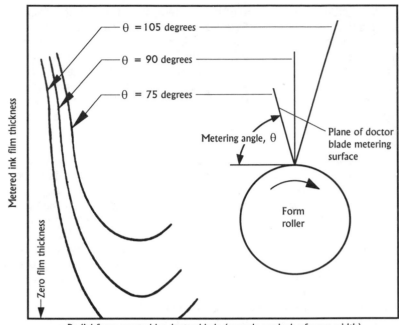

Figure 7.13 Curves showing relationship between metered ink film thickness and doctor blade parameters for doctor blade shown in Figure 7.12.

possible to vary the temperature and, hence, the viscosity of the ink being metered, thereby providing another method for adjusting the thickness of the metered film.

It was also claimed that lint and foreign matter did not clog or otherwise impair the metering action. Demonstrations of the system that were given at an international trade show and to a group of TAGA meeting attendees in May of 1983 appeared to substantiate these claims. Nevertheless, few if any installations remain. There is no information in the literature, available to the author, on the reasons why this concept did not survive.

4. ANPA Newspaper Design. In about 1980, ANPA began a program to adapt the principles of flexo inking, as described in Section 7.3.1, to offset newspaper presses (ANPA, 1983). A flexo inking system cannot be directly applied to a lithographic press because litho plates are not compliant, and because water must also be fed to the plate. The researchers at ANPA addressed these differences by placing two form rollers between the anilox roller and the plate cylinder and adding a dampening system (Matalia and Navi, 1983). Figure 7.14 is a diagram of the retrofit installation of the ANPA design that was made on a double-

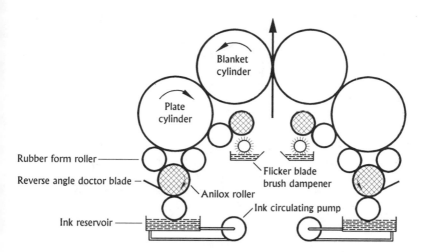

Figure 7.14 Prototype of anilox-roller-type keyless inking system developed by ANPA (ANPA, 1983). Doctor blade removes excess ink from roller leaving only the ink contained in anilox roller cells.

width newspaper press at the Burlington County Times in Willingboro, New Jersey in June, 1982. Following modifications to correct problems uncovered in the early tests, this installation was run for a five-year trial under production conditions (Matalia, 1989). Even so, problems remained in printing color due to the lower tolerance for water exhibited by color inks.

A number of newspaper press manufacturers licensed the ANPA technology and this seems to have brought an end to the need for further work by ANPA.

7.3.5 Current Designs. As of this writing, at least six different keyless inking system designs are available from the following manufacturers of double-width newspaper presses around the world: Goss Graphic Systems, Koenig & Bauer-Albert (KBA), MAN Roland, Mitsubishi Heavy Industries, TKS, and WIFAG. Descriptions and roller diagrams of all six designs are presented in the remaining paragraphs of this section.

1. Goss Design. The Goss positive-feed keyless inking system, shown in Figure 7.15, is available on the Newsliner model of tower presses (Goss, 1994). The design is distinguished by two key features: ink is metered by an eight-stream planetary gear pump to the ink rail on each couple so as to produce a uniform film of ink on the rollers in the across-press direction, and printed ink film thickness is maintained at a relatively constant value through the use of a scraper that bypasses a large fraction of ink fed to the ink train, back to the supply reservoir for reuse (Niemiro, 1994). Each

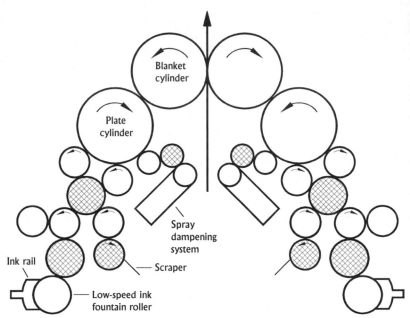

Figure 7.15 Goss Graphic Systems keyless offset double-width newspaper press design.

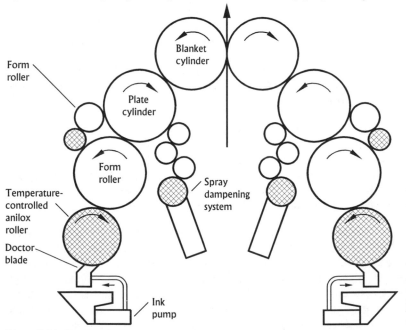

Figure 7.16 Koenig & Bauer-Albert keyless offset double-width newspaper press design.

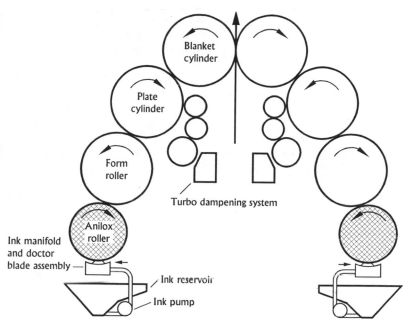

Figure 7.17 MAN Roland keyless offset double-width newspaper press design.

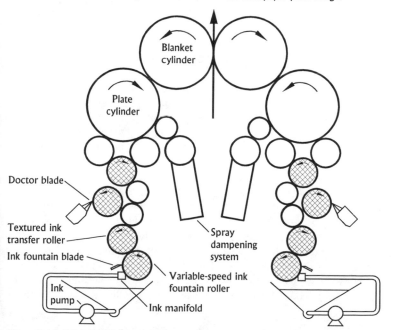

Figure 7.18 Mitsubishi Heavy Industries keyless offset double-width newspaper press design.

eight-stream planetary gear pump is driven by a separate drive motor that tracks press speed, and which can be modulated to adjust print density. A spraybar feeds water to the plate via a separate train of three dampening rollers.

2. **KBA Design.** KBA's anilox keyless inker, shown in Figure 7.16, is available on both arch-type (shown in Figure 7.16) and common impression cylinder model offset presses (KBA, 1995). This design is distinguished by the use of an anilox roller and doctor blade for ink metering, and a large form roller the same size as the plate cylinder. A second smaller-diameter form roller is also provided. The proprietary anilox roller has a coating with a service life of more than 40 million cylinder revolutions, while service life of the doctor blade is over one million cylinder revolutions (KBA, 1995). A spraybar supplies water directly to the plate through a train of four dampening rollers.

3. **MAN Roland Design.** The MAN Roland design, shown in Figure 7.17, is distinguished by the proprietary MAN Roland Turbo dampener that includes a train of three rollers for feeding water directly to the plate (Dylla, 1997). This keyless design utilizes an anilox roller for ink metering, and a single form roller the same size as the plate cylinder.

4. **Mitsubishi Heavy Industries Design.** This design is available on both tower and satellite, or common impression cylinder, models of Mitsubishi double-width offset presses (Mitsubishi, 1996). Ink metering is carried out with an overshot fountain blade, and an additional doctor blade provides regulation in accordance with the bypass principle set forth in Section 7.3.3. Print density is easily adjusted by varying the speed of the fountain roller. Dampening is provided by a two-roller dampening roller train fed by a spraybar.

5. **TKS Design.** TKS offers its keyless design on both tower press models, as shown in Figure 7.19, and common impression cylinder models (TKS, 1995 and Shafer, 1997). The heart of the system is the TAK roller, a proprietary, random cell, anilox roller used in conjunction with a doctor blade for final ink metering. Long anilox roller life is achieved through the use of a coating matrix that contains minuscule cavities, or bubbles, distributed throughout. The cavities exposed at the ground roller surface act as cells. Long roller life is achieved because as the roller surface wears and cells are removed, new cells are created at the same time. The same principle is utilized by the roller illustrated in Figure 7.5(b). Only a relatively small amount of excess ink must be removed from the anilox roller by the doctor blade because a train of three rollers, supplied by an ink fountain, feeds a thin film of ink to the anilox roller. Thus, it is possible to run inks with viscosities as high as 100 poise. The dampening system consists of a spraybar and a two-roller train that supplies water directly to the plate.

6. **WIFAG Design.** The WIFAG keyless design, shown in Figure 7.20, is distinguished by the use of a carbide doctor rod in conjunction with a

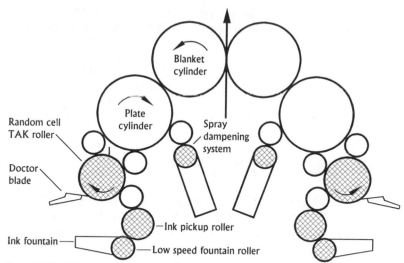

Figure 7.19 TKS keyless offset double-width newspaper press design.

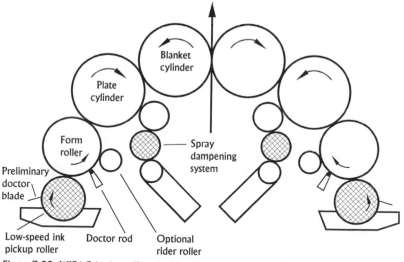

Figure 7.20 WIFAG keyless offset double-width newspaper press design.

large resilient form roller, to meter ink (WIFAG, 1997).

Each doctor rod is the length of a page (for a total of four per couple) and has means for adjusting both its pressure and angle relative to the form roller. Only a relatively small amount of ink must be removed by the doctor rod because ink is fed to the form roller by a slow-speed pickup roller, also fitted with a preliminary doctor blade that provides initial metering. In addition to the direct-feed spray dampener, shown in Figure

7.20, the units can be supplied with brush dampeners. The WIFAG keyless inking system is available on both new tower-type presses and add-on units.

These designs, currently in worldwide use, offer evidence of the great progress made in keyless technology for offset newspaper printing. Further advances no doubt will be made to address the challenges posed in sheetfed printing, where the currently employed inks are much more viscous and dry by oxidation. The higher viscosity complicates the task of metering, and oxidative drying may rule out ink recirculation.

7.4 Emulsion Printing

Emulsion printing refers to a type of lithographic printing in which the water is delivered to the plate in the form of small globules dispersed in the ink, i.e., as a water-in-ink emulsion. The various programs undertaken to perfect it range in time from recently to at least sixty years ago. All were driven by the prospect of achieving one or more of the following advantages:

1. Elimination of problems associated with maintaining ink/water balance using independent ink and water controls (Chou and Bain, 1995).
2. More efficient dampening, i.e., reduce the minimum required water feedrate to the plate (Fadner, 1996). This is desirable because it is generally accepted that a lower water feedrate to the plate results in higher print quality.
3. Elimination of the maintenance caused by ink feedback into the system for supplying fountain solution.
4. Elimination of printing problems arising from ink buildup on dampening system rollers.
5. Eliminate need to add isopropyl alcohol or an alcohol substitute to the fountain solution when printing on coated stocks (Fadner, 1996).
6. Eliminate need to dispose of used fountain solution.
7. Eliminate need for fabric roller covers, as for example, used on conventional and some brush dampeners.

For this type of printing to succeed, the stability of the emulsion must lie between two limits, as follows (Rowell, 1937):

1. A low enough stability to enable the emulsion to break or separate when pressed by a form roller against the plate and thereby release water to the nonimage areas.
2. A high enough stability to prevent the emulsion from breaking in the ink fountain or in roller nips and thereby prevent the release of water that would interfere with the metering action and/or cause roller stripping.

A very pertinent requirement of lithography is that the water feedrate required in the across-press direction is relatively constant whereas ink feedrate can vary by a factor of more than 10 due to ink coverage, as shown in Figure 4.24. In fact, this requirement becomes a barrier to success if water feedrate is made dependent on ink feedrate, as explained below.

Detailed information on emulsion printing concepts reduced to practice is given in the following paragraphs. The designs are classified according to whether the emulsion is formed off press, i.e., premixed, or whether it is generated on press.

7.4.1 Premixed Emulsion Systems. To the best of the author's knowledge, two attempts have been made to develop a premixed system: one for small sheetfed presses, and one for newspaper presses.

The sheetfed concept envisioned using a patented premixed ink on a standard press (Rowell, 1937). The press was presumably of the duplicator type, because the patent was assigned to Addressograph Multigraph Corporation, a manufacturer of that type of press. According to the patent, the principle of emulsion printing was well known at the time.

The problem addressed by the patent was that of formulating an emulsion with the required stability limits. It claimed to solve this problem by including a thickening agent to raise the viscosity of the fountain solution that was emulsified into the ink. This patent also stated that the concentration of fountain solution in the emulsion had to be varied depending on ink coverage and relative humidity, with lighter coverages and lower relative humidities requiring 10 to 30 percent more fountain solution in the ink.

The second known attempt to develop a workable premixed system was made on a double-width newspaper press in the 1970's (Krzeminski, 1977). In the initial tests of this program an emulsion of tap water in letterpress ink, at a water concentration of 50 to 55 percent, was used in letterpress printing. This was done to demonstrate that print density can be maintained with ink carrying large amounts of water. Further testing with lithographic plates led to the evolution of a successful system wherein an alkaline fountain solution was premixed into the ink at a concentration of 48 percent. The mixture was then fed to the ink rails on the press. It was also necessary to include an auxiliary water system to enable press operators to inject additional water into each line leading to an ink rail. This was because not enough water was carried by the ink to areas of low or zero coverage, as on open pages, in gutters, and at the ends.

The need for adding this auxiliary water system points up an inherent disadvantage of a pure premixed emulsion system: its inability to satisfy the requirement for a relatively uniform transverse water feed because water feedrate is tied to ink feedrate. This probably accounts for its demise.

This inherent weakness of a premixed emulsion system is explained further by the example given in Figure 7.21 in which the form to be

(a) Ink coverage on plate (b) Ink feedrate (c) Water feedrate

Figure 7.21 Example that illustrates inherent drawback of a premixed emulsion system. Because ink coverage on plate, shown in (a), governs ink feedrate, shown in (b), the actual water feedrate, as determined by ink feedrate and shown in (c), can differ greatly from zone to zone. Thus, the required water feedrate, also shown in (c), cannot be satisfied in every zone. Zones refer to regions in the across-press direction in which ink feedrate is controlled by ink keys or the like.

printed consists of four zones across the press, having varying amounts of ink coverage. This is reflected in the ink coverages on the plate, shown in Figure 7.21(a) as 15, 50, 25, and 15 percent in Zones 1, 2, 3, and 4, respectively. The required ink feedrate in each zone is proportional to coverage, as shown in Figure 7.21(b). Because water is delivered to the plate by the ink, actual water feedrate will also be proportional to ink feedrate, as illustrated by the solid line plot in Figure 7.21(c). In contrast, the required water feedrate, shown by the dotted line plot in Figure 7.21(c), does not vary strongly with ink coverage and therefore has a flatter curve. If the amount of water premixed into the ink is adjusted so that slightly more water than needed is supplied in Zone 3, the relative magnitude of the required and actual feedrate curves will be as shown in Figure 7.21(c). In such a case, far too much water will be fed to Zone 2, while not enough will be supplied to Zones 1 and 4. Thus, no matter how the water content in the ink is adjusted, it is not possible to provide just the right amount of water to all zones at the same time. In actual practice, this problem is much more complex because an inker is divided into many more zones than four.

7.4.2 On-press Generated Emulsion Systems. An emulsion system of the on-press generated type is characterized by the feeding of water into the train of inking rollers at a point that is removed from the plate by at least one inking roller nip. The qualification of one inking roller nip is necessary because, otherwise, the water on the roller surface will survive as a film and be delivered to the plate in that form, instead of becoming emulsified into the ink. Thus, systems such as those shown in Figures 7.9 and 7.11 are excluded, as are the inker feed dampeners described in Chapter 5, because they all apply water in film form to the plate.

On-press generated emulsion systems possess the advantage, vis-à-vis premixed systems, of having independent ink and water feedrate controls.

Thus, the problem of not being able to simultaneously satisfy the ink and water needs of the plate, illustrated in Figure 7.21, is avoided.

The concept of applying an emulsion to the plate, mixed on press, is by no means new. As already mentioned in Chapter 5, the idea of feeding water directly into the inker was disclosed almost simultaneously in Germany and the United States in the 1930's (Larsen 1939, and Godike, 1938). It was not until the 1970's, however, that the idea was put to use on a widespread basis in the form of ink train dampeners, of the brush type, on Goss Metroliner and Headliner newspaper presses, illustrated in Figure 7.22. Also, many newspaper presses of this type were equipped with ink train dampeners of the spray type. Thus, there are many newspaper presses in the U.S. today that employ emulsion systems of the on-press generated type.

It is generally accepted, however, that presses with ink train dampening, as configured in Figure 7.22, do not perform as well as do presses that employ dampeners of more traditional design (Crandall, 1986 and Fadner, 1995). Most likely, this accounts for the more recent trend on newer double-width newspaper presses to employ dampeners with separate roller trains, i.e., of the plate-feed type.

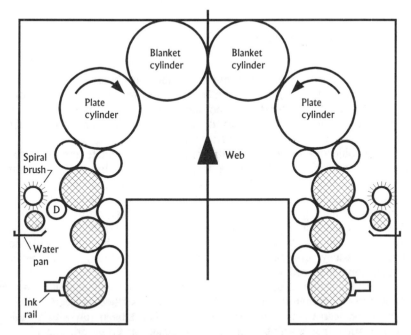

Figure 7.22 Roller diagram of double-width newspaper press unit with ink train dampeners. Water is flicked onto rubber Transfer Roller D and emulsified into ink by passage through at least two inked roller nips prior to delivery to plate.

Sharply contrasting this assessment is a recent claim (Fadner, 1996) that ink train dampening is in fact superior, if correctly practiced. The key to correct operation, as claimed in this patent, is that the water must be applied to a train of inked rollers at a point that is removed from the plate by at least four nips, not including the nip formed with the plate. If this is done, the same patent claims that the following advantages will be realized, vis-à-vis traditional dampening systems that utilize one or more water-receptive rollers:

1. More efficient dampening in the form of a significantly lower water usage rate. (Less water produces improved print quality.)
2. Elimination of the need to add isopropyl alcohol or an alcohol substitute to the fountain solution.

Results of tests run by the author on a sheetfed press, using coated paper and sheetfed inks, have confirmed that ink train dampening, carried out in accordance with the above prescription, does indeed work with light coverage forms. Furthermore, the data obtained showed that the two advantages claimed above were realized. It remains to be demonstrated, however, if the same results can be achieved with heavy coverage.

7.5 Waterless Printing

In traditional lithographic printing, the nonimage areas of the plate are coated with a thin layer of fountain solution to prevent them from accepting ink. The water film is not permanent and therefore must be continuously replaced, leading to difficulties in maintaining the proper balance between ink and water feedrates to the plate.

The objective of waterless lithography is to eliminate the need for water by utilizing a solid nonimage area material that, by itself, does not accept ink. The first U.S. patent on waterless plates (Curtin, 1970) disclosed that silicone, a rubble-like inorganic polymer, is well-suited to this purpose. Although many other patents on waterless plates have been allowed since, silicone has been the choice in all of them for the nonimage area. For the image areas, a variety of materials have been specified and used successfully, including support substrates of aluminum and polyester and photopolymer coatings.

An interesting aside is that the first plate developed for reverse lithography (Gruebel and Russell, 1966), and described in Section 7.2, could have been used for waterless printing. Had it been run with an oil-based (rather than water-based) ink by mistake, waterless printing would have been discovered several years earlier, albeit serendipidously.

Another note of interest is that the first company to receive a U.S.

patent on a waterless plate, Minnesota Mining and Manufacturing Company (3M), named the process driography (Corey, 1976). The company that is generally credited with reducing the process to commercial practice, Toray Industries, however, opted for the name waterless printing (Kobayashi, 1991).

Waterless printing has gained a toehold in the U.S. and possesses many important advantages. Therefore, it is described in detail below, starting with a section on theoretical aspects. This is followed by sections on current plate designs, press cooling requirements, desirable press modifications, and relative merits.

7.5.1 Theory. Two different models have been used to explain why waterless printing works. The first is based on the relative wetability of the materials used for the image and nonimage areas of the plate. The second, called the Weak Fluid Boundary Layer Model, is based on a series of experiments carried out on a variety of waterless plates and inks (Gaudioso, Becker, and Sypula, 1975). Both models are explained briefly in this section.

To obtain a quantitative explanation of the first model, numerical values of the surface free energies and interfacial free energies of the materials involved are needed. There is, however, no universally accepted method for calculating interfacial free energies or tensions from measurement of other surface phenomena, as noted in Section 1.2.1 in connection with a similar discussion of traditional lithographic printing. For the sake of simplicity, surface properties obtained using the method of Zisman (Fox and Zisman, 1950) will be used here to explain the first model.

In this method, a group of homologous (chemically similar organic) liquids is used to determine the maximum surface tension a liquid can have and still spread on a given solid in the presence of air. This maximum value is defined as the critical surface tension of that solid, although it is not a fundamental material property, as is (say) the surface tension of a liquid.

If the liquid or liquids of interest are entered on one side of a chart in order of their surface tensions, and the solids of interest are entered on the other side in order of their critical surface tensions, the chart can be used to determine whether a given liquid will spread on a given solid (Singleterry, 1964). Figure 7.23 is such a chart, prepared using published values for typical materials of interest here. From it one can thus read that ink will spread on the image area of a waterless plate, but not on the nonimage area. Water, having a higher position, will not spread on either, but will bead up instead.

The tenet of the second model, set forth to explain waterless printing, is that a lower viscosity fluid is interposed between the image area of the plate and the ink. Consequently, splitting occurs in the weaker (low-viscosity) layer, rather than the ink, thereby preventing transfer of ink to the nonimage area. The presence of the lower-viscosity fluid film comes

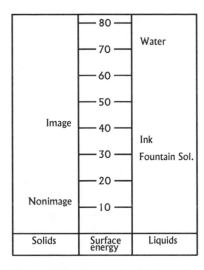

Figure 7.23 Chart of critical surface tensions of solids used in waterless plates (Lanet and Gandini, 1995) and surface tensions of some liquids (from Table 1.1). A given liquid will only spread on solids that are in higher positions on chart.

about as a result of low-viscosity components of the ink vehicle diffusing into the non-image area material. This model is supported by a considerable body of experimental data. It is also appealing because it is applicable to traditional lithography as well.

Two recent investigations (Lanet and Gandini, 1995, and Lanet and Gandini, 1996) have produced data that lend support to both models. Because of this and the compelling arguments that can be made on both sides, there is no justification at present to favor one model over the other.

7.5.2 Current Plate Designs. Presently, two different types of waterless plates are in commercial use: photographic plates (both positive- and negative-working) that are exposed and developed in a more or less traditional manner, and thermal plates that are laser-imaged.

Figure 7.24 shows the various stages in the preparation of both a positive- and a negative-working plate of the photographic type (Maltby, 1986). Although the positive plate (Kobayashi and Iwamoto, 1975) was developed first, the negative plate (Kinashi, Fujita, and Kawabe, 1982) is very much like it. In both, the unexposed plate consists of an aluminum support or base to which are applied successive coatings of a primer, a light-sensitive photopolymer, a silicone rubber, and a protective film. The silicone coating on the as-received plate is about 0.0002 inch (5 microns) thick and has a tacky surface. Because of the latter, a thin protective film of polyester is laminated to it to prevent the silicone from sticking to either the positive or negative film during exposure to light. Following exposure, the protective film is peeled away and discarded.

The as-received plates differ in that the silicone layer is strongly bonded to the photopolymer in the case of the negative-working plate, whereas it is weakly bonded on the positive plate. In the case of the negative-working plate, the effect of light is to weaken the bond between the silicone and photopolymer, while in the case of the positive plate it creates a strong bond. Thus, after exposure, the silicone layer in the image areas of both type plates is weakly bonded to the photopolymer layer.

The next step in processing these plates consists of applying a developing fluid containing a hydrocarbon solvent to the surface of the

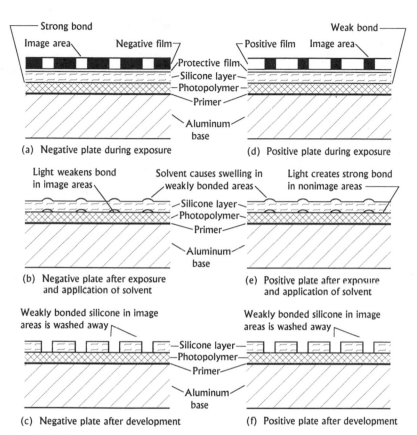

Figure 7.24 Schematics of negative- and positive-working photographic-type waterless plates in various stages of preparation.

silicone. The solvent causes the silicone in the image areas to swell and take on a crumpled appearance. While still wet, the plate is then swabbed with a soft cloth or brush until the crumpled silicone is completely removed. After rinsing and drying, the plate is ready for printing.

In its simplest form, a waterless plate of the thermal type consists of three layers: a bottom support sheet of aluminum, an intermediate ablation layer, and a top layer of silicone (Lewis, Nowak, Robichaud and Cassidy, 1994). The ablation layer consists of a material that is a good absorber of the energy used to image the plate. Generally, this energy is generated by a laser operating in the near IR region (830 nm wavelength). A power level of about 1.0 watt is all that is needed for imaging.

The plate is imaged electronically in accordance with the principles described in Section 7.6.2. During imaging, the laser is turned on while scanning the image areas of the plate. When the laser is turned on, much of

its energy is absorbed by the ablation layer, reducing it to debris and debonding the silicone above it.

After it has been imaged, the plate is cleaned with a brush to remove the debonded silicone in the image areas and any debris remaining from the ablation layer. The finished plate is similar to the reverse lithographic plate shown in Figure 7.4(d) in that it consists of nonimage areas of silicone and recessed image areas of aluminum.

More elaborate thermal plate designs have been developed that use a second ablation layer to better contain the debris and to prevent charring of the topmost silicone layer (Lewis, Nowak and Robichaud, 1994). The imaging principle, however, remains the same.

7.5.3 Cooling Requirements. The problem of maintaining the proper ink/water balance in traditional lithographic printing is replaced in waterless printing by the need to control plate temperature accurately. This is because it has been found that, for a given system of ink and plate surface energies, there is a so-called critical plate temperature, above which toning of the nonimage areas occurs (Krishnan and Klein, 1991). In laboratory studies of 18 different combinations of plates and inks, all run on the same press, this temperature was found to range from 80 to 122 degrees Fahrenheit (27 to 50 degrees Celsius). The combinations of inks and plates used in practice, however, appear to exhibit critical toning temperatures in the low end of this range, i.e., 80–90 degrees Fahrenheit (27–32 degrees Celsius). Because of this and the elimination of the evaporative cooling provided by the use of fountain solution, press cooling by mechanical means is virtually essential in waterless printing, especially on modern presses capable of running at high speeds.

In addition to an upper limit, there is also a lower limit on plate temperature governed by ink transfer. That is, if the temperature of the ink is too low, it will not transfer properly from roller to roller and roller to plate image areas. Thus the success of waterless printing is dependent on maintaining temperatures of the plate and inking rollers within a relatively narrow band.

On sheetfed presses, adequate control of plate and ink roller temperatures when printing waterless usually can be achieved by equipping the press with water-cooled vibrating ink rollers. On web presses, however, additional cooling of either the plate or blanket cylinder must be provided at speeds above about 1200 feet/minute or 6 meters/second (WOA, 1996).

Some quantitative information on heat generation rates in press rollers and cylinders is given in Section 3.2.3. In addition, Section 4.7 contains sample information on the total heat generation rate in press roller trains.

7.5.4 Desirable Press Modifications. Although it is possible to use the same press configuration for both traditional and waterless printing, waterless printing can be enhanced by using a press that has the following features:

1. **Water-cooled Vibrating Ink Rollers.** The need for this press feature has been discussed in the preceding section.

2. **Water-cooled Plate Cylinders.** It was pointed out above that it is necessary to cool the plate cylinder as well on web presses that run at speeds over about 1200 feet/minute (6 meters/second). At these speeds, the heat generated by the blankets increases to a level where it can no longer be removed efficiently by the vibrating ink roller cooling system. In fact, it is advisable to water-cool both the plate and blanket cylinders. An air-cooled system can be used for cooling on existing presses where it may be impractical to retrofit a water-cooled system to the plate and blanket cylinders (Kurz, 1994).

3. **Harder Form Rollers.** It has been reported that waterless plates print cleaner when harder form rollers are used (Dankert, 1996 and WOA, 1996).

4. **Smaller-Diameter Form Rollers.** It has also been reported that waterless plates print cleaner when smaller-diameter form rollers are used (Dankert, 1996). Generally, however, it is not possible to change the diameters of the form rollers on an existing press.

5. **Stiffer Ink Fountain Structure.** In general, waterless inks have higher viscosities and therefore generate higher pressures that result in greater ink fountain blade deflection. Consequently, it is necessary on some presses to stiffen the ink fountain support structure (WOA, 1996).

6. **Sheet/Web Cleaner.** Dust particles, carried into the press by the paper, are a major problem in waterless because they stick to the plate and produce hickeys on the printed material. Therefore, some type of cleaning device must be installed at the press infeed to remove these dust particles from the sheet or web (WOA, 1996).

7.5.5 Relative Merits.
The merits of waterless printing, vis-à-vis traditional lithography, stem from replacing a temporary fluid coating, water, used to prevent the plate image areas from accepting ink, with a permanent solid coating, silicone rubber. Thus, the merits of waterless printing can be divided into two groups: those that accrue from the elimination of water, and those that accrue from the employment of silicone and the inks that must be used with it.

The advantages and disadvantages of waterless printing that are a consequence of eliminating fountain solution are described in the following numbered paragraphs. The reader is reminded that this group of waterless advantages is a mirror of the disadvantages of using water in traditional lithography. Conversely, the disadvantages mirror the often ignored benefits of the water-based fountain solutions used in traditional lithography.

1. The employment of a single fluid, ink, greatly simplifies the printing operation because it is no longer necessary for the press operator to

balance ink feedrate against that of water. This makes for faster makereadies, less makeready waste, and more consistent color during the run. It also means that less time is required to train new operators.

2. The absence of water results in fewer register problems in multicolor printing. This is because the paper does not undergo dimensional changes, caused by water pickup, as it passes through the press.

3. In theory, drying of printed materials should be improved by the absence of water pickup by paper; faster drying in the case of sheetfed printing, and a reduction in required dryer energy in the case of heatset offset. There is some question, however, whether faster drying times are actually realized in sheetfed printing on paper. In contrast, it has been found that drying definitely is faster when printing with the waterless process on plastic (Lind, 1997).

4. A major drawback of waterless printing is the need for much higher cooling capacities to maintain press temperatures. As noted in Section 4.7, this increase can amount to as much as a factor of four. The reason for this increase is the loss of cooling provided by the evaporation of fountain solution.

5. Another major drawback of waterless printing is the significant increase in the number of hickeys generated by paper dust carried into the press by the paper. It is theorized that this is due to the fact that in traditional lithography, the paper dust takes up water and becomes non-ink-receptive.

6. A third disadvantage of waterless printing is that static, and hence problems induced by it, are worsened in the absence of water.

The following second list of numbered paragraphs describe the advantages and disadvantages of waterless printing that are a consequence of using silicone rubber coating as the plate nonimage area material.

1. All waterless plates in current use are characterized by image areas that are recessed with respect to the silicone coating. Because of this and the stiffer inks used, there is significantly less dot gain at a given printed solid density, or ink film thickness (Kobayashi, 1991). For example, data obtained by one web printer shows that dot gains with waterless printing are about one-half that of conventional offset (Wong, Xie, Strong, and Stone, 1995).

2. The ink and plate combinations used in waterless printing must be operated in a relatively narrow temperature band, as discussed in Section 7.5.3 above. Consequently, the press cooling equipment is made more expensive by the requirement for very accurate temperature control. It is not uncommon, for example, to employ a noncontacting plate temperature sensor as part of a closed-loop temperature control system for each printing unit.

3. The ink and plate combinations used in waterless printing are

significantly more expensive than the corresponding materials used in traditional lithographic printing. Part of this cost difference is due to the currently lower volume of waterless sales, so there is some expectation for improvement as waterless grows in use.

4. The silicone coating on waterless plates is much more susceptible to mechanical damage, e.g., scratching during handling.

7.6 Alternatives to Conventional Halftones

Figure 7.1 identifies two alternatives to the conventional halftone layout described in Section 2.1.2: frequency modulated halftones, and plates imaged in continuous tones. Based on the description given in Section 2.1.2 it will be realized that, as defined here, a conventional or traditional halftone is a picture in which gradations in tone are achieved by varying the size of small equally spaced dots that have the same optical density or ink film thickness. The process of creating a halftone from a continuous-tone original picture is called screening, and it can be accomplished in two different ways: photographically or electronically. These two screening methods are discussed first as a prelude to the descriptions of the two alternatives to conventional halftones given in Sections 7.6.3 and 7.6.4.

7.6.1 **Photographic Screening.** Until recently, halftone images were produced on a lithographic plate by exposing the plate through a film bearing a like halftone image. The halftone film was in turn produced by photographing a continuous-tone original in a camera fitted with two key elements: a high-contrast film, and a screen, or rectangular grid, having small openings through which light can pass. The screen is placed in front of the film, as shown in Figure 7.25.

High-contrast film is defined as one that has only two tones when exposed and developed: light (transparent) and dark (black). Thus, there is some threshold value of exposure above which the film turns from transparent to black, in the case of a negative film. (Exposure is defined as the intensity of the light, incident on the film, multiplied by the time during which the film is subjected to this light.)

Historically, two types of screens have been used: the glass line, invented about 100 years ago (Levy and Levy, 1893), and the color dye contact screen that superseded it 50 years later (Murray, 1943). These are illustrated in Figure 7.26.

The glass line screen, shown in Figure 7.26(a), consists of a rectangular grid in which the openings and lines preferably are of equal width. This type of screen is positioned a short distance, very accurately controlled, from the film to be imaged.

For example, according to calculations given by Jaffe, the typical spacing between screen and film is about 0.250 inches (6.35 mm) for a

Figure 7.25 Schematic of photographic screening method. Halftone image is created by
photographing a continuous-tone original using a camera equipped with a screen
located in front of high-contrast film to be imaged. Spacing between the halftone
dots is governed by line spacing on screen. Dot size is determined by the amount
of light passing through the corresponding openings in the screen.

133-lines/inch or 52-lines/cm screen (Jaffe, 1962). The effect of this
spacing is to project a fuzzy image of the grid upon the film.

As perfected in the 1940's (Yule, Johnson, and Murray, 1943),
the contact screen consists of a dyed transparent support bearing a fuzzy
image of a grid, as shown in Figure 7.26(b). (Magenta is the dye color
most commonly used for black-and-white reproductions, while color
reproductions require a gray screen.) This type of screen must be held
tightly in contact with the film to be imaged, hence its name. To
accomplish this, a vacuum camera back is generally used.

Regardless of the type of screen used, the principle governing halftone
generation is the same. Each opening in the screen grid corresponds to a

(a) Glass line screen (b) Contact screen (Yule, 1942)

Figure 7.26 Greatly enlarged views of types of screens used to produce halftone images.
Glass line type was superseded by the contact type in the 1950's.

halftone unit cell on the film. Light from the main exposure is reflected from corresponding areas on the original and passes through the screen openings to expose the film beyond. Because the corners of the screen openings attenuate the light more than do the centers, the distribution of the reflected light, and hence the film exposure produced by it, will vary along the diagonal of each halftone cell on the film in a manner shown by the solid curves in the upper part of Figure 7.27. Although all of these curves have the same shape, their maximum values vary in accordance with how much light has been reflected from the corresponding areas of the original. Thus, a highlight, or light area, on the original will produce a high level of exposure, while a shadow will produce a low level.

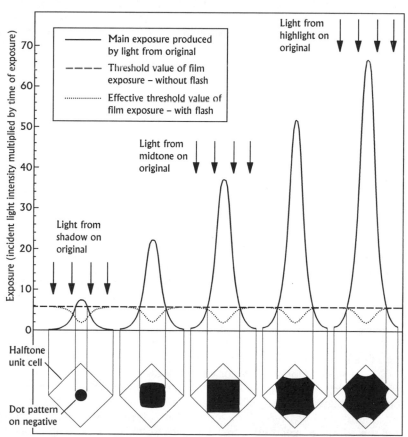

Distance along diagonals of unit cells on negative film

Figure 7.27 Diagram showing how halftone dots are formed in photographic screening process. Shape of main exposure curves corresponds to Figure 4 in early patent on dyed contact screen (Murray, 1943). Size of halftone dots are for main exposure only.

The area in each unit cell on the negative film that turns black is governed by the intersections of the exposure curve with the threshold exposure curve of the film, indicated in Figure 7.27 by the straight dashed line. In the lower part of Figure 7.27, these intersections are projected onto the corresponding halftone unit cells to show how the various dot patterns are formed. From this, it can be seen that a shadow area on the original is reproduced as a small round black dot on a negative film, while a highlight is reproduced as a large black area containing a small round transparent dot. The midtone dot is square, while intermediate size dots are square with bulging sides.

In practice, the range of tones that can be reproduced by a given screen is limited. Thus, to reproduce certain types of originals it is necessary to extend this range. This is accomplished by making two exposures: a main exposure as described above, and an additional flash exposure, made with the original removed but with the screen in place. This serves to effectively depress the threshold exposure of the film at the centers of the unit cells, as shown by the dotted curves in the upper part of Figure 7.27.

The net result is that still smaller shadow dots, that otherwise would be lost or would drop out, are imaged on the negative, and hence on the reproduction. At the same time, the flash exposure has little effect on the midtone and highlight dots.

With other types of originals, a different effect occasionally may be desired, i.e., to reduce the tonal range so as to accentuate the highlights. In such a case, the main exposure is reduced and a compensating bump exposure is made with the screen removed and the original in place.

The effect of reducing the main exposure is to reduce the size of all of the halftone dots. The effect of the bump exposure is to reduce the threshold value of the film in proportion to the amount of light reflected by the original. Thus, as shown by the dotted curve in Figure 7.28, the threshold value of the film is reduced significantly in the highlights, but hardly at all in the shadows.

The magnitude of the two exposures is adjusted so that the dot size corresponding to the brightest highlight is unchanged. As a net result there is a progressively increasing reduction in dot size toward the shadows such that some shadow dots are lost or dropped out. This is illustrated in Figure 7.28 by the loss of the shadow dot vis-à-vis Figure 7.27.

In theory, the magenta contact screen provides a wide range of control through the use of different color filters and light sources. Nonetheless, its displacement of the glass line screen and widespread use until the advent of electronic screening was due to two central advantages over the glass screen: speed, and ease of operation (Jaffe, 1962).

More precise information on the use of contact screens can be found in a number of publications prepared specifically for that purpose (Cogoli, 1992; Kodak, 1982; and Kodak, 1988).

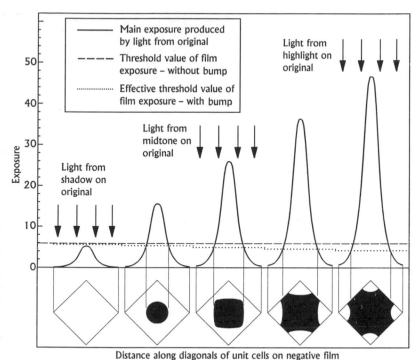

Figure 7.28 Diagram showing effect of adding a bump exposure. To compensate for bump, main exposure is 70 percent of that shown in Figure 7.21. Size of highlight dot is unchanged because reduction in main exposure is offset by reduction of threshold value of film exposure. Shadow dot drops out because threshold value of film in this area is essentially unchanged.

7.6.2 Electronic Screening. In contrast to the photographic method, electronic screening is typically carried out with a system such as the one shown in Figure 7.29, consisting of an electronic scanner, a digital workstation with memory, and an imagesetter. (Although this system is hypothetical, it is functionally equivalent to most commercial electronic systems.)

The continuous-tone original is divided into unit cells corresponding to the desired halftone unit cells in the reproduction. These unit cells in the original are scanned in some sequence to obtain analog measurements of the relative lightness of each cell. The analog measurements represent the information needed by the imagesetter to determine what size dots it should create in the corresponding cells of the reproduction. (The term imagesetter is used here to define a high-resolution device for outputting an image onto paper, film, or plate.) To accomplish this, the analog signals are first converted to a file of eight-bit digital values and then stored in memory. (A bit is the smallest unit of information in a digital language, and

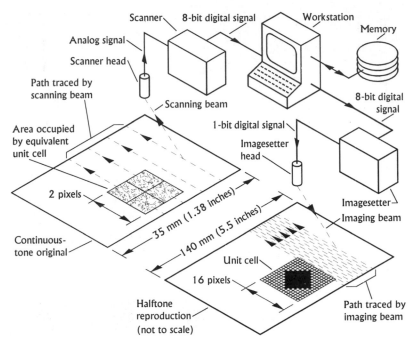

Figure 7.29 Simplified diagram of a hypothetical electronic system. Original and repro-
duction are not drawn to scale nor are the respective pixels. The choice of a unit
cell in the reproduction comprising 16 X 16 pixels is based on the desire to be
able to reproduce 256 levels of gray.

in the binary language it has two possible states: on or off. Thus an eight-bit
binary digital number has a range of values represented by whole numbers
between zero and 2^8, or 256.)

When needed, the file is fed to the imagesetter where the eight-bit
values are converted to a series of single bits where each bit is in either the
"on" or "off" state. This serial signal is then used to control the head of the
imagesetter. Because many imagesetters use a thin beam of light, e.g., as
from a laser, to expose the reproduction, that type of imagesetter is
assumed here. Creation of the required dot in each cell is accomplished by
dividing the area occupied by the cells of the reproduction into pixels (for
picture elements) that are then sequentially exposed, or not, by the
imagesetter head, as controlled by the serial signal. That is, the one-bit
digital serial signal causes the light beam from the imagesetter head to be
turned on or off as necessary, as it traverses each pixel. The end result is
the creation of a dot in each cell of a halftone, made up of adjoining pixels,
as shown in Figure 7.29.

Given this overview of electronic screening, the pertinent details can
now be discussed, beginning with the required size of the pixels, into which

the reproduction must be divided.

The reader is reminded that the object of the imagesetter is to create an image made up of halftone unit cells, each of which contains a dot with an area that can be any size from almost zero to 100 percent of the area of the unit cell. Consequently, to produce such a wide range of dot areas, the size of the light beam emitted by the imagesetter head must be very small relative to the area of the unit cell. To illustrate, suppose that the beam area is only one-fourth the area of the halftone cell. In such a case, only five dot areas or shades of gray could be imaged: 0, 25, 50, 75, and 100 percent, corresponding to zero, one, two, three, or four pixels being imaged, i.e., the beam turned on.

Typically 256 shades are desired. This requires that the imaging beam width be equal to one-sixteenth the width of the halftone cell, as shown in Figure 7.29, so as to produce a halftone cell comprising 16X16, or 256, pixels. Thus, for example, exposing or imaging 85 of the pixels would create a dot with an area of 33.2 percent (85/256) as also shown in Figure 7.29. Alternately, if 128 pixels were imaged in a halftone cell, the corresponding dot area would be 50 percent (128/256).

The pixel size required in the original is not nearly as small because the scanning head produces an analog signal corresponding to the brightness (or level of gray) of each pixel scanned. This signal is then converted in the scanner to an eight-bit digital signal wherein each eight-bit datum corresponds to the level of gray of the respective pixel.

One might think that the size of the pixel in the original could be chosen to correspond to the size of the halftone cell in the reproduction. It was proven many years ago, however, by Nyquist (Bellamy, 1982) that in order not to lose any information when sampling, the sampling frequency must be at least twice the bandwidth of the input. Nyquist's criterion translates to a required pixel width one-half that of the halftone cell. Because scanning is carried out in two dimensions, four pixels are thus required for each equivalent halftone cell in the original, as shown in Figure 7.29. The four signals thus obtained for each unit cell in the original are, however, averaged to obtain a single value used in imaging. (Some controversy exists in the industry as to whether or not Nyquist's criterion can be relaxed in some cases.)

With these guidelines in mind, the dimensions of the two different grids and pixels portrayed in Figure 7.29 can be calculated based on typical sizes for the original and reproduction, an assumed screen ruling of 150 lines/inch (59 lines/cm), and 256 levels of gray in the reproduction. More specifically, consider an original in the form of a 35–mm (1.38–inch) transparency that is to be enlarged by a factor of four when reproduced, i.e., to 140 mm (5.5 inches).

The desired screen ruling of 150 lines/inch for the reproduction is equivalent to a half cell spacial frequency of 150 cells/inch. To achieve 256 levels of gray in the reproduction, the halftone cell must be divided

into 16 pixels on a side, yielding a pixel spacial frequency of 2400 pixels/inch in the reproduction, i.e., 16 times 150.

To determine the intervals at which the original must be scanned, it must first be divided into the same number of equivalent halftone cells as in the reproduction. For example, the long length of the original must be divided into the same number of equivalent halftone cells as in the long length of the reproduction; in this case 5.5 inches times 150 cells/inch or 825 cells. Note that this yields a halftone spacial frequency of 600 cells/inch in the original, i.e., 825 cells divided by 1.38 inch.

Alternately it could be reasoned that, because the original is one-fourth the size of the reproduction, it must be divided into an array of equivalent halftone cells that have a spacial frequency of four times that of the reproduction, i.e., 600 cells/inch. Based on Nyquist's criterion, each such cell of the original must be two pixels in width, yielding a pixel spacial frequency of 1200 pixels/inch, i.e., 2 times 600.

Alternately, the above calculations can be looked upon as a sequence of steps wherein each step constitutes a choice or decision that results in the establishment of a parameter of the screening process as follows:

1. Decide on screen ruling to be used in the reproduction. For the choice of 150 lines/inch, this establishes the size of the unit cell in the reproduction at 0.0067 inch or 169 micron (one divided by 150 lines/inch).

2. Select desired levels of gray in the reproduction. The selection of 256 levels requires that the unit cell in the reproduction contain 256 pixels and this in turn yields a pixel width of 10.6 microns for a square (16 X16) array of pixels.

3. The choice of making the size of the reproduction four times the length of the original establishes that the width of the unit cell in the reproduction must be one-fourth the width of the unit cell in the original: 169 divided by 4, or 42 microns (0.00167 inches). The corresponding spacial cell frequency in the original is thus 1/42 micron or 600 lines/inch.

4. The use of Nyquist's criterion dictates that the unit cell in the original must contain at least four pixels. Therefore the width of the pixel must be one-half the width of the unit cell, or 21 microns.

All of this calculated data is listed in Table 7.1. The required pixel widths are important because they constitute upper limits on the sizes of the scanning and imagesetter beams. For example, the beam of light emanating from the imagesetter head that exposes the film or plate cannot be larger than about 10 microns in diameter, i.e., the size of the pixels of the reproduction. Similarly, the scanner head beam must not exceed 21 microns.

These requirements on beam size are oftentimes expressed alternately as a resolution, in dots per inch. Thus, in this example, the required

scanner resolution could be stated alternately as 1200 dots/inch and that of the imagesetter as 2400 dots/inch. This practice of expressing scanner and imagesetter resolutions in dots/inch can (and often does) lead to confusion, because the word dot is thereby given a second meaning, i.e., the smallest area the scanner or imagesetter can resolve. To avoid such confusion the word dot in this book is only used to denote the image region or regions within a unit cell of the halftone.

Table 7.1 Sample data for the electronic scanning operation illustrated in Figure 7.23. Pixel frequency in the reproduction is based on a screen ruling of 150 lines/inch and 256 (16 X 16) levels of gray. Pixel frequency in the original is determined by screen ruling in the reproduction, the ratio of the size of the reproduction to that of the original, and Nyquist's criterion.

		Original	Reproduction
Length of longest side	(mm)	35	140
	(inches)	1.38	5.5
Halftone spacial frequency	(cells/inch)	600	150
Width of halftone cell	(inches)	0.00167	0.0067
	(microns)	42	169
Pixel spacial frequency	(pixels/inch)	1200	2400
Width of pixel	(inches)	0.00083	0.00042
	(microns)	21	10.6

It is also recommended that the reader always think in terms that the heads of the scanner and imagesetter resolve or address pixels or spots and not dots, i.e., that dots be looked upon as an assembly of smaller imaged pixels or spots within a halftone unit cell. More is said about this in the following section on frequency modulated screening.

Even if the electronic method of screening were limited to mimicking the photographic method, which it is not, it possesses many important advantages including the following:

1. Plates can be imaged directly, thereby increasing the speed of and reducing the number of steps in the platemaking operation.

2. Film can be eliminated from prepress operations because plates can be imaged directly with this method.

3. Different dot patterns can be employed, as in frequency modulated screening, described in Section 7.6.3.

On the debit side, electronically screened dots are not always regular in shape and frequently have jagged edges.

Before leaving the subject of electronic screening, several terms

associated with it will be defined for the sake of completeness. (The key terms, bit and pixel, have already been defined above.)

When an array of bit-controlled pixels is used to define or store an image, it is referred to as a bitmap. For example, the 16 x 16 array of on or off spots that depicts the 33.2 percent halftone dot on the reproduction in Figure 7.29 is a bitmap.

As an alternate, some images such as type, page layouts, and engineering drawings can be defined and stored as vectors. These are mathematical expressions that define images in terms of geometric shapes, as, for example, a portion of a circle having a given radius and center location. The advantage of using vectors is that less memory storage space is needed for those types of images where they are applicable.

A raster is an array of parallel paths that are traversed in succession to either record or produce an image, as illustrated by the scanning and imaging paths in Figure 7.29. In order to produce raster forms of images that are stored in computer memory in either bitmap or vector form, the stored data must be converted to serial form, i.e., a series of sequential single bits. The device or software for carrying out this conversion is called a raster image processor, or RIP. It may be incorporated either in the imagesetter or exist as a stand-alone device.

7.6.3 Frequency Modulated Halftones. This type of halftone only became possible with the advent of screening by electronic means. For this reason, it is only a little over ten years ago that the printing industry was first made aware of the practicality and advantages of frequency modulated halftones (Scheuter and Fischer, 1985).

Conceptually, a frequency modulated halftone differs from a conventional halftone in two respects, as follows:

1. The halftone unit cell is made up of an array of equal-size spots where the size of the spots is large enough that it can be printed consistently, i.e., a printable spot.

2. Gradations in tone are achieved by varying the frequency at which the spots occur, i.e., the spacing between the spots.

These differences account for the name "frequency modulated," vis-à-vis amplitude modulated for the conventional halftone. That is, in the former, tone graduation is achieved by varying the spacial frequency at which the spots, contained in a halftone unit cell, occur; while in the latter, it is achieved by varying the size or amplitude of the single dot contained in a halftone unit cell. This fundamental difference between the two types of screens is illustrated in Figure 7.30.

Figure 7.30(a) shows how two different shades of gray, corresponding to dot areas of 24 and 50 percent, are achieved in an electronically screened conventional halftone. Here the halftone cell contains an assembly of contiguous imaged spots or pixels that form a square dot with jagged

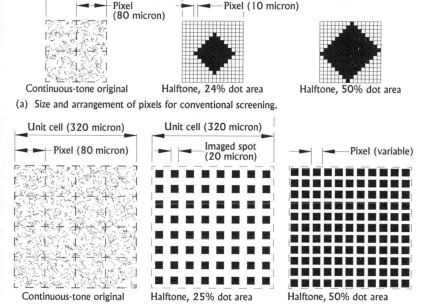

(a) Size and arrangement of pixels for conventional screening.

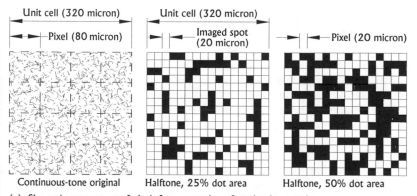

(b) Size and arrangement of pixels for pure frequency modulated screening.

(c) Size and arrangement of pixels for one version of stochastic screening.

Figure 7.30 Scale drawings showing makeup of halftones obtained with three different types of screening. Pixel width in (a) is based on a screen ruling of 150 lines/inch and 256 (16 X 16) levels of gray. Pixel width in (c) is representative of one commercial brand of stochastic screen. Pure frequency modulated halftones, shown in (b), have no practical use and are included only to illustrate the contrast between the concept of amplitude modulated halftones, shown in (a).

edges, with the dimensions based on rounded-off values for the example given in Table 7.1.

This is contrasted with Figure 7.30(b), drawn to the same scale, that illustrates how two similar shades of gray would be achieved with ideal frequency modulated halftones, using a spot size of 20 microns. A comparison of the two halftones in Figure 7.30(b) reveals that both exhibit regular patterns and that pixel width varies with dot area. The latter is so because spacial frequency of the spots varies with dot area. Thus, frequency modulated halftones in their pure or ideal form are not practical for two reasons:

1. The variable pixel width poses a prohibitively complex computational task for the imagesetter.

2. Undesirable patterns will appear in multicolor prints due to the moiré effect. The moiré effect, illustrated in Figure 7.31, is defined as the result of superimposing a repetitive design on the same or different design, i.e., a resultant undesirable pattern distinct from its components.

To eliminate these problems, commercial embodiments of frequency modulated halftones incorporate two modifications. First, the spacing between spots is made equal to some integral multiple of spot size. This results in a constant pixel size. Second, the spacing between spots, for a given dot area, is not constant, but instead is made variable in a random manner. This eliminates the potential for the occurrence of the moiré effect in multicolor printing.

The latter modification, dubbed a stochastic arrangement (Fischer and Scheuter, 1984) has led to the name stochastic screening for this type of frequency modulated halftone. One example of such a halftone is shown in Figure 7.30(c) where it will be noticed that the randomness of the spot spacing results in the clustering of some spots. The spot size of 20 microns used in this figure is in keeping with the range of 20 to 40 microns used in various commercial systems. Figure 7.30(c) is of interest because it points up several of the other unique characteristics of stochastic halftones relative to the conventional halftones shown in Figure 30(a) as follows:

1. To achieve the same levels of gray, the unit cell of the stochastic screen must be wider, in this example twice as wide. This is because the pixel size is double (20 versus 10 microns).

2. The unit cell of the original is divided into a number of pixels larger than required by Nyquist's criterion. (Figure 30(c) shows eight, but other complements are used.) This is done so that tone variations within the unit cell of the original, as obtained from scanner measurements of each pixel, can be reproduced in the halftone. Thus the scanner signals for the pixels in a given unit cell of the original are not averaged to obtain a single value to be used in imaging the halftone.

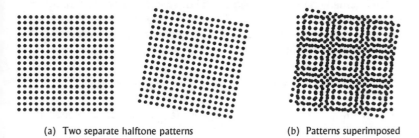

(a) Two separate halftone patterns (b) Patterns superimposed

Figure 7.31 Example of moiré effect. Superimposing two grid patterns shown in (a) results in the creation of a third pattern that can be seen in (b).

Stochastic screening was the subject of much study in the first half of the 1990's, and at least four different commercial versions have been developed (Schläpfer, 1994). Its advantages are as follows:

1. No moiré effect.
2. Screening computations are much less complex because it is not necessary to angle multicolor screens to avoid the moiré effect.
3. Improved image detail.
4. Faster imaging times due to the smaller number of pixels that must be addressed by the imagesetter. (For the pixel sizes given in Figures 30(a) and (c), imaging time for the stochastic halftone is one quarter that of the conventional.)

Perhaps the most important drawback of stochastic halftones is the significantly higher dot gain that occurs in printing (Stanton and Warner, 1994). As a consequence, both the imagesetter and proofing system must be recalibrated and the printing process strictly controlled when switching to stochastic halftones (Stutzman and Lind, 1994). This may account for the fact that, so far at least, stochastic halftones have not been widely accepted by the industry.

7.6.4 Continuous-Tone Plates. This type of plate is produced by exposing it through a continuous-tone photographic film (positive or negative) in the absence of an intermediate screen. Its objective is to eliminate the degradation in image resolution that arises in converting a continuous-tone image into a halftone image. In addition, continuous-tone plates also eliminate the problem of moiré, because the imaged spots are randomly spaced.

All of the continuous-tone plates that have proved to be practical can be classified into two groups: grained aluminum, and gelatin-coated. These plates differ significantly in their preparation, the methods that must be used to print with them, and the resulting prints. Therefore, they are treated in two separate sections below.

1. **Grained Aluminum Plates.** This type of screenless plate was invented over thirty years ago (Ruderman, 1966). It is a surface plate, as described in Sections 2.4.2 and 2.4.3, manufactured in accordance with the following constraints:

(i) The surface of the aluminum metal base must be grained.

(ii) The average roughness of the grained surface must be large relative to the accuracy to which the thickness of the as-developed light-sensitive coating can be controlled.

More will said about these two constraints once the principle upon which this type of plate is based has been explained. The explanation given here closely follows the one given in a landmark paper on the subject, published thirty years ago (Pobboravsky and Pearson, 1967). In that paper, it was pointed out that the principle had been known since before the turn of the century, and was first employed to produce continuous-tone images on litho stones.

A thin coating of the light-sensitive material is applied to the grained surface such that the peaks in the grained surface are barely covered, as shown in Figures 7.32(a) and (d). Thus the light-sensitive coating has a variable thickness, ranging from a maximum in the areas over the valleys to a minimum in the areas over the peaks. In the case of a negative-working plate, shown in Figure 7.32, the exposure is adjusted to the level just necessary to harden the maximum thickness of light-sensitive material covered by film regions that are clear.

Thus, in film regions having some darkness or opacity, only the upper layers of the light-sensitive coating will be hardened in regions over the deepest valleys. In film regions with higher opacity, as shown in Figure 7.32(a) compared to Figure 7.32(d), the same exposure will produce a thinner layer of hardened coating, as shown in Figure 7.32(b) compared to Figure 7.32(c). Consequently, when the plate is developed, those areas of coating that have not been hardened through to the base will be washed away. The regions of fully hardened coating remain to form randomly sized and spaced dot-like image areas. In accordance with this, film regions of greater opacity will produce larger fractional image areas, as can be seen by comparing Figures 7.32(c) and (f).

Figure 7.33 provides illustrations for a positive-working plate that are analogous to those in Figure 7.32 for a negative-working plate. A comparison of Figure 7.32(f) with Figure 7.33(f) points up a significant difference between negative- and positive-working continuous-tone plates of this type. In the former, the image areas in highlight regions comprise hardened coating bonded to the peaks of the grained aluminum surface. In contrast, the coating forming the image areas in highlight regions of the positive-working plate in Figure 7.33(f) lies in the valleys of the grained

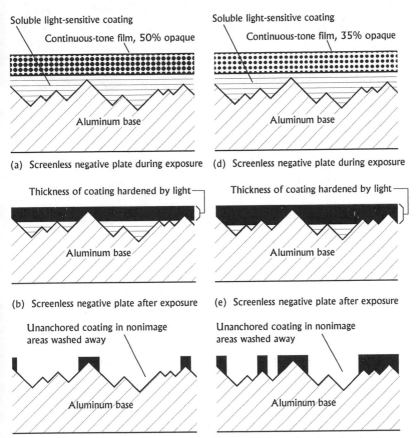

(a) Screenless negative plate during exposure (d) Screenless negative plate during exposure

(b) Screenless negative plate after exposure (e) Screenless negative plate after exposure

(c) Screenless negative plate after development (f) Screenless negative plate after development

Figure 7.32 Schematics of a negative-working continuous-tone aluminum plate in various stages of preparation. The effect of tone variations in the original on plate image area can be observed by comparing (c) with (f).

surface. This explains why negative-working plates are subject to higher wear rates and have corresponding shorter run lives compared to positive-working plates of this type.

Given the above explanation, it becomes obvious why the aluminum surface must be grained, for with a perfectly flat plate surface, the light-sensitive coating would be uniform and there would be no tone differentiation. It will also be understood that in the plate manufacturing operation, the thickness of the light-sensitive coating must be controlled very accurately relative to the depth of graining. For example, if the coating thickness on a positive-working plate was double (rather than about the same as) the maximum depth of graining, tonal density on the finished

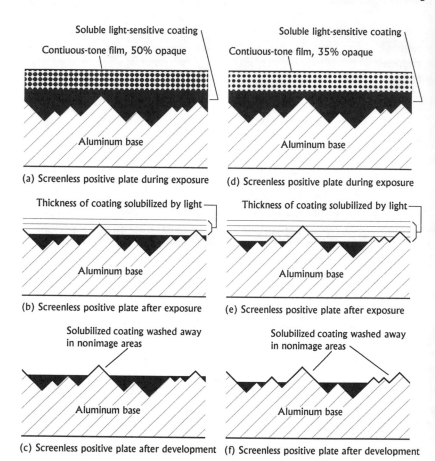

Figure 7.33 Schematics of a positive-working continuous-tone aluminum plate in various stages of preparation. The effect of tone variations in the original on plate image area can be observed by comparing (c) with (f)

plate would saturate near the midtones due to filling in of the shadows, assuming an exposure just sufficient to solubilize the coating regions over the deepest valleys in the grain with a clear film. Too thin a coating will also limit contrast. For example, a coating thickness one-half the maximum depth of grain would limit maximum tone to about the mid-tone level.

The thickness of the light-sensitive coating in the hardened state, on a finished plate, is also important, because any wear during printing will change image area and the corresponding tonal value. For this reason, it is a general rule that continuous-tone or screenless plates have much shorter run lives than do plates that are imaged with halftones.

The shorter run life and the greater control needed in the manufacture and preparation of continuous-tone aluminum plates have

limited them to niche applications where very high image resolution is required. In this regard, one worker has reported that the pitch of image elements of a typical screenless plate range from that of an equivalent 650-line/inch screen in the midtones to around a 300-line/inch screen in the highlights and shadows (Lawson, 1978).

2. Gelatin-Coated Plates. There is a widely held opinion that the print quality achieved when printing with gelatin-coated plates used in the collotype process is unmatched by any other photomechanical printing system (Reardon and Kirby, 1991). Although there have been many other processes that have employed gelatin-coated plates, collotype achieved the greatest degree of success and lasted for over 100 years. For these reasons, it is the one to be described here.

Except where noted, the information presented below is based on a summary article (Reardon and Kirby, 1991) and a relatively recent book (Kirby, 1988) on the subject.

The word collotype is derived from the Greek word for glue, kolla. While it is not clear who was the first to conceive the idea of using gelatin, this type of plate goes back to the period 1840–1850, and thus predates screening. By the turn of the century, collotype had been perfected to the point where it was a popular choice for printing reproductions of fine art. Starting with the depression of the 1930's, the number of collotype printers declined steadily to the point where today there are perhaps no more than three printing companies in the entire world that employ the process.

Its demise has been attributed to three factors: the craft nature of the process, the walls of secrecy maintained by individual printing firms, and the improvements made in competing processes. Of these, the walls of secrecy were perhaps the most important because they posed a bar to common development programs and standards that led to great advances in other forms of printing.

It is interesting to speculate what might have become of collotype if, for example, the same effort had been expended to develop a presensitized gelatin-coated plate as was expended in developing a presensitized surface type plate.

Collotype can be looked upon as a form of lithography because it is based on the same principle, i.e., that a greasy ink will not transfer to a moistened surface. Beyond that, it differs significantly from lithography as currently practiced in the following respects:

(i) Printing is carried out directly from plate to paper, i.e., a blanket is not used.

(ii) Gradations in tone are achieved by varying both printed areas and printed ink film thickness. This comes about because the plate is not planographic.

(iii) A dampening system is not needed because the nonimage areas of the plate are redampened by absorbing moisture from the ambient air. This, of course, requires that the humidity of pressroom air be accurately controlled.

These differences all stem from the unique characteristics of the plate that is used, and that will now be described.

Table 7.2 Summary of steps followed in preparation of a collotype plate.

Step No.	Description	Comments
1	Heat mixture of water, gelatin, and a dichromate to a temperature of 135 degrees F (57 degrees C) to form coating.	Can be carried out in room light.
2	Pour hot coating onto a whirling plate heated to same temperature.	Can be carried out in room light.
3	Cool plate to room temperature with whirler on.	Becomes sensitive to light when cooled.
4	Expose plate through continuous-tone negative.	Areas exposed to light are hardened.
5	Wash out plate with water at 55 degrees F (13 degrees C) for one hour to remove unexposed dichromate.	Unexposed areas are swelled and surface becomes reticulated.
6	Dry in whirler and cure for 24 to 48 hours.	The curing improves runability on press.
7	After mounting on press, soak with 2:1 mixture of water and glycerine.	No further dampening is needed.

A collotype plate consists of a support such as an aluminum sheet coated to a thickness of 0.005–0.008 inch (125–200 microns) with a light-sensitive matrix consisting of a dichromate of either potassium or ammonia, dispersed in gelatin. In practice, a fully developed plate was always prepared by the printer because of its relatively short shelf-life. In preparing a plate, the printer would follow steps similar to those listed in Table 7.2.

The areas of the plate coating exposed to light become hardened in proportion to exposure. In the subsequent step of washing out the unexposed dichromate, the gelatin absorbs water in amounts inversely proportional to exposure, or hardness, and this in turn causes the gelatin to swell. Thus, swelling is greatest in the highlight areas and least in the shadows.

The swelling, caused by the absorption of water, produces one of the unique features of a collotype plate—its reticulated or wrinkled surface. The mechanism that accounts for this phenomenon was explained in one of

Hardened valley　　　Unhardened peak

(a) Plan view of highlight region of developed and soaked collotype plate.

Gelatin coating

(b) Section A-A through plate in (a) showing profile of peaks and valleys.

Figure 7.34 Schematic of highlight region of a collotype plate. Reticulated pattern is distinguishing feature of collotype prints.

the very few scientific studies of the collotype process ever published (Smethurst, 1949).

According to the model set forth in this study, the gelatin coating is constrained along its lower surface by its bond to the support, and constrained along its upper surface by the regions that have been hardened by exposure. Thus the swelling caused by moisture absorption generates compressive stresses that produce local buckling or bulging in the less hardened areas. (This is likened to the buckling that a slender column undergoes when its critical load is exceeded.) Furthermore, the moisture taken up by the gelatin produces swelling to such a great extent that the elastic limit of the matrix is exceeded, leaving some permanent deformation when the coating is subsequently dried.

The net result, illustrated in Figure 7.34, is to produce a plate surface consisting of valleys and rounded peaks, where the softer peaks can take on or absorb water and the hardened valleys cannot. Thus, after the surface has been soaked with a water-glycerin solution as in the last step, the peaks are made non-ink-receptive, while the valleys remain ink-receptive.

When the soaked plate is subsequently inked on press, it will be readily understood that the thickness of the ink film transferred to the plate, and hence to the paper, will not be constant as in traditional lithography, but instead will vary from a maximum in the areas of the valleys to a vanishingly thin layer approaching the crest of the hills. It is this feature,

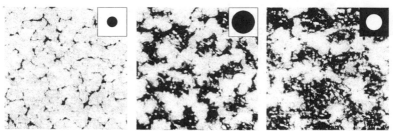

(a) Highlight region, 10% dot (b) Midtone region, 50% dot (c) Shadow region, 75% dot

Figure 7.35 Comparison of tone patterns achieved in collotype and those of conventional halftones. Photographs are of three different regions of a black-and-white collotype print at 50X magnification. Superimposed in upper righthand corners are 150-line per inch halftone dots at same magnification.

together with the finer grain achieved, that produces the high quality associated with collotype printing. Evidence of this is provided by the contrast between the tone patterns of collotype and traditional halftone printing, illustrated in Figure 7.35.

Two other unique features of the collotype process that should not go unmentioned are the manner in which the plate is dampened, and the direct printing from plate to paper.

The action of the glycerine in the mixture used to soak the plate prior to printing has been explained as adjusting the vapor pressure of the mixture to possess the same vapor pressure as the pressroom ambient air (Smethurst, 1952). Thus, any moisture lost from the plate during printing is made up by absorption from the air, and printing can proceed all day without the need for redampening.

The author has been unable to learn the reason why collotype printing was carried out direct rather than offset. One possible explanation is that there was some advantage to the resultant lower ink film thickness needed on the plate in the absence of a blanket. Alternately, the decrease in ink spread that resulted may have been significant. Of course, the explanation may be as simple as offsetting was not necessary because the plate surface was soft enough to conform to the contours of the surface of the paper.

The major advantage of collotype printing has already been mentioned: the very high print quality achieved. This benefit, however, was attended by many significant drawbacks. These included the difficulty of achieving consistent performance, very short plate life (e.g., 3000–5000 impressions), the need to control pressroom humidity very closely, the inability to print type well, and the vulnerability of the soft plate surface to mechanical damage, e.g., as caused by dust, lint, or paper wrapups.

Over the course of the existence of collotype, a number of variations were devised to eliminate these disadvantages. One such system, Optak, was developed by the printing firm of Edward Stern and Company, in Philadelphia (Tobias, 1996). In this system, the plate was made light-

sensitive after it had been coated with gelatin and partially hardened with paraldehyde. This was accomplished by soaking the coated plate in a solution of ammonium dichromate.

Upon drying, the coating became sensitized and was then exposed to light, using a screen. Following this, the unexposed dichromate was washed out with water in a manner similar to the step used in preparing a collotype plate. While washing out did not cause reticulation, the image areas became recessed as a result of swelling in the nonimage areas. This made it possible to use screen resolutions as high as 400 lines/inch (160 lines/cm) and partially offset the reduction in resolution resulting from using a screen. Printing was carried out on a lithographic press, and the plate was continuously dampened with water only.

To summarize, the Optak process differed from collotype in four respects, as follows:

(i) The plate was sensitized only after it had been coated with gelatin and partially hardened.
(ii) Exposure was through a screen to produce a halftone pattern with recessed image areas, rather than a reticulated surface.
(iii) Printing was carried out by offsetting.
(iv) During printing, the plate was dampened continuously with plain water, using the existing press dampening system.

These changes eliminated some, but not all, of the disadvantages of collotype. Most notably, run lengths of 35 to 40,000 impressions were achieved, the process was far less finicky, there was no need to control pressroom humidity, and existing presses could be used. Nevertheless, the Optak process had a relatively short life. Most likely this was due to the advances made in traditional lithography during the same period of its existence.

7.7 Summary

The alternate forms of lithographic printing described in this chapter are distinguished from the traditional form in one or more of the following ways: the sequence of dampening and ink is reversed (reverse dampening), the surface properties of ink and fountain solution are reversed (reverse lithography), the need for zone controls in the inking system is eliminated (keyless inking), a single printing fluid is used (emulsion printing and waterless printing), a different type of halftone is used (stochastic screening), or the need for screening is eliminated (continuous-tone plates).

1. The viability of reverse or water-last dampening was accidentally

discovered in adapting the lithographic process to newspaper presses of the type that required printing couples that could be run in either direction. Although it is viable, water-last dampening is not the equal to the traditional mode of water first, and therefore has not gained favor. Reverse dampening is still in use on many newspaper presses but has never been employed elsewhere.

2. Reverse lithography was developed in the 1960's with the objective of using a water-based ink to eliminate the odors given off by traditional oil-based inks. These odors are objectionable and limit the use of lithography in the printing of food packages. It was further distinguished by the use of an oil-based fountain solution and a plate having image areas that were water-receptive, and nonimage areas that were oil-receptive. Printing was carried out on existing presses equipped with modified dampening systems. The concept was used in the four process color printing of ice cream cartons but did not survive.

3. A long-sought objective of lithographic press designers has been to develop a keyless inking system. The advantages sought are reduced makeready time (due to the elimination of the need to adjust ink keys) and the elimination of starvation ghosting. The technology has been advanced in recent years to the stage where at least six different designs are now available and in use on many double-width newspaper presses throughout the world. Further advances in this technology are expected, particularly if it is to be adapted to sheetfed printing.

4. It has been known for over sixty years that lithographic printing can be carried out by applying a single fluid, consisting of an emulsion of water in ink, to the plate. Two approaches have been tried: premixing the emulsion, and generating the emulsion on press. Premixed systems are doomed to failure on conventional presses by the inability to match actual water feedrate to the plate (which varies across the press in proportion to ink feedrate) to the required water feedrate (which is more or less constant in the across-the-press direction). In on-press generated emulsion systems, alternately referred to as ink-train dampening systems, water is fed to an inking system roller that is at least one roller away from the plate. Although ink-train dampening systems have been used successfully on double-width newspaper presses for many years, it is generally accepted that they do not perform as well. There is recent evidence, however, to support the claim of one inventor that a properly designed ink train dampener will, under conditions of light coverage, outperform a press equipped with a traditional dampener.

5. Waterless printing has become established in the U.S., and possesses many important advantages due to the elimination of water. These advantages include faster makereadies, more consistent color, fewer register problems, faster drying, and less demands placed on operator skill. Two significantly different theoretical models have been set forth to explain how waterless works: one based on the relative wetability of the plate

materials used and one referred to as the Weak Fluid Boundary Model. Both are supported by experimental evidence. All of the current waterless plates utilize a silicone compound for the nonimage areas, with two different types available: photographic and thermal. The design of these plates yields an additional advantage to those that accrue from eliminating water: significantly lower dot gain from plate to print. The problem of maintaining the proper ink/water balance in traditional lithographic printing is replaced in waterless printing by the need to control plate temperature. Thus, in general, more accurate temperature controls and greater cooling capacities are needed on press. Other disadvantages of waterless printing are the significant increase in hickeys, the current higher cost of plates and inks, and aggravated static problems.

6. Frequency modulated halftones became possible as alternates to conventional ones with the advent of electronic screening. Conceptually, they differ in that tone is varied by varying the space between spots of a fixed size. In practice, the space between spots is made equal to some integral multiple of spot size, and spacing is varied in a random way. This is referred to as stochastic screening, and possesses the advantages of eliminating moiré, reducing imaging time, and improving image detail. On the debit side, there is much greater dot gain, the imagesetter and proofing system must be recalibrated, and the printing process carefully controlled. So far, at least, stochastic halftones have not been widely accepted by the industry.

7. It has been known for over a hundred years that the need for screening to produce halftones can be eliminated by exposing a properly grained plate through a continuous-tone film. In the 1960's and 1970's, considerable success was achieved in continuous-tone printing using grained aluminum plates. (The principle upon which they and their predecessors were based is fully understood, and explained in Section 7.6.4 on continuous-tone plates.) These plates provide higher image resolution and eliminate the problem of moiré. Nevertheless, continuous-tone aluminum plates are limited to niche applications. This is most likely due to their shorter run lives and the greater control required in their manufacture and preparation.

8. The collotype process, based on the use of a gelatin-coated plate, offers another way of achieving continuous-tone printing. It is thought by many to produce the highest print quality of any known photomechanical system. The process is characterized by direct printing to the paper (i.e., no blanket), a variable printed ink film thickness, and dampening by absorbing moisture from the pressroom air. Collotype also has many drawbacks, including difficulty in achieving consistent performance, a very short plate life, the need to control humidity in the pressroom, and the inability to print type well. The process was invented between 1840 and 1850, and survived well into the post-World War II era. Today, it has died out as a commercial process.

7.8 References

ANPA, "Offset Anilox Keyless Inker," ANPA, preliminary assessment paper, November, 1983, 7 pp.

Bellamy, J., *Digital Telephony,* John Wiley and Sons (New York), 1982, p 86.

Chambon, L.J., "Wiper Roll Inking Device for Machines Using Fatty Ink," *U.S. Patent 3,283,712,* Jan. 3, 1966.

Chase, C.W., and Doyle, F.J., "Inking Arrangement for Rotary Printing Press," *U.S. Patent 2,986,088,* May 30, 1961.

Chevalier, J. "A New Approach to Fast Proofing," *1976 TAGA Proceedings,* p 116.

Chou, S.M., and Bain, L.J., "Theoretical and Practical Aspects of Single Fluid Lithography," *1995 TAGA Proceedings,* Vol. 1, p 121–139.

Cogoli, J.E., *Graphic Arts Photography: Black and White,* GATF, 2nd edition, 1992, 319 pp.

Corse, L.G., "Inking Device for Printing with Greasy Ink," *U.S. Patent 4,211,167,* July 8, 1980.

Cory, J., "The 3M Driographic System," *Lithographic Dampening Conference Proceedings,* GATF, February 17–18, 1976, Session VI, Tape.

Crandall, R.C., "Dampening Problems Encountered in Newspaper Printing," *GATF 1986 Dampening Conference Proceedings,* p 6-1 to 6-4.

Curtin, J.L., "Printing Plate and Method," *U.S. Patent 3,511,178,* May 12, 1970.

Dahlgren, *Dahlgren Newsprinting System,* Dahlgren Manufacturing Company (Dallas),1978, 4 pp.

Dahlgren, H.P., "Newspaper Printing System," *U.S. Patent 4,452,139,* June 25, 1980.

Dahlgren, H.P., "Dampening Fluid Evaporator and Method," *U.S. Patent 4,208,963,* June 5, 1984.

Dahlgren, H.P., "Inking Metering Apparatus," *U.S. Patent 4,538,518,* Sept. 3, 1985.

Dahlgren, H.P., Sullivan, W.A., Gardiner, J.W., Taylor, J.E., "Portable Ink Fountain," *U.S. Patent 4,373,442,* Feb. 15, 1983.

Dahlgren, H.P., Taylor, J.E., and Gardiner, J.W., "Inking Systems," *U.S. Patent 4,453,463,* June 12, 1984.

Dahlgren, H.P., Taylor, J.E., and Peters, D.W., "Dampening Fluid Removal Device," *U.S. Patent 4,527,471,* July 9, 1985.

Dankert, F., "A Theoretical Model of Waterless Planography Which Explains Some Observed Phenomena," *1996 TAGA Proceedings,* Vol 2, p 862–875.

Fadner, T.A., "Where the Water Really Goes, II," *1995 TAGA Proceedings,* p 264.

Fadner, T.A., "Dampening System for Lithographic Press," *U.S. Patent 5,526,743,* June 18, 1996.

Fadner, T.A., and Bain, L.J., "Worldwide Status and Progress of Lithographic Keyless Inking Technologies," *1989 TAGA Proceedings,* pp 545–568.

Fischer, G. and Scheuter, K., "Method for Autotypical Tonal Value Analysis," *U.S. Patent 4,482,923,* Nov. 13, 1984.

Fox, H.M., and Zisman, W.A., "The Spreading of Liquids on Low-energy Surfaces, I, Polytetrafluoroethylene," *J Colloid Interface Sci.,* Vol 5, 1950 pp 514–531.

Gaudioso, S.L., Becker, J.H., and Sypula, D.S., "Mechanisms of Ink Release in Waterless Lithography," *1975 TAGA Proceedings,* pp 177–194.

Goedike, J.G., "Water Feed for Rotary Offset and Lithographic Presses," *U.S. Patent 2,106,732,* Feb 1, 1938

Goss, *"Newsliner,"* Goss Graphic Systems (Westmont, Illinois), June, 1994, 16 pp.

Greubel, P.W., "Method for Planographic Printing," *U.S. Patent 3,167,005,* January 26, 1965.

Greubel, P.W., "Planographic Printing Plate," *U.S. Patent 3,209,683,* Oct 5, 1965.

Greubel, P.W., "Planographic Printing Method," *U.S. Patent 3,356,030,* Apr. 30, 1967.

Greubel, P.W., and Ely, J.K., "Apparatus for Applying Fountain Solution in Planographic Printing," *U.S. Patent 3,283,707,* Nov. 8, 1966.

Greubel, P.W., and Russell, W.J., "New Planographic Printing Plate and Method for Producing Same," *U.S. Patent 3,241,486,* Mar. 22, 1966.

Ijichi, Yuji, "Ink Roller for Rotary Press," *U.S. Patent 5,184,552,* Feb. 9, 1993.

Jaffe, E., *Halftone Photography,* GATF, 1962, p 107.

Jaffe, E.R., "ANPA's ANA Press Concept," *1980 TAGA Proceedings,* pp 148–155.

KBA, *KBA Anilox Offset,* Koenig & Bauer-Albert (Würzburg), 270/95-e, 16 pp.

Kinashi, T., Fujita, T., and Kawabe, N., "Dry Planographic Printing Plate and Preparation Thereof," *U.S. Patent 4,342,820,* Aug. 3, 1982.

Kirby, K. B., *Studio Collotype,* Heliochrome Press (Dalton, Mass.), 1988, 217 pp.

Kobayashi, M., "Experiences with Waterless Plates," *Proceedings of Fourth International Web-Offset Conference,* PIRA, Mar. 21–22, 1991, p 10.1–10.4.

Kobayashi, M. and Iwamoto, M., "Dry Planographic Printing Plate," *U.S. Patent 3,894,873,* July 15, 1975.

Kodak, *Kodak Halftone Calculator,* Kodak Imaging Systems (Rochester), Q-15, 1982.

Kodak, *Halftone Methods for The Graphic Arts,* Kodak Imaging Systems (Rochester), Q-3, 1988.

Krishan, R. and Klein, D., "Ink/Plate Interactions in Waterless Lithography," *1991 TAGA Proceedings,* pp 478–489.

Krzeminski, F.T., "Direct Litho Shows Promise for the Milwaukee Journal and Sentinel," *R.I. Bulletin,* ANPA Research Institute (Easton, Pennsylvania), Bulletin 1272, 1977, pp 442–446.

Kurz, H.J., "System for Keeping the Printing Plates of a Printing Press at a Moderate Temperature," *U.S. Patent 5,375,518,* Dec. 27, 1994.

Lanet, V., and Gandini, A., "Characterization of Surface Energies of Waterless Plates," *1995 TAGA Proceedings,* Vol. 2, p 1182–1193.

Lanet, V., and Gandini, A., "Studies Related to the Weak Fluid Boundary Model in Waterless Lithography," *1996 TAGA Proceedings,* pp 577–588.

Larsen, C.E., "Process and Arrangement for Dampening the Flatbed Printing Forms of a Printing Press, Particularly in Offset Printing," *German Reich Patent 678,543,* Jul. 17, 1939 (in German).

Lawson, L. E., "Exposing and Processing Screenless Plates," 1978 TAGA Proceedings, pp 45–59.

Levy, L. E. and Levy, M., "Screen for Photomechanical Printing", *U.S. Patent 492,333,* Feb 21, 1893.

Lewis, T.E., Nowak, M.T., Robichaud, K.T., and Cassidy, K.R., "Lithographic Printing Plates for Use With Laser-Discharging Imaging Apparatus," *U.S. Patent 5,339,737,* Aug. 23, 1994.

Lewis, T.E., Nowak, M.T., and Robichaud, K.T., "Lithographic Printing Members Having Secondary Ablation Layers for Use With Laser-Discharging Imaging Apparatus," *U.S. Patent 5,353,705,* Oct 11, 1994.

Lind, J.T., GATF, personal communication, May 29, 1997.

Maltby, J.A., "The Toray Plate in Japan and the United States," *GATF 1986 Dampening Conference Proceedings.* pp 24-1 to 24-24.

Dylla, *Anilox Offset,* MAN Roland (Augsburg), June 12, 1997, 1 p.

Matalia, H., "Anilox Offset Press Technology Offers High Quality with Simple Inking System," *Presstime,* December. 1989, p 58.

Matalia, H.D., and Navi, M., "Method of Enhancing Inking in Offset Presses," *U.S. Patent 4,407,196,* Oct. 4, 1983.

Milton, W.H., and Greubel, P.W., "Roller for Applying Fountain Solution in Lithographic

Printing," *U.S. Patent 3,225,419,* Dec. 28, 1965.

Mitsubishi, *Keyless Tower Unit,* Mitsubishi Heavy Industries (Chiyoda-ku), HE90-C-OT44E1-A-O, June 1996, 4 pp.

Murray, A., "Halftone Screen," *U.S. Patent 2,311,071,* Feb 16, 1943.

Niemiro, T. A., "Keyless Inking System for a Printing Press," *U.S. Patent 5,315,930,* May 31, 1994.

Pobboravsky, I., and Pearson, M., "Study of Screenless Lithography," *9th IARIGAI Research Conference Proceedings,* 1967, pp 229–239.

Reardon, T., and Kirby, K. B., "Collotype, Prince of the Printing Processes," *Printing History,* American Printing History Association (New York), Vol. XIV, No. 1, 1991, pp 3–18.

Rowell, G.S., "Emulsoid Inks," *U.S. Patent 2,090,704,* Aug. 24, 1937.

Ruderman, M.M., "Planographic Printing Plate and Process," *U.S. Patent 3,282,208,* Nov. 1, 1966.

Savageau, R.G., Personal communication, Flint Ink Corporation (Ann Arbor, Mich.) Aug. 9, 1996.

Scheuter, K.R., and Fischer, G., "Frequency Modulated Screening," *GATF Technical Forum Proceedings—Process Developments, Process Measurements, and Productivity,* Oct. 7–9, 1985, pp 11-1 to 11-18.

Schläpfer, K., "Assessing Visual Noise Produced with Regular Screens, Random Screens, and Screenless Techniques," *1994 TAGA Proceedings,* pp 52–64.

Shafer, M., TKS (U.S.A.) Inc. (Richardson, Texas), personal communication, July 13, 1997.

Shell, *Hydrocarbon Solvents,* Shell Chemical Company (Houston, Texas), SC: 1056-91, June, 1991.

Singleterry, C.R., "The Control of Liquid Spreading," *Report of Naval Research Laboratory Progress,* July 1964.

Smethurst, P.C., "Reticulation in Gelatine Layers," *The British Journal of Photography,* Aug. 12, 1949, p 371–374.

Smethurst, P.C., "The Technical Background of the Collotype Process," *The Photographic Journal,* Vol 92B, 1952, p 115–123.

Stanton, A.P., and Warner, R.D., "Color Reproduction Characteristics of Stochastically Screened Images," *1994 TAGA Proceedings,* pp 65–91.

Stutzman, M. and Lind, J.T., "Tone Correction for Stochastic Screening," *GATF World,* Vol 6, Issue 6, 1994, pp 21–28.

TKS, *TKS Spectrum Double-Width Offset Presses,* TKS (U.S.A.) Inc. (Richardson, Texas), received 1997, 16 pp.

Tobias, P., Personal communication, Tobias Associates (Ivyland, Pennsylvania), 12/30/96.

Tyma, L., Personal communication (Hinsdale, Ill.), Sept. 9, 1996.

WIFAG, *Keyless, Short Yet Adjustable,* WIFAG (Bern), received June 1997, 8 pp.

WOA, "An Inside Look at Waterless/Single Fluid," panel discussion, Web Offset Association Annual Conference, May 6–8, 1996, reprinted in *The Hard Copy (WOA),* pp 100–104..

Wong, B., Xie, W., Strong, D., and Stone, R., "A Study of Waterless Web Offset Print Characteristics," *1995 TAGA Proceedings,* Vol. 1, pp 81–95.

Yule, J. A. C., "Halftone Screen," *U.S. Patent 2,292,313,* Aug 4, 1942.

Yule, J. A. C., F. B. Johnson, and A. Murray, "A New Type of Contact Screen," *Journal of the Franklin Institute,* Vol 234, No 6, December 1942, pp 567–582.

Glossary

anilox A trademark registered by Interchemical Corporation (the predecessor of Inmont) in the 1930's and used to designate the aniline process of printing that subsequently became known as flexo.

A-B problem Refers to differences that sometimes occur between odd and even prints or signatures on a web press equipped with blanket cylinders that are twice the diameter of the plate cylinder.

AIChE Acronym for American Institute of Chemical Engineers; New York, New York.

ANPA Acronym for American Newspaper Publishers Association. Former name of NAA.

ASTM Acronym for American Society for Testing and Materials; Philadelphia, Pennsylvania.

ANSI Acronym for American National Standards Institute, Inc.; New York, New York.

atomization The process wherein a fluid is disintegrated into small particles.

back cylinder Alternate name for impression cylinder on a sheetfed press.

bareback A compliant dampening system roller that is run without a fabric covering.

bearers Hardened steel rings mounted on the ends of printing cylinders used to control the center-to-center spacing between cylinders.

bit The smallest unit of information in a digital language. In the binary system, it has two possible states, e.g., on or off, zero or one, and light or dark.

bitmap An array of bit-controlled pixels used to define or store an image.

blanket A sheet of composite rubber material, mounted on a cylinder, used to transfer the inked image from plate to substrate or paper.

blinding The failure of an ink-receptive surface to accept ink.

bump exposure In the photographic screening process, an exposure supplementary to the main exposure, used to accentuate the highlight region of the image.

caliper Thickness.

capillary number Of a fluid film, product of fluid viscosity and characteristic velocity divided by fluid surface tension.

CCD Acronym for charge-coupled device. A semiconductor device consisting of an array of photo diodes for converting light energy into an electrical charge.

characteristic velocity Of a fluid film, the velocity of the member on which the film is spread, e.g., the surface of a roller bearing a film in question.

coldset Alternate name for non-heatset. Not to be confused with cold setting inks that are melted by heat during application, and are cured by the cooling that occurs when applied to a cold substrate.

color deck A printing couple installed on top of a newspaper printing unit.

compliance In a web of paper, the ratio of web elongation to applied tensile load, i.e., stretchability.

compressible A material that does not expand proportionately in a lateral direction when compressed in the longitudinal direction, i.e., undergoes a volume reduction when compressed.

computer to plate A process wherein a photographic plate is exposed by a scanning modulated beam of radiant energy, as from a laser, as opposed to exposure through a positive or negative photographic film.

conventional blanket A blanket constructed of materials that expand proportionately in a lateral direction when compressed in the longitudinal direction, i.e., retain the same volume when deformed.

couple In newspaper printing, one half of a perfecting printing unit.

critical toning temperature In waterless printing, the temperature of the plate above which toning occurs.

CTP Acronym for computer to plate.

CUIM Acronym for continuous undulating inking mechanism.

curing The process wherein a wet printed ink film is converted to either a very viscous liquid or a solid film that has adequate resistance to ruboff and wear in the design end use of the printed product.

cutoff Repeat length in web printing. Usually a submultiple of plate cylinder circumference, e.g., 1/3, 1/2, or 1.

cylinder undercut On a printing cylinder, the height of the bearer surface above that of the cylinder body.

densitometer An instrument for measuring density.

density In printing, the logarithm, to the base ten, of the ratio of two light intensities. See reflection and transmission density for further definitions.

DIN Acronym for Deutsches Institut für Normung e.V., Munich, Germany.

direct lithography A form of lithography wherein the inked image is transferred from plate to paper, i.e., no blanket is used.

doctor Any wiper or scraper type device such as a rod or blade for removing fluid from a surface.

dot gain Any real or apparent change in the size of a halftone dot that occurs during reproduction, e.g., in duplicating a film, imaging a plate, or printing.

doubling A form of slurring that occurs in printing and characterized by the appearance of a second slightly misplaced image of the same dot.

driography An early name given to the waterless printing process by the 3M company.

drying In ink curing, any chemical process that causes a wet ink film to be converted to a solid.

ductor A roller that swings back and forth between two positions to alternately contact a slow-moving roller in one position and a fast-moving roller in the other position.

elastomer Any polymer material having elastic properties similar to natural rubber.

EHL Acronym for elastohydrodynamic lubrication.

emulsification The formation of an emulsion.

emulsion The dispersion of small globules of one liquid in a second liquid with which the first will not mix, e.g., a water-in-ink emulsion. See also *micro-emulsion.*

exposure The act of exposing a sensitive photographic film or plate to radiant energy, e.g., light. The magnitude of exposure is defined as the product of the intensity of the incident energy and the duration of the exposure.

finishing Various operations, such as folding, trimming, and cutting to length, that are performed following printing to produce a final product such as a brochure or newspaper.

flash exposure In the photographic screening process, an exposure supplementary to the main exposure, used to expand the tonal range of the screen at the shadow end.

flexo Flexography, a form of letterpress printing that utilizes compliant plates and relatively fluid inks. Formerly known as the aniline or anilox process.

FOGRA Acronym for Deutsche Forschungs-gesellschaft für Druck-und Reproduktions-Technik e.V.; Munich, Germany.

form The design or layout of images to be printed, as appearing on a plate.

form roller Any press roller that is run in contact with the plate cylinder.

fountain A reservoir on a press for storing either ink or fountain solution.

fountain solution The fluid applied to a lithographic plate so as to form a thin film thereof on the nonimage areas and thereby prevent the transfer of ink thereto, thus providing discrimination (to ink) between image and nonimage areas of the plate.

free water Fountain solution present on inking rollers and plate image areas but not emulsified in ink.

GATF Acronym for Graphic Arts Technical Foundation; Pittsburgh, Pennsylvania.

gear streaks Horizontal streaks with regular spacings that correspond to the pitch of the cylinder drive teeth.

ghost The appearance of an unwanted phantom-like reproduction of either a pattern or the edge of a pattern that appears somewhere else on the form being printed. Caused by mechanical or chemical ghosting.

ghosting, chemical Abrupt variations in appearance of printed areas caused by abrupt changes in ink gloss.

ghosting, mechanical Abrupt variations in print density caused by the uneven films of ink that are left on the form rollers by the difference in ink transfer to image and nonimage areas of the plate.

grain A finely roughened surface as in a grained plate.

gravure A printing process in which the image areas on the plate are recessed, i.e., in the form of wells.

half deck An alternate name for color deck.

halftone An image in which tone gradations are achieved by varying the size or spacing of lines or dots of uniform density or ink film thickness.

heatset A form of printing wherein the wet printed ink film is set by conversion to a very viscous liquid using heat to drive off or evaporate the bulk of the ink oil.

hertz Cycles per second.

hickey An unwanted spot, usually in the shape of a doughnut, that appears in a solid printed area. Also the name given to the foreign particle that produces it.

highlight A light area of a photograph or picture.

hydrophilic An alternate term for water-receptive.

IARIGAI Acronym for International Association of Research Institutes for the Graphic Arts Industry. Current president is Anders Bovin of IMT.

IFRA The International Research Association for Newspaper Technology, Darmstadt, Germany. (IFRA is the acronym for IFRA's predecessor, INCA Fiej Research Association, wherein INCA is the acronym for International Newspaper Colour Association).

IGT Acronym for now defunct Netherlands Research Institute for Printing and Allied Industries.

image area The printing area of a plate, blanket, or print.

imagesetter A high-resolution device for outputting an image onto paper, film, or plate.

IMT Acronym for The Institute for Media Technology, Stockholm, Sweden.

ink coverage The fraction of a plate or print taken up by image areas, usually expressed as a percentage of the maximum printable area.

ink gloss Surface shininess or luster of a printed ink film.

ink keys Controls for adjusting ink feedrate in the across-the-press direction.

ink-receptive A material is said to be ink-receptive if it is wet by ink in the presence of fountain solution.

ink/water balance Any given combination of ink and water feed settings in a printing unit.

in-line finishing Finishing operations carried out on a printing press in conjunction with, and generally subsequent to, printing.

intaglio A form of gravure printing that utilizes very pasty inks. So named because it originated in Italy.

interfacial surface free energy A material property that is defined as the work necessary to create a unit area of additional surface. Its value is dependent on the second material with which the interface is formed.

interfacial surface tension Alternate name for interfacial surface free energy.

keyless inking system An inking system in which controls for adjusting ink feedrate in the across-the-press direction are not required.

levels of gray The number of shades or tones of a given color.

LTF Acronym for Lithographic Technical Foundation, former name of GATF.

macroslip Gross slippage between two contacting rollers caused by a mis-match in driving speeds, i.e., the slip existing over and above microslip.

master An alternate name for a printing plate.

mean resident time In a fluid system, the average time spent by a fluid particle in a given region of interest. It is usually equal to the volume of the fluid in the given region divided by the volumetric flow rate of the fluid through the region.

metering The act of controlling the amount of fluid that passes through an opening or a conjunction.

metering angle In a system consisting of a metering blade and a roller, the angle formed between the metering blade surface and the tangent to the roller.

metering element A device such as a rod, blade, or roller used in conjunction with a second element, such as a roller, for metering.

micro-emulsion An emulsion in which the sizes of the dispersed fluid droplets are much smaller than the wavelength of light, i.e., much smaller than 0.4 microns.

micron One millionth of, or 10^{-6}, meters. One micron equals 0.0394 thousandths of an inch (0.0000394 inch).

microslip Slippage between a compliant-surfaced roller running in contact with a rigid roller due to changes in the tangential strain in the compliant roller surface as it passes through the common nip.

midtone A region of a photograph or picture having a tone midway between the highlights (very light) and the shadows (very dark).

mil One thousandth of an inch. One mil equals 25.4 microns.

modulus of elasticity A material property defined as the slope of the curve of applied uniaxial stress versus resulting strain in the same direction, in the elastic region, i.e., in the region where no permanent deformation occurs.

Mohs' number A measure of hardness used by mineralogists that ranges from zero to ten wherein the hardest material, diamond, is assigned a hardness of ten.

moire An undesirable pattern, distinct from its components, that is produced by superimposing a repetitive design on the same or different design.

monotone printing Printing consisting of a single tone of color as in line work or text.

NAA Acronym for Newspaper Association of America; Reston, Virginia.

nanometer One billionth or 10^{-9} meters. One nanometer is equal to 0.001 microns.

NAPIM Acronym for National Association of Printing Ink Manufacturers; Hasbrouck Heights, New Jersey.

negative working A photographic plate wherein the unexposed energy-sensitive coating is hardened or insolubilized by exposure.

newsprint Uncoated paper upon which newspapers are printed.

nip The contact area formed at the conjunction of a roller or a cylinder with a surface, such as another roller or cylinder.

nonimage areas The nonprinting area of a plate, blanket, or print.

non-heatset Any form of printing wherein ink is cured solely by absorption of ink oil into the substrate to produce a surface film of very high viscosity.

nonwetting The condition where the contact angle between a drop of a given liquid on a given surface, as defined in Figure 1.7, is greater than 90 degrees.

NPIRI Acronym for National Printing Ink Research Institute; Bethlehem, Pennsylvania.

Nyquist's criterion In the theory of sampling systems, states that the sampling frequency must be twice the bandwidth of the input in order to extract all information from the input.

offset Alternate name for the lithographic printing process. Derived from the fact that the inked image on the plate is first transferred, or offset, to the blanket and then transferred to the paper.

oleophilic Alternate term for ink-receptive.

overshot In an ink fountain, refers to an arrangement where metered ink flows out over the top of the fountain roller.

packing Thin precision-thickness sheets of paper or the like placed under plates and blankets to adjust squeeze.

packing gauge A device for measuring the height of a blanket or plate relative to the bearer height, and hence the amount of packing beneath.

perfecting press A press capable of printing on both sides of the paper during one pass through the press.

photographic plate A plate with a radiant energy-sensitive coating that is imaged by exposure thereto and subsequent development.

PIA Acronym for Printing Industries of America, Alexandria, Virginia.

piling Debris that builds up on the rollers and cylinders of a press.

PIRA Acronym for the Research Association for the Paper and Board, Printing and Packaging Industries; Leatherhead, England.

pixel Picture element.

plate In printing, an element, in the form of a relatively thin sheet, that carries the inked images or form that is repetitively transferred to paper.

plate coverage Same as ink coverage.

Poisson's ratio The ratio of lateral strain to longitudinal strain under the condition of uniaxial stress in the longitudinal direction, in the elastic region, i.e., in the region where no permanent deformation occurs.

positive working A photographic plate wherein the unexposed energy-sensitive coating is softened or solubilized by exposure.

printing cylinder Any one of the plate, blanket, or impression cylinders on a press.

printing nip In a printing press, the cylinder conjunction in which ink is transferred to paper.

raster An array of parallel paths that are traversed in succession to either record or produce an image.

raster image processor Hardware or software for converting images, stored as either bitmaps or vectors, to serial form as a prelude to creating a raster image.

reflectance factor In densitometry, ratio of the light intensity reflected by a target area to the light intensity reflected by a perfect reflector.

reflection density In densitometry, the logarithm, to the base ten, of the reflectance factor.

release The collective properties of a blanket that control the amount of force needed to peel the printed paper from the blanket surface.

R & E Council Shortened name for Research and Engineering Council; Chadds Ford, Pennsylvania.

reverse A small nonimage area within an image area or solid.

reverse dampening The process of applying water at a point on the plate beyond the point or points where ink is applied.

reverse lithography A lithographic process that employs a water-based ink and an oily fountain solution.

RIP Acronym for raster image processor.

RIT Acronym for Rochester Institute of Technology; Rochester, New York.

RMA Acronym for Rubber Manufacturers Association; Washington, D.C.

roll A web of material rolled up, e.g., as in a roll of paper.

roller A cylindrical member that is rotated about its own axis.

roller train An assembly of touching rollers designed to transport a fluid, in film form, from one point to another.

roughness A property that quantifies the height of the microscopic hills and valleys on a surface. Unless otherwise defined, the surface roughnesses given in this book are average roughnesses, denoted by R_a. These are defined as the average distance of the hills and valleys above and below a theoretically perfectly flat surface located midway between the hills and valleys.

RTF Acronym for roller top of (folder) former.

runout A type of ghost caused by an abrupt change in ink transfer to the plate in the around-the-cylinder direction, as at the edge of a solid.

screen A rectangular grid for producing halftones by the photographic method.

screening The process, either photographic or electronic, of producing a halftone image.

screen ruling The frequency of dots in a halftone image. Derived from the frequency of lines on a screen used to produce a halftone.

scumming A form of toning caused by insufficient water feed to the plate, or failure of the nonimage area on a plate.

sensitized In plate technology, any surface that responds to exposure to energy, such as light, is said to be sensitized. In lithographic printing, any surface that is ink-receptive is said to be sensitized.

setting In ink curing, the process of converting a wet printed ink film to a highly viscous liquid such that operations like trimming can be carried out without smudging the ink.

shadow A dark area of a photograph or picture.

sharpening In halftone dot reproduction, a reduction in the size of the dots, i.e., negative dot gain.

shear rate The rate of shearing strain. For the case of a fluid between two parallel flat sliding plates, it is the ratio of the relative velocity of the plates to the distance between the plates.

sheetfed press A press used to print on sheets of paper fed from a stack or pile.

signature A folded printed sheet.

sinking Uniform reduction in blanket thickness due to the repeated compressions and relaxations that occur through use.

slip nip A roller conjunction characterized by the presence of macroslip, i.e., by gross slippage between the two roller surfaces.

slurring The spreading of a halftone dot in one direction.

smearing A form of slurring caused by relative motion, during transfer, between the surface transferring the dot and the surface receiving the dot.

snowflaking A print defect in the form of small white spots in a solid area.

spreading In halftone dot reproduction, an increase in the size of the dots, i.e., positive dot gain.

squeeze The magnitude of interference between contacting rollers or cylinders.

squeeze roller A compliant roller run in conjunction with a rigid roller for the purpose of limiting the amount of fluid that passes through the conjunction or nip.

steady state A stable condition where the variables of interest are substantially unchanging relative to time.

streaks A print defect in the form of an unwanted line or lines.

stress In mechanics, load per unit area.

stripe The width of the contact area between touching rollers.

stripping In lithographic printing, the failure of ink to wet a roller surface that is normally ink-receptive.

substrate A material on which a pattern or form is printed such as paper, plastic, or metal.

surface finish Alternate term for roughness.

surface plate A plate wherein the image or nonimage areas are formed by the removal of an extremely thin coating, i.e., where there is no etching of the base metal.

surface tension Interfacial surface free energy of a liquid, with respect to air, unless otherwise stated.

SWOP Acronym for Specifications Web Offset Publications. SWOP Incorporated has an office in New York, New York.

tack In fluid film splitting, at the exit of the nip formed by two rollers, the negative pressure generated beyond the nip exit, resulting in the manifestation of tensile forces exerted on the diverging films and roller surfaces.

TAGA Acronym for Technical Association of the Graphic Arts; Rochester, New York.

TAPPI Acronym for Technical Association of the Pulp and Paper Industry; Atlanta, Georgia.

thermal plate A type of photographic plate wherein exposure to radiant energy results in the generation of heat in the energy-sensitive coating.

threshold value of exposure The minimum exposure necessary to produce a change in a high-contrast film, e.g., to change a negative film from light to black.

time constant In a system whose transient response can be described by a first-order differential equation, the time required for the output to change 63 percent of the steady state change produced by a step change in the input.

tinting A form of toning caused by dispersion of ink in fountain solution.

tone Shade of a color, e.g., as with gray being a shade of black.

toning A print defect wherein nonimage areas randomly accept ink.

torque The measure of a force's tendency to produce a rotation about a given point, expressed as the product of the magnitude of the force and the shortest distance between the line along which the force acts and the point or axis of rotation, in foot-pounds or like units.

transfer roller The name generally reserved for any non-vibrating roller that is used to transport fluid from one roller to another.

transmission density In densitometry, the logarithm, to the base ten, of the ratio of incident light intensity to the intensity of light passing through a target area.

true rolling Rolling action wherein there is zero macroslip.

tympan On a rotary printing press, a thin sheet of paper or the like covering the impression cylinder. Used on letterpresses to adjust printing pressure.

tympan cylinder Alternate name for the printing cylinder that presses against the plate cylinder, e.g., the impression cylinder in letterpress and direct lithography, and the blanket cylinder in offset lithography.

unit cell The smallest elemental shape in a repetitive geometric pattern.

UGRA Acronym for Verein Zur Forderung Wissenschaftlicher Untersuch-unggen in Der Graphischen Industrie (Association for the Promotion of Research in the Graphic Arts Industry); care of EMPA, ST-Gall, Switzerland.

vector A mathematical expression for defining some part of an image in terms of a geometric shape.

vibrating roller A press roller that is caused to oscillate back and forth along its axis.

vibrator Another term for a vibrating roller.

viscoelasticity A material property wherein the response to the application of a stress or load is part elastic and part viscous.

viscosity A fluid property defined as the ratio of the shearing stress to the shear rate generated by the fluid when subjected to a given rate of shearing strain, i.e., the resistance a given fluid presents to flow.

water-receptive A material is said to be water-receptive if it is wet by fountain solution in the presence of ink.

web press A press used to print on a web of paper fed from an unwinding roll.

wetting The condition where the contact angle between a given liquid drop on a given surface is close to zero so that the liquid spreads over the solid easily.

WOA Acronym for Web Offset Association, an affiliate of PIA, Alexandria, Virginia.

Young's modulus Alternate name for modulus of elasticity.

Index

About the Author

John MacPhee is an engineer with a career in research and development that spans over 45 years. For the past 25 years he has worked for Baldwin Technology, first as Vice President of Engineering, then as Vice President, Research and Technology, and currently as Senior Scientist.

During his tenure at Baldwin, he co-invented two of Baldwin's most successful products: the cloth/pressure-pad type of automatic blanket cleaner and the Delta Dampener. MacPhee also carried out many research programs that led to a better understanding of the lithographic process. With the encouragement and cooperation of Baldwin, this newly gained knowledge was shared with the industry through the publication of over 50 articles and papers on various aspects of lithographic technology.

Earlier in his career, MacPhee made an important contribution to the understanding of deep-drawing, a metalworking process, by developing and publishing a rationale for sizing the tooling used in redrawing. He also worked in the field of industrial robots for almost five years, and as a nuclear engineer/reactor physicist for thirteen years.

His career is marked by over 20 inventions in the nuclear, industrial robot, and graphic arts industries that have been the subject of over 100 patents worldwide.

MacPhee was first trained as an electronics technician in the U.S. Navy where he achieved the rank of Petty Officer, First Class. In 1952, he graduated from Rennselaer Polytechnic Institute with a bachelor of electrical engineering degree. He was also trained as nuclear engineer as a result of completing the one-year program at the Oak Ridge School of Reactor Technology in 1954. In addition to subsequently completing six graduate courses in servo technology and materials science, MacPhee obtained a masters degree in business policy from Columbia University in 1983.

MacPhee's contributions to the graphic arts industry have been recognized by three awards: The TAGA Honors Award, from the Technical Association of the Graphic Arts; the Robert F. Reed Award for Technical Achievement, from the Graphic Arts Technical Foundation; and the Craftsman's Award, from the National Association of Printers and Lithographers.

John and his wife of almost 50 years reside in Rowayton, Connecticut. He can be contacted by email at the following address: JMacPhee@JUNO.COM